ROBERT GWATHMEY

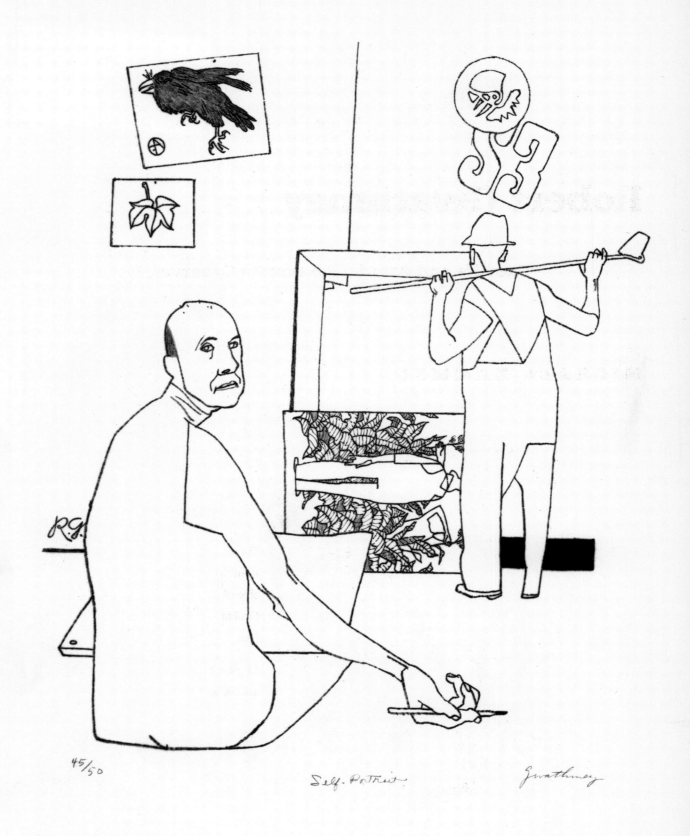

45/50 Self Portrait Gwathney

Robert Gwathmey

The Life and Art of a Passionate Observer

MICHAEL KAMMEN

The
University
of North
Carolina
Press

Chapel Hill
and London

© 1999 The University of North Carolina Press. All rights reserved. Designed by April Leidig-Higgins.

Set in Monotype Joanna by Eric M. Brooks. Manufactured in Hong Kong. The paper in this book meets the

guidelines for permanence and durability of the Committee on Production Guidelines for Book Longevity

of the Council on Library Resources. **Library of Congress Cataloging-in-Publication Data** Kammen, Michael G.

Robert Gwathmey : the life and art of a passionate observer / Michael Kammen. p. cm. Includes biblio-

graphical references and index. ISBN 0-8078-2495-X (cloth: alk. paper).—ISBN 0-8078-4779-8 (pbk.: alk. paper)

1. Gwathmey, Robert, 1903–1988. 2. Artists—United States—Biography. I. Title. N6537.G9K36 1999

759.13—dc21 98-48441 CIP. **Frontispiece:** Fig. 1. *Self-portrait* (1961), lithograph, 17 1/4 × 15. Courtesy of the

Terry Dintenfass Gallery, Inc., New York. **Details:** p. vi, from *Bread and Circuses* (plate 16), Museum of Fine Arts,

Springfield, Mass.; pp. viii–1, from *City Scape* (plate 28), Terry Dintenfass Gallery; p. 12, from *From Out of the South*

(plate 1), Smart Museum of Art; p. 34, from *Poll Tax Country* (plate 4), Hirshhorn Museum and Sculpture Garden;

p. 148, from *The Observer* (plate 31), National Museum of American Art; p. 184, from *End of the Season* (plate 48),

William M. Landes; p. 204, from *Painting of a Smile* (plate 22), Sheldon Memorial Art Gallery.

03 02 01 00 99 5 4 3 2 1

Publication of this book was supported by the Wachovia Fund for Excellence.

For Elizabeth Trapnell Rawlings and Hunter R. Rawlings III

Virginians by birth and tradition

Ithacans by persuasion and affection

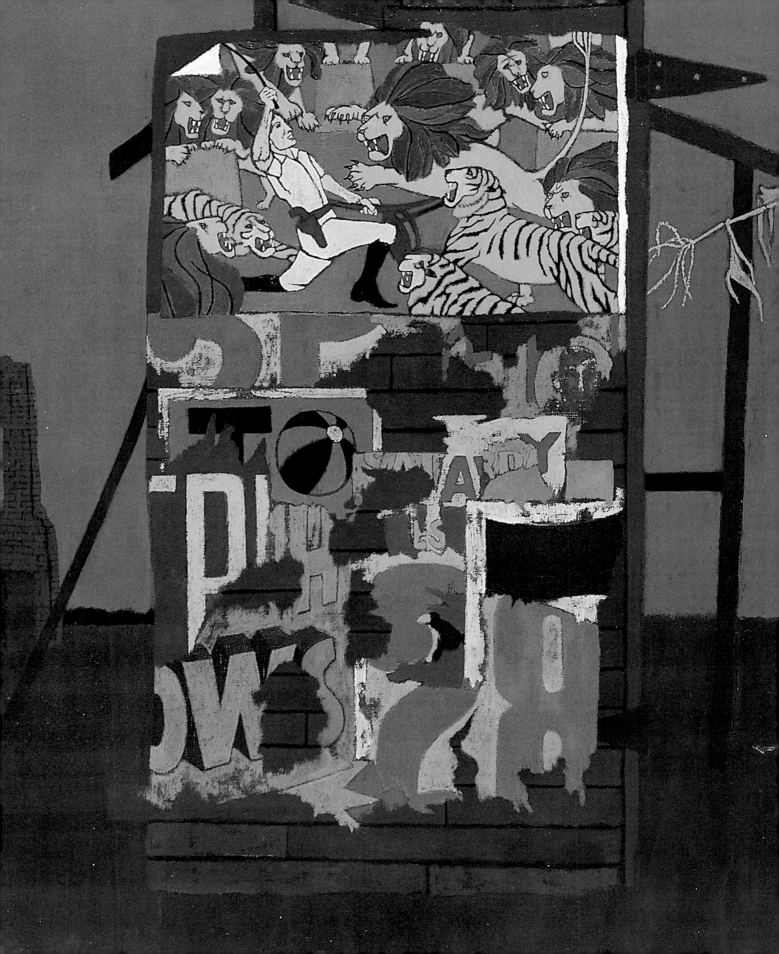

CONTENTS

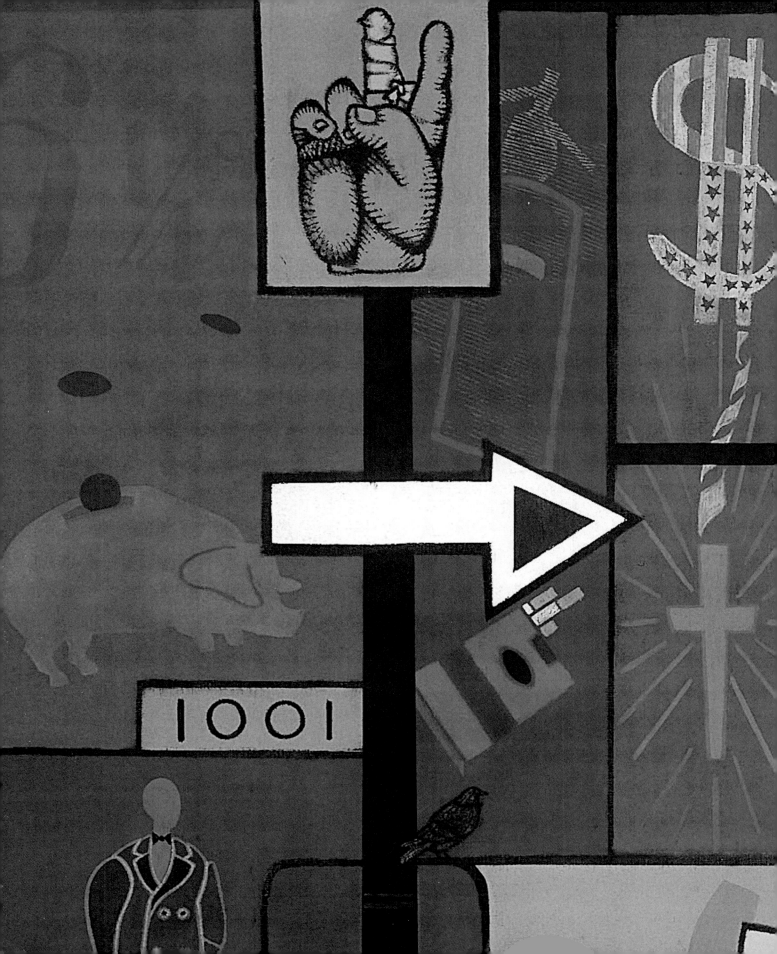

If you are a canvas do you shudder sometimes when the painter stands before you? All the others lending their color to him. A composition being made. Himself the composition. . . . Consciousness of brown men, brown women, coming more and more into American life—by that token coming into him too.

—**Sherwood Anderson,** *Dark Laughter* (1925)

You can't understand it. You would have to be born there.—**William Faulkner,** *Absalom, Absalom!* (1936)

I was not leaving the South to forget the South, but so that some day I might understand it, might come to know what its rigors had done to me, to its children.—**Richard Wright,** *Black Boy* (*American Hunger*) (from the conclusion added to the 1945 edition), referring to his trip on a northbound train in 1927.

I am constantly observing.—**Robert Gwathmey,** July 30, 1967

INTRODUCTION

We know from the men and women who were closest to him that Robert Gwathmey, despite being delightfully charming and loquacious—a captivating raconteur—customarily remained reticent about his own art. He simply would not talk about it—certainly not about particular paintings and their composition and meanings. Like many other artists, he did not want to believe, nor did he want to lead others to believe, that what he did visually could be expressed adequately in words. On occasion, when the curator of a museum that had purchased one of his works would request a written statement for the institution's archives, he would oblige, but never with full disclosure concerning autobiographical aspects of the work. Innate modesty and disdain for the pretentious chastened him. The same inhibitions prevented him from putting dates on his work, except for one oil painting in 1946, *Field Flowers* (fig. 21), and a second in 1948. Why he dated those alone is unclear; most likely they were brief lapses.[1] In 1977, when the curator for archives at the Hirshhorn Museum and Sculpture Garden in Washington, D.C., asked him for autobiographical information, Gwathmey wrote, "I've never kept records, as it were, thinking it pretentious or something." Gwathmey did not anticipate immortality.[2]

Unlike some artists, he did not keep a journal concerning his work, nor was he a prolific correspondent. Yet he did, when pressed, reply to general questions about art and his overall outlook as a painter. In response to that same inquiry from the Hirshhorn, which came late in his career, he made this acknowledgment: "I consider myself a 'social realist.' I'm interested in the human figure and the human condition." In a 1966 interview that he gave in conjunction with an exhibition at the Brooklyn Museum that included several of his paintings, Gwathmey replied to an inevitable question (Is there a "moralizing tone" in your paintings?) by declaring, "I don't feel like a moralist at all. I feel like an observer."[3] That description happens to be the title of one of his most important and meaningful works (see Chapter 6) as well as a phrase that recurs numerous

times in interviews and occasional writings that he has left. Indeed, with rare exceptions his work is not preachy. It contains social and moral messages—points of view, to be sure—but it describes, and it even satirizes, without becoming didactic.[4]

Social Realists sought to use art to identify and protest injustices to members of the working class, exposing brutalities that the artist believed to be the result of capitalist exploitation or racism or the presumed privileges of higher social status. Social Realism is perceived by many critics to have been the dominant mode of artistic expression in the United States during the 1930s and 1940s. The other major movement at that time, American Scene Painting, or Regionalism, seems to be better remembered today, and perhaps better represented in many museums, than Social Realism. But as several scholars have remarked, almost every issue of any art journal during the 1930s and early 1940s included an article, review, or story on some aspect of Social Realism or the political role of the artist in the United States during the Depression.

Social Realists had little use for the nineteenth-century notion of art as primarily a mode of self-expression and a contribution of aesthetic value. Instead, they preferred to think of art as a means of communicating social values in a critical yet constructive way. Their paintings showed the wretchedness of unemployment, the fortitude of workers (however desperate their circumstances), the insensitivity and corruption of the ruling class, and the degradation of poverty. Their art exposed privilege and pretense, demanded social justice, and issued a call for major changes in the prevailing socioeconomic system.

Social Realism and Socialist Realism are virtual opposites in terms of attitude. The former, as noted, emphasizes the negative aspects of life under capitalist exploitation and opposes the ruling class. The latter, as it developed in the Soviet Union, was meant to support the governmental system and glorify the ruling class (ostensibly "the people"). It emphasized the positive aspects of life under socialism, such as cheerful, industrious workers and the wonders of productive factories and fertile agricultural areas. During the 1930s and 1940s there were few, if any, misunderstandings in the United States about the differences between Social Realism and Socialist Realism. Such misperceptions did occur, however, during the anticommunist frenzy following World War II, most notably in Congress.

Because of Robert Gwathmey's habitual reticence, in order to understand and appreciate his art and the influences that affected him, we must notice the stories of southern contemporaries such as Erskine Caldwell, study the documentary photographers of the later 1930s, and look broadly at European art from Goya to Picasso, both of whom Gwathmey admired deeply, as well as caricatures by Honoré Daumier and peasant scenes by Jean-François Millet. Gwathmey's appreciation of Western art ran almost as deep as his internalization of southern culture. Regarding the latter, consider, for example, Gwathmey's somewhat enigmatic self-portrait, drawn in 1961 at the request of his new dealer, Terry Dintenfass. Why has he positioned himself so awkwardly? (See the frontispiece, fig. 1.)

On August 23, 1959, Robert Penn Warren, a Kentuckian educated in Tennessee who also came north to make a career, published a misunderstood novel called *The Cave*. That title invited symbolic interpretation because it used an epigraph from Plato's *Republic*, with its allegory of the cave whose occupants, turned toward a wall, mistake the shadows they see for reality. Warren regretted that emphasis and explained that he had originally intended to title the novel *The Man Below*. The man below, he explained, "is the man inside, of course, inside you. The submerged man in you and the man in the ground." Warren may well have been responding to Ralph Ellison's *Invisible Man* (1952), and Gwathmey, a sympathetic painter of African American life, very likely responded to both Warren and Ellison.[5] There may also be a much less cerebral explanation, however. Robert Gwathmey customarily painted from a seated position rather than standing at his easel. (See fig. 47.)

The symbols that Gwathmey included in his self-portrait range from enigmatic to self-evident, which is characteristic of all his art. The ubiquitous crow (in this instance deformed), represented Jim Crow and segregation. Barbed wire, so commonly used in the rural South, connoted segregation as well, but also the inhumane economic treatment of African Americans (see fig. 13). The lynching rope is self-explanatory. The sharecropper in bib overalls with a hoe, and tobacco as well as barns also appear frequently in his work. Images of the rooster or cock's head are a bit more complicated. Gwathmey was raised by his mother and three older sisters, who never married. There were also numerous aunts nearby, and they all adored Robert. Hence he was the only male in the hen house, so to speak: the cock of the walk.[6]

The number "666," pervasive in Gwathmey's art, referred to a widely used southern elixir that was considered a cure-all for just about any conceivable ailment, a metaphor in Gwathmey's mind for southern self-deception and foolishness. The number "666" is also the symbolic number designated for the Antichrist in *Revelation* 13:18, so it has apocalyptic connotations, particularly in popular prophetics for evangelical Christians. The people who concocted this elixir presumably wanted to imply that it would serve as the ultimate antidote for whatever ailed you—that it could literally knock the devil out of you, so to speak.

It is entirely possible that "666" appealed to Gwathmey as an iconic symbol for a reason that went beyond its aggressive appearance on posters advertising the elixir all over the South. A close reading of *Revelation* 13:16–18 can also reveal a condemnation of commercialism or even capitalism as an evil system of constraint. The crucial passage refers to the "image" of the beast (Antichrist): "It causes all, both small and great, both rich and poor, both free and slave, to be marked on the right hand or the forehead, so that no one can buy or sell unless he has the mark, that is, the name of the beast or the number of its name. This calls for wisdom: let him who has understanding reckon the number of the beast, for it is a human number, its number is six hundred and sixty-six." So "666" now served as the name of the necessary antidote to evil, and if the beast could be destroyed, the necessity for buying and selling might be minimized. What iconology

could possibly be more appealing to a Marxist like Gwathmey? And to think that posters for "666" were omnipresent throughout the rural South!

For the most part, Gwathmey's symbols are not particularly subtle. He did not wish to be obscure. He wanted his meanings to emerge with bold clarity. His personal and intuitive style conveyed warmth and open-hearted generosity, a genuine desire to relate to people through his art and his effusively genial personality. Those paintings that are somewhat less accessible, mostly done later in his career, were done "for himself," I believe, and gave vent to feelings such as frustration about the trajectory of his work and his views about contemporary art. (See plates 41, 44, and 45.)

Gwathmey's temperament and gregarious persona were so distinctive that he became an unforgettable figure for anyone who met him. A marvelous storyteller, his rich Tidewater drawl sounded enthralling even when it seemed a bit difficult to understand. Several of his closest friends believe that he appeared to be so outgoing in order to disguise an innate shyness. Several also testify that if he spoke too fast, he might stutter. Gwathmey related to others in a manner so courtly, engaging, and natural that he could utter a string of four-letter words in the course of an ordinary conversation without seeming profane. He enjoyed talking about other artists but almost never in a mean or catty way. Moreover, Gwathmey could be a harsh critic of his own work. He frequently destroyed newly finished paintings—thereby exasperating Rosalie, his wife and favorite model— and invariably felt virtuous when he did so.[7]

Gwathmey presented a distinctively colorful appearance as well as a unique persona. Friends regarded him as the most spectacularly attired artist. He liked gingham shirts; but they were not readily available in the 1940s and 1950s, so Rosalie made them for him. Attired in complementary hand-knit argyle socks, tweed jackets, and trousers in assorted colors, he cut quite a figure—almost as vivid as his own paintings.[8]

Considering his sartorial concerns and the obvious love of coloristic patterns and effects manifest in such works as *Poll Tax Country*, *Winter's Playground*, and *Sunday Morning* (plates 4, 6, and 9), it would be easy to dismiss Gwathmey as a brilliant, almost obsessive colorist; yet we know from his own words as well as many other compositions that structural coherence mattered even more to him than decorative effect. In several conversations he acknowledged that "I am more interested in the two-dimensional than the three-dimensional. I like color next to color rather than light and shadow, and shape next to shape." Ultimately, however, Gwathmey insisted that excellence in art did not arise from "ornamentation or surface pyrotechnics. Beauty never comes from decorative effects but from structural coherence."[9]

I have two principal objectives in the pages that follow. First, I want to understand and explain the intimate relationship between Gwathmey's life and his art, for as he declared in a 1960 interview, "Every work of art done with conviction is autobiographical." In Gwathmey's case that seems to be especially true, yet his reticence about individual

works presents us with special challenges of interpretation. Milton W. Brown, a historian of twentieth-century American art and a friend of both Gwathmey and his closest pal, Philip Evergood, made the following observation about them. Most artists, and particularly Evergood, would say that his last painting was his best. Gwathmey, however, would say just the opposite: "My last is my worst." That stance epitomized Gwathmey's temperament, modesty, and diffidence. Despite a very palpable and physical exuberance, his sense of achievement was invariably undercut by sincere self-deprecation.[10]

My second objective is to develop and give voice to Gwathmey's aesthetic values, and especially the transformative way that he responded to certain artistic influences. Most of the analysis that we have of Gwathmey's work hitherto emphasizes his southern heritage and his use of regional themes and motifs.[11] Without denying for a minute the importance of both, I also want to explore what has always been ignored: the significance for him of certain European artists, above all Honoré Daumier (1808–79) and Jean-François Millet (1814–75). As Gwathmey himself acknowledged, "No man is an island unto himself. He is inexorably a part of tradition, [but] forever contemporary, and an integral part of the mores and attitudes of his day. . . . All great artists have shown influences of artists who have preceded them."[12]

The consequential validity of that insight has been demonstrated repeatedly in recent years—invariably with the inference that the influenced artists were not derivative as a result. Quite the contrary, their creativity would have been enhanced. For example, the later work of Filippino Lippi (1457–1504) was "inspired" by Leonardo da Vinci, and the ornamental vocabulary of Raphael was, in turn, inspired by Filippino Lippi. We know that Edgar Degas made copies of masters such as Leonardo, Andrea Mantegna, Quentin de la Tour, and Eugène Delacroix, even late in his life. (Delacroix himself had been deeply influenced by Goya.) In addition to Degas's obsession with the work of Ingres, he had so much respect for Daumier that when Degas died, he owned nearly 800 impressions of Daumier's prints. Finally, to shift generations as well as continents, Jackson Pollock made drawings from Michelangelo's motifs in the Sistine Chapel of the Vatican. During the later 1930s Pollock also made drawings based on works by El Greco, Rubens, and the great Mexican muralists José Orozco and David Siqueiros. These are eclectic selections, to be sure, but impressive validation, indeed, of Gwathmey's observation.[13]

As an artist, Robert Gwathmey was not simply a southern maverick who loved lively colors and hated social injustice. His mind and his vision were vastly more cosmopolitan than students of American art have hitherto recognized. In addition to Daumier (who provided a model for the art of social satire) and Millet (whose French peasants provided precedents for Gwathmey's sharecroppers and tenant farmers), Henri Matisse (1869–1954) supplied figural inspiration on occasion (see plate 10); Vincent Van Gogh offered challenges in terms of coloration, bold outlining, and rural subjects; and Picasso and Rufino Tamayo (1899–1991) legitimized innovative and brilliant coloration. Even Gwathmey's affection for the numeral "5" resonated from notable works by Charles Demuth and had echoes in Robert Indiana's art.

In a 1966 interview Gwathmey acknowledged that *The Hitchhiker* (fig. 2) marked the start of fashioning his own style. "It was my first breakaway. I thought it was a point of departure. That's right, like for instance, like you take an early Picasso drawing. If you, or an uninitiated person, or even me, could be persuaded, it may be a Lautrec. You take some of Lautrec's earlier drawings, they could be Degas. In other words, I mean don't be fearful of the person who precedes you. Just hope and pray you choose a good one to be influenced by. And I feel comfortable with my influence."[14]

Yet, beginning gradually in 1936–37 and developing rapidly after 1939, Gwathmey's style, mode of composition, use of flat two-dimensional figures boldly outlined, unusual color combinations, and forms of expression were distinctively his own. He had seen and internalized a great deal of diversity in artistic techniques but filtered that inchoate variety through a mind that had also imbibed an assortment of texts ranging from Thomas Mann to his fellow southerner Erskine Caldwell. Caldwell's classic story "Kneel to the Rising Sun" (1933) has its counterpart in Gwathmey's notable painting about the horror and hypocrisy of lynching, *Revival Meeting* (plate 19), and in the blood orange sky that he powerfully dramatized on occasion.

As with his artistic influences, however, Gwathmey did not imitate or even follow his literary sources slavishly. Far from it. In Erskine Caldwell's fiction, for instance, terrible, gut-wrenching events occur. There is an excess of violence and sexual depravity. In Gwathmey's art we are shown the *consequences* of undesired social circumstances: segregation, bodies distorted by rheumatic conditions, and sharecroppers trapped in cycles of peonage. Serenity prevails more often than sadness, however. We need not brace ourselves for shock. Instead we encounter dignity without sentimentalism, empathy rather than pity, biting satire without revulsion, and compassion rather than romanticization.

A small irony stemming from Gwathmey's youth somehow reverberates throughout his artistic career. As a student at John Marshall High School in Richmond, he performed in a minstrel show, taking the part of an end man. By the time he found his own vocational identity in 1940, it was as a white man depicting African American rural life. By the early 1950s, with works such as *Painting of a Smile* (plate 22) and *Painting the Image White* (fig. 39), Gwathmey offered wry yet unmistakable assaults on racism. After 1960 he took the process of "race mixing" a major step farther by painting figures whose racial identity was either ambiguous or indeterminate. Because of his commitment to a color-blind world, he created images whose humanity, but not their race, was evident.

Gwathmey's idealism emerged from what he frequently referred to as his Calvinism. That claim is credible so long as we do not confuse Calvinism with Puritanism, because Gwathmey found women and liquor irresistible. He indulged in the sins of the flesh despite being a committed moralist about social conditions and social relations. Perhaps we can simply call him a flawed Calvinist. He would not have complained about such a designation. In 1977, after all, at age seventy-four, he did repeat these words on a form that the Hirshhorn Museum sent him: "I'm interested in the human figure. Also the human condition." I earnestly hope that the essential humanity of this deliberately two-

FIGURE 2
The Hitchhiker (1936),
oil on panel, 30 × 36.
Brooklyn Museum of Art.
Gift of David Teichman.

dimensional painter emerges in a three-dimensional way in the pages that follow. He had a hearty laugh, and I believe that that asymmetry would have amused him.[15]

This book is offered to the reader as a requiem for an unusual artist, a man who continually composed his own requiem for his native region, which he somehow managed to regard with a modicum of affection along with alienation, but without either bathos or bitterness. Gwathmey's requiem is resonant with William Faulkner's "rhetoric of blood," the sometime southern obsession with racial purity and separation. Gwathmey's requiem also responded to the "blood and soil mysticism" of a region that he only saw clearly and completely after he had left it for schooling in "the North," meaning Baltimore and Philadelphia. Returning home, his vision broadened and clarified. Then and only then could he achieve the attitude that underwrote his requiem for the South.

A note about primary sources is in order here. Gwathmey gave two lengthy interviews in 1966 and 1968 (which have been transcribed but remain unpublished) as well as an array of shorter interviews in conjunction with magazine or journal articles about his work. He also supplied a lengthy interview at his studio on July 30, 1967, with Karl Fortess that (to the best of my knowledge) is previously unknown. Restrictions prohibit its transcription; but it is an invaluable source of attitudes, and extracts from it can be quoted. These interviews are all essential for our purposes because they explicitly make clear Gwathmey's aesthetic concerns and provide a plethora of biographical information. For the latter, however, they must be used cautiously because Gwathmey's memory was more fallible than one might expect. (Just as he poured bourbon in his coffee or orange juice in the morning, he used spirits liberally to steel himself for an interview.) In his 1968 interview with Studs Terkel, for example, Gwathmey placed his Rosenwald Fellowship experience, when he lived and worked with tenant farmers on a North Carolina farm, in 1936. The actual year was 1944.[16] Errors as egregious as that one are not common, but readers must look at Gwathmey sources with care. He could be casual about chronology, and he loved the effect of a good tale well told.

I have quoted generously from the interviews for two reasons. First, because not many letters written by Gwathmey have survived, the interviews provide an abundance of autobiographical detail, much of which can be verified or checked through consultation with archival records and interviews with people still living who knew him well. Second, extracts from the interviews convey some sense of the speech patterns—occasionally repetitive and often highly colloquial—of a man beloved as a loquacious storyteller. Although I believe that the transcriptions of the tapes are essentially accurate, there are occasional slips that I have silently corrected. Where there are apparent lapses in grammar or curiosities in phrasing, the reader is asked to bear in mind that these quotations are from conversations that were meant to enhance the visual evidence of Gwathmey's views and career. They were never revised or edited with an eye to publication. I have tried to avoid a tedious sprinkling of *sics*, all the while respecting the integrity of the transcript. The benefit, I believe, lies in the feeling that we achieve for Gwathmey's distinctive Tidewater phrasing, word usage, and inflection.

All interviews conducted by the author of this book are simply cited in the notes as "interview with . . ." followed by the date. All interviews conducted by others during Gwathmey's lifetime are cited in the notes with the name of the interviewer, the date, and the location of the transcript or tape.

In the captions for the color plates and half-tone illustrations, the artist is Robert Gwathmey unless otherwise specified. Oil on canvas is denoted by o/c, and all dimensions are in inches, with height preceding width. Media other than oil are specified in full.

The title of each chapter in this book is taken from a major painting by Gwathmey that is especially pertinent to the period or focus of the chapter. All eight of these pictures appear in the book. The first one, *From Out of the South* (plate 1), was frequently re-

produced during the 1940s, particularly by the *New York Times Book Review* when it printed a review of a new book about the South. It is in many respects a reprise or overview of Gwathmey's early work: A curving road bisects two configurations of vignettes. In the lower right a white guard with a rifle across his shoulders supervises three black convicts toiling with pickaxes. Above that we see a compressed view (anticipatory) of *Ancestor Worship* (plate 2), and in the distance a billboard evokes *The Hitchhiker* (fig. 2). On the left a shabby service station (featuring a big pig emblazoned with "Bar-B-Q") has Gwathmey's signature posters plastered on one side: "666" and a tattered ad for the circus that has come and gone. Behind that, black sharecroppers tend young tobacco plants, and in the left foreground, misshapen, rheumatic black women are about to cross the road, heading toward the workers wearing prison garb. The painting provides a tour de force of Gwathmey's visual memories and an anticipation of his best-known art, mainly composed during the 1940s.

CHAPTER ONE

From Out of the South

Owen Gwathmey, a Welshman from the island of Anglesia, near the coast of Wales, emigrated to Virginia during the 1680s and settled in Gloucester County east of the York River in the Tidewater area, where he married Mrs. Cleverious, the widow of a German physician. They produced two children, and their line eventually became prolific. The Gwathmey stem of interest here had settled in King and Queen County north of Gloucester by the 1780s and subsequently established a continuing presence in the Richmond area for more than a century thereafter. By the mid-nineteenth century they had intermarried with Harrisons and Nicolsons, branches of older English families that had neither prospered notably nor achieved particular prominence. A few Gwathmey descendants moved on to Kentucky, favoring Louisville, but most remained in the environs of Richmond.[1]

Robert Gwathmey, the artist, an eighth-generation Virginian, was born on January 24, 1903, in Manchester, a community close to Richmond. His father, also Robert, a railroad engineer, had been born in Richmond in 1866 and died on May 27, 1902, eight months before Robert Jr. entered the world. He was killed instantly when his locomotive exploded. Witnesses could never obliterate the memory of seeing him blown forty feet in the air. Burial took place promptly the next day in Hollywood Cemetery. His wife, Eva Mortimer Harrison, two years younger than Robert Sr., had been employed as a public school teacher. She died near Petersburg, Virginia, on June 1, 1941, when a bus skidded into the station wagon in which she occupied the front passenger seat. Her daughter-in-law, Rosalie Hook Gwathmey, who was driving, and her two surviving daughters, Katherine and Ida Carrington, who were riding in the second seat, were severely injured. One of the daughters suffered cruel cuts and was partially scalped. The other lost a number of teeth in this collision. Robert, the artist, and his three-year-old

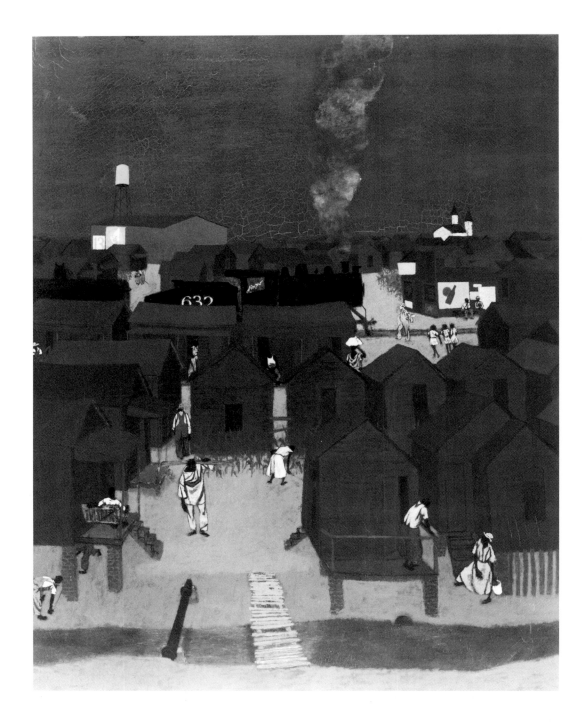

son, Charles, were seated in the rear of the wagon and escaped with bumps and bruises. Eva was buried next to her husband two days after the accident.[2] The sequence of strange tragedies is even longer. Eva and Robert Sr. had four children. The oldest, Mary Louise, died in 1923 at age twenty-six in a horseback riding accident.

Robert Gwathmey rarely mentioned the disastrous circumstances of his father's death.

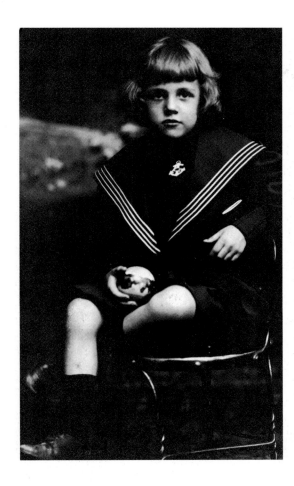

FIGURE 4
Robert Gwathmey (1909).
Private collection.

He would, on occasion, say that "I just made it," and his 1951 painting *Shanties* (fig. 3) features a steam locomotive and its tender in the middle distance. But bitterness about the past was not in his nature. Although he was sent to a Baptist Sunday school, religion did not "take" with him. In the winter of 1949–50 he wrote to a friend from Paris after reading the first short story developed by eleven-year-old Charles, "I lost control and laughed uncontrollably as in church."[3]

People remembered Robert as a spoiled child (see fig. 4), and he was considered a "mischievous boy" at John Marshall High School in Richmond. Despite poor grades, however, he stayed out of trouble and worked for three years on the Chesapeake and Ohio railroad as a "car attendant." While in high school he also had a job with a florist during several summers as well as Easter and Christmas. Learning to arrange flowers while still in his teens may help to explain his brilliance later as a painter of floral still lifes, though his preference would always be to paint field flowers rather than cultivated ones. (See plates 25 and 29.) Looking back in 1968, the year that he retired from teaching at the Cooper Union School of Art in New York, Gwathmey explained why he never used chiaroscuro in his art. "I was raised in Tidewater Virginia there where the land is

flat and the roads are wide. That's where I had all of my good times. And there you see everything in silhouette. You see a tree from its roots up to the topmost leaf. Whereas in some other part of the land, the Piedmont or the mountains, you would have, we'll say, a backdrop of landscape, a mountain as it were."[4]

Other legacies from Gwathmey's youth also influenced his art in critical ways. The Museum of the Confederacy, for example, is located in Richmond. There and elsewhere in town young Robert saw a surfeit of portraits of Confederate generals, so many of whom appeared pompous despite defeat. Those proud images provided Gwathmey with models to caricature when he wished to satirize southern politicians and puffed-up patricians excessively arrogant about their ancestors. (See plate 2, *Ancestor Worship*.)

Robert also retained vivid memories of store signs—for fishmongers, tailors, barbers, and the like—that he would later incorporate into his paintings along with logo-laden seed bags and weathered posters, which he saw plastered all over barns in the countryside, for events such as the circus. Turning to influences that must have been more overtly political, he read Edward Bellamy's utopian novel, *Looking Backward* (1888), and attended speeches given by Socialist Norman Thomas when he passed through Richmond on the summer lecture circuit. Those talks provided Gwathmey's introduction to impassioned political criticism from the left.[5]

At age nineteen Gwathmey took business courses at North Carolina State College in Raleigh (1922–23). When that seemed a dead end, he worked on a freighter that visited ports in Europe and the Americas. Following a preparatory year of study at the Maryland Institute of Design in Baltimore, he enrolled in 1926 at the Pennsylvania Academy of the Fine Arts in Philadelphia and studied there for four years, winning the prestigious Cresson scholarships that enabled him to travel in Europe during the summers of 1929 and 1930. Modest sums sent by his sisters could not begin to cover tuition and living expenses, so Gwathmey cobbled together an array of jobs during his student years. He did filing for the *Philadelphia Inquirer* three nights a week, worked as a handyman at the Philadelphia settlement house for $70 per month, modeled for artists, and even cleaned the brushes of his teachers.

One of those teachers, a muralist named George Harding, talked with enthusiasm about Daumier and Degas, and consequently they became two of Gwathmey's favorite painters. Daniel Garber, another of his teachers, was a latter-day impressionist of the New Hope school who liked to compose serene rural scenes with old buildings—pleasant and attractive but neither distinctive nor innovative. He always remained a cheerful traditionalist, hostile to "modern" art.[6] Franklin C. Watkins was the best-known artist among Gwathmey's teachers and therefore the one whose influence he would ultimately reject most emphatically in search of his own distinctive style and subject matter. Watkins painted a few Daumier-like caricatures, such as *Soliloquy* (1932) and *Solitaire* (1937), but primarily he did highly prized social portraits (including dogs, cats, and even monkeys) and still lifes of fruits and flowers. Most of these canvases lack any sort of social commentary or criticism, and some are rather cloying. But *Negro Spiritual* (ca. 1932),

a figure of an ecstatic black man with very large hands in an open field, may well have remained in Gwathmey's mind; *Crucifixion*, painted in 1931, almost seems to anticipate Gwathmey's *Unfinished Business* (1941), in which a Klan outfit in the foreground is draped over a cruciform fence post surrounded by barbed wire, while a black soldier, his mother, and a white landowner walk away in the middle distance. Gwathmey commented about this picture, "The Negro soldier goes to war. . . . Prejudices are alleviated for the moment. But there is still unfinished business . . . the Klan, the poll-taxer, the 'Posted' areas."[7]

Although a typical still life of flowers by Gwathmey—extraordinarily tight and precise—bears no resemblance to a loose and leafy Watkins still life, the teacher's emphasis on the importance of doing floral still lifes at all had a very clear impact. Moreover, one of Watkins's favorite maxims as a teacher seems extraordinarily applicable to Gwathmey during the decade following 1926, when he searched for his own artistic identity: "What students know . . . they already know, but don't know they know. It is a question of bringing what they know up to the level of their awareness."[8]

On October 6, 1926, Gwathmey completed the application form for the Academy of Fine Arts. At the very end it asked, "Why are you studying art and what use do you expect to make of it? Give your aims and aspirations." The hopeful twenty-three year old answered with the following:

> I am studying art because it has always interested me to the fullest degree. Even as a child I remember discarding all books that were not illustrated and enjoying the pictures, rather than the text, of those that were.
>
> From this interest in pictures I developed a desire to draw such pictures myself and today that same desire is stronger than ever.
>
> Of course everyone who is interested in art would like to accomplish the finest in fine arts, but due to the circumstances, I shall devote my efforts to illustration which I think is the nearest approach to fine arts in the commercial field.[9]

Gwathmey was admitted, and his mother paid the tuition fees. He did sufficiently well in all of his classes to receive a full scholarship in subsequent years. During the first two summers he lived at a construction camp in Maryland where a powerhouse was being built. Gwathmey worked there as a railroad brakeman, which surely helped to develop his fine physique. Once again, however, he had to complete the same application form. His response repeated what he had written almost eleven months earlier, but he added a new closing paragraph. "Everyone, sooner or later has to consider a means of livelihood and this livelihood always carries its share of work. But if we enjoy our work there are most certainly better results in the work we do and the life we live."[10]

In December 1927, when Gwathmey applied for a special summer program in 1928, his ultimate statement indicated that he had moved a step closer to contemplating the kind of artist he would actually become a dozen years later. "Thus far I have been studying illustration because of the fact that a commercial artist is usually scheduled to arrive before a fine artist. Recently, due to still life painting, I have become interested in color

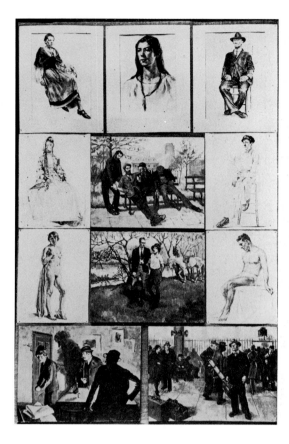

FIGURE 5
Works by Robert
Gwathmey illustrated
in the Pennsylvania
Academy school catalog
of 1929–30. Courtesy
of the Archives of the
Pennsylvania Academy
of the Fine Arts,
Philadelphia.

and Mr. Breckenridge has advised me to really use color, as there is quite a large field commercially for color men. There is always the desire to do the finest in fine art, and after gaining a foot hold financially I really want to paint and I realize what an excellent opportunity Chester Springs offers."[11]

Once again his application met with success. The Cresson scholarship that he won for travel in 1929 took him to Paris, Madrid, Barcelona, Genoa, Pisa, Florence, Venice, Vienna, Munich, and London. The provincial young man may or may not have become more cosmopolitan, but his mental comprehension of Western art expanded enormously that summer. A second Cresson scholarship in 1930 brought his studies at the Pennsylvania Academy to completion.[12] His accomplished oils and sketches from 1929, published in the school catalog of 1929–30, are engaging and diverse, ranging from what appears to be a gathering of gangsters to male and female nudes (see fig. 5). They bear no relationship to his mature efforts, but they were good enough to win him the prestigious Cresson and are indicative of the work he did as a magazine illustrator while he was still an art student. Two summers in Europe provided abundant exposure to an immense range of remarkable art, from Giotto and Piero della Francesca to El Greco, Goya, and Picasso. Decades later he would also recall his enthusiasm for medieval sculpture: "The

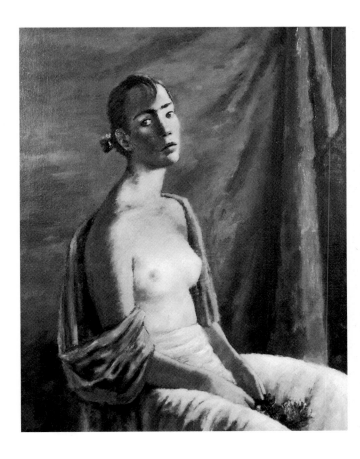

FIGURE 6
Alexander Brook,
Southern Girl [Rosalie
Gwathmey] (1933),
o/c, 36 × 30. Butler
Institute of American
Art, Youngstown, Ohio.
Painted at Cross River,
N.Y., during the summer
while Rosalie Gwathmey
studied portraiture with
Brook.

Gothic excites me no end," he declared, "whereas the Baroque I do not enjoy. . . . Gothic is for me."[13]

During Gwathmey's last full year at the Pennsylvania Academy he met another art student from the South, Rosalie Hook of Charlotte, North Carolina, the daughter of a successful architect and a progressive woman active early in the century on behalf of voting rights and racial toleration. Petite, lovely, and five and a half years younger than her beau, Rosalie "kept company" with Robert for more than six years. (See fig. 6.) Finally, in 1935, their income still too meager to make marriage possible, they went to her parents to explain their plight. Ida MacDonald Hook said to her future son-in-law, "I know that you are a bad boy and a communist, but you are the most Christ-like man I have ever met." Her husband, Charles C. Hook, gave the couple $5,000, a substantial sum at that time, and they were married in Alexandria, Virginia, on November 2, 1935. (The ceremony took place there rather than in Charlotte because the couple did not want a large, formal wedding; just their immediate families and a few friends attended.) That nest egg lasted for much of the decade, and when their son, Charles, was born in Charlotte in 1938, Rosalie's parents paid for that, too. Having the baby cost $150. Thereafter they were largely on their own except for an occasional Christmas gift of cash.[14]

Gwathmey laughed in 1968 when he told Studs Terkel that 1930 "was the proper time for any artist to get out of school. Everybody was unemployed, and the artist didn't seem strange any more." While briefly teaching drawing at Temple University in Philadelphia from 1930 until 1932, Gwathmey also got a regular job at a girls' school, Beaver College, in the Philadelphia suburb of Glenside. His salary was $1,100 a year. He taught "everything" (that is, painting and drawing) two days a week so that he would have time for his own art and for trips to New York City, where the heart of the American art world pulsed at that time. In the spring of 1937 Gwathmey took a group of advanced students to the city to look over schools and art in the major museums. At the end of the day Gwathmey and the girls went to a restaurant where they had "alcoholic beverages" with dinner. When the president of Beaver College learned about this behavioral aberration, he discharged Gwathmey. The narrative of this episode in his own words is engaging.

> I lost my job at Beaver College. I used to discuss articles out of *The Nation* at lunch time, where the teachers gathered. They didn't say this was the reason. I'd done simply this. Four girls were graduating. They wanted to come to New York to do some grad work. I drove them up and we went to see some of the schools. Also, we saw Marc Blitzstein's *Cradle Will Rock*. Then we went to an Italian Restaurant, and we had a cocktail and ate and returned to Pennsylvania.
>
> The president wrote me a letter . . . : "It has come to my attention that you have been in a drinking establishment with your students. You have been unfaithful to your president and your institution. . . ."
>
> The president of Beaver College was a Presbyterian minister, but he acted like a traveling salesman. He lost his job because he ordered furniture from the purchasing agent for his married daughter and didn't reimburse the college. The guy that fired me.[15]

Robert and Rosalie returned from Philadelphia to her family home in Charlotte during the last stage of her pregnancy, and Charles was born there in June 1938. Coming back to the South for a spell had immense consequences for Robert's sense of place and its implications for his art. He later recalled the initial shock of returning to Richmond following his first year at the academy: "Suddenly, I saw with terrible clarity how it was, especially how it was for the Negro in the South. Things I had always taken for granted. That's when my politics changed, long before the Depression came along." Recalling another return visit a decade later, he remarked in a different interview: "I never quite realized the Negro was so omnipresent as when I returned. In Philadelphia you get a little bit removed. . . . You return home and never realized exactly."[16]

In a follow-up interview on March 19, 1968, however, Gwathmey acknowledged that he did not come home an ideological innocent. He had become an activist in Philadelphia—vice-president of the Artists Union—protested on behalf of the Loyalists in Spain, participated in radical May Day parades, and read Karl Marx. Considerations of dialectical materialism received serious reflection. In 1938 Gwathmey went with a delegation to the eccentric Dr. Albert C. Barnes of Philadelphia, a wealthy art collector and creator of

the Barnes Foundation, to ask for enough money to complete a fund-raising campaign that would pay for two ambulances sorely needed by Spanish War Relief during the civil war there. Barnes consented.

Looking back to his southern visits in 1938–39, Gwathmey later reflected, "I was a little more adjusted to looking for people and for conflict. Almost as a novelist I had to have conflict. I was looking for the thing that was conflict. And I dare say that within this conflict there was a business of conflict in colors, conflict in values. All these conflicts. They're so involved in the psyche that if I'm looking at conflict, we'll say, in the social scene, then even in my painting itself, the formal elements in painting, there'd be more conflict. I think it becomes that involved. I really do."[17]

Gwathmey liked to remind his interviewers that he was as much a product of the Depression as he was of the South. When asked whether one of his earliest surviving paintings, The Hitchhiker (fig. 2), might be viewed as a forerunner of pop or billboard art, he bridled. "Now here we have the Depression and have these several billboards," he replied,

and they have several smiling handsome girls and this Pepsodent smile, and the handsome girl and these hitchhikers who are in the depths of Depression seems so much like a contradiction. And so, you use these certain, what are now called pop symbols . . . but not as an isolated thing, not like a series of 25 or 30 or 45 or 50 cans of a given soup . . . but these things have an interrelation with, I'll say, a social comment. . . . Now I would say this . . . you can integrate [advertising symbols] into the total scene and show the shallowness we'll say of this opulent society as opposed to the poor guy who's unemployed.[18]

The Hitchhiker is one of perhaps half a dozen or eight works done by Gwathmey prior to 1940 that have survived, and one of only two or three oil paintings from that period. The others are a pencil drawing, two watercolors, a serigraph (silkscreen), and a large mural. In 1938 (and possibly 1939) he destroyed virtually all of his earlier work, declaring that "it takes about ten years to wash yourself of academic dogma." Looking back at the contrast between his art before and after 1940, he explained in 1966, "The earlier paintings I would say were rather brushy, free-hand application, where I think . . . my later work . . . was more defined, more defined, I would say color against color, shape against shape rather than expressionistic areas against expressionistic areas."[19]

Before turning to Gwathmey's art during the 1940s, the work for which he is best known, we must take into account patterns of social change in the South during the interwar years, and especially the rich body of writing about the South, fiction as well as nonfiction, that proliferated. It is unlikely that he read large amounts of it, but he clearly read some and had to be aware that a burst of southern soul-searching took place, most notably during the 1930s. However much Gwathmey did or did not read, a remarkable proportion of this material explicitly anticipated his own visual responses and documentation from the 1940s. His art may well have been far more innovative in style than

in substance. Although his message was only acceptable to a small minority "at home," the message had indeed been clearly posted on the boards by the close of the 1930s.

Gwathmey might have grown up in what H. L. Mencken disparagingly called the Sahara of the Bozart, but by 1925 native voices began to be heard as harbingers of change. Ellen Glasgow (1873–1945), whose ancestors settled in the Shenandoah Valley during the 1760s, was born in Richmond and lived most of her life at 1 West Main St., where she did almost all of her writing. Early in the century she became the lover of a married man, assumed that the aristocratic tradition had outlived its usefulness, and subsequently asserted that the South needed "blood and irony." Gradually she decided that her true subject would be the social history of Virginia in fictionalized form. Glasgow was determined to portray the retreat of an agrarian culture in the face of industrial change: hence *Barren Ground*, for example, a rural novel that appeared in 1925. Glasgow's became the first southern voice raised in loving anger against the falseness and sentimentality of accepted traditions in the region.[20]

James Branch Cabell (1879–1958), a novelist, essayist, and historian, was also born in Richmond to a prominent family. In 1913 he settled into his wife's home at Dumbarton Grange, and she became a Richmond socialite. Cabell, however, wrote skeptical and sardonic novels about the South, received plaudits in the 1920s for rejecting orthodox American pieties, and eventually produced more than fifty books. Ellen Glasgow insisted that Cabell alone had "survived the blighting frustration of every artist in the South."[21]

Sherwood Anderson (1876–1941) moved to the mountains of southwestern Virginia in 1925, just after publishing *Dark Laughter*, his only financially successful novel and one in which he explicitly described the lives of poor blacks in terms of vivid colors that could supply an attractive challenge to any artist. Like Robert Gwathmey, Anderson disdained middle-class conventionality and disliked sexual repression. (He married four times.) In 1929 he began reporting on the lives of southern mill workers, and his novel *Beyond Desire* (1932), while uneven in quality, was partially based on the southern textile strikes of 1929–30. Although Anderson supported left-wing causes throughout the 1930s, his admiration for communist opposition to socioeconomic injustice was offset by his skepticism toward all ideological causes and commitments.[22]

Most important in providing a literary backdrop for Gwathmey's art, however, was Erskine Caldwell (1903–87), his exact contemporary and a man determined to "tell the truth about Dixie." Caldwell's first job as a journalist in Atlanta exposed him to the harshness of racial segregation and discrimination, unreported lynchings, and the plight of the white underclass. His earliest stories about racial violence and exploitative labor practices were rejected by genteel editors. Meanwhile, a book about black folklore attracted this young man whose father had taught him racial toleration in rural Georgia. His *Kneel to the Rising Sun and Other Stories* became a best-seller in 1934. The lead story is a tragic tale of a biracial friendship between two sharecroppers.[23] Caldwell's description of "a rising sun running blood" instantly brings to mind several of Gwathmey's most striking pictures, such as *Sun-Up* (ca. 1948) (fig. 7), *Boughs and Bags for Shade* (n.d.), and *Cotton Picker* (1950).

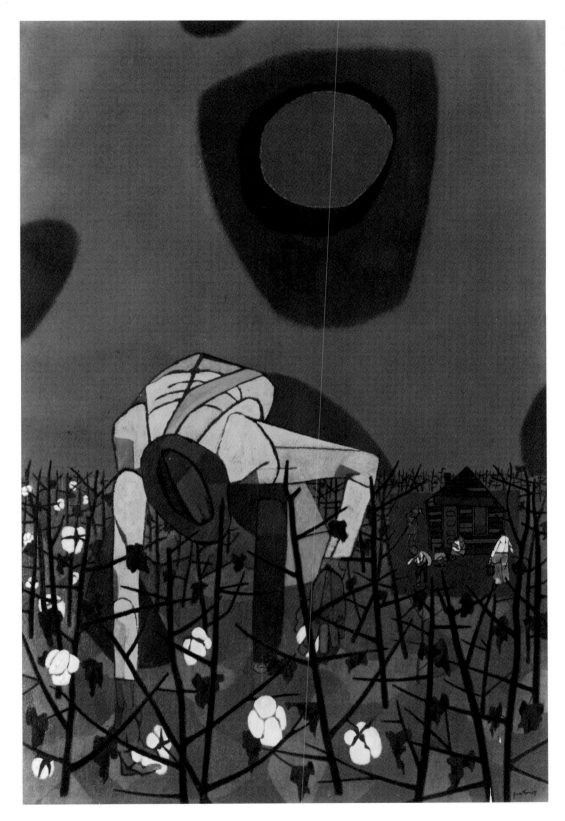

FIGURE 7
Sun-Up (ca. 1948),
o/c, 40³/₄ × 27¹³/₁₆.
Williams College
Museum of Art. Gift
of Elia Kazan, Class
of 1930.

By 1929–30 Erskine Caldwell had become involved in anticapitalist politics, and Lewis Mumford's praise for Caldwell's promising early prose might easily have been written about Gwathmey less than a decade later. Mumford recognized Caldwell's commitment to exposing the tough realities of the rural poor. "Caldwell has a thorough familiarity with materials and modes of life that are outside the scope of the more urbane middle-class novelist," Mumford wrote. "If a picture of proletarian life, without sentimentality, without false idealization or simplification is to come out of American letters," he predicted, "it will come, as like as not, through Caldwell himself."[24] Caldwell's *Tobacco Road* (1932) and *God's Little Acre* (1933) eventually sold many millions of copies, and the Broadway adaptation of *Tobacco Road* became the longest-running hit in American theatrical history, with 3,180 performances from 1934 to 1941. It also toured the country, so that by the end of the 1930s people in the United States believed that they knew all about southern sharecroppers, rural poverty, and degeneracy. At the very least, they had some awareness of these problems.[25]

In the homely language of southern farmers during the early decades of the twentieth century, their region was "still sucking hind tit on the national hog" and still responding like the runt of the litter as well. During the mid-1930s the South alone had nearly 2 million tenant families totaling some 9 million people. Those figures do not include the tens of thousands of day-wage laborers who moved from one farm to the next, or the very considerable numbers of migrant agricultural workers who simply followed the harvesting seasons. In addition, there were displaced coal miners and still other rural laborers left stranded by the Depression, which intensified a sense of crisis in the southern backcountry. Ironically, the cigarette industry remained quite profitable during the 1930s even though the men and women who harvested tobacco earned very little—which perhaps helped to keep the industry in the black. As late as 1944–46, which may well have been Gwathmey's apogee in producing images of African American workers in the rural South, per capita income in the region remained less than $400 per year. For blacks it was closer to $200.[26]

A Southerner Discovers the South, published in 1938 by Jonathan Daniels, is perhaps the best travel account written about the South during the Great Depression. But the South seems to have been discovered and rediscovered almost continuously throughout the 1930s, most notably by North Carolinians. In 1934 William T. Couch, the innovative director of the University of North Carolina Press, edited a huge volume on a very unusual topic at that time, *Culture in the South*. The opening chapters defined "The Southern Heritage" and described a "Profile of Southern Culture." Five years later Couch published *These Are Our Lives*, a collection of oral histories and narratives by workers in North Carolina. Many other studies concerning various aspects of southern life and culture appeared throughout the 1930s. Some were sympathetic; others, harshly critical; and still others, a combination of the two.[27]

During Franklin D. Roosevelt's first term as president, 1933–37, the desperate plight of tenant farmers and sharecroppers seemed emblematic of so much that ailed the United

States as a whole. Millions of small farmers faced the prospect of total failure, and in the South, still predominantly agricultural, these problems were particularly pervasive and acute. In 1935 the University of North Carolina Press published a highly critical study of southern agriculture that had a very swift impact on governmental policy. Roosevelt himself praised *The Collapse of Cotton Tenancy* even though it came as a sharp indictment of early New Deal policies, and it directly influenced the substance of the Bankhead-Jones Act and the second Agricultural Adjustment Act. The book had three authors who, like Robert Gwathmey, had deep southern roots: Charles S. Johnson of Fisk University in Nashville, Will W. Alexander of the Commission on Interracial Cooperation, and Edwin R. Embree of the Rosenwald Fund, the philanthropic arm of the owner of Sears Roebuck.[28] Four years earlier Embree had published *Brown America*. The Rosenwald Fund had a strong commitment to improving the legal and living conditions of African Americans. In 1944 it awarded Gwathmey a fellowship that profoundly affected his art and his career.

In February 1937 a judicious document appeared bearing the title *Farm Tenancy: Report of the President's Committee* (Prepared Under the Auspices of the National Resources Committee in Washington, D.C.). The principal objective of its 108 double-columned pages was to persuade Congress to take serious action on the problem of farm tenancy. In 1941 James Agee made fun of it in *Let Us Now Praise Famous Men*, for he believed that the situation for poor farmers in the South was futile and the recommendations of the president's committee were utterly inadequate in addressing the massive economic, social, and medical problems. Nevertheless, some New Deal programs did accelerate economic recovery in the South, which helped to keep the region solidly Democratic despite the disdain of its white politicians for social programs that it feared might be envisioned by racially liberal Democrats in Washington.[29]

Perhaps I should say *most* of its white politicians. There was an economically liberal wing of the southern Democratic Party, characterized by figures such as Claude Pepper, that lingered into the later 1940s when the intensification of racial politics doomed their moderate "straddling." Congressman Maury Maverick from San Antonio, a brash and liberal reformer, won a seat in the U.S. House in 1934 and developed a reputation for outspoken candor. His love-hate relationship with his own region ran parallel to Gwathmey's. "With all her faults," Maverick said of the South, "I love her still. But this will not keep me from telling the truth and lambasting her when she needs it, and she needs it plenty."[30]

The South's greatest single problem, of course, involved race relations, a subject that gathered increasing public attention during the 1930s but had received notice through serious publications for several decades before that. Howard W. Odum, a complex but highly prominent sociologist at the University of North Carolina, led the way. In 1910 he published *Social and Mental Traits of the Negro: Research into the Conditions of the Negro Race in Southern Towns*, a book that may seem patronizing to us (in some respects) but appeared as a pioneering study at the time. Odum himself later disclaimed that work as being based on

outmoded racial stereotypes. In 1925 Odum brought out *The Negro and His Songs: A Study of Typical Negro Songs in the South* and followed it a year later with *Negro Workaday Songs*. Two years after that Odum introduced a trilogy of folk chronicles built around a savvy black Ulysses named John Wesley "Left Wing" Gordon. The first was called *Rainbow Round My Shoulder: The Blue Trail of Black Ulysses* (1928). Then came *Wings on My Feet: Black Ulysses at the Wars* (1929), about a Negro soldier's experiences in France, told in his own words and interspersed with ballads. Odum completed the series in 1931 with *Cold Blue Moon: Black Ulysses Afar Off.*[31]

Odum was not alone in his outlook, however, and there were others who were ultimately more activist in their determination to improve rather than merely describe the racial situation in the South. As John Egerton has written, "Mildly radicalized by their religious and educational experiences, a handful of young people born within five years or so of the turn of the century stepped forward in the twenties to advocate a new course of action in the South, a way of living that would uplift the poor, unite the races, and bring peace and prosperity to the region, the nation, and the world."[32]

Perhaps the most striking member of that group—certainly the individual most comparable to Robert Gwathmey in his values and commitments—was Howard "Buck" Kester. Two years older than Gwathmey, Kester had an impassioned commitment to racial and social justice. He may well have enjoyed more friendships and contacts across racial lines than any other white southerner in the 1930s. He understood that segregation had deleterious effects on whites as well as blacks. During the 1930s Kester, who described himself as a "Norman Thomas Socialist," worked for the Fellowship of Southern Churchmen, the National Association for the Advancement of Colored People (NAACP), and the Southern Tenant Farmers' Union (an Arkansas-based interracial organization of field hands that had been organized in 1934 by H. L. Mitchell, the militant son of a Tennessee sharecropper). In 1936 Kester published a book that blended description with prescription, *Revolt among the Sharecroppers.*[33]

Kester's principal work for the NAACP involved lynching investigations, a highly risky undertaking. Despite the Southern Commission on the Study of Lynching, created in 1930 under the chairmanship of George Fort Milton, the progressive young editor of the *Chattanooga News*, and Young Women's Christian Association antipathy and pressure in the South against lynching, a law making it a federal crime repeatedly failed to pass in Congress, and lynchings as well as vigilante killings remained problematic in the South. These crimes averaged more than one per month during the 1930s, and 90 percent were perpetrated against black victims. Beyond the official statistics on lynching, moreover, many other deaths of blacks at the hands of whites were classified as "disappearances" or accidents, or as some "legitimate" form of homicide, such as involuntary manslaughter or self-defense.[34]

Another prominent figure at that time whose views must have been known to Gwathmey was Frank Porter Graham, a historian and president of the University of North Carolina from 1930 until 1949. As early as 1931 Graham had the courage to host Langston

Hughes for a well-publicized reading at the university. Graham's personal sympathies for laboring people, tenant farmers, sharecroppers, minorities, and underdogs in general were well known. He outraged many tradition-oriented whites yet had enough political savvy on two occasions to dodge the explosive issue of racial desegregation in the university student body.[35]

Dangerous though it may have been, some African Americans joined activist groups in the years following World War I and worked with whites on behalf of voter registration, antilynching campaigns, and issues of racial discrimination such as segregation and tolerance of Ku Klux Klan activity. Black writers who came of age in the 1930s regarded themselves as Social Realists. They wanted to depict African American life as it really was, warts and all, with its brutalization, subjugation, and their harsh consequences. Robert Gwathmey would not have been oblivious to Richard Wright's *Uncle Tom's Children: Four Novellas* (1938), *Native Son* (1940), and *Black Boy: A Record of Childhood and Youth* (1945).[36] Gwathmey could not have ignored all of this fiction and nonfiction swirling around during the decade following 1934. It would have been even more difficult to avoid the controversies generated by some of these writings. Gwathmey did not live a sequestered life.

He was also aware of the many socially engaged photographers making their documentary records of southern rural life during the mid- and later 1930s. These included Walker Evans, Dorothea Lange, Ben Shahn, and others working for the Farm Security Administration, but especially Margaret Bourke-White, who collaborated with her husband, Erskine Caldwell, on *You Have Seen Their Faces* in 1937.[37] Less than a decade later Gwathmey titled a painting *You Have Seen Their Faces* (location unknown). (In Chapter 3 I examine more closely Gwathmey's art in the context of documentary photography in the South, but here his awareness of it on the eve of his own creative breakthrough must be noted.)

Patterns of influence are not unidirectional, however, and perhaps even more to the point, sometimes several individuals can all be on the same wavelength yet entirely independent of one another. In 1939 Gwathmey received a commission to paint a very large mural for the post office in Eutaw, Alabama. Titled *The Countryside* (fig. 8), it shows three whites and two blacks engaged in agricultural work. The postmistress, as spokesperson for the county, had requested a mural of "the boys in gray fighting," a valorous memory of the Confederacy. In 1968 an interviewer asked Gwathmey what he had actually painted. "Well, it's up there. It shows men picking cotton and men working in lumber and cattle. That was it. Cotton, lumber, and cattle. That was indigenous. I guess in a funny way you can understand them wanting something glorifying their pretensions."[38]

In 1941, just after Gwathmey's mural was completed and installed, Wilbur J. Cash published *The Mind of the South*, which swiftly became a classic. It attacked southern hypocrisy on the matter of race, but above all Cash came through as an iconoclast determined to expose the southerners' misuse of their past on account of "pretensions." Gwathmey and Cash knew nothing of each other's work. But they had reached the same

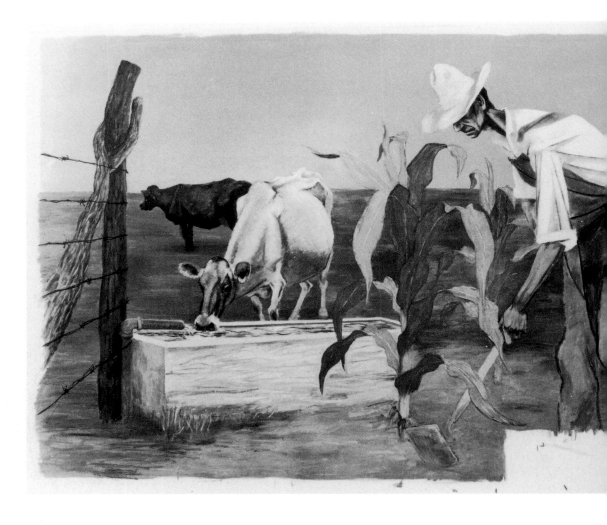

conclusion about the need to depict the real South rather than a specious one. Cash, a journalist, committed suicide in Mexico City less than five months after publishing his book.[39] For Gwathmey, however, 1941 marked the start of his most successful decade as a painter.

Years later Gwathmey returned to Eutaw, entered the post office, and bought a one-cent stamp "just in order to be able to see the mural." "How did it look?" Paul Cummings asked in 1968. "Fierce," replied Gwathmey. "Fierce" clearly had a facetious intent; that is, the work being performed may have been strenuous manual labor, but it was hardly unusual for that time and place. "Fierce" surely meant droll candor and contestation on the artist's part. Here was an implication of racial integration in the workplace being shown in a region that could not abide the idea that Benny Goodman performed with a racially integrated orchestra in 1938. Nevertheless, Gwathmey's proletarian mural somehow managed to avoid the heated controversies that flared around many other federally sponsored murals in the South.[40] So how did this painting come about?

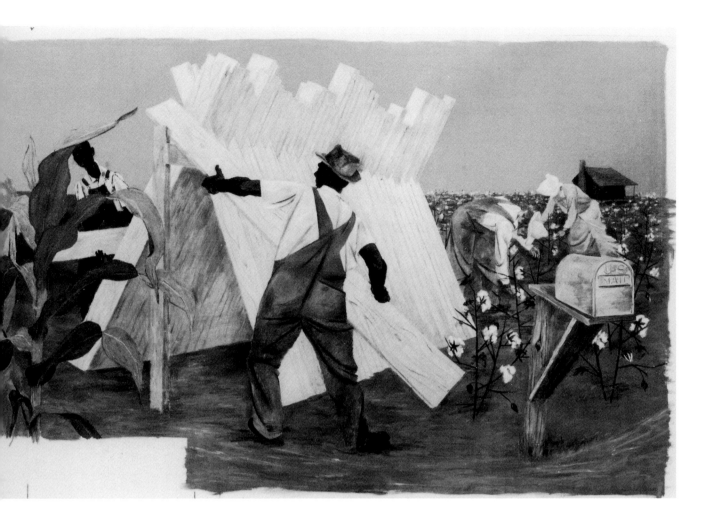

FIGURE 8
The Countryside
(1939–41), o/c mural,
160 × 56. Post Office,
Eutaw, Ala. Courtesy of
the National Archives.

When the Fine Arts Section of the Federal Works Agency announced its Forty-eight States Mural Competition in 1939, Gwathmey submitted an entry for the post office at Phoebus, Virginia, in the Hampton Roads area right on the Chesapeake Bay. The jury chose a different applicant for Phoebus, but the Fine Arts Section offered Gwathmey $740 to do the project in Eutaw, a place he knew nothing about. Then, on December 4, 1939, *Life* magazine ran a feature story about the design winners in the competition. The photographs included the artist's design for Phoebus, now apparently (and quite arbitrarily) assigned to Eutaw, Alabama. The caption declared, "Robert Gwathmey's vivid mural will picture Negroes unloading and packing fish from nearby waters." James S. Coleman, editor of the Eutaw *Greene County Democrat*, observed that Eutaw lay 200 miles from the Gulf of Mexico. Because Gwathmey had just taken a teaching job at the Carnegie Institute of Technology in Pittsburgh, this appeared to be yet another instance of a southern mural being assigned to a northern artist utterly ignorant of the South and indifferent to the region's feelings and to local particularities as well.[41]

Once the contretemps caused by *Life's* confusing pictorial essay had been resolved, Gwathmey made conscientious efforts to learn about Eutaw. The county agricultural agent assured him that Greene County "was simply cotton, corn, cattle, and the lumbering of what we call field pine." When Gwathmey asked the postmistress for demographic information about the white and black residents, particularly the proportion of each in the local population, she responded that Gwathmey should follow the local history books by painting scenes of the Confederacy and military valor. Although Gwathmey blithely ignored that suggestion, he did compromise by showing three whites and two blacks, even though blacks outnumbered whites in the county, according to the 1940 census, by a ratio of five to one. When Gwathmey's mural was installed in the spring of 1941, the postmistress acknowledged that "very few complimentary expressions" had been heard about the work. On the other hand, she conceded that the new mural was so much more appropriate than the Phoebus design that by comparison she was prepared to accept it, albeit without praise. The editor of the *Greene County Democrat*, when asked to publicize or comment on the mural, declared that he "had nothing to say" on the subject.[42]

After more than three decades of subsequent quiescence, a much stormier ruckus arose in 1975 when militant blacks decided that the mural perpetuated a stereotypical view of African Americans as menial farmhands inevitably subservient to whites. Spiver Gordon, a leader in the local chapter of the Southern Christian Leadership Conference, proclaimed the mural "racist," "offensive and discriminatory . . . because they [sic] depict only Blacks in job categories traditionally considered negative and in a servant-slave like fashion." Four years later a black probate judge in Greene County asserted that "the Black citizens of this community felt that the picture was dehumanizing" and asked that it be removed. Ten years later the controversy had subsided somewhat, yet Gordon continued to insist that Gwathmey's mural presented negative images for African American children, adding that "we have enough memory of cotton fields that we don't need a public mural to remind us." He and others in the black community clearly ignored the prominent role of whites also working in the fields. Color had blinded these impassioned combatants to Gwathmey's concern for socioeconomic and class parallels between the races.[43]

The U.S. Postal Service preferred that the mural remain, but it commissioned a study to determine whether Gwathmey's work had sufficient artistic merit to justify keeping it. An investigation conducted by the director of the Birmingham Museum of Art determined that the mural was "a good picture, although not a great one" and that it should be allowed to remain. The report added that the post office staff in Eutaw should undertake basic conservation steps in order to preserve the mural from deterioration. The document identified the artist as "a black" born in Richmond, Virginia.[44]

The ironies associated with this large mural (four and a half feet high and more than thirteen feet wide) are endlessly intriguing. Holger Cahill, who ran the Federal Arts Project (FAP), had written to a supervisor in Alabama well before the Phoebus-Eutaw

mix-up to remind him that "it is most essential that on all mural projects . . . sketches be approved before any actual work is undertaken."[45] It is not clear, however, whether that meant FAP approval from Washington (most likely), approval from the community destined to receive the mural (logical), or both. It does not appear that Gwathmey received clearance for his ultimate design from either Washington or Eutaw. If *Life* magazine had reason to believe that the fishing motif intended for Phoebus was actually destined for Eutaw, then the FAP's publicity material must have been very confusing indeed.

Another irony arises from the fact that Gwathmey was only eligible for a Works Projects Administration (WPA) commission in 1937–38, because no artist with regular employment could receive a commission. He had received nothing in 1937–38 when he and his wife had limited resources, but he got the commission in 1939 despite being hired by Carnegie Tech to teach art. In any event, I do not believe that Robert Gwathmey would have been very happy as a regular WPA artist because the directives from Washington urged that these public projects be very upbeat about the American past and the country's present prospects.[46]

In Gwathmey's vision of life in the United States, "progress" had been for the few and the privileged, not for the masses and the minorities. He preferred to depict the tough realities of manual work for the underclass. There are no labor-saving devices or "improvements" in his pictures. Gwathmey gave his toiling men and women dignity, but he did not glorify them. Their lives had been hard, their backs were bent, and their hands were gnarled. Their spirits, however, were not broken, and unlike so many of Erskine Caldwell's white crackers, they were neither degenerate nor lascivious predators. Except for one lynching scene mainly characterized by hypocrisy, violence does not appear in Gwathmey's art until the mid-1960s, and then in response to the war in Vietnam, resistance to the civil rights movement, and urban violence. (See Chapter 7.) Sex and lust are not even suggested, though the psychological complexities of managing multiple personal relationships are conveyed in very subtle, highly subjective ways. (See Chapters 5 and 6.)

During Gwathmey's period of unemployment, and perhaps even despite it, he began to think about himself and the prospects for his art in new ways. He and Rosalie spent most of that period in Philadelphia and New York City, going to Charlotte early in May 1938 so that Rosalie could have their child in familiar environs. In seeking both a job and now a dealer for the first time, Robert clearly anticipated a career as a serious artist rather than as a commercial illustrator. "I thought it was best to work from New York as an address," he later recalled, "rather than Philadelphia and sure enough I got the job at Carnegie Tech and I think that might have had some bearing. I didn't want to leave New York without having a dealer but it's a very embarrassing position to go to a dealer and especially when you're only half-baked."[47]

He not only found a dealer who became a cherished friend for the next two decades, but sometime during 1938, as noted above, Gwathmey destroyed almost all of his previous work because it seemed so derivative from that of Watkins and Garber. He made a

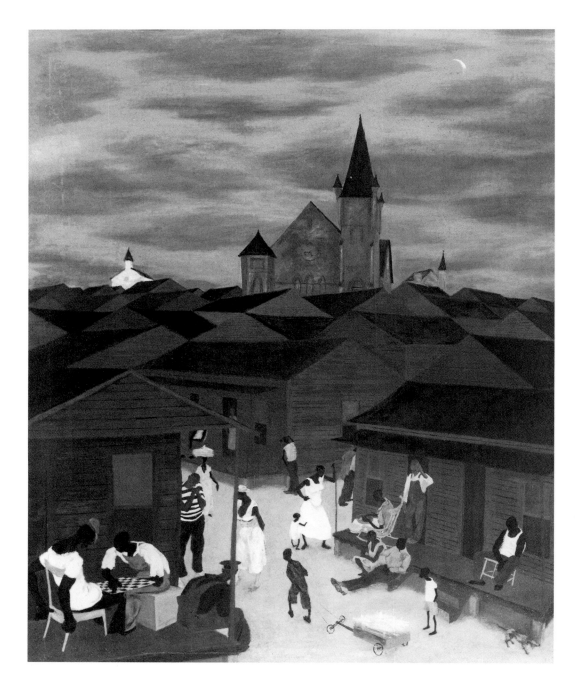

new beginning in 1938–39 with a freshly defined approach to visual presentation emphasizing race and class (see fig. 9), the genesis of his utterly distinctive style, a newborn son, and a better job in Pittsburgh, Pennsylvania, where he would stay until 1942. The year 1938 turned out to be transformational for Robert Gwathmey.

On August 16, 1932, Herman Baron, a graduate of New York University in 1922 and an aspiring writer in his early years, opened the ACA Gallery in Manhattan, a brave undertaking at that time. As the *New York Times* noted the next day, "The American Contemporary Art Gallery opened its doors at 1269 Madison Avenue at what is practically the nadir of the New York art season." (It soon moved to Eighth Street, a block from the original Whitney Museum of American Art in Greenwich Village.) The ACA occupied a small, street-level store with about a dozen pictures hung rather casually. Elegant and fashionable it was not, but warm and homey, to be sure. Herman and Ella Baron became involved with progressive political activism on behalf of struggling artists. The Artists Union, an organization of workers primarily in the WPA arts projects, pioneered in white-collar unionism.[48] Herman Baron suggested the creation of its monthly magazine, *Art Front*, and served as its first managing editor. He also became a central figure in the Artists' Congress, which began in 1936, and he continued to champion what he called "socially conscious art," even when it came under political and ideological attack at mid-century because of the House Un-American Activities Committee (HUAC) and McCarthyism.[49]

The Barons were staunch advocates of young, unknown American artists. Consequently they created an annual competitive exhibition for individuals who had never had a one-person show. That contest provided Gwathmey with his next major break after winning the competition to prepare the post office mural in 1939. His painting *Land of Cotton* (1939) won the competitive exhibition, but because Gwathmey worked so deliberately, indeed slowly, almost two years elapsed before he had enough work available to sustain a one-man show. His exhibition occurred early in 1941, and it initiated a remarkable series of triumphs for a thirty-seven-year-old artist who had recently rejected most of his previous painting in an effort to create a fresh artistic identity that would be distinctively his own. One critic praised the clarity of Gwathmey's style, noting that his paintings

> built up largely of flat areas of paint that underline the simplification to which he submits his material, are colorful, adroitly managed, and well-knit. . . . Though he is not given to outright propaganda, Gwathmey surveys his world objectively and makes social comment that is both penetrating and restrained. He is animated by a very definite idea which he wishes to communicate in every canvas on view here. . . . Far less happy is his work when the bitterness that he feels against the social order swamps his expression. But he will be interesting to watch, for he has force in his painting language and something to say.[50]

Gwathmey's most notable decade was now well launched. He would cultivate his best-known subject matter, epitomized in *From Out of the South* (plate 1).

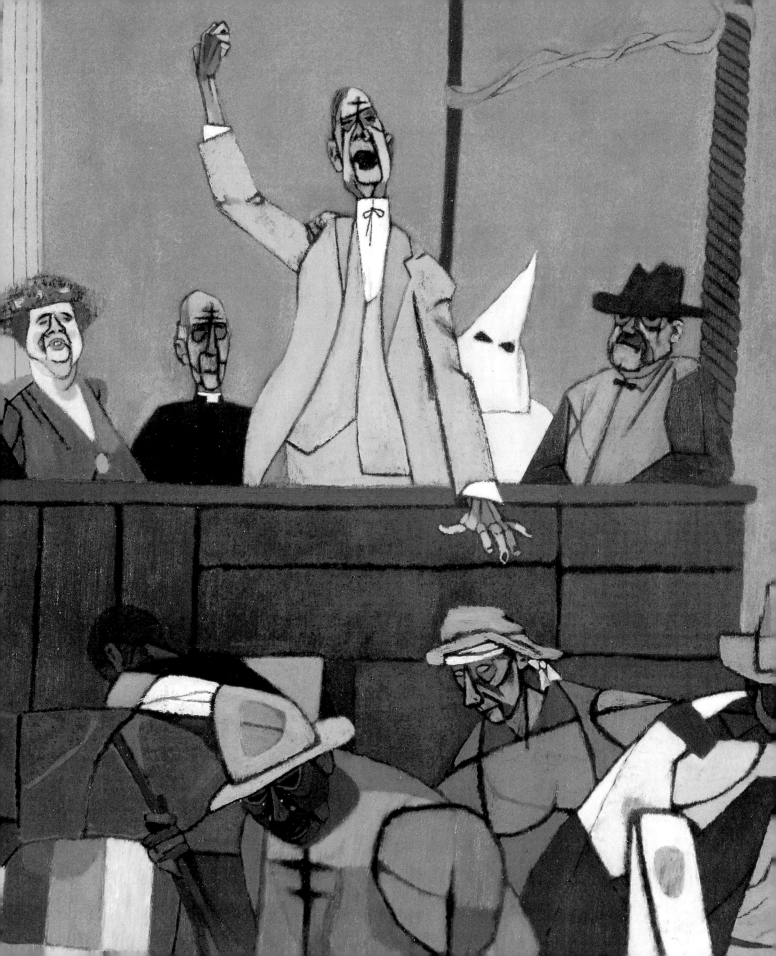

Poll Tax Country

Visibility, prompt recognition, and warm praise came swiftly once Gwathmey determined his distinctive idiom and subject matter as a southern artist. In 1940 Ralph Ingersoll, the editor of New York's left-oriented journal PM, decided to revive the late nineteenth-century concept of the artist as illustrative reporter, a tradition that had suffered almost total eclipse with the dramatically successful rise of photography. In collaboration with the Museum of Modern Art, PM announced a competition to find artists "who can report the news with brush or pen." One of the prizes went to Gwathmey for a wash drawing, titled *Undermined*, that vividly showed the rescue of a woman from the second story of a shanty that was collapsing into the street.[1]

The following year Gwathmey won the watercolor prize of the Associated Artists of Pittsburgh for a "tricky but effective experiment in textures and angularity" called *Share Croppers*, in which two African American figures were outlined against a barren background. That same picture subsequently won the First Purchase Prize in the Contemporary Water Color Show held at the San Diego Fine Arts Gallery during the summer of 1941. Meanwhile his *Sharecropper and Blackberry Pickers*, depicting black farm laborers working in a field, was purchased by Boston's Museum of Fine Arts (MFA) in 1942. That acquisition represented a real coup for Gwathmey because the Boston museum had previously given very little support to contemporary art. The MFA became active in the current art scene only after it established the Gallery of Provisional Acquisitions in 1941. Purchases were hung provisionally in a special gallery and then, following a trial period, were either added to the permanent collection or exchanged for another work by the same artist. The MFA curators liked *Sharecropper and Blackberry Pickers* and kept it.

In October 1943 Gwathmey's *Hoeing* (plate 3) won the $700 second prize at an exhi-

bition, *Painting in the United States*, sponsored by the Carnegie Institute of Technology in Pittsburgh. The institute subsequently purchased the painting for its permanent collection despite the fact that it provoked a fair amount of controversy at the time of the show. Edward Alden Jewell, art critic for the *New York Times*, regarded *Hoeing* as "a success only in that it travesties art." Jewell seems to have been referring negatively to radical innovations in style, however, because he went on to say that for those who feel that the artist of today has "an increasing sense of participation in the life and thoughts and movement of his time and a deepening interest in social ideas," Gwathmey's painting appears "biblical in its simplicity . . . fine painting as well as social commentary. The hewers of wood and drawers of water could have no better spokesman than Gwathmey, who knows how to paint a picture the while he pleads their cause."[2]

In the fall of 1943 Gwathmey won yet another award, first prize in the Artists for Victory exhibition that was part of the National Graphic Arts Competition sponsored by a wartime association of leading art organizations. Because Gwathmey's winning entry, *Rural Home Front* (fig. 10), is a serigraph (a screenprint), I will discuss it later in another context. I mention it here to indicate that between 1939 and 1944 meaningful recognition came quickly for Gwathmey, and it surely must have gratified this late bloomer. He was also represented in the Whitney's 1943–44 annual exhibition of contemporary art and in the annual exhibition of American painting and sculpture at the Art Institute of Chicago. In 1942, hoping for employment at the Pennsylvania Academy of the Fine Arts, he wrote to the "secretary" (that is, the director), explained his aspirations, enumerated his awards along with the three museums that had recently purchased his paintings, and listed the venues where his work had been exhibited: the academy itself, the Whitney Museum of American Art, the Phillips Collection (in Washington, D.C.), the New York and San Francisco World's Fairs, the Chicago International Watercolor Show, the Cincinnati Academy and the Cincinnati Modern Art Society, the Four Arts Club of Palm Beach, the Museum of Modern Art, the New School for Social Research, the Butler Institute of American Art, Cornell University, and galleries in Grand Rapids and Milwaukee. His career had taken off.[3]

Although no position opened for Gwathmey at the Pennsylvania Academy, he did receive an offer to teach introductory drawing on a part-time basis at the Cooper Union School of Art in New York City. He was delighted to accept the invitation because New York meant mecca for artists and because part-time teaching would leave him free to pursue his own painting intensively. The Gwathmeys moved to Manhattan late in the summer of 1942, rented a modest flat for a little more than a year, and then relocated to a roomy apartment on Central Park West at Sixty-eighth Street with a splendid view across to the park. The rent amounted to $103 a month, but Gwathmey always told his wife that it was $98 so that she would not worry that they were living beyond their means. In 1955 they bought a house on Tenth Street in Greenwich Village (with financial help from friends and from Rosalie's mother). They moved several more times until Gwathmey's retirement from Cooper Union in 1968, when they relocated permanently

FIGURE 10
Rural Home Front (1943),
color serigraph on paper,
16 × 24. National Mu-
seum of American Art,
Smithsonian Institution,
Washington, D.C.
Bequest of Olin Dows.

to the Village of Amagansett on Long Island, where an artists' colony had developed de-
cades earlier just east of the Hamptons.[4] Between their departure from the apartment on
Central Park West in 1955 and the resettlement on eastern Long Island more than a de-
cade later, considerable turmoil took place in the Gwathmeys' living arrangements (a
saga discussed in Chapter 5).

Early in 1944 Robert Gwathmey successfully applied for a Rosenwald Fellowship at a
time when Will Alexander served as director of race relations at the Rosenwald Fund.
Leon Kroll (1884–1974), an influential teacher and significant figure in the realist tradi-
tion in American art ("abstract art is merely the beginning of a picture"), wrote an im-
portant letter on Gwathmey's behalf.[5] Robert, Rosalie, and six-year-old Charles spent the
summer on the Robert Cicero Brown family farm near Rocky Mount, North Carolina, an
unusual place where black and white workers toiled side by side. Robert recalled the ex-
perience fondly for Studs Terkel in 1968.

They had three sharecroppers on this farm. I said I'd give each of the three guys a
day a week. Harvesting tobacco is difficult. It's almost communal in a way. Here are
six farmers. There are six days in a week, one day for rest, right? These six get together
and they would prime tobacco.* Mondays on this farm, Tuesdays the next farm, and
so forth.

I picked tobacco because I wanted to know the whole story. An instant observer
could do all this [with] surface quality. To be involved, it has to have a deeper mean-

*Priming tobacco means
pulling the leaves off the
stalk, starting with the
bottom leaves because
they mature first. There
may be thirty-five to
forty leaves on a stalk.

FIGURE 11
Rosalie Gwathmey, *Blackberry Picker, North Carolina* (1947). Gelatin silver print. Ramona Javitz Collection, Miriam and Ira D. Wallach Division of Art, Prints, and Photographs. New York Public Library. Astor, Lenox, and Tilden Foundations.

ing, right? We're all total fellows, aren't we? Right. I insist on being a total fellow. I couldn't sit there and make a sort of representational [image] and calling it priming tobacco, if I hadn't done it myself.[6]

That experience turned out to be typical as well as transformational for Gwathmey's art. It was typical of his intense curiosity and intellectual integrity. Later in his career, when he became fond of painting still lifes, he studied with meticulous care the structure and growth pattern of each field flower. The tobacco priming experience was transformational because Gwathmey felt the body rhythms of workers on the land, learned about their rheumatic aches and pains, and understood their lives in a way that simply would not have been possible otherwise. His numerous paintings of weeding, topping, and priming tobacco, along with his scenes of tobacco barns, possess the authenticity that only an insider can provide (see plate 8).

During that summer of 1944 and for several summers thereafter, Rosalie, who had become a professional photographer, took pictures of the sharecroppers and their work.[7] What Robert subsequently painted in his studio owed a good deal to photographs that Rosalie took in the fields and on the farm. (See fig. 11.) Also in 1944, two books appeared that reassured Robert Gwathmey that he had chosen to concentrate on a subject of paramount and rising significance: race relations in the United States. The books were *An American Dilemma* by Gunnar Myrdal and *Strange Fruit* by Lillian Smith.

But what of the paintings themselves? What makes Robert Gwathmey's art from the early and mid-1940s so striking? He did, after all, have some notable precursors who had depicted the agricultural lives of African Americans. One thinks especially of works such as Winslow Homer's *The Cotton Pickers* (1876), but Gwathmey probably never saw it. More likely he must have been familiar with the quaint field scenes of William Aiken Walker and Eastman Johnson, painted late in the nineteenth century.[8] Gwathmey subsequently declared, however, that "the Negro never seems [merely] picturesque to me." Indeed, he sought fundamental realities rather than picturesque sentimentalities. Thomas Hart Benton, the popular regionalist barely half a generation older than Gwathmey, included African Americans in his history-oriented murals, but his objective was to indicate that they, too, helped to build America and that they had been mercilessly caricatured in minstrel shows.[9]

Although Gwathmey made major artistic statements concerning racism (see *Poll Tax Country*, plate 4), he primarily painted blacks as members of an agrarian subculture, either at work in the fields or at their leisure, going to church or singing in their homes.

FIGURE 12
Mountain Flowers and Mouth Organ Music (1940), o/c, 17$\frac{1}{2}$ × 24$\frac{1}{2}$. Collection of Carol and Michael Kammen.

(See *Mountain Flowers and Mouth Organ Music*, fig. 12.) Black people are not historical emblems for Gwathmey. They have their own humanity and unromanticized dignity despite their humble socioeconomic circumstances. Although Gwathmey was not musical himself, he enjoyed Dixieland and black jazz. Above all, however, he appreciated the importance of music in African American life. Early in the twentieth century James Weldon Johnson and his brother Rosamond had written "Lift Every Voice and Sing," which subsequently was referred to as the Negro national anthem.[10] Because of Gwathmey's orientation to popular culture, he frequently depicted a black man playing the guitar and singing, as in *The Ballad Singer* (1940), an unusual work (perhaps his only one) in which he actually painted a frame directly on the edges of the canvas. *Singing and Mending* (plate 5) is another work that features a guitar, and the father in *Children Dancing* (plate 10) also plays the instrument. Ultimately, in *Country Gospel Music* (plate 40), impassioned melodies are shown as uplifting, energizing, and profoundly spiritual sources of inspiration.

At the very heart of Gwathmey's work during these years, however, is agrarian labor in the South, white as well as black, but especially the latter. That much is obvious, but what has been utterly neglected is his striking debt to Jean-François Millet (1814–1875). Millet's toiling French peasants become Gwathmey's sharecroppers and tenant farmers, albeit with abundant artistic ingenuity and specific political accents that make Gwathmey's compositions not only characteristically southern, but sometimes satirical and at other times narrative as well. There are differences, to be sure. Where Millet may evoke compassion or sadness from the viewer, a stressful Darwinian sense of the inevitable, Gwathmey is more likely to evoke anger, even outrage, or a sense of moral indignation. Consider the similarities and contrasts between Gwathmey's *Hoeing* (plate 3), of which he did numerous variations, and Millet's profoundly influential *Man with a Hoe* (1860–62), of which countless pictorial and poetic versions exist.

Gwathmey's *Hoeing* depicts a black fieldworker wiping his brow, an old woman, children, cows, trees, and a church, none of which casts a shadow and none of which adhere to conventional rules of perspective. The impoverished "landscape," such as it is, provides a flat backdrop for allegorical elements that become piercing arrows in the artist's quiver. The barbed wire in the foreground, symbolic of the farmer's servitude and segregation, underlies other elements in the story. The young girl carrying a baby on her hip, a standard sight in the South at that time—poor women often had more children than they could care for by themselves—appears in a much larger version, *Non-Fiction* (fig. 13), also done in 1943.

The old white sharecroppers at the left are driven by their exhaustion to seek respite at a cattle trough. The potential for class unity is more important here than racial difference. Both races, in this instance, are oppressed by a harsh system and hence they are bone-weary. In the background, laborers toil in the cotton fields and try to hoe the unyielding, dry red earth. Facing them are pathetic crops, signified by the hoer's limp cornstalk; premature death (suggested by the grave just beyond the child); and contemptible demagogic politicians, suggested by the man pictured in the sign on the fence post. Even

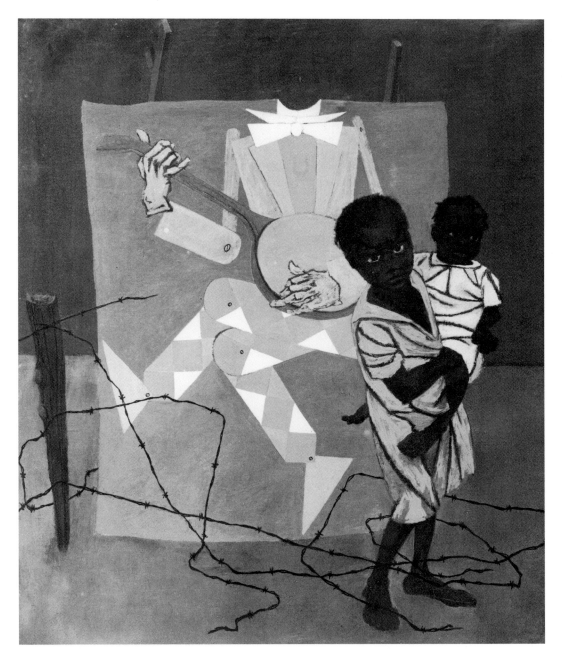

FIGURE 13
Non-Fiction (1943),
o/c, 29 × 24. Memorial
Art Gallery of the
University of Rochester,
Rochester, N.Y. Marion
Stratton Gould Fund.

so, Gwathmey offers hope for the future. The workers draw strength from their church; from their industriousness, seen in construction work at the right; and even from the children, next to whom a flower blooms behind its barbed wire barrier. *Hoeing* uses a series of unsubtle symbols to describe elements of southern life on the land at a time of great stress that nonetheless might be mitigated by change. Gwathmey has confronted critical social issues while intensifying the viewer's aesthetic interest in his composition.

An older, more traditional generation of critics did not like it. The jury for the Carnegie prize, on the other hand, loved it.[11]

Millet's *Man with a Hoe*, an immensely iconic source that entered American culture through Edwin Markham's widely read poem *The Man with a Hoe* (1899), also became controversial, but for ideological rather than artistic reasons. Because the figure appears to be so brutalized by his labors (see fig. 14), the painting aroused once again the familiar accusations that had been made during the 1850s against Millet's *Gleaners* and *Woman Pasturing Her Cow*, namely that the artist was a socialist determined to deny the wonderful progress made during the Second Empire of Louis Napoleon by calling attention to the downtrodden, hopeless fieldworker. Although none of the peasants previously painted by Millet appeared so devastated by their work as the figure in *The Man with a Hoe*, Millet denied that he was engaged in socialist agitation and insisted that he found many beautiful things in man's relation to nature. The fact that the peasant is simply resting for a moment is merely a predictable fact of rural life.

One contemporary observer called attention to the briars in the lower left of the painting that evoked a crown of thorns for this *lamentable Christ du labour eternal*, a rendering that should hardly spark fears of a peasant revolt or any other political threat to the sta-

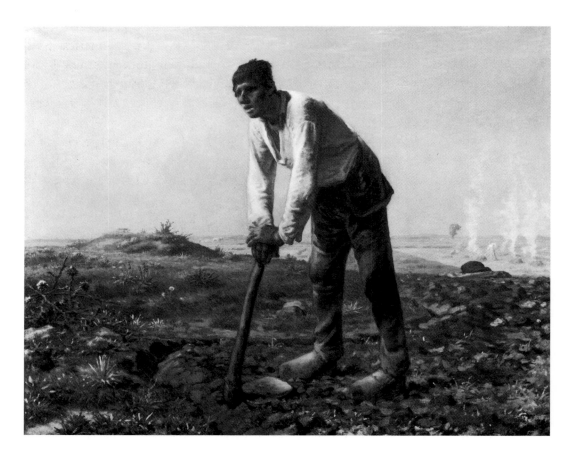

FIGURE 14
Jean-François Millet,
Man with a Hoe
(1860–62), o/c,
$31^{1}/_{2} \times 39$. J. Paul Getty
Museum, Los Angeles.

bility of a state that had not known enduring stability since well before 1789. Critics of the picture remained adamant in their hostility, however, because Millet seemed to deny the peasant a shred of sentient intelligence and, even worse, the prospect of social mobility that lay at the heart of faith in social progress among the French bourgeoisie.[12]

Be that as it may, this work soon joined *Gleaners* as an ur-text of Social Realism. Even though it provided a motif that served as a clear point of departure for Gwathmey, he did not give to his own *Hoeing* and its numerous variants the stultifying meaning that Edwin Markham gave his well-known poem from 1899.

> Bowed by the weight of centuries he leans
> Upon his hoe and gazes on the ground,
> The emptiness of ages in his face,
> And on his back the burden of the world. . . .
> Who loosened and let down this brutal jaw?
> Whose was the hand that slanted back this brow?
> Whose breath blew out the light within this brain?

Gwathmey's field-workers do not have empty or mindless faces, and one does not feel any absence of light within their brains. They are sentient beings whose lot has been hard but whose endurance and perseverance bespeak hope rather than despair. The grounds for Gwathmey's guarded optimism are not entirely clear, but it surely owed much to his having worked alongside and talked at length with African Americans, especially in 1944. He knew the conditions of their lives and their attitudes at first hand. To be a sharecropper or a tenant farmer in the South meant being caught up in a cycle barely one step removed from slavery—essentially peonage. As John Egerton has written, "You rented the land from its owner, and made the crop for him with his furnish of seed and fertilizer and mules and tools; he sold you food and other necessities on credit at high interest in his commissary; he kept the books, handled the sales, and divided with you at harvest time. You were lucky if you broke even; some went in the hole, and not one in ten actually came away with a few dollars in profit."[13]

Cotton pickers in the mid-1930s received twenty cents for 100 pounds, so little that even the strongest and quickest among them had less than a dollar to show for a tough, backbreaking day's work. During the interwar years the bottom also dropped out of the tobacco market for laborers. Meanwhile, John and Mack Rust had invented a cotton-picking machine that by 1947 virtually emptied the cotton fields of the black belt in the South. Gwathmey's many scenes of picking cotton done during the 1940s and early 1950s were literally painted historically at the eleventh hour. He frequently became the artist as reporter; in this case, he was recording the end of an era. I believe he recognized that and felt that the black migration from field to factory for wartime employment meant personal dislocation but better times ahead—hence his sense of hope. Meanwhile, he painted what he knew and had seen in the interwar South, always cognizant of Franklin D. Roosevelt's concern about "the forgotten man at the bottom of the eco-

nomic pyramid."[14] This was Gwathmey's concern as well, and he illustrated it with both unforgettable starkness and yet a certain long-suffering dignity.

While examining Gwathmey's depictions of life and labor for black farmworkers, a curious anomaly must be kept in mind. During the mid- and later 1930s, sharecropping and its attendant ethos of manipulative paternalism was dying. Its gradual demise developed from many causes: the numerically large migration of rural blacks to the urban North; supportive intervention by the New Deal Resettlement Administration and Farm Security Administration; farm cooperatives created by and for the rural poor; farmworkers' unionization (not highly successful in terms of economic results but often biracial in composition); massive evictions of tenants by their landlords to counteract demonstrations and to protest a federal ruling that tenants' shares of subsidies must be mailed directly to tenants; and the slow but steady mechanization of agricultural work.[15]

To sum up the situation with reference to a single symbol, the hoe that Gwathmey so often depicted in the gnarled hands of a bent black field-worker was swiftly ceasing to be a primary tool by 1941–45 when Gwathmey painted his most memorable scenes of men toiling with that timeless but primitive implement. Whether he fully understood it or not, in his first wave of major works Gwathmey recorded not merely a doomed system of labor but a way of life moving inexorably toward oblivion. Gwathmey offered not so much history in the making but a harsh past barely lingering in the present. Almost unwittingly, it seems, his scenes from the 1940s provided a more faithful representation of African American life and labor two decades earlier, when it had been the norm rather than a dying residue.

In 1941 when the MFA in Boston selected his *Sharecropper and Blackberry Pickers*, which is quite similar to the central part of *Hoeing*, the curator of paintings wrote to Gwathmey asking for information about "the date and circumstances in which the picture was painted." He added that such data "is not only a value to us in preparing the Museum Catalogue, but should be of real interest to posterity." The artist's response is applicable to much of his work during this period. "I have long been interested in our local scene and always return to my native heath with the coming of summer. The plight of the sharecropper, the evils of the usual one crop farming, with its contingent poverty, and the worn earth have all too long been smothered by a traditional romanticism. The berry pickers are typical and the uncultivated thickets in some part supplement their restricted diet."[16]

Twenty-two years later, responding to yet another query from the MFA, Gwathmey explained the close relationship between the museum's painting and *Hoeing*, a relationship characteristic of his work pattern throughout his career. "More often than not," he explained, "I use the same figure in more than a single composition. Your painting and the one at Carnegie both derive from the same drawing. I make 'working drawings' and then paint from there. When I try to paint directly from the object I'm utterly bound. Its being once removed allows me the area of adjustment I need." (For a similar early version of *Sharecropper and Blackberry Pickers*, see fig. 15.) In the paragraph that followed he called

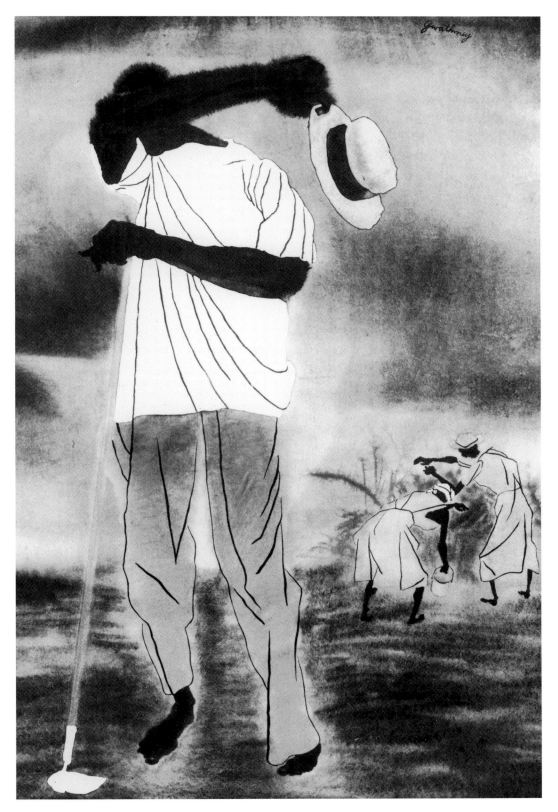

FIGURE 15
*Sharecropper and
Blackberry Pickers*
(ca. 1941), watercolor
and brush and ink on
paper mounted to paper-
board, 24$\frac{1}{2}$ × 18$\frac{7}{8}$.
Hirshhorn Museum and
Sculpture Garden,
Smithsonian Institution,
Washington, D.C. Gift
of Joseph H. Hirshhorn,
1966.

FIGURE 16
The Woodcutter
(ca. 1945), o/c, 22 × 15.
Collection of the
Harn Museum of Art,
University of Florida,
Gainesville. Museum
purchase, gift of the
James G. and Caroline
Julier Richardson
Fund and funds given
by Caroline Julier
Richardson.

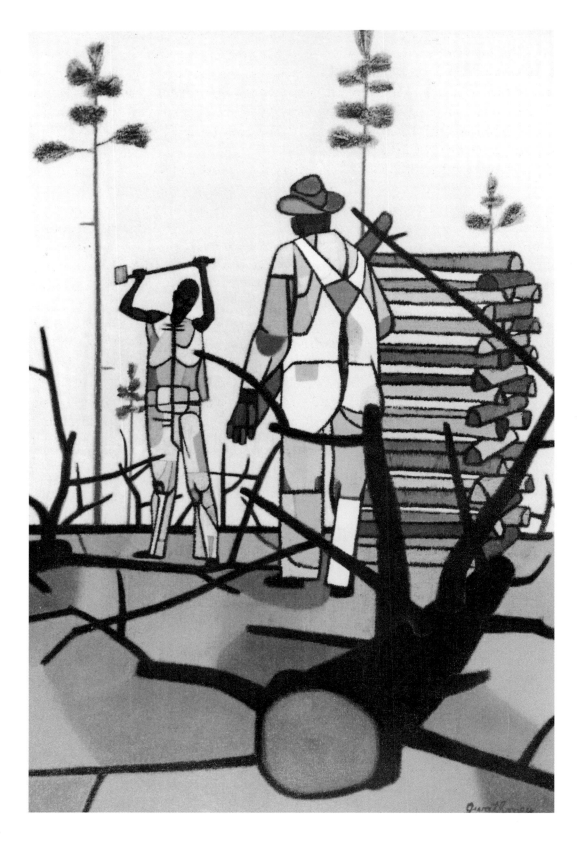

attention to Rosalie's roots in North Carolina and his own in Virginia and declared, "I do hope that my work is rather out of the bone rather than an expression of 'regionalism'. I might insist that I'm also completely emancipated."[17] He simply meant that he did not harbor the racial prejudices customarily ascribed to southerners—a curious disclaimer for him to feel any need to make after twenty-five years of painting pictures with titles such as *Segregation* (1938), *Jim Crow* (1930s), *Poll Tax Country* (plate 4), *Across the Tracks* (1945), and *Painting the Image White* (fig. 39).

The context or backdrop for his renderings of fieldwork and southern race relations was, inevitably, the physical structures, bold advertisements, and bright posters that were ubiquitous in the upper South that he knew so well. Searching beyond farmers and sharecroppers of both races, he recalled that "I looked for things that were contrasting. For instance billboards, advertisements for patent medicines, baking powder, cigarettes, soft drinks. All those sorts of signs that were plastered on the side of barns, grocery stores, things of that sort. Surface posters. And things that were brash."[18] Later in the same interview, Paul Cummings asked once again about Gwathmey's interest in billboards "because some of the historians say billboards only became important with the big painting of Pollock and people like that." Gwathmey responded by insisting that Stuart Davis, Charles Demuth, Charles Sheeler, and Niles Spencer all incorporated billboards into their art in one way or another. "This wasn't anything new at all," he declared modestly, even though none of those painters had used posters and commercial advertising in the prominent manner that he did. "And by the way," he added, "it's attractive if you're interested in the countryside and people and the social scene. . . . I don't say I want to see these dessicate the countryside. I don't want to see them build billboards, but from a pictorial point of view at the particular time it was very exciting."[19]

Gwathmey recalled on several occasions that when he returned to the South from Philadelphia or Pittsburgh or New York, he found it startling to see once again the red clay and the green pine trees, and "the Negro seemed to be everywhere too." Along with tobacco, cotton, and corn as well as unpainted homes on the black side of town and tobacco barns, he featured the red clay and green pines frequently. *The Woodcutter* (fig. 16), for instance, highlights standing pines as well as pine wood being harvested.[20]

The entire bottom half of *Non-Fiction* (fig. 13), one of Gwathmey's most biting works, is red clay, but this painting is important for other reasons. On a summer visit to North Carolina early in the 1940s, Rosalie and Robert saw a black minstrel show at a nightclub. To their surprise and embarrassment, they watched black comedians wearing blackface. (See fig. 17.) A racist tradition that by then was a century old seemed to have been unabashedly internalized.[21] The headless harlequin wearing a minstrel outfit appears to have been Gwathmey's way of portraying the bizarre business of whites and blacks putting on contradictory faces. There is no landscape to soften the setting; clashing colors create a jarring effect; the use of line is angular and piercing; and the extensive network of barbed wire suggests pain, otherness, and entrapment. Above all, the motif of a youngster with full responsibility for a child suggests that both parents are very likely at

work in the fields, and that given large families, siblings caring for one another at an early age was normative even though not ideal. The motif of sister and child, a commonplace sight in the southern countryside, suited Gwathmey, and he repeated it several times as an element in larger, more complex works.[22]

Gwathmey's frequent use of the emphatic black line to set figures off and to highlight bold planar patterns on the clothing of individuals was a striking technique. One thinks immediately of paintings by Georges Rouault (1871–1958), even though he is rarely mentioned by Gwathmey. (See figs. 18 and 29.) The black outlining apparently arose from his fascination with stained glass in medieval churches, a device that he adapted in a distinctive way to his painting. In November 1949 Gwathmey wrote from Paris to three couples at home: "After visiting the cathedral at Chartres I was willing to believe that the stained glass there was the finest visual art expression ever. I still think it can't be beat. While most of the windows are too far away to recognize any exact image, the placing and the color sensations in relation to the half-light within the cathedral is overwhelming." In a 1966 interview (not well transcribed) Gwathmey stated, "The stained glass business is a compartmentalizing . . . of one color against another color, in a stained glass of the twelfth century in France where the best of the stained glass [is] because the glass was so fragmented that the compartmentalizing of the leaded division was very very inventive because it had to accommodate itself to the limits of the size of the glass."[23]

Winter's Playground (plate 6) provides abundant evidence of Gwathmey's fondness for black line to accentuate body structure as well as his adaptation of traditional stained glass windows to envision "modern rose windows" in the form of beach umbrellas. For

FIGURE 17
Walker Evans, *Minstrel Show Poster, Alabama* (1936), gelatin silver print, 7^1/$_2$ × 6^9/$_{32}$. J. Paul Getty Museum, Los Angeles.

almost a decade the Gwathmeys spent several weeks each summer at Wrightsville Beach on the Carolina coast near Wilmington. Robert Gwathmey liked to say that he found the ways in which people behaved at public beaches very amusing. In this painting he has taken some interesting liberties, because the beach *appears* to be racially integrated, which it certainly was not in the later 1940s.[24] Perhaps the dark-skinned people are simply well-tanned Caucasians, but the isolated head in the lower left and the one peeking above the predominantly yellow umbrella clearly belong to African Americans—or at least *belonged*, if the soul at the lower left has, in fact, been decapitated. The bald and pot-bellied pink-ish man waddling forward in the center is a favorite Gwathmey caricature of the crude southern bigot.

The lavish, almost lush coloration in this work clearly indicates the influence of the artist that Gwathmey most admired. He said the following in 1966: "I think Picasso is the greatest colorist that ever lived in the sense of combination of colors as it were. I think he is the most inventive of designers which includes the two dimensional aspect of design on canvas, and I've never seen a Picasso in my life, I do believe, from which I didn't gain some instruction. I think he's the greatest teacher that ever lived. . . . I adore him."[25]

Twenty years earlier, even before he painted *Winter's Playground*, Gwathmey responded to a question about his aesthetic orientation by praising Picasso "most of all," followed by Orozco, Matisse, and the late work of Marsden Hartley. Two categorical sentences followed: "Modern painting must, first off, have a simplified two-dimensional base and, second, a three-dimensional spatiality. These should be considered in direct color relations, with elimination of atmospheric effects created by chiaroscuro and impressionistic fuzziness."[26]

Perhaps because other qualities were more obvious than such conceptual matters, reviewers of Gwathmey's work at exhibitions offered somewhat different emphases. The characteristic that elicited comments most often was satire, starting as early as 1939. Several reviewers of his first one-man show in 1941 called attention in a positive way to his use of caricature as social criticism and observed that "it deepens to satire" in his best work. At Gwathmey's two well-received one-man shows in 1946, one reviewer praised the satirical element in *Non-Fiction*, and a second critic declared that "what for another artist would be a clever invention, a form of painting suitable for joyous decoration, actually with Gwathmey becomes an instrument of pointed satire."[27]

Among the most engaging satirical compositions from this period is *Ancestor Worship* (plate 2), one of the few paintings by Gwathmey that he seems to have felt comfortable discussing. He did so at some length in 1968 with Paul Cummings.

RG In this painting I have a broken down aristocrat. And as a symbol the broken down aristocrat is always apparent to me. Again, that's where the family pretension comes in. It's best expressed or most outrageously expressed by the broken down aristocrat. In fact, I knew this Negro sharecropper, an older man, and I asked who was Mr. so and so. What

about him? He said well he's too poor to paint and too proud to whitewash. That to me is a wonderful image we'd say of a broken down aristocrat.

PC Here you have a man standing in front of a fireplace.

RG It's a façade of an interior of a Georgian home. And he's standing in front of the fireplace with a portrait of his forebear over the fireplace.

PC And he's standing the same way.

RG He's rather emulating the attitude of the forebear.

PC Do you consciously build these up or how do they evolve?

RG I'll tell you what I really do. For instance, I had a feeling one time, I'm not certain this is true any more, that if you tell or do your painting with say three symbols it will be better and more succinct than if you had to use an additional one, four. And I'm not certain that's true because I believe now my painting can be more elaborated than I once thought. That's a change in my general attitude. So I would say in this case I've used varying degrees of light and darkness suggesting miscegenation. I have those three [boys] to use. I can place them any place I want them. But I made them separate and distinct as an image. Then I had the broken down aristocrat, separate and distinct as an image. I had the façade of the interior of this Georgian house, separate and distinct. Then I had the two women who were in the graves beyond, preoccupied.

PC In the field behind the house.

RG That's right, behind the house. I had these certain images. Now, how to arrange these. Now I make a number of sketches. And I arrange them this way and that way and this way and that way, change, adjust, re-adjust and change again. With pencil and paper by the way before I start painting. Finally I conclude what is my best solution and then I apply it to the canvas.[28]

It is incidental yet interesting that seven-year-old Charles modeled for the white boy on the left, the black boy in the center, and the mixed-race child on the right. Considerably more important is the most plausible source of inspiration for this work, a lithograph by Honoré Daumier (1808–79) titled *Even So, It Is Flattering* (fig. 19).[29] We do not know when or where Gwathmey saw a copy, though books of Daumier prints were commonplace in art libraries to which he had easy access during the 1940s. In 1949–50, when Gwathmey spent ten months in Paris, he purchased a number of Daumier prints that still hang at the top of the living room stairway at his home in Amagansett. He loved Daumier's irreverent satires, which he shrewdly adapted to suit his own critical objectives. (See Chapters 3 and 4.)

Gwathmey took a little longer to decide how he would deal with political issues in his painting. *Nobody Around Here Calls Me Citizen* (1943), depicting one very dark-skinned and disgruntled farmer with an angry lion, posterlike, on the wall behind him, is a striking though not very subtle piece.[30] Combining satire with politics proved to be much more potent and interesting. In *Sunny South* (1944), for example, he created a complex panoramic configuration that challenges an array of southern political myths. A monument

_C'est tout d'même flatteur d'avoir son portrait à l'exposition.

FIGURE 19
Honoré Daumier, *C'est Tout d'Même Flatteur* [Even so, it is flattering] (from the series Le Salon de 1857), lithograph. Bequest of William P. Babcock. Courtesy of Museum of Fine Arts, Boston.

to the Confederate war hero dominates the upper center, and in front of it three dowager Daughters of the Confederacy have placed a wreath and listen to the local congressman give an oration. Gwathmey described the rest of the painting thus:

> On one side I have a man and a woman farmer in a given attitude, a struck attitude, and then they are white. On the other side I have a Negro and a Negro woman in exactly the same struck [attitude], identical, which I hope to express that the sharecropper, make him white or black, is on the same economic level. And the sadness of the case, it seems to me, is that they, the whites, become the Ku Klux Klaners and they're the ones who are not fighting against a given class structure but they're fighting against themselves, in a funny way. By attacking a man who is an equal in the same economic position.[31]

Gwathmey actually became a political activist well before he started to paint such sociopolitical commentary. He began in Philadelphia during the 1930s as a very involved member of the Artists Union and subsequently was a founding member of Artists Equity in New York City. In Pittsburgh, meanwhile, where he lived from 1939 until 1942, he belonged to the Associated Artists of Pittsburgh and the American Artists' Congress. He also hosted meetings at his home on Howe Street in an attempt to organize the local WPA project into a union. He even lectured on several occasions, usually on the topic of art and society, at the Contemporary Book Shop, known to be the "official" bookstore of the Communist Party in Pittsburgh. It should come as no surprise, then, that by the early

summer of 1942 the FBI regarded Gwathmey as a key figure in Communist Party activities and kept him under surveillance, with intermittent degrees of intensity, for twenty-seven years, until 1969.[32]

During the early 1940s, if a white man demonstrated a strong interest in and support for black culture, he frequently aroused suspicion that he must be some sort of wild-eyed radical. As George H. Roeder Jr. has graphically demonstrated, during World War II most white Americans reacted quite negatively to visual images that showed interracial contact, especially in a social or theatrical situation. The U.S. military, moreover, remained strictly segregated throughout.[33] Consider what happened to Orson Welles in 1941 when he directed a stage version of Richard Wright's *Native Son*. Although Welles was not much of a political activist, he had, in fact, supported issues and causes that were also endorsed by communists. It did not help, apparently, that Welles had befriended figures such as Duke Ellington and Louis Armstrong. He was white and they were black. During the spring of 1941 the FBI began to gather information about Welles. They placed Erskine Caldwell under surveillance in 1943.[34]

The earliest FBI report on Gwathmey originated from Pittsburgh in December 1942, just after he had moved to New York, and it covered the years 1929 to 1942 in eleven single-spaced pages boldly marked CONFIDENTIAL. Particularly fascinating is the sheer amount of detail gathered from a considerable number of informants. Even more striking is what the FBI either got wrong or presented in the most peculiar ways. A special agent wrote, for example, "The most noticeable characteristic of the subject [Gwathmey] is his lack of prejudice of any kind. On many occasions subject would make the statement that the average person is very anti-Semitic." It is unclear whether the FBI regarded toleration as a virtue or a fault, but that initial report concluded by indicating that an informant believed that Gwathmey's "family background would militate against any subversive tendencies on his part [because] he seemed to come from an old Virginia family."[35]

The next report, prepared less than two months later, added these insights from an informant: "Subject was brought up by enlightened middle class people. . . . Stated that the subject is over-impressionable out of sympathy to the people less fortunate than he. Subject's life has been difficult and he has had to struggle constantly. . . . Further stated that subject is receiving outside income through his wife who is of some means." The report ended a thorough inquiry into Gwathmey's life in Philadelphia during the 1930s with the information that in 1938 he regularly attended the Philadelphia Workers School where the group studied "Historical Materialism."[36]

Early in 1944 a report based on information from several informants seemed to minimize Gwathmey as a risk: "The subject, although being a Communist, is not subversive in any respect nor has the subject ever been heard to make any criticism of the United States Government, but rather embraces the idea of Communism from the intellectual standpoint."[37]

As the war drew to a close, J. Edgar Hoover was advised that Gwathmey was listed

as a sponsor of the Artists Committee of the National Council of American-Soviet Friendship in New York City. Nevertheless, "it is not believed that subject is potentially dangerous to the internal security of the United States." Consequently the New York FBI office recommended the cancellation of its ominous Security Card Index concerning Gwathmey.[38] The FBI never seemed entirely clear that both Gwathmeys had, in fact, joined the Communist Party of the United States and met at roughly three-week intervals to discuss passages from the writings of Karl Marx in general and dialectical materialism in particular. Starting in 1944, moreover, the group of about a dozen usually met at the Gwathmey apartment on Central Park West because it had the largest and most comfortable living room.[39]

The FBI did know that in April 1942, before leaving Pittsburgh, the Gwathmeys hosted a dinner at their home for thirty people to raise money on behalf of Russian War Relief. Given the terrible suffering that occurred in the Soviet Union, America's wartime ally during 1941–45, their activism seems more humane than heinous. At one point Gwathmey's file declared that he had been born in England and spoke with an English accent. The FBI learned otherwise during the 1950s when they resumed surveillance "up close and personal."

In a curious sense, however, the FBI did catch one important paradox correctly, even though they did not remotely understand its implications. In a report dated January 19, 1944, they designated Gwathmey's "Nationalistic tendency" as "Communist." Perhaps the agent simply meant ideological tendency or commitment. But during the war Gwathmey was, indeed, an American nationalist who supported the Allied cause, and the FBI would have known that if they had paid attention to his activities as an artist instead of concentrating exclusively on the theoretical discussion groups he attended and the relief efforts he supported.

Early in 1941 he wrote to the director of the Pennsylvania Academy of the Fine Arts that "these are upsetting times but it is revealing that our cultural institutions have still the energy to keep going. It will be this in part that will help greatly toward a sane aftermath." The following year Gwathmey joined Artists for Victory (1942–46), an organization formed by artists who wanted to assist in the war effort. By 1944 he had become the group's recording secretary, and that same year, at the second annual conference of the Committee on Art in American Education and Society, Gwathmey suggested that art would be excellent therapy for returning war veterans.[40]

Most notable, however, in 1943 he won the Purchase Prize in the America at War Competition sponsored by Artists for Victory. His winning serigraph, *Rural Home Front* (fig. 10), has been misunderstood as depicting "*Tobacco-Road*-like characters, debased by their social status and without redeeming values." Gwathmey actually intended it to represent the patriotic feelings and efforts of the underclass, those too old or too young to fight who did their best on the home front. As for the long-armed farmer in overalls, Gwathmey commented that he was "particularly fascinated by farmers, for they tend toward leanness, have stiffness of movement and are very deliberate in their actions." The

farmer became something of a civilian martyr, struggling with the land under difficult social and economic conditions.[41]

Although the composition predictably makes visual statements about race as well as class, the lamentable situation of all neglected Americans at the bottom of the ladder predominates in the image. The farmer and his wife are white. The ragpicker in the rear left is black, and the sharecropper couple at the rear right are black, leaving permanently for work in a factory that may be north or west. The naked infant is directly based on baby pictures taken of Charles Gwathmey that remain in the family photograph album that Rosalie started when Charles was born. An example of Gwathmey's visual memory is seen in the quilted bed-covering in this composition; it has the same pattern as the comforter in Gwathmey's vividly striking oil painting executed thirty-four years later, *The Quilt* (plate 39).

An additional episode compounds the irony in the FBI's wartime concern about the adequacy of Gwathmey's Americanism. In 1946 the State Department organized a collection of seventy-nine paintings by contemporary American artists to be sent on an overseas tour as a goodwill promotion of American culture. Called *Advancing American Art*, the exhibition turned out to be controversial in Congress, where conservatives complained that the federal government should not be engaged in selecting and supporting American art. Whereas Gwathmey, the radical, was glad to have two of his paintings included, *Workers on the Land* (1945–46) and *Worksong* (1946), a national chauvinist such as Andrew Wyeth would not allow his work to be included because he did not believe in using art to make any sort of political statement, and he particularly refused to participate in a program that smacked of Cold War propaganda.[42] There is a curious reversal of the expected conventional roles and attitudes here, but we are obliged to conclude that Gwathmey, a political activist (whereas Wyeth was not), certainly cannot be considered anti-American, never mind subversive.

It is essential to bear in mind the distinction between anti-Americanism and a wry willingness to engage in demonstrative political satire. *Poll Tax Country* (plate 4) is a devastating, unsubtle commentary on white southern demagogues and the complicity of white clergy, socialites, and self-satisfied black educators. The public presence of a Klansman and a raucous black crow competing with the orator all stand (and sit) in sharp contrast to the colorful toilers with their hoes in the foreground. The painting also serves, once again, as a reminder that Gwathmey could be a dazzling colorist, much bolder in that regard than his principal teacher, Franklin Watkins, who remarked rather oddly in 1971 that "I'm very critical about my color. I think it must mean a great deal to me because most of the color that I come up with is unsatisfactory."[43] Gwathmey always remained his own harshest critic, but by the mid-1940s he should have felt rather good about his use of color. Joseph Hirshhorn was sufficiently smitten by *Poll Tax Country* to purchase it promptly from the ACA Gallery in 1945.

Every southern state had initiated a poll tax around the turn of the century as a means of disfranchising poor whites as well as blacks. The tax of one or two dollars a year was

rationalized as a revenue raiser, but in some states the tax was retroactive to age twenty-one, cumulative for up to twenty-four years. It also had to be paid months before election time. By 1937 North Carolina, Florida, and Louisiana had repealed their poll taxes. Georgia did so in 1945, while South Carolina and Tennessee followed suit early in the 1950s. The remaining southern states, including Virginia, clung to this discredited device until 1964, when the Twenty-fourth Amendment to the U.S. Constitution made it illegal.[44]

The year 1946 was a banner one for Gwathmey. From January 21 through February 9 he had a one-man show of twenty works at the ACA Gallery for which Paul Robeson wrote an eloquent three-page introduction. Robeson concluded that "in the coming years, when as we all hope, true equality and the brotherhood of man, will be a reality, Gwathmey's paintings will have earned him the right to feel that he has shared in the shaping of a better world." Later that year Gwathmey had a one-man show at the Virginia Museum of Fine Arts in his native Richmond, a deeply personal triumph. Both exhibitions featured one of his most charming and poignant pictures, *Lullaby* (plate 7), which received the $1,500 third prize in a national competition called "Painting of the Year" sponsored by Pepsi Cola. It captures our interest as a modernistic version of a late medieval madonna and child. The woman is clearly singing a lullaby to her baby, and the childish cartoons on the walls behind her are copies that Robert Gwathmey made of drawings that his son had done directly on the wallpaper of his bedroom.[45]

In 1946 he also finished several important pictures with motifs that he had worked on for several years, such as *Hoeing Tobacco* and *Standard Bearer* (see fig. 20 for a pencil drawing of the oil painting), the latter showing a pompous white man with a distended belly proclaiming the dominance of his class and kin.[46] Three other works from 1946 deserve more extended discussion. *Field Flowers* (fig. 21), which is unique among his works because it has a date, very likely used the same model who posed a few months earlier for *Lullaby*. More important, however, what differentiates this woman from the figure in *Lullaby* is that her face is explicitly like an African mask, yet she is clearly wearing spectacles. Gwathmey was not notably attracted to primitivism as that concept was then understood, but this experiment with the mask may reflect the influence of Picasso. In any case, it certainly anticipates a variation of the masklike face in one of Gwathmey's finest works, *Sowing* (1949).

In *Tobacco* (plate 8), Gwathmey moved from depicting any particular phase in the process, or the crippling nature of chopping and hoeing to a narrative tour de force of the entire cycle. The painting should be read clockwise, starting in the lower left, where a field-worker picks leaves off the stalk of a tobacco plant. The women above him are tying the leaves into bundles so that they can be hung in heated barns for the curing phase. Because the fire used to provide heat commonly set the barns ablaze, Gwathmey shows that event at the top (as he also does in several other works). Once the leaves have been cured, they must be sorted by color, a process known as grading, which ordinarily takes place indoors. Gwathmey has displaced the barn wall in the lower right so that the women grading tobacco can readily be seen. The triangular tobacco patch provides an inverted

FIGURE 20
The Standard Bearer
(*Senator*) (n.d.), pencil,
19$\frac{1}{2}$ × 17. Courtesy
of Stephens, Inc.,
Investment Bankers,
Little Rock, Ark.

"reflection" of the roof structures above it, and the colors are deliberately, indeed wonderfully, intense.[47]

A third composition, conceived and largely completed in 1945, was exhibited in 1946 and has been shown several times since then. *The Vacationist* (fig. 22), is important for a variety of reasons. First, it anticipates the many versions of crabbing and clamming that became favorite motifs for Gwathmey in later years, especially the 1950s and 1960s. Second, it introduces the image of the long-handled net, yet another emblem that Gwath-

mey liked as a symbol of entrapment, of what aggressive humans could do to their prey. (Consider also *Soft Crabbing* [1955] and *Butterfly* [1972].) Third, in terms of representing the human body, the painting depicts the rounded shoulders that Gwathmey occasionally referred to and the exaggerated size of the man's hands, a characteristic that became virtually a signature item for him. Gwathmey felt comfortable talking about this picture also, as he did in a 1966 interview when the Brooklyn Museum displayed it. He acknowledged once again his fondness for satire.

> I think of a person going to the summer vacation land and then going to the seashore for two weeks to gain your sunburn assiduously and you learn to pick up a crab without being bitten and things of that sort. . . . Now that sounds a little droll because I'm not poking fun at the guy that only has two weeks vacation. I'm pointing to the fact that within two weeks you can only do certain things. You can never become, let's say, an aficionado . . . [of] those crabs . . . and things of that sort, so that's just the idea of it. Here's a bird goes to the seashore for two weeks and becomes completely involved and happy with it but he can never be native in a sense.[48]

By 1946 museums as well as private individuals had eagerly begun to collect and feature works by Gwathmey. He was a Social Realist with an absolutely distinctive style and subject matter, and his art was appealing and unlike any other. Even among the Social Realists, his paintings are immediately identifiable. Moreover, as *Life* magazine noted in a feature story late in 1946, the American public had started to appreciate and connect with contemporary art to an unprecedented degree.[49] Surprisingly, perhaps, southern art museums were among the first to acquire works by Gwathmey, and he achieved early visibility in the Midwest as well. The Walker Art Center in Minneapolis displayed works by Gwathmey in exhibits in 1943, 1944, and 1952. It did not hurt that Hudson Walker, an affluent collector based in Minneapolis who supported Artists Equity, admired Gwathmey's art and became acquainted with him during the 1940s. The Walker Art Center featured *The Vacationist*, for example, in its 1946 show.[50]

Critics and writers who reviewed Gwathmey's work in these exhibitions commonly called attention to his concern about social injustices perpetrated against African Americans in the South. They would often comment that his subjects bore a look of patient resignation, or else compliment him for not romanticizing his depictions of them. They also remarked with some frequency that he was clearly sympathetic to poor whites as well.[51] (This sentiment was already apparent in *Rural Home Front*.)

In addition, however, these works provide glimpses of a characteristic that became pronounced in Gwathmey's painting during the early 1960s, namely, the creation of figures whose racial identity is not immediately evident. Often he put fairly Caucasian features (often a modified self-portrait, in fact) on a tawny body, as in *The Vacationist*. In 1947 Gwathmey created a work with ink on paper called *Christmas Carol*. One man sits cross-legged while playing a guitar and singing. From his facial features it is impossible to tell whether he is white, black, or even Asian (because of the almond-shaped eyes). The

FIGURE 21
Field Flowers (1946), oil
on composition board,
$37^5/_8 \times 25^3/_4$. Collection
of the Whitney Museum
of American Art, New
York. Gift of Mr. and Mrs.
Sidney Elliott Cohn.

artist's brief explanation in 1981 to the museum that owns the painting deliberately ignores race because Gwathmey had long since moved to the "family of man" mentality, emphasizing the universality of the human condition. "The occasion was a group Christmas show," he remarked, "and I used a farmer in over-alls, which is a usual image for me. The use of a twig of an evergreen, I hope, sets the occasion."[52]

By 1948–49, however, Gwathmey had not only achieved a national reputation; he had brought his presentation of African American life and culture to a more powerful level of affirmation and engaging presentation, whether the subject was church or family life, individual labor or community interaction. Four notable paintings show the artist at the very top of his form in those highly creative and productive years.

The first is *Sunday Morning* (plate 9), a glorious colorfest—almost though not quite carried to excess—in which three women and a man, joined by a girl and a boy, are obviously going to church. The older woman prominent in the foreground is based on a real person, Mrs. Sarah Wade, who worked for Rosalie Gwathmey's family in Charlotte, primarily as a cook. She makes a solo appearance in the *Farmer's Wife* (plate 18) four years later. The artist became fond of "Aunt Sarah," but on one occasion, when he gave her a picture he had drawn, Charles and Ida Hook made it clear that they regarded such generosity as highly inappropriate, for reasons that combined race and class.[53] Of greater importance is the way that Gwathmey turned a white stereotype about the social aspects of black church-going into a dignified and staunch affirmation. Consider this extract from Sherwood Anderson's 1925 novel, *Dark Laughter*: "On Sundays—when they go to church, or to a bayou baptizing, the brown girls do sure cut loose with the colors . . . deep purples, reds, yellows, green like young corn shoots coming up. They sweat. The skin colors brown, golden yellow, reddish brown, purple-brown. When the sweat runs down high brown backs the colors come out and dance before the eyes. Flash that up, you silly painters, catch it dancing. Song-tones in words, music in words—in colors too" (p. 77).

In 1968 Gwathmey explained exactly how he chose his color combinations and patterns, virtually responding, in a sense, to Anderson's challenge. Paul Cummings commented on the "terrific range" of the artist's color combinations.

RG Well, say for instance, I have argyle socks, I have neckties, I have sweaters, I have many sheets of paper, multicolored papers. And I throw these things around and I pick up several different combinations.

PC You use paper as a collage type of thing?

RG No, just looseleaf paper, fragments, that I pick up. It's as if you were playing a hand of cards. You have five colors, five cards, as it were. You take one and move it back in position, move it back in another position again. I think I told you earlier that I saw a Van Gogh exhibition in Amsterdam once and they had paraphernalia out of his studio, his easel, his palette. And then they had a kind of shoebox just full, crammed full, of swatches of multicolored cloth.

PC Oh really?

RG And I know darn good and well he took a handful of these things out and put them on the floor or the table and found some beautiful color combinations that attracted him. And he'd use them. That doesn't mean he stuck to them religiously, you see, but I know it was a springboard.[54]

Gwathmey then mentioned that Matisse had an aviary, "and I know his gaily bedecked birds were a part of the basic color [scheme]. Absolutely."[55] It should come as no surprise that Gwathmey knew and appreciated Matisse's work, because his other masterpiece from 1948, the much-admired *Children Dancing* (plate 10), clearly reveals more than a touch of inspiration derived from Matisse. In 1909, while working on a large commission from Sergei Shchukin, Matisse enjoyed going to the Moulin de la Galette on Sundays to watch people dance, particularly the lively Provençal farandole. Matisse said subsequently that he sang a particular tune that he heard at the Moulin de la Galette while he worked on his large and now well known canvas called *Dance* (see fig. 23). Because of the work's immediate appeal, he did a close variation the following year, titled *Dance II*, now located at the Hermitage Museum in St. Petersburg.[56]

An art critic who saw *Children Dancing* exhibited in 1949 noted the obvious influence of Matisse as well as Picasso on Gwathmey's work and called attention to his modified flat cubism along with his blend of realism and abstraction.[57] Particularly striking in this picture, beyond the wonderful sense of movement, exuberance, and family cohesion, are the large extended hands of the mother. By this time, large hands had become one of Gwathmey's most characteristic devices, and whatever it may have meant to him, it transcended race. *The Vacationist* (fig. 22) has huge hands, and so does *Chauffeur*, an oil-on-canvas caricature of a white, working-class snob that Gwathmey painted in 1938–39.[58]

During the summer of 1949 Gwathmey completed two major paintings that seem to have satisfied him quite well. A community study that he titled *Saturday Afternoon* (plate 11) (a kind of mate to *Sunday Morning*) he described in these words to Herman Baron, his dealer at ACA: "a landscape of homes, store and church with 16 people, most out of other canvases."[59] Note the processional echo of *Sunday Morning* slightly to the right of center. The deliberately sun-bleached letters above the cigarette ad on the left read BAR B-Q and, below that, EER and ALE. All of the commonplace comestibles and beverages of a working-class community are in evidence, along with signs of family life, commercial activity, and the all-important community church poking up behind the shops. Amidst all of the detail, Gwathmey has quietly placed two chevrons on the tan sleeve of the man just left of center, who achieved the rank of corporal serving his country during World War II.

Gwathmey described the other major work done in mid-1949, *Sowing* (plate 12), in this manner: "I believe it's the best I've done. A woman sowing with the sun setting behind some pine trees and a scare crow made out of a fertilizer bag with an old fruit [?] for on top of a stick."[60] The composition pleased him so much, in fact, that he made a variant in watercolor and a small oil version as well as the oil painting that was purchased by the Whitney Museum of American Art (its only purchase of a Gwathmey; *Field*

Flowers was a gift to the Whitney in 1956). In the watercolor Gwathmey has a rose-colored foreground, an apricot sky, a bright yellow sun, and an orange and red checkerboard base for the insect deterrent. The woman's billowing skirt is blue and her top is green, yet it all works very well.[61] In the small oil version (plate 13), Gwathmey responded to Millet's penchant for depictions of peasant couples working in the fields. In this jewel of a painting, the man and woman sow their seeds in an antiphonal manner against an autumnal, burnt-orange background.

The large oil version of *Sowing* is not important just because Gwathmey expressed unabashed pride in what he had accomplished. It demonstrates clearly how the artist adapted French peasant scenes made famous by Millet to the world of southern sharecroppers. Millet's *The Sower* (1850), his first great work, actually appeared in several versions beginning in 1846–47. It is a powerful image, quite specific in terms of activity yet ultimately somewhat mysterious (fig. 24). The single figure has a length of cloth tied across his chest and then gathered up in his left hand to form a sack for the seed grain. He strides across the broken ground of a hillside in Normandy. His legs are wrapped in straw for warmth, and his cap is pulled down over his ears because the sowing of winter wheat is done in November. The impoverished southern sharecropper also wrapped his legs with whatever materials he could find (see fig. 25). The last rays of a setting sun (like Gwathmey's) make the sower's face dark and shadowy. Nevertheless, the highly unusual evening light reminds us that Millet, too, was an inventive colorist. Above all,

FIGURE 23
Henri Matisse, *Dance* (*first version*) (1909), o/c, 8' 6½" × 12' 9½". Museum of Modern Art, New York. Gift of Nelson A. Rockefeller in honor of Alfred H. Barr Jr.

FIGURE 24
Jean-François Millet,
The Sower (1850), o/c,
40 × 32½. Gift of Quincy
Adams Shaw through
Quincy A. Shaw Jr. and
Mrs. Marian Shaw
Haughton. Courtesy of
Museum of Fine Arts,
Boston.

however, *The Sower* is historically significant because Millet made a fundamental break by applying his considerable skills to the most commonplace rural activity. As one scholar has observed, "Unlike the numerous small-scale genre scenes of peasants that frequently found a place in the Salon, *The Sower* makes no apologies for presenting a contemporary French peasant with the dignity and declamatory power of a historical figure."[62]

Critics responded positively to the work's aesthetic qualities, but when they turned to the substance of the image itself, it is clear that they were not sure what it meant. Acknowledging "the strangeness and power of the figure," they could not agree on whether its interpretive content was religious, a socialist protest on behalf of the rural proletariat, or something else altogether. Although Millet always insisted that his art carried no political messages, such a denial in conjunction with this picture (and others that followed) was surely disingenuous. Millet needed commissions from the affluent bourgeoisie, and he sought success in the salons whose judges were considerably more conservative than he. Under the circumstances, what he did in this painting was courageous. The revolution of 1848 enfranchised all male citizens, a dramatic change from the substantial property qualifications that had severely limited French suffrage previously. (There are obvious parallels in the gradual, state by state abolition of the poll tax in the South beginning in the 1930s and ending in 1964.) Would the newly expanded electorate demand retribution for years of excessive taxation and exploitation? A big peasant who moved resolutely across a darkening field, wearing a red shirt and with his face hidden and shadowy, could only be perceived as a challenging if not threatening image. A careful student of Millet has offered a less intensely political reading of this picture,

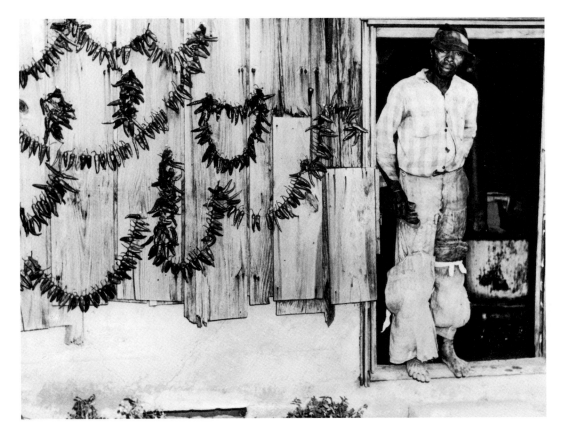

FIGURE 25
Rosalie Gwathmey,
*Sharecropper Lives
in a Tobacco Barn,
No Windows, No
Conveniences* (n.d.),
gelatin silver print.
Ramona Javitz Collec-
tion, Miriam and Ira D.
Wallach Division of Art,
Prints, and Photographs.
New York Public Library.
Astor, Lenox, and Tilden
Foundations.

however: "With *The Sower*, Millet brought the archetypal peasant from the background of so many paintings to the foreground of a picture of his own, thereby reinstating the three-quarters of the French population who earned their daily bread (as well as the bread of the other quarter) by the sweat of their brows in the main cultural forum of the day. Not since the appearance of the wool carders and the diggers and the reapers on the portals of the great cathedrals of France had the peasant taken his place so prominently among the powers of the nation."[63]

Millet's *Sower* is as strong and determined in his stride as his *Man with a Hoe* appears to have been beaten down by years if not generations of bone-wearying toil. By the same token, the woman in Gwathmey's *Sowing* seems almost sprightly. Perhaps in part because there is a graceful, fluid rhythm to her bodily movement, she does not appear to have been brutalized by her chores.[64] (See Chapter 3 for further discussion of Millet's influence on Gwathmey's art, in the context of his work in relation to an array of influences, ranging from photography to European art.)

In 1949–50 the Gwathmeys spent ten months in Europe, mainly in Paris. Responding in 1963 to a query from the MFA in Boston, Robert Gwathmey looked back to that transi-

tional year in particular but generalized in a manner whose meaning is not entirely clear, except perhaps to suggest that French influences on his work would be less important or evident in the years ahead. "American artists are so indoctrinated by the French school that influence therefrom was not extended. In fact I was completely ready and anxious to return home." Considering that one of Gwathmey's major teachers, Daniel Garber, had been a latter-day American impressionist, Gwathmey probably had the French impressionists in mind rather than Millet and Daumier, who always remained important to him.[65]

In any event, three things must be said of Gwathmey by 1949. First, he clearly had hit his stride as a Social Realist with an unmistakable and compelling métier. Second, he had achieved national recognition through prize competitions, museum purchases, invitations to serve on art juries, and requests for participatory appearances. He was also teaching at the New School for Social Research in addition to the instruction he gave at Cooper Union. On Sunday, April 3, 1949, he served as the principal speaker at the opening of Atlanta University's Eighth Annual Exhibition of Painting and Sculpture by Negro Artists.[66] Third, he and his wife, along with many other political activists and particularly fellow members of the Communist Party, were beginning to find the ideological climate in the United States decidedly scary.

McCarthyism had emerged in the wake of intense scrutiny from HUAC. Some former party members had become informants following an attitudinal flip-flop. Monthly meetings of the Gwathmeys' party discussion group were uneasy occasions.[67] The Supreme Court agreed to hear the Dennis case and, consequently, would soon uphold the convictions of American Marxists who had violated the Smith Act of 1940 by daring to discuss revolutionary concepts, not even overtly advocating them. The climate of opinion in the United States had become exceedingly grim for radicals on the left.[68] Going to Europe to get some breathing room seemed prudent indeed. On board ship, by chance, Gwathmey met the brilliant Mexican artist Rufino Tamayo. They struck up an instantaneous friendship, which added yet another layer of influence to Gwathmey's aesthetic repertoire.[69]

During the summer of 1949 Gwathmey made preparatory sketches of southern scenes "to be used when I get to France."[70] Despite his own deliberate act of sowing, however, his ten months in France turned out to be as professionally unproductive as they were personally delightful. What he *did* produce in Paris he mostly destroyed soon after returning to the United States. Being in the home of great art only seemed to make him homesick for his "native heath," for he had not yet exhausted his creative responses to and uses of that native heath.

Bread and Circuses

Because the 1940s were not merely the seminal decade in Gwathmey's career but also the most creative and the most fecund, we need to look more fully at the broad variety of artistic sources of inspiration and influence available to him. What traditions did he accept? Which did he reject and why? What did he adapt or modify in order to make or alter his own work, such as serigraphy? What is the relationship of his painting not merely to nineteenth-century European art but to documentary photography in the United States during the later 1930s and early 1940s? What about film, moreover, such as Walt Disney's warm but racially romanticized *Song of the South* (1946), and the appeal of composer-performers such as Hank Williams, whose moody guitar-playing achieved a peak of celebrity by the later 1940s? Some parallels between Gwathmey's art and the written word must also be explored because there is a notably striking anomaly: although he did not read voraciously, he enjoyed being read to while he painted. Finally, how did these diverse sources, visual as well as lyrical and even sometimes literary, combine to shape his particular version of Social Realism, a movement in the art world that reached its apogee in the later 1930s and 1940s?

It is considerably easier to pin down and elucidate Gwathmey's political commitments than to sift through the manifold connections between his images and the diverse range of artistic modes available to him, because they were so numerous and pervasive during and after World War II. What makes these relationships interesting, ultimately, is Gwathmey's ambiguity about most of them. He had a penchant for iconoclastic comments concerning patterns of influence, yet he is strangely silent about some of the most obvious ones. Nevertheless, such configurations are surely present. Gwathmey acknowledged many influences with enthusiasm and had ambivalent feelings about others. I do

not find his ambiguities at all disingenuous, however, because I not only regard him as sui generis among the artists of his time, but believe that (at least inwardly) he knew that he was. No one among his contemporaries painted his subject matter in the manner that he did. A few younger artists who greatly admired Gwathmey did work that is unabashedly derived from his,[1] but Gwathmey himself stands alone as a man with a singular vision combining content and style whose compositions compel immediate recognition because of their originality and freshness.

During the 1940s, especially, Gwathmey was receptive to influences that range from classic art of museum quality to recent camera shots taken for documentary reasons to music that he heard on the radio. Above all, he internalized and reconstructed as visual memories scenes recalled from the coastal and rural South. These memories were so powerful that he could reproduce them repeatedly as distinctive regional commentaries that transformed history, parochial mythology, and experience into startling iconographic statements capable simultaneously of pleasing the eye and pricking the conscience. His own commentary in 1945 concerning questions of artistic influence, integration, and separation is eloquent.

> A social artist is a man who is going to integrate the life of his times. Since the moving picture camera exposes the ills of contemporary life so convincingly and authentically, what style is the painter to use?
>
> Social painting is not, to the mind, limited to the obviously pictorial. You can transcend the literary, as I said before, if your imagery is strong and inventive enough.[2]

Gwathmey's feelings about the still camera and its implications for his art were complicated, in ways both positive and negative. As he explained in the same interview, conducted late in 1945, "Another reason I paint the way I do is that I think that the camera has been the most liberating influence for the painter. One only has to contrast World War Two war-painting with its war photography to see that the camera can create realism for the better."[3] Consequently he regarded the still camera as a source of emancipation for the painter. For that reason he felt gratitude because the existence of photographic records left him free to take all sorts of liberties, sometimes even whimsical ones, with perspective, with the human form, with shadow (or the absence thereof), and with chiaroscuro.

In 1940 Frederick Lewis Allen, a keen observer of developments in publishing from his editorial post at *Harper's*, noted that popular magazines were printing articles about the fine arts accompanied by color reproductions. He also observed that since 1938–39, "there has been a well-rewarded rush to bring out books of masterpieces of art, old and new." The timing of that trend is important because it reinforced Gwathmey's growing conviction that painting should go far beyond the replication of reality in conventional colors.[4]

Formal photographs or even pictures that he clipped from magazines and newspapers provided Gwathmey with points of departure, for which he felt suitable appreciation.

But most painters of his generation found it difficult to regard photography as an authentic, serious art form. In Gwathmey's case, moreover, he believed that painting could convey "reality" even more effectively than still pictures taken with a camera. Whereas the photographer could only define the boundaries of an image, including some things and excluding others, the painter could highlight through the use of color and exaggerate size and spatial relationships in order to make a pictorial statement whose meaning could be conveyed with particular clarity and power. As one critic observed late in Gwathmey's career, responding to an exhibition at the Guild Hall in East Hampton, he developed a style that "transcends the camera view."[5]

Gwathmey's ultimate declaration in this matter, essential to keep in mind while attempting to take into account a series of possible sources and influences on his painting, was that he preferred "art to be removed from its reference. You manufacture a scene."[6] That is exactly what he did. He created artistic scenes that he had actually observed (rather than imagined) in one form or another, but then he transformed them into highly evocative, vivid, often startling visual statements. Between the later 1940s and the end of the 1960s his compositions became crowded with figures, structures, signs, and symbols. (See *Winter's Playground* [plate 6], *City Scape* [plate 28], and *United* [plate 34].) During his last fourteen years as an active painter, however, Gwathmey created works that seem simpler, often almost austere, and frequently less exuberant in terms of color and action, though his impact as a colorist perhaps became more controlled and certainly more refined. These later works are among his most subtle and poignant. It is useful to reiterate an admonition that Gwathmey made at the end of his career: "Beauty never comes from decorative effects, but from structural coherence."[7]

Major artists have always been influenced by other great artists without becoming derivative; it is a dynamic of self-disciplined inspiration and transformation rather than of imitation. Peter Paul Rubens, a Flemish master born one year after the death of Titian, copied the latter's work in order to discover secrets of the Italian painter's genius. Rubens made a faithful copy of *The Rape of Europa* (1562), for example, and his great portrait of the *Earl of Arundel* (1630) closely parallels the *Duke of Urbino* (1537) by Titian. Indeed, we know that Rubens made *at least* thirty-three copies of works by Titian. This has been a common practice for centuries, not only in the West but in China and Japan. Paul Gauguin was an artist who seems utterly distinctive (and unprecedented) in his own way, just as Gwathmey does in his. Yet Gauguin confided the following to his journal: "With the masters I converse. Their example fortifies me. When I am tempted to falter I blush before them."[8] Gwathmey shared that sentiment in his feeling for what he called "continuity."

In Gwathmey's case we must return to the work of Jean-François Millet, a French socialist who went beyond the rural landscapes of the Barbizon school by peopling them with humble peasants either performing their characteristic agricultural labors or taking their ease from such relentless and wearisome work. Except for the melodramatic *Man*

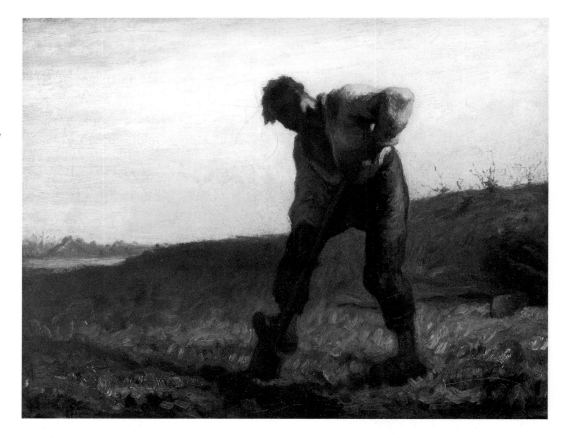

with *a Hoe* and a few others, most of Millet's peasants are not beaten down, broken in spirit, or even overtly oppressed.[9] They perform chores that men and women of their station had performed for generations, but with dignity, sturdiness, and adequate clothing and without much in the way of romanticization. To list some characteristic titles of paintings by Millet provides a virtual litany of farm labor in mid-nineteenth-century France: *Man Turning Over the Soil* (fig. 26); *In the Vineyard* (1852–53); *Peasant Spreading Manure* (1854–55); *Gleaners* (1855–57), in which three women are gathering wheat, a picture that qualifies as Social Realism and brings to mind several Gwathmey paintings of cotton pickers (see plate 14); *Woman with a Rake* (1856–57); and *Peasant Couple Going to Work* (1866), which has its counterpart in Gwathmey's *Carrying the Sack* (fig. 27), a watercolor that he did in 1950 directly following his return from ten months in France.

Three other works by Millet immediately bring to mind pictures on parallel subjects that engaged Gwathmey's imagination. Needless to say, the topics themselves are hardly distinctive to these two artists alone. They have long been prominent themes in the history of art, but the manner of treatment and execution compel us to recognize how important Millet's painting was as an influence on Gwathmey.[10] First, Millet's *Harvesters Resting* (1851–53), which itself contains echoes from both Poussin and Michelangelo, was the most important of three works that Millet sent to the Salon of 1853. Its resonance

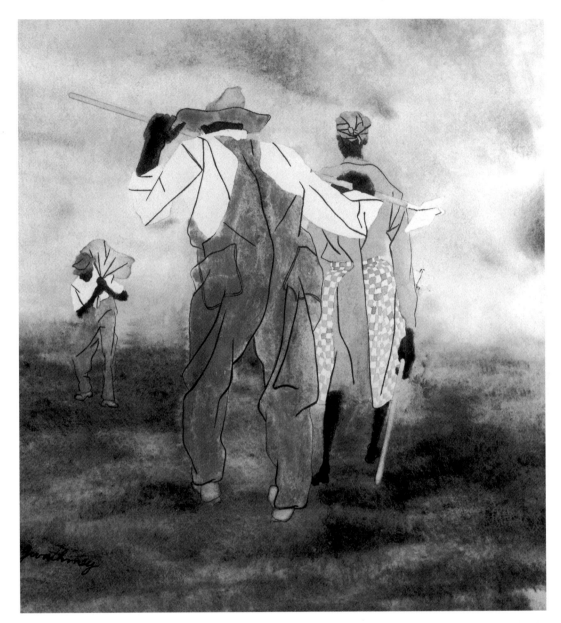

FIGURE 27
Carrying the Sack (1950),
watercolor and brush
and ink on paperboard
sheet, 16¼ × 13.
Hirshhorn Museum
and Sculpture Garden,
Smithsonian Institution,
Washington, D.C. Gift
of Joseph H. Hirshhorn,
1966.

with secular art of the northern Renaissance as well as its biblical allusions had great appeal and earned Millet a second-degree medal. Its counterpart in Gwathmey's work is a simple but beautiful drawing (pencil and wash on paper) called *Dialogue* (1965), which depicts six seated figures. Four are women wearing bonnets who look like either nuns or Amish farm figures; the other two are men in overalls. They appear to be engaged in serious conversation against a background of immature, low-growing tobacco plants. The figures are evidently a white farming group taking a break, a deceptively understated piece yet deeply moving in its simplicity.[11]

The second painting by Millet that parallels one by Gwathmey is *After the Day's Work* (ca. 1863), which also has an echo in Charles Burchfield's *End of Day* (1936–38), a watercolor based on a study the artist made in 1921. Above all, *After the Day's Work* corresponds to Gwathmey's *End of Day* (plate 15), a striking composition that he did in oil and as a serigraph, in 1944–45, and which Frances Serber then rendered as a ceramic piece that appeared at Gwathmey's one-man exhibition in 1946.[12] The third example is Millet's *Potato Planters* (1861–62) (fig. 28), in which the man digs a hole and the woman deposits the seed potatoes, a graceful composition in which the geometric rhythm of the two figures makes a serene study in cooperation and antiphonal organization.[13] There are several counterparts in Gwathmey's oeuvre, most notably *Sowing* (plate 13), *Hoeing Tobacco* (1946), and *Hoeing* (n.d.), the last two located at the University of Georgia Museum of Art in Athens and at Brandeis University, respectively.

Gwathmey does not mention Millet in the several interviews that he gave, and one can only speculate why. After Markham's *Man with a Hoe* was published in 1899 and then endlessly reprinted, Millet came to be viewed, at least in the United States, as a sentimental artist. That most certainly was not Gwathmey's self-perception, and he may have chosen

FIGURE 28
Jean-François Millet, *Potato Planters* (ca. 1861), o/c, 32½ × 39⅞. Gift of Quincy Adams Shaw through Quincy A. Shaw Jr. and Mrs. Marian Shaw Haughton. Courtesy of Museum of Fine Arts, Boston.

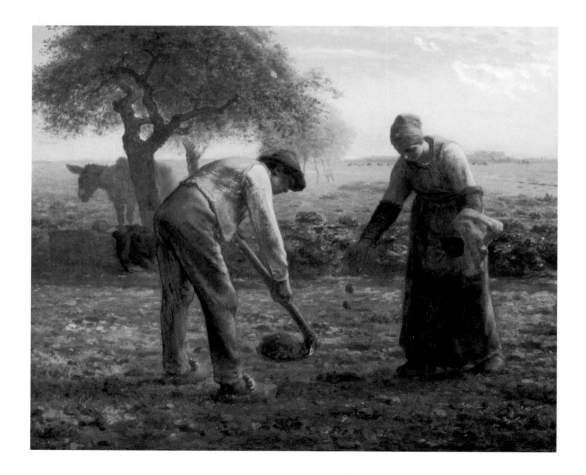

to avoid "guilt by association." Alternatively, his indebtedness to Picasso, Tamayo, and Daumier may have felt and looked less direct or less deep. Perhaps Gwathmey unconsciously felt no need to mention the artist who clearly served as his most notable and direct source of subject-matter inspiration.

In the case of Daumier, an artist Gwathmey greatly admired, the patterns of influence were direct, as in *Ancestor Worship* (plate 2), but also indirect. The latter category includes a considerable number of guitar players done by Gwathmey and, by Daumier, *The Singing Guitarist* (late 1850s) as well as *Le Troubadour* (ca. 1868–73) and his very familiar *Pierrot Playing the Guitar*.[14] Daumier also provides antecedents for the chalky white faces that Gwathmey gave to women that he satirized in the later 1960s and 1970s.[15] There are also direct models for the pompous men and vain old women wickedly caricatured by Gwathmey within a year of his return from Paris during the late summer of 1950. (See plate 21 and Chapter 4.)

It is easy to understand why Philip Evergood was Gwathmey's best friend. Evergood shared his enthusiasm for Daumier and his passion for social justice.[16] In reference to Stuart Davis, Evergood observed, "He was afraid—a lot of artists have been afraid of making strong social statements because they wanted to avoid any taint of sentiment. Whereas I always felt that the very great artists like Goya and Daumier were not afraid of that." In the same 1968 interview Evergood added, "Take Daumier's *Railway Carriage*. The pathos of the crowded atmosphere, the woman nursing her child right there crowded next to a lot of men in rough overcoats and funny-looking plug hats. And the human thing I suppose is what really drives the artist."[17]

It comes as no surprise that Gwathmey admired the art of Georges Rouault, especially his later work. Rouault served an apprenticeship as a painter of stained glass and subsequently restored medieval windows. Both experiences obviously affected the works for which he is best known (see fig. 29). The appearance of heavy leading (as a color separator) and the patterning of medieval stained glass provided a particular inspiration for the rugged drawing, the compartmentalization, and the vibrant luminosity of his painting, most notably in his last decades. Gwathmey did not meet Rouault during 1949–50, but he brought home a striking lithograph by Rouault that he happily hung in his living room.

Only recently have we learned that some of Picasso's most striking paintings from 1906–7 and later owe at least part of their inspiration to late nineteenth-century bordello photographs and to images made by Edmond Fortier, a photographer based in Dakar, Senegal, at the turn of the century.[18] Just as Picasso would have denied much if any indebtedness to those pictures, despite obvious similarities, I suspect that Robert Gwathmey would have responded in a similar fashion to a comparable confrontation. Fully aware of the striking photographs taken in the South during the later 1930s, particularly of southern farmworkers, he mistrusted what he viewed as misleading prints that had been cropped for maximum dramatic effect or that included posed subjects or

even scenes deliberately staged. At best he feared the careless manipulation of prints that resulted in the creation of melodramatic effects. Years later, as noted earlier, he even contended that painting rather than photography conveyed reality more effectively because painting contained a humanistic element that the camera could not match.[19]

Be that as it may, a close examination of such photographs followed by comparisons with Gwathmey's work during the 1940s indicates that at the very least he derived ideas and themes from them if not specific subjects. In 1936, for example, Erskine Caldwell and his second wife, Margaret Bourke-White, already a prominent photographer, toured Caldwell's native South and collaborated on a book that blended her pictures with his text. When their volume, *You Have Seen Their Faces*, appeared in 1937, it caused an immediate sensation, and reviewers perceived it as a devastating critique of the "tenant farmer problem."[20]

Sometime during the later 1940s Gwathmey actually titled a painting *You Have Seen Their Faces*; it was exhibited at the ACA Gallery in April 1949. One of Bourke-White's pictures, bearing the caption "Little brother began shriveling up eleven years ago," shows an adolescent girl strikingly similar to the one Gwathmey dramatized so powerfully in *Non-Fiction* (fig. 13). Gwathmey's overall composition is totally different from Bourke-White's, but I have no doubt that he had seen her startling picture and very likely had it at hand when he painted *Hoeing* as well as *Non-Fiction* in 1943.[21]

As early as 1935 Walker Evans, Dorothea Lange, and Ben Shahn went south to make a photographic record of poor tenant farmers and sharecroppers for the Resettlement Administration. Other writers and photographers soon followed under Farm Security Administration auspices, but in 1936 Evans joined James Agee on a journalistic assignment in Alabama to learn in depth about the circumstances of sharecroppers there. They lived with three tenant families for six weeks, just as Gwathmey and his wife and son lived on a farm in eastern North Carolina during the summer of 1944. Evans and Agee were enraged by the popular success achieved by *You Have Seen Their Faces* in 1937, in part because that book seemed both superficial and willfully sensational in comparison with what they were attempting to do. But they also encountered infuriating delays, and *Let Us Now Praise Famous Men* was not published until 1941. Ironically, the latter book was a commercial disaster at the time of publication, yet it came to be regarded as a classic almost three decades later, after *You Have Seen Their Faces* had long since been forgotten as an ephemeral piece of photojournalism.[22]

The sharp differences in approach, motive, and impact between *You Have Seen Their Faces* and *Let Us Now Praise Famous Men* are important, both because of the fierce rivalry and the contrasting impact that the books had, and because Gwathmey's art resonated so much more closely with the emphases that Evans and Agee sought to achieve. William Stott provided a comparison in depth, subsequently elucidated by southern historian Burl Noggle:

Bourke-White "made her subjects' faces and pictures say what she wanted them to say." She showed "faces of defeat, their eyes wizened with pain . . . ; people at their

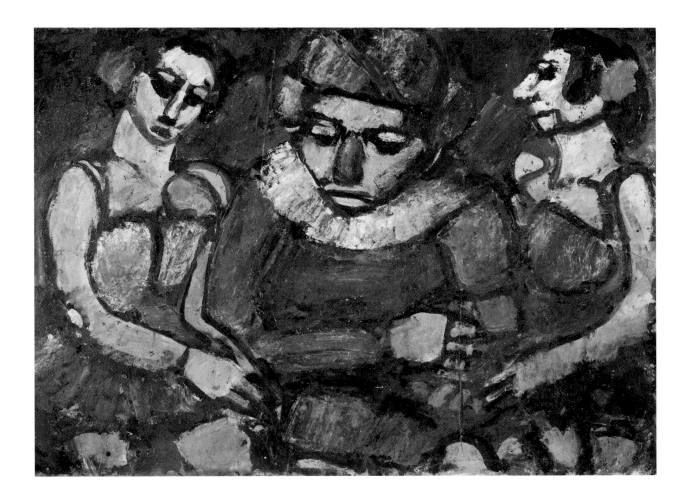

most abject: a ragged woman . . . on her rotted mattress, a palsied child, a woman with a goiter the size of a grapefruit. . . ." Agee treated his sharecropper hosts with respect, even with love. Evans saw beauty and dignity in them. In Bourke-White's photographs, "No dignity seems left in them: we see their meager fly-infested meals, their soiled linen; we see them spotlit in the raptures of a revival meeting . . . ; we see a preacher taken in peroration, his mouth and nostrils open like a hyena's." And if the viewer failed to get the message from Bourke-White's photographs, Caldwell's inscriptions (Evans's photographs had none) under the photograph "made them as abject as possible." Agee wrote of the tenant hovels he and Evans visited: "It seems to me necessary to insist that their beauty . . . inextricably shaped as it is in an economic and human abomination, is at least as important a part of the fact as the abomination itself." Here, notes Stott, "is the crucial difference between Bourke-White and Evans." She, using whatever lighting trick or bizarre angle was necessary for the job, tried to move her audience and to "expose sharecropper life as an unrelieved abomination." Evans showed its abomination but also, like Agee, its beauty. This was not conven-

FIGURE 29
Georges Rouault,
Circus Trio (1924), oil
on paper, 29½ × 41½.
Phillips Collection,
Washington, D.C.

FIGURE 30
Margaret Bourke-White,
Montgomery, Alabama
(1936). Margaret Bourke-
White, *Life* magazine,
© Time Inc. Photograph
courtesy of the Syracuse
University Library,
Syracuse, N.Y., Special
Collections.

FIGURE 31
Walker Evans, *Roadside
Barn, Monongalia
County, West Virginia,
June 1935*, gelatin
silver print. Division of
Prints and Photographs,
Library of Congress,
Washington, D.C.

tional beauty but tragic beauty and "tragic twice over: because it cannot be recognized or appreciated by those who create it."[23]

We know that Gwathmey found himself engaged by statements that Walker Evans made about art and society. We know just by looking at Gwathmey's paintings of buildings located in the black section of town, often covered with advertisements for tobacco, cold medicines, and soft drinks, that he viewed such signs simply as a decorative part of the human landscape. Beneath two of Bourke-White's pictures of just such structures near Montgomery, Alabama, Caldwell indulged in overkill to call attention to southern racism (see fig. 30). His caption read, "Of course I wouldn't let them plaster signs all over my house, but it's different with those shacks the niggers live in."[24]

Caldwell himself, of course, originated in the Deep South and knew its rural folk quite well. But he had relocated to Maine. Much of the documentary work undertaken in the South during the later 1930s was done by Yankees, in fact. Gwathmey, therefore, was not a unique observer, but he surely was distinctive as a critical insider who simply reported on the South to anyone interested. He resisted the temptation to sensationalize the region by making it seem titillating. As he told Paul Cummings in a matter-of-fact way in 1968, if you drove a mile out of town, you would see "these garish signs advertising the carnivals coming. And also these cure-alls, medicines. One of the famous ones is Six-Six-Six."[25] The signs could be found on structures belonging to whites and blacks alike.

The similarities between some of Gwathmey's townscapes and Walker Evans's photographs are striking (see fig. 31).[26] But it should not be surprising that Gwathmey's paintings most closely parallel the photographs taken by Ben Shahn, who became one of the best-known Social Realists. Shahn's *Picking Cotton* (fig. 32), taken in Arkansas in the fall of 1935, has a close counterpart, for example, in Gwathmey's *Cotton Pickers* (plate 14). (Late in the fall of 1949, after Gwathmey had made observations of peasant life in the Valley of the Loire, he wrote to friends in the United States that "the groups bending and picking looked like cotton farmers except there was absolutely no color in their dress.") Shahn's *Circus Poster* (fig. 33) from Smithland, Kentucky, taken in September 1935, brings to mind quite a few Gwathmey images, but above all one that he called *Bread and Circuses* (plate 16), painted in that pivotal year 1945.[27]

The wild animals appealed to Gwathmey as a decorative touch, and he included them on many occasions. But to make a social statement without resorting to crude captions and bathos he needed weathered posters to signify the dessicating passage of time, and he needed the chimney of a burned-down tobacco barn to indicate both a commonplace disaster and the monopolistic dominance of a single crop in certain areas. Above all, he included the poor ragpicker who could not have afforded the price of admission to the circus in any case.[28] (See also plate 26.)

The relationship of southern African Americans to the circus is peculiarly problematic, and perceptions of it were fraught with ugly racism. They loved the circus, but they were not particularly welcome there. On the other hand, the pittance that they could pay

was welcome, so they were placed in sections called the "blues" at the round ends of the big tents (like being behind the goal posts at a football game). In Allen Chaffee's novel *Sully Joins the Circus* (1926), there is an episode where "shiny-black country negroes" appear in such great numbers that "the cry went up 'double the Jim Crow section.'" Although there were some black performers, a few of them even stars, white performers disliked being anywhere near the black sections of the audience. Dixie Willson candidly recalled her feelings when she rode past the "negro" section. "I can't describe the impression of it—so unexpected! So much of it all together . . . so terrifically shady! I love colored people very much indeed. I have many good friends among them. But I felt a tremendous relief that day and other southern days, when the tournament got well around that side of the tent!"[29]

Both of the best-known circus troupes that toured the country, Forepaugh and Barnum & Bailey had a long history of explicit racism. The Ringling Brothers 1895–96 route book included a six-page article, "The Plantation Darkey at the Circus." It stressed that blacks were especially fond of the clowns, because "the nigger and the laugh . . . it is with him under every inch of his black skin." Whereas the other acts might delight "the average mortal," they "awe the negro [because] to the average negro there is a mystery, a necromancy in the performances . . . associated in his mind with spooks and uncanny spirits." The wild animals, moreover, were "to the negro weird beings from a world rather more remote than the sun or moon. They fill him with horror." There is no bet-

ter window on white stereotypes than in the highly public, commonplace publicity material for the big-time circus.[30]

Although several of Gwathmey's paintings clearly resonate with early photographs by Ben Shahn, the most important photographer in his life was his wife, Rosalie. She had intended to become a portrait painter while she was a student at the Pennsylvania Academy of the Fine Arts, but when it became clear that she would marry Robert, she decided that "two painters in one marriage" might not work. When Charles was born in 1938, she wished to record his development, so she took abundant pictures with a basic Kodak. After the family moved to Pittsburgh in 1939, the city intrigued her, and she wanted to take pictures of street life. She got a 35mm Contax and studied with Luke Swank, a colleague of her husband's at Carnegie Tech and a professional photographer for corporate advertising.[31]

When the Gwathmeys relocated to New York City in 1942, Rosalie wanted to continue her work as a photographer, which she enjoyed. She went regularly to the Photo League, a social as well as a professional gathering of socially concerned photographers. Because the members were all on the left, they did not discuss politics very much because they had other venues for doing so. "We were interested in the life around us," Walter Rosenblum recalls. "We had a realist point of view toward life." The league met at a loft

on Twenty-first Street, mainly to discuss their shared vocation, but also for classes. Rosalie studied with Paul Strand, a perfectionist, and she enjoyed a wide circle of friendships that included Berenice Abbott, Henri Cartier-Bresson, and Nancy and Beaumont Newhall.[32]

By the end of the 1940s, however, intensification of ideological anticommunism, and particularly hearings by HUAC, created considerable anxiety among participants in the Photo League because it had been identified by the FBI as leftist and possibly "un-American." Eventually members discovered they had a female mole in their midst, an FBI informant who enthusiastically volunteered to participate in any new program. Some prominent members simply moved away in order to evade intense scrutiny. Paul Strand went to France, for example, and the Newhalls moved to Albuquerque. Rosalie had been one of the most active participants, serving as editor of the league's newsletter, *Photo Notes*. But when the pressure became so intense that her closest friends in the league left, she abruptly abandoned photography in 1951 and, four years later, gave away all of her equipment, destroyed her negatives, and donated her prints to the New York Public Library.[33]

Her driving impulse toward photography had been far more documentary than aesthetic. Like her husband, Rosalie was a Social Realist at heart. "I wanted to take pictures of the human condition," she recalled four decades later. "I always wanted to do that. I wanted to show how the poor have to live in the squalor that they live in, no money for food or clothes or anything. Therefore they go to church, get a release." In 1946 she exhibited her work at the Museum of Modern Art with a group of seventeen new photographers, and later one of her prints appeared in Edward Steichen's famous *Family of Man* exhibition. She can no longer remember which one and retains possession of almost none of her own pictures.[34]

In the mid-1940s Robert Gwathmey expressed considerable enthusiasm about her work, both because he liked it and because it was helpful to him. When they visited the South and he saw a scene or situation that offered possibilities for a painting, he would ask Rosalie to photograph it, and subsequently he would use her work as the inspiration for a composition of his own. As he wrote to Herman Baron after three weeks in North Carolina during the early summer of 1946, "I think Rosalie is getting some fine photographs and I'm being revived. A lot of sunshine and bathing and a lot of looking." *A lot of looking*: he was always the artist as observer. Later that same year Rosalie and Robert had a joint exhibition in Richmond.[35]

The couple's social interests and concerns absolutely converged. In 1946 Rosalie summarized her approach to picture-taking in preparation for the group show at the Museum of Modern Art: "I am particularly interested in photographing the Negro in my native South because of the problems that face him—housing, jobs, discrimination. These things I would like to see bettered." Almost half a century later she recalled their summer visits to Charlotte during the 1940s.

My family's home backed right onto the houses on the next street, back to back. That street became the black neighborhood. And the woman who cooked for us [Sarah

Wade; see plate 18] lived in the house behind us. She used to walk right through the yard to get to our house. On that street, there were only blacks. On our street there were some wealthy whites. Our home was located somewhere in between. Two streets back were the real slums. [See fig. 34.] Bob and I were interested in the neighborhoods where all these poor people lived. And when friends came to town to visit, we'd get in the car and drive through all the different neighborhoods to show them how the people lived. One was called "Black Bottom." My mother used to say, "Why don't you take them out to the country club and show them where people play golf and swim? Why do you have to show them all the awful things?" But this is where we thought the people were.[36]

FIGURE 34
Rosalie Gwathmey, *Backyards of Negro Houses, Charlotte, North Carolina* (1945), gelatin silver print. Ramona Javitz Collection, Miriam and Ira D. Wallach Division of Art, Prints, and Photographs. New York Public Library. Astor, Lenox, and Tilden Foundations.

When the Gwathmeys spent the summer of 1944 on a farm in Rocky Mount, North Carolina, the pictures taken by Rosalie proved invaluable to Robert during his burst of creativity and productivity in 1944–46. An exemplary instance of the way that he

blended sources of inspiration and influence can be seen in *Family Portrait* (plate 17), most likely done in 1945. Rosalie's photograph, also called *Family Portrait* (fig. 35), shows a parental couple and numerous children, but they are standing in front of the house rather than being seated as well as standing on the porch as in the painting. Because it was 1945, Robert added the same small service flag (signifying at least one family member

serving in the military) that appears in *Rural Home Front* as a small touch of color hanging at the top of a window.

The harlequin diamond-pattern dress worn by the girl standing in front of the door evokes an immediate memory of Picasso's famous *Family of Saltimbanques* (fig. 36), a configuration clearly in Gwathmey's mind, especially since it is a very early Picasso (1905). The same harlequin pattern also appears in some of Daumier's lithographs of clowns, especially his *Parade of Saltimbanques* (1867–70). (See Chapter 4 for further discussion of this motif.)

In Manhattan during the 1940s there were weekly routines, almost ritualized, for the Gwathmey family. On Monday evenings Rosalie and Charles would walk the short distance from their first apartment on Waverly Place to meet Robert at six o'clock at the Sea

FIGURE 36
Pablo Picasso, *Family of Saltimbanques* (1905), o/c, 83³/₄ × 90³/₈.
National Gallery of Art, Washington, D.C.
Chester Dale Collection.

Fair Restaurant so that they could share a meal before he taught night classes at Cooper Union. As Charles recalls, "He believed that anyone who could work at a job by day and still have the energy to go to school at night to pursue art deserved this extra time and commitment." Later in the 1940s, every Tuesday and Thursday night they walked from their apartment at Sixty-eighth Street and Central Park West to the TransLux Theater on Fifty-second Street and Broadway to watch the newsreel. En route they would talk and look at appliances and cars in the showroom windows. Following the one-hour newsreel they went out to a bar on Eighth Avenue "where the bartender couldn't wait to see the man who told great jokes, wore tweed jackets and plaid shirts, and watched his little kid eat raw clams."[37]

On Saturdays father and son went to college football games, track meets, or basketball games or on "excursions to simply experience events, crowds, weather, travel, competition, and variety." On Sunday mornings they rose early and had breakfast at the corner diner, followed by a subway and bus trip to La Guardia Airport to watch planes take off and land, "again fulfilling our mutual fantasies and aspirations." Sunday afternoons were set aside for art museums, and Charles recalls "being the recipient of a continuous explanation of the history of art, with descriptions of intentions and perceptions of paintings and sculptures through the eyes of my artist/teacher father." Those memories are from the end of the 1940s and early 1950s. A bit earlier, in the mid-1940s, young Charles felt perplexed after listening to what the fathers of his friends did for a living. His own father was at home on most days, painting in a very modest space in his bedroom that he kept meticulously clean. The boy recalls running into the "studio" to ask his father, "What are you going to be when you grow up?"[38] Robert invariably took Charles to the Ringling Brothers Circus when it came to Manhattan each year, and they went several times to the very different French circus in Paris during the winter and spring of 1949–50.[39]

Charles acquired a clear sense of his parents' social and political values because they lived them in manifest ways every week. On Wednesday nights there were meetings of Artists Equity at the apartment on Central Park West, "where I could listen to his fellow artists and friends discuss at length the socio-political climate and problems of the times." On Friday evenings there would often be a dinner party or a private fund-raiser for a fellow artist, writer, or actor, usually to defend the friend against a HUAC inquiry or some other threat to a person's reputation, livelihood, or both. Charles walked with his parents each year in the May Day parade, a radical vestige of what had once been an all-American tradition, but by the 1940s it "belonged" only to the socialist worker tradition. Charles vividly recalls that "I was always holding his hand as a participant in the picket line or demonstration to protest a form of intellectual, social, or moral injustice."[40]

Charles also has vivid memories of spending 1949–50 in Paris when he was eleven and attended an international school. The trio traveled extensively, he recalled, "and there is no doubt that I confirmed my commitment to becoming an architect during this

experience. We went to every cathedral, chateau, museum and medieval town possible: the scenario being that Bob had to race me either before or after. He always won—but when I was thirteen—I finally won—and there was a subtle emotional shift in our relationship."[41]

Charles also recalled being taken to see *The Informer* with Victor McLaglen in 1948 and to *The Grapes of Wrath* twice before he turned twelve. That impulse and inclination raises the question of Robert Gwathmey's response to film as an art form and its relationship to his own concerns about painting. There is not a great deal of evidence to go on, but I believe that he enjoyed the newsreel because he was so alert and responsive to whatever was happening in public affairs, and that he appreciated movies that had some valuable social or political content. An undated fragment of a letter suggests that film did not affect his painting in any significant way as an art form during the 1940s and early 1950s.

> You have said something to the extent that the film, a new visual media, has certainly affected painting. Both times you were interrupted and were unable to further your precept. Anyway I was left with a feeling of understatement on your part. Certainly all visual media have many overlapping elements. First off I can think of no painting before the advent of the camera that was "photographic". In the most profound way this expresses the inherent difference. The films, an entity, might demand twenty minutes, an hour, etc. A camera no set time. While many favorite paintings are not inviting as a daily diet there has never been a film that could attract me as often as your Kuhn clown for instance. . . . I don't have to even like one art form more than another.[42]

Films that aimed at pure entertainment, and particularly those in the 1940s that catered to southern myths and orthodoxies about race relations, surely appalled Rosalie and Robert Gwathmey. I have in mind, especially, Walt Disney's popular *Song of the South* (1946), in which James Baskett starred as an appealing, unthreatening black plantation storyteller, an Uncle Remus. Baskett charmed most of the white audiences with Joel Chandler Harris's vernacular tales of Brer Rabbit and Brer Fox. His warm performance won him a special Oscar, but a *New Yorker* review spoke truth to power when it commented that the film consisted of "the purest sheep-dip about happy days on the old plantation." Walter White mounted a vigorous campaign against the film on behalf of the NAACP, and Adam Clayton Powell Jr. called it an "insult to American minorities" and to "everything that America as a whole stands for."[43]

Baskett looked very much like a figure in one of Gwathmey's agrarian scenes from the early or mid-1940s, except for two striking deviations: the solid flesh of Baskett made him appear overfed and underworked, and his spectacular smile was foreign to Gwathmey's sharecroppers. They rarely grimaced, but neither did they grin. The women in Gwathmey's paintings look less distraught and downtrodden than the women in photographs by Walker Evans and Dorothea Lange, but they are also less plump and less cheerful than Hattie McDaniel and the Aunt Jemimas of *Gone With the Wind* or *Song of the South*.

One of Gwathmey's most affecting works, *Portrait of a Farmer's Wife* (1951) (plate 18), is

well known because in 1953 he made a successful serigraph based on it in an edition of 200 copies. Just in case anyone might confuse this figure with an aging Aunt Jemima, it is worth quoting what Gwathmey said about her in 1972: "Farmer's Wife is my response to a lady of character who has borne the scars of outrageous circumstances and has refused to be destroyed." The model, of course, was Sarah Wade, who had cooked for the Hook family in Charlotte and appeared in both *Saturday Afternoon* (1949) (plate 11) and *Sunday Morning* (ca. 1948) (plate 9). Despite her gnarled hands and protruding bunions, her dignity and wise visage demand the viewer's attention directly.

The immense appeal of Gwathmey's screenprint of *Farmer's Wife* (it commands a higher price than most of his other prints) indicates how swiftly serigraphy gained popularity during the 1940s, among artists as well as collectors. From the perspective of the latter, serigraphs democratized art because a copy of a limited edition, often signed, could be purchased for as little as ten dollars, yet it could legitimately be considered "art" rather than a mere reproduction. (By the mid-1990s a single Gwathmey screenprint might sell for $2,500 to $6,500.) From the artist's perspective serigraphy not only gave his or her work greater visibility, the process itself provided an intriguing change of pace from working at an easel. For more than a decade, from 1944 to 1955, Gwathmey clearly felt enamored of screenprinting. In the fall of 1950 he and Harry Sternberg taught a course at the New School for Social Research. Called "Silk Screen: Serigraphy," it met each semester on Thursday from 10:00 P.M. to 1:00 A.M. and cost $40.[44]

Although quite a few artists made silkscreen prints as early as the mid-1930s, Gwathmey somehow came to be known as one of the pioneers in this art form that had almost instantaneous appeal. Perhaps it was because of his colors, or because the medium was so well suited to the two-dimensional effect that he preferred, or possibly because his unconventional spatial arrangements seemed odd for oil painting yet appropriate for the new medium of serigraphy. In any event, his *Rural Home Front* (fig. 10), based on a 1942 painting called *The Farmer Wanted a Son*, won first prize in the national Artists for Victory competition in the fall of 1943. When a publication reproduced the print in 1949, Gwathmey provided two sentences for the caption: "I've simply taken various rural images and combined them in a composite picture, showing the total effort of farm people, including the children. I've used ten flat colors and have been particularly aware of the two-dimensional space."[45]

Reba and Dave Williams, scholarly collectors with the greatest knowledge of Gwathmey's efforts as a printmaker, believe that works such as *Rural Home Front*, *Topping Tobacco*, and *End of Day* (plate 15) lend themselves perfectly to serigraphy because of their distinct and vivid color planes. Screenprinting, "with its ability to apply flat and consistent colors, is ideal for this art." In 1945 Gwathmey published what appears to have been the only essay of his career, a hands-on piece simply titled "Serigraphy."[46]

Gwathmey began this short article with several semi-chauvinistic assertions. (He must have written it as both theaters of World War II were winding down. Nationalism was inescapably in the air, even for a man of the radical left.) He acknowledged that

methods for making stencil color prints had been devised centuries earlier, and that Europeans had successfully used the silkscreen process for reproductions in recent years. Nevertheless, he insisted, "it is the American development that has produced the degree of refinement that has established serigraphy as a fine arts medium. Indeed, Carl Zigrosser has called it an American medium."[47]

He then offered a clarification that he returned to at the end, an important one that dealers who sell these prints frequently fail to mention: the process of silkscreen printing, like lithography, has been and still is widely used commercially, both to advertise products and literally to *reproduce* works of art such as oil paintings. What differentiates the serigraph from the ordinary silkscreen reproduction process is that in the former "the artist's sketch is really just the starting point. Once the print is begun, it grows and develops with all of the exploratory possibilities inherent in all creative works of art." He concluded that clear explanation on a personal note: "These very possibilities have, naturally, produced many varied expressions. . . . I happen to work in a more or less pure stencil form with flat, opaque colors, somewhat limited in number, and with a broad use of line."[48]

Gwathmey then offered a bit of history, pointing out that while experimentation with this aspect of the graphic arts had begun as early as 1932, it was not until 1938, when the WPA of New York City made materials and facilities available, that serigraphy attracted broader participation. Within a few years the National Serigraphy Society came into existence and promoted the new medium through lectures and exhibitions, not just in the United States but in Canada, Cuba, South America, England, and the Soviet Union. It also established fair trade practices in order to provide protection for creative artists, became the most important distributor of work in this medium, and maintained a master file of all work created by its entire membership.[49]

Writing as he did when serigraphy was still a novelty and when the market for printmakers generally was shrinking (he believed), Gwathmey pointed to a very simple explanation for the appeal of serigraphs: color. Just as the color reproduction of paintings had cut into the once-thriving field of original black and white prints, he felt that mere color reproduction of an existing work was being "superseded by the serigraph, an original print in full color."[50] Gwathmey's emphasis on originality helps to explain (or even rationalize) my disappointment when the colors in a serigraph are less brilliant than (and often quite different from) the colors in an oil painting on which the serigraph is based. The serigraph is not meant to be an exact reproduction. It was considered a work of art in a fresh medium requiring different techniques and offering alternative possibilities to oil painting and watercolor. It certainly democratized art, and it seems more than serendipitous that Rosalie's enthusiasm for photography coincided with Robert's passion for serigraphy, in the years 1945 to 1950.

If and when a catalogue raisonné of Gwathmey's work is assembled—and the difficulties in doing so are very great because he did not date his work and the ACA Gallery that represented him for almost two decades kept woeful records—it will become read-

ily apparent that he repeated motifs and images constantly, often using the same motif in oil, in watercolor, and as a serigraph. Moreover, before or after completing a large and complex canvas he would frequently isolate one figure or cluster of figures and make a separate oil painting of that, as he did with *Man with Hoe* (1944) prior to *Poll Tax Country* (1945), and with *Saturday Afternoon* (1949) following *Sunday Morning* (1948). He was not cannibalizing his own art, at least no more so than other artists of his generation did. The practice was common among his contemporaries. According to Will Barnet, "In the thirties and forties, artists repeated motifs—it came from murals. It was easy to trace the same image over and over onto a mural or onto a canvas." Moreover, as Gwathmey's friend and colleague Harry Sternberg put it, "Posters and displays for store windows were screenprinted. It was a logical thing to do, to try to make prints that way."[51]

Perhaps it comes as no surprise that by the later 1950s Gwathmey had grown tired of serigraphy and abandoned it, at least for a while. In 1968 Paul Cummings asked him, at a time when he had in fact just done quite a few lithographs, "Did you do any graphics ever? Have you made lithographs or anything?" The following dialogue ensued:

RG No, no. I'll tell you what I did. Ten years ago I did about eight silkscreens and I didn't find it a congenial medium. I'm not trying to knock silkscreen for a moment but I think one should be conscious of the fact that artists of record have not become involved in silkscreen. Maybe they tried it and discarded it. I discarded it in a sense.

PC Well, it's become very popular in the last couple of years.

RG Well that and there are many advances in the processes, I'm sure that's true. But I could never control it and people would say to me off-hand, "your way of doing things lends itself to the screen and therefore you ought to try it." And so I tried. The design elements can be all right. And then you put it behind glass and stand back about ten feet, it may stand up. But it would [not] stand for perusing. There is always a kind of a matteness free of nuance. I never liked it.[52]

During the 1970s, however, after Gwathmey had retired from Cooper Union and moved permanently to Amagansett, he collaborated with Arnold Hoffman, an artist and master printmaker living in East Hampton, to make larger and more satisfactory screenprints than the ones he had done between the early 1940s and the 1950s.

Singing and Mending is a revealing and symptomatic work by Gwathmey for multiple reasons. First, the work had a sequential development: the oil painting in 1945 (plate 5) was followed by a serigraph of the same subject, almost but not quite identical, in 1946. Second, the rapport between the man and the woman mirrors the relationship between Robert and Rosalie in the mid-1940s when her photography meant so much to his painting and when they were deeply engaged in political activities and discussion groups together. Third, it introduces guitar playing as an accompaniment to singing, a

frequent and favorite motif that would recur over the next thirty-five years, right down to *Harmonizing* in 1979.

In Gwathmey's depiction of a guitar player, it is not surprising that the right forearm and hand of the man are powerful. He encompasses the guitar comfortably. Somewhat more noteworthy are the arms and huge hands of the woman. Her left forearm, in particular, is virtually a Popeye caricature of strength, all the more noticeable because the activity of mending that she performs is so delicate and, in those days especially, considered to be women's work.

Although Gwathmey himself was not musical, he enjoyed certain forms of jazz and country music. I believe that the initial appearance of guitars in his art was more than a casual occurrence. Country music gained popularity rapidly during the 1940s, and in 1944 a small recording studio in New York City released records featuring folk songs written and played by Woody Guthrie and black prison songs from the South sung by Leadbelly (Huddie Ledbetter). Above all, Hank Williams, a melancholy but creative writer and performer of country music, achieved the peak of his celebrity during the later 1940s and early 1950s. At mid-century Tin Pan Alley decided that it had better cash in on the Nashville phenomenon, and throughout the 1950s, country music moved from being a modest subculture to playing a central role in American popular culture.[53] Robert Gwathmey could not have been oblivious to the impact of the Carter family, Woody Guthrie (a creative spokesman for the radical left), and Hank Williams, three distinct sources and styles that converged in the 1940s with powerful effect.

The question of what Gwathmey read or did not read, and how reading affected his art, if at all, is difficult to answer. He wrote in one of his few surviving sketchbooks, "I don't read novels." We do know, however, that he liked to be read to while he painted, and he enjoyed works ranging from Shakespeare and Tolstoy to Thomas Mann and Herman Melville. Rosalie recalls reading *Moby Dick* to him while he painted *Children Dancing* (plate 10) and believes that he retained every word. She also read *Sophie's Choice* by William Styron to him while he worked. Gwathmey surely must have been intrigued by that novel because Stingo, the narrator, an aspiring writer from Tidewater Virginia, comes to New York City right after World War II and becomes intimately involved with Jewish liberals while trying to come to terms with the complexities of his southern heritage. Unlike Styron himself, however, Gwathmey never felt compelled to defend his native region against harsh northern critics. During the 1960s Gwathmey's dealer, Terry Dintenfass, would read to him while he painted; she usually read from biographies and sometimes from the *Nation* or other journals of opinion on the left.[54]

Because Howard Odum wrote so much about the race problem in the South, and with so much sympathy for African Americans, it is difficult to imagine that Gwathmey did not notice his work. In 1928, when *Rainbow 'round My Shoulder: The Blue Trail of Black Ulysses* was in production, Odum wrote the following to journalist Gerald Johnson: "The story

shows up the black man in a pretty realistic form and sometimes seems a little hard on him, but the story is first and last an exact picture and as such must stand. It is a sort of untouched photograph, nevertheless presented with the idea that the Negro after all is a human being, with a sort of timeless and spaceless folk urge. . . . We have refused to sentimentalize the Negro, on the one hand, or to ignore his finer points of humor, pathos, and poignancy."[55]

Odum expressed a more patronizing point of view than the feelings shared by both Gwathmeys, who undoubtedly had more personal and genuine interactions with southern blacks than Odum did. Odum also seems to have accepted stereotypical perceptions more readily than the Gwathmeys did. Nevertheless, Odum's feelings were vastly more enlightened than those of most southerners in the late 1920s and early 1930s. Even if Robert Gwathmey never read the trilogy about the black Ulysses, he surely heard or read *about* it.

It is inconceivable, however, that Gwathmey did not read at least some work by his fellow southern radical with proletarian sympathies, Erskine Caldwell. Certainly Gwathmey read the "early" Caldwell before he began to grind out formulaic fiction in a mechanical fashion during the later 1940s and 1950s. By 1934 Caldwell had achieved recognition as the foremost Social Realist among southern writers, and his "stark social landscape," like Gwathmey's a few years later, was peopled by sharecroppers, tenant farmers, and oppressive racist bigots who were prone to violence. Caldwell's series on southern poverty that first appeared in the *New York Post* was reprinted in 1934 as a pamphlet titled *Tenant Farmer* and received widespread praise. Even Caldwell's later fiction in the 1940s persisted relentlessly in addressing racism and racial violence, oppression of the rural poor, and the disintegration of extended family networks that had once provided mutual support.[56]

At some point, although just when is unclear, the Gwathmeys became aware of Lillian Smith's *Strange Fruit*, a novel completed in 1941 but rejected by seven publishers and consequently not published until 1944, when it became a best-seller (but was banned in Boston). Born in 1897, Smith grew up in Jasper, Florida, and spent summers "up north" in Clayton, Georgia. She studied piano over an extended period of time and ran schools and camps for girls in different parts of the coastal South from Florida to Virginia and Maryland. In 1939 she received a Julius Rosenwald Fellowship for a travel-study project in the South, and the next year she received a second Rosenwald award that enabled her to write *Strange Fruit*, a book that bears traces of Caldwell's influence although its central theme, the tragic consequences of interracial love in the intolerant South, was not an idea that Caldwell developed.[57]

Strange Fruit describes an intimate romantic relationship between a white man and a black woman. He is the young son of a town doctor, and she is a pretty college graduate who has returned to the town to work in domestic service. The couple never expected to marry, nor is it clear whether they ever discussed where or how their relationship would end. The young man is persuaded to marry a white woman he has dated

occasionally in order to keep up appearances. He is cajoled into giving money to his real sweetheart and paying his black servant (and friend) to marry her, even though she is now pregnant by the white lover. When the woman's brother learns of the situation, he kills the white lover and leaves the body lying along the path from "colored town." After the body is discovered, the white community seeks revenge, and the innocent servant becomes the victim of a brutal lynching.[58]

Lillian Smith's central theme (and moralistic motive) was to demonstrate that contemporary culture and mores in the South were the strange fruit of white supremacist attitudes. As an avid reader of Sigmund Freud, moreover, she regarded the insistence on white supremacy as one manifestation of a still-deeper problem—sexual repression. The book had an extraordinary impact across the North, ranging from perceptions that it was deeply immoral and vulgar to the belief that it delivered a profound message against racial prejudice. The phrase "strange fruit" became synonymous with interracial love affairs, and the book became a cause célèbre, intensely talked about for more than a year. Smith herself adapted it into an unsuccessful play that opened late in 1945. Part of its theatrical problem lay in the fact that in September 1945, two months before the curtain went up on *Strange Fruit*, a play based on a similar theme written by a good friend of the Gwathmeys, Armand d'Usseau, opened to warm praise. The main difference is that in *Deep Are the Roots* a white woman is in love with a black man. That play had a solid run, and the Gwathmeys got back the $500 they had invested in it.[59]

Clearly, Robert Gwathmey knew all about Smith's novel as well as her play, though the postscript to this dramatic literary saga involves a song whose subject and title inspired Smith's novel. Sometime in 1937–38 a left-wing schoolteacher named Lewis Allan (a pseudonym for Abel Meeropol) wrote a minor-key dirge about the brutalities of southern lynching. "Strange Fruit" was performed for about a year (1938–39) before two entertainment producers offered it to Billie Holiday, who at first felt reluctant to sing it because she feared that audiences would dislike it. Barney Josephson, one of the men who ran Café Society, a leftist nightclub in New York where Holiday performed, insisted that Holiday close each show with it every night. "I was doing agitprop," Josephson later recalled, "to me it was a piece of propaganda. . . . Lights out, just one small spinlight, and all service stopped. . . . There were no encores after it. My instruction was walk off, period. People had to remember 'Strange Fruit,' get their insides burned with it." Holiday's introduction of "Strange Fruit" at Café Society in the spring of 1939 marked a fusion of jazz and political cabaret, or as Michael Denning has put it, of Bessie Smith and Lotte Lenya.[60]

During the 1940s and 1950s, "Strange Fruit" became one of Holiday's signature songs. She often implied that she had written it, perhaps because it meant so much to her artistically as well as personally, since she associated it with the death of her father, jazz guitarist Clarence Holiday. When her regular record company, Columbia's Brunswick label, refused to issue the song, Holiday recorded it for a small label, Commodore Records. Robert Gwathmey loved that record and could not listen to it often enough.[61]

Sometime during the later 1940s or early 1950s (the work is undated), he painted one of his most affecting and powerful pictures of white hypocrisy, *Revival Meeting* (plate 19), in which the black silhouette of a lynched man hangs from a tree in the background while self-righteous bigots, including a man of the cloth, a sheriff "looking the other way," and a businessman collecting money from churchgoers, dominate the foreground.

According to Robert O'Meally, perhaps the most astute of those who have studied Billie Holiday's life and music, "Strange Fruit" marked the beginning of a new, second phase of her career, a period dominated not by the jump tunes of her early recordings, but by her torch songs in "a new key of dramatically enacted sadness." In 1946 the folk and blues singer Josh White also adopted the song and performed it at Café Society. "I loved her interpretation of the song," he recalled, "but I wanted to do 'Strange Fruit' my way. For a time she wanted to cut my throat. . . . One night she called by the Café to bawl me out. We talked and finally came downstairs peaceably together. . . . We became the best of friends." Curiously, however, with the exception of "Strange Fruit," one of Holiday's most famous songs, the European-style cabaret song never really became a part of her repertoire. That lone exception not only helped to inspire Lillian Smith's sensational novel of 1944 but haunted Robert Gwathmey as well.[62]

One other book about southern life during the Depression era had a powerful impact on both Gwathmeys. *Let Us Now Praise Famous Men*, a long, rambling, impassioned text by James Agee with photographs of Alabama sharecroppers by Walker Evans, appeared in 1941. The Gwathmeys did not "discover" it, however, until sometime later in the decade when Rosalie read it aloud to Robert while he painted. After listening to Agee's meticulously detailed, sometimes overwrought descriptions of how the white sharecroppers lived, Robert responded that he would have described the scene visually in just the same way.[63] When Rosalie was asked about her reaction to Agee's prose in 1994, she replied with great enthusiasm.

> His writing is just marvelous. You feel you are in the room he describes. He would write about a nail on the wall, and it gave me the shivers to think about it. He loved everything. I think his writing is almost better than a photograph. I share his love of the South and the way it looked. I still like to read Flannery O'Connor and Eudora Welty. Tennessee Williams I love. Southern writing seems so real, it seems to me like the only real art in this country. And I think more and more people are appreciating Southern literature.[64]

Another artistic influence that ought to be taken into account, even though it is not literary, documentary, musical, or a work of graphic or plastic art, is the exquisite "art" of the natural world, a force that Robert Gwathmey had responded to ever since he worked for a florist in high school. His only surviving sketchbooks contain his precise and detailed studies of field flowers. A 1947 oil painting that he called *Front Porch* (fig. 37) is striking because the masklike face of the African American woman is totally obscured by the leaves and flowers of two potted plants, while two other plants sitting on the

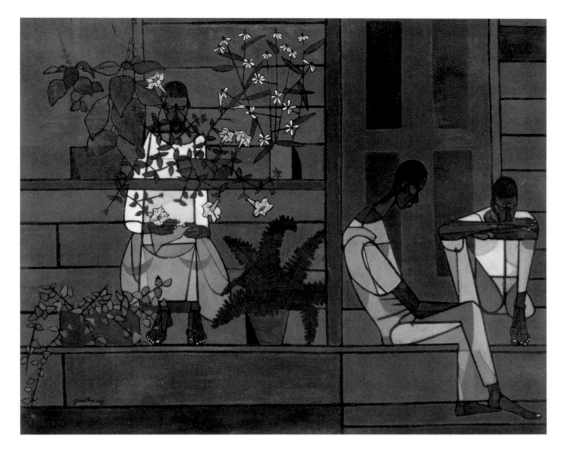

FIGURE 37
Front Porch (1947), o/c,
31⁷/₈ × 39⁵/₈. Hirshhorn
Museum and Sculpture
Garden, Smithsonian
Institution, Washington,
D.C. Gift of Joseph H.
Hirshhorn Foundation,
1966.

porch floor symmetrically surround her feet and legs. In 1966 Gwathmey declared that "I've never done a painting in my life . . . without some . . . botanical form."[65]

He always preferred field flowers or wild plants to cultivated or cut flowers, and he invariably referred to the botanical forms that he included in his art as "vegetation." They became increasingly important in his repertoire during the 1960s and 1970s, and he returned to the symbolism of southern front porches in a starkly contrasting composition of 1966 that is almost identical in size but perhaps not in meaning.[66] (See fig. 58.)

There were, of course, African American artists during the later 1930s and 1940s painting scenes of agrarian life in the black South, some of which resonate with Gwathmey's work. There is no evidence, however, that Robert Gwathmey was aware of these artists. From the later 1920s to the end of the 1930s, for example, Henry Lee McFee (1886–1953) wintered at Bellevue, a former plantation in Bedford County, Virginia, where he painted black farmworkers. John Biggers (1924–), a North Carolinian who taught art for many years at Texas Southern University, perpetuated the tradition of socially conscious figuration and mural painting that harks back to the influential Mexican muralists and

Thomas Hart Benton. Biggers's dominant subject is richly hued scenes of black life. One observer responded to a major retrospective of his work in 1996 by praising "his ability to convey pathos with subtly distorted form. . . . [He] may remind some viewers of early Chagall; Mr. Biggers' work has a tremendous emotional gravity and dignity."[67]

I do not know whether Gwathmey read Richard Wright, though it seems likely, if not inevitable. Certainly Gwathmey would have smiled an affirmative response to a sentence that Wright added to the conclusion of the 1945 edition of *Black Boy* (*American Hunger*). Wright recalled his nearly traumatic train ride northward in 1927, one year after Gwathmey left Richmond for Philadelphia. "I was not leaving the South to forget the South," Wright recalled, "but so that some day I might understand it, might come to know what its rigors had done to me, to its children."[68] Robert Gwathmey never experienced the humiliations and torment of Richard Wright, but he would have understood and shared the writer's sentiment—in 1927 and in 1945.

Painting of a Smile

The 1950s emerged as a challenging decade for Bob Gwathmey (everyone called him Bob by then, though he humorously signed letters to close friends "Rye-butt," his given name spoken with a strong Tidewater drawl) for four principal reasons. First, his art needed to explore new directions following the notable success he had enjoyed during the 1940s. Although he wanted to grow and find new perspectives, he certainly could not abandon the motifs that had shaped his identity as an artist and that he cared so much about. Second, as Abstract Expressionism began to dominate the art world at mid-century, the impact and influence of Social Realism declined—precipitously from the perspective of its practitioners. That shift became a vexing and pervasive concern. Third, the intensification of FBI surveillance compounded the malignant pressures that resulted from McCarthyism, HUAC hearings, and red-baiting in general. Finally, Bob Gwathmey in his mid-fifties grew restless with his domestic situation and became self-indulgent in terms of alcohol and personal relationships. (The circumstances of these relationships and their effect on his art and network of friends span the later 1950s to about 1967; see Chapter 5.)

A ten-month stretch in France during 1949–50 expanded Gwathmey's horizon as an artist and left him with many vivid memories, yet ultimately it turned out to be an unsatisfactory year for him in terms of artistic productivity and lifestyle as well. Friends in the United States sent the Gwathmeys all sorts of things that they missed, such as "real" salt, but their gratitude was offset by embarrassment at their inability to adapt. As Rosalie wrote to Herman and Ella Baron early in 1950, "We should have been able to come over here and get along like the French do. Many of the things you sent can't be got here and if some of them can they are usually inferior. We haven't been here long enough to be satisfied with culture instead."[1]

During the initial stages of their stay in Paris, Bob seemed hopeful about what he might achieve. At the very least he would be able to see and respond to a great deal of art that had not been accessible to him in 1929–30, or had not even been painted yet. He wrote the following to the Barons around the turn of the year: "I'm painting now and if I fail to accomplish something its [sic] all my fault. The Picasso show proved most disappointing to me. He was really throwing it this time and I must say carelessly, a number being on some kind of plastic board that was even buckling in the middle. Of course there was quite a degree of electricity but his sense of invention is becoming more and more contrived."[2]

Later, in 1968, Gwathmey looked back with mixed feelings about the consequences or implications of foreign travel for his development as an artist. "I guess in that year and these other years," he declared, "I've seen seventy-five percent of all Western art face to face. And of course it's a thrilling experience. Of course it is. But I got tired of France that year because I couldn't accomplish the language. I don't have any linguistic gifts at all." In retrospect, it seemed not merely an unproductive year, but a negative experience as well.

RG　A very interesting thing happened. When we went to Paris we could get completely lost. Right? Not in Washington, not in North Carolina, not in Virginia or what not. And so I had a lot of things I wanted to do but out of the things that I had been doing all this time. And so I painted practically every day, like I do here. And at the end of the year I got these nice French frames, carved. I packed them, I shipped eight paintings home. And I had to destroy all except the first two. Now to me that suggests that an artist has to be completely at home, completely at home. Otherwise he's disturbed.

PC　They don't come off.

RG　You're disturbed. I mean, you don't know what it is but you've got to live within your ambience. Now I know what's behind my back without even looking. In France I didn't know what was in front of my face.[3]

The year in Europe did not turn out to be a total disaster, however, particularly in terms of significant influences and sources of inspiration for Gwathmey's art. In January Rosalie reported to the Barons that "several days lately we have gone print shop brousing [sic] and found the place that probably has every Daumier lithograph ever made. We bought several and had a wonderful time looking."[4] The time spent in France also enhanced Gwathmey's interest in the art of Georges Rouault, with its jewel-like colors, black outlining that created a stained glass window effect, and creation of iconic figures. Gwathmey brought home a Rouault lithograph, and artists ranging from Raphael Soyer to Jack Levine to Raymond Saunders all concur that Rouault's art had a decided influence on Gwathmey's.[5]

The most immediate impact of Gwathmey's enriched interest in Daumier can be seen in two droll (some might even say wicked) satires that he painted in 1950 and 1951. In a 1966 interview Gwathmey acknowledged that "I have a strong feeling for satire and I

think I'm one of the best critics on satire."[6] Although paintings such as *Non-Fiction* (1943) and *Poll Tax Country* (1945) had displayed satirical aspects, the direct influence of Daumier can be seen in a fierce picture called *Reflections* (plate 20), showing an old hag, presumably vain, looking at her grotesquely distorted features in a mirror—distorted in the manner of Picasso's cubism. Her blouse is bright orange with some touches of red. Her visage is almost violently contorted in response to her vanity. As the Morris Museum's catalog explains, "It is perhaps the most quintessentially Southern image on a twentieth-century theme in this collection. The elderly belle, in her gown and tiara, staring fiercely into the mirror, is the moral equivalent, in visual terms, of Oscar Wilde's Dorian Gray. Searching for either youth or beauty, she finds neither—only the returned gaze of a distant past. She is, therefore, that symbol of the Old South that fascinated Southern writers at mid-century."[7] Daumier made countless images of vain people scrutinizing their distorted visages in mirrors—or in the case of Narcissus, in the water—but the most apt, perhaps, were done in 1869 and 1878, the latter bearing the caption, "Mon vieux Talma, tu peux te fouiller!" [My old Talma, you are able to scrutinize yourself closely!][8]

Gwathmey's harshest satires related to issues of class, affluence, and pride as well as vanity, rather than race. In 1951 he made a watercolor based on an earlier serigraph of *Parade* (plate 21); the former had more delicate detail, but the latter lost none of the picture's punch. Gwathmey's figure closely follows Daumier's *Monsieur Arlépaire* (1833) (fig. 38), a politician whose discolored and distended nose cannot seem to contain its contents. Moreover, Daumier also did numerous variations of a work titled *La Parade*. The most famous version was initially owned by Alexandre Dumas *fils* (who loaned it to Daumier's exhibition of 1878); it is now in the Louvre. Daumier's parade involved *saltimbanques* making a preliminary public display in order to drum up a crowd for a popular entertainment. In Gwathmey's work the parade in question was Macy's Thanksgiving Day parade, which always began at Seventy-seventh Street and Central Park West, passing directly beneath the Gwathmeys' window en route to Macy's at Thirty-fourth Street. Charles recalls the apartment being filled with friends because his windows had such a wonderful view of what was going on below. Needless to say, there were no pompous fat cats present in the apartment. Bob Gwathmey had simply adapted a cherished caricature by Daumier to a familiar annual event that had become a family ritual.[9]

It has been suggested that Gwathmey abandoned social commentary during the 1950s and then returned to it in the following decade. I do not agree, though it is certain that he painted more works of social commentary or criticism during the 1940s and 1960s than he did during the 1950s.[10] Nevertheless, a glance at *The Painting of a Smile* (plate 22), of which the artist did at least two variations later in the 1950s, indicates that the racist use of lawn jockeys by insensitive white owners of pretentious homes provided Gwathmey with marvelous ammunition for his deadly marksmanship during the 1950s. By the middle of the decade he had completed *Painting the Image White* (fig. 39), in which an African American man wearing overalls is repainting the face of a lawn jockey chalk white. As in *The Painting of a Smile*, a single man kneeling off to the side picks cotton. As a clear

FIGURE 38
Honoré Daumier,
Monsieur Arlépaire
(June 5, 1833), litho-
graph. Collection of
Frederick R. Weisman
Art Museum at the
University of Minnesota,
Minneapolis. Gift of Ione
and Hudson Walker.

statement that also happens to be artistically ingenious, Gwathmey's "metaphorical" use of the lawn jockey turned out to be a masterstroke.[11]

The ironies of race relations in the United States, and especially in the South, fascinated Gwathmey. Late in the summer of 1949 he visited a youth conference sponsored by Baptists in Charlotte, North Carolina. He enjoyed reporting to Herman Baron that before the meeting began, "they had a little song fest with the lyrics mimeographed on individual sheets. Don't forget that it was an interracial conference and one of the songs was 'When Johnny Comes Marching Home,' one of the most stirring of the songs of the confederacy." Two years later Gwathmey's curiosity prompted him to join a local reporter and photographer who went to observe a big Ku Klux Klan demonstration along the North and South Carolina border. The sheer excitement generated by the event impressed Gwathmey even while it repelled him.[12]

Candor and realism continued to characterize his presentation of African American life even when his pictures did not overtly concern race relations. *Shanties* (fig. 3), depicting the crowded and busy black part of town, might almost have been painted in 1941 rather than 1951, especially because it shows a steaming locomotive, an explicit reminder of his father's tragic death. *Farmer's Wife* (plate 18), also done in the summer of 1951, which Gwathmey casually referred to as "the spotted dress woman," is a splendid

portrait of Sarah Wade. In 1972, when the Hirshhorn Museum asked Gwathmey to supply "observations" about it, he wrote the following: "The 'Farmer's Wife' is a worker, subject to the trials of arduous labor. A kind of stiffness, basically rheumatic, is prevalent. Also a hospitable and prideful quality that often grows out of those who live close to and from the soil."[13]

Perhaps Gwathmey depicted Sarah Wade in repose because of her advanced years and because she did actually model for him. During the early and mid-1950s he continued to show African American laborers at work in the fields. *Cotton Picker* (1950) is striking because it shows just one man set against an olive-colored sky and an intense red-orange sun. The painting provides an interesting example of the way Gwathmey subordinated historical narrative in order to achieve his artistic ends. He wrote the following about it for an exhibition catalog early in 1951:

FIGURE 39
Painting the Image White (ca. 1953), o/c, $16^1/_2 \times 19^1/_2$. Courtesy of Gwendolyn Knight and Jacob Lawrence. Photo by Richard Nicol.

FIGURE 40
Pick until the Rain Hits
(1955), watercolor,
22 × 9. Butler Institute
of American Art, Youngs-
town, Ohio. Gift of Mr.
and Mrs. Lowenthal.

I'm interested in telling a story. However, those qualities that are all too often considered independent of the subject must be resolved implicitly; the greater reality being reached only with a true fusion of all the elements involved. I'm interested in people and ideas. The cotton picker is outmoded by the great flat planted areas of Texas and California that lend themselves to the mechanical harvester. My *Cotton Picker* with his stunted crop and grubbing poverty, the highway marker and the red sun rising in a hot sky are part of a scene I know intimately. I hope these several images transcend mere pictorial props.[14]

The color of the sky in *Cotton Pickers* (plate 14), pale peach, is similar to Millet's sky in *Calling the Cows Home* (ca. 1872), which was acquired by the Metropolitan Museum of Art in 1950 and promptly placed on exhibit. There are two men and one woman; the latter wears an orange and red skirt, seemingly an improbable combination, except that Gwathmey himself dressed "like a peacock," according to Jack Levine. The rolling hills are colored like a quilt in several shades of green and brown. But most striking of all, the three figures picking cotton are bending to the left, their synchronized bodies moving in unison. They are working toward the left because they have picked all of the plants that were growing on the right.[15]

Gwathmey loved to use seed bags in his paintings because they had bold and colorful emblems on the sides that provided a delightful decorative effect. They also served as symbols of the sharecropping system that forced men to borrow in order to pay for seed and fertilizer, which became more difficult because banks and loan companies remained reluctant to lend to tenant farmers. His *Boughs and Bags for Shade* (n.d., early 1950s?) is a fine example. A single sharecropper with a humped back slowly hauls his bucket past a fence hung with seed bags, while a brilliant sun blazes overhead against a devilishly red sky. His gait is methodical and unhurried. As Gwathmey remarked in a 1966 interview, "If I say that the Negroes I paint have a sense of dignity it's because they are inherent with dignity."[16]

In *Pick until the Rain Hits* (fig. 40), a watercolor, the dignity of fieldwork is obscured by the sheer difficulty of laboring under adverse circumstances: scorching heat, drought, torrential downpours, and even the risk of being struck by lightning. In this work Gwathmey may have been adapting to his own favorite motifs a dramatic device familiar from impending storms in the art of Martin Johnson Heade and Winslow Homer.[17]

Gwathmey liked to incorporate music into his pictures, particularly by means of the mouth organ and the guitar. *Playing* (1948) is a typical piece showing a black man strumming a guitar.[18] It was first exhibited in a show called *Rhythm of Life: Gwathmey, Lawrence, and Bearden*. One wonders whether Gwathmey encountered the following passage from Sherwood Anderson's most successful novel, *Dark Laughter* (1925): "The words coming from the throats of the black workers could not be understood by the boy but were strong and lovely. Afterwards when he thought of that moment Bruce always remembered the singing voices of the negro deck-hands as colors. Streaming reds, browns, golden yel-

lows coming out of black throats" (p. 106). By the mid-1950s Gwathmey had found ways to combine his affection for music with his affirmation of the cohesiveness of African American family life. He does so with great success in *Family Singing* (plate 23), a picture that also includes another element that began to be prominent in Gwathmey's art at this time: what he liked to call "vegetation." Gwathmey regarded this as one of his most important paintings. Early in 1969 he had to plead with the owner to lend it for an exhibition of his work to be held in Boston: "I don't think I'm completely represented without your canvas."[19]

There is also an echo in *Family Singing* from another passage in Anderson's *Dark Laughter*: "Negroes singing had sometimes a way of getting at the ultimate truth of things" (p. 248). Equally interesting, because the Gwathmeys went to Europe in 1949 on the same boat with Rufino Tamayo, is the latter's depiction of two adults and a child called *United Family* (1953). Not long before Gwathmey died in 1988, Tamayo painted *Three Characters Singing* (1981) and *The Family* (1987).[20] The two artists were kindred spirits in several respects, from subject matter to an intense concern about the innovative uses of color.

Gwathmey's love of vibrant color and his way of working with color swatches in order to achieve certain effects owed a great deal to painters as diverse as Tamayo, Picasso, and Josef Albers, a German refugee who came to the United States in 1933 and became an acquaintance of Gwathmey's. Gwathmey liked the word "colorist," and he meant it as a high compliment when he called another artist a "fine colorist." He believed that the use of flat patterns and unusual juxtapositions of color were inseparable in his work because each color had become an interdependent tool for him as an artist. "Color can best be expressed by the use of flat relations," he once wrote. In 1968 Paul Cummings observed "the terrific variety of colors in your work," and Gwathmey responded,

> Yeah, yeah. Well, now in my way of painting where I don't have chiaroscuro the demand of color combinations is imperative. It's most, uppermost. The thing that always amazes me is when people use the word subtle. They say here's a person who uses moody colors, so that's supposed to be subtle—where the values are so close that they're almost imperceptible, whereas I think subtlety in color is like a guy like Picasso. Put a red against a yellow. Almost right out of the tube you know, and make them work. I mean that's what I call subtlety. It's easy to mute colors. It's almost as if you covered everything with a gauze which makes them cohere. To make them cohere with strength of color, to me that's subtlety.[21]

Gwathmey's notion of subtlety in coloration actually translated into work that seems reminiscent of Rouault's "jewel colors." Yet the apparent similarities with Rouault also owed a great deal to Gwathmey's deep affection for medieval sculpture and stained glass windows. As he remarked in 1968, "I like medieval sculpture because those figures are not too unlike, say, Share Croppers. Share Croppers are thin and wiry and rheumatic. . . . In doing Share Croppers you'll find that there's never any elaborated action."[22]

The intensification of Bob Gwathmey's enthusiasm for color during the 1950s was also related to the fact that Rosalie took up textile and wallpaper design during the mid-1950s as a way of replacing her abandonment of photography in 1951. Sarai Sherman, a friend of both Gwathmeys after they moved to their first home on Tenth Street in Greenwich Village, introduced Rosalie to interior design and found her use of unique, "slightly off the real-color sense" very elegant. She also perceived Rosalie as warm, receptive, highly intelligent, and self-effacing. The two women worked initially as part of a group of designers; but when they decided that paying an agent's commission of one-third seemed ridiculous, the group ceased to function as a cooperative in 1960, and the members began to work individually on a free-lance basis. Meanwhile, Bob became intensely interested in Rosalie's work with textiles and occasionally revealed the influence of her fabric designs in his art.[23]

It is no coincidence, therefore, that colorfully choreographed flowers began to appear in Gwathmey's work with increasing frequency during the 1950s. Beginning in the later 1940s, flowers had emerged as an incidental accompaniment to paintings in which figures were the focus of attention, such as The Flower Vendor (plate 24). Within a decade, however, field flowers became the focal point for lush paintings such as Daisy Chain (1959), Flower Freshness (1959), and Flowers for the Pulpit (plate 25). By 1960–61 Gwathmey was devoting increasing attention to floral still-life painting, a genre in which he eventually produced some of his most meticulous and tightly composed works. Whereas Rouault's iconic figures carry intense Christian messages, many of Gwathmey's most symbolic works include floral arrangements. (See Man with Apples [1962], Wild Roses [plate 29], Ecstasy [1968], and Ophelia [1970].)

Gwathmey created quite a few of these images both in oil and in watercolor. He explained why in a 1979 letter to the Hirshhorn Museum: "I find that when I do water colors the switch in media from oil takes added concentration before I get into the groove. Therefore when I make the adjustment I stick with the medium for a period of time. Consequently my water colors come in batches and most often are in the same subjects as those done previously in oil."[24]

In 1968 Paul Cummings elicited a revealing response by asking Gwathmey whether he began a painting with a drawing. The artist replied that if he had the actual object or scene directly before him, "I'm commanded by it." He felt constrained creatively.

PC If you have a still life in front of you, that's it.

RG Right! I'm commanded by it. I really am. Utterly. I always make what they call working drawings. Say there's one element I want to do in great detail, and another element I'd rather sketch in. And then I paint from the drawings. This allows me [to be] once removed from naturalism. In my figures as well as in my still-lifes I have to make drawings of the object. It allows me much more sense of flexibility.

PC Well, the working drawings. They're not as finished as the other drawings?

RG For instance, there's something in a drawing I'll make that I understand completely.

An element. But there may be another one I don't understand quite completely. And so then I will make that in more detail. That particular element I don't understand. I do it in tremendous detail so that I can transpose it better.

PC Well is it drawn in the same style, the same way, the same line quality? Or is it . . .

RG No, no, again, the working drawings are perfectly explicit. I mean you could almost say this is it. It's almost a rendering. And then from the so-called rendering or the thing approaching rendering I can take over. But if I paint direct from the object I'm rather commanded by it. I have no sense of changing it. And I would like to. But from the drawing I can place the emphasis where I care to. And then I can juggle as I care to, and arrange and rearrange.[25]

By all accounts Bob Gwathmey was meticulous in his work habits, and no aspect of a composition occurred by accident or serendipity. Just as Jack Levine customarily enlarged the heads of his figures for the sake of emphasis, Gwathmey often made the heads on his figures a bit undersized, especially for African Americans, in order to highlight their bodily strength, especially in their arms and hands, but also the torsos of male figures on a beach.[26] The heads of his women, moreover, often resemble masks—not necessarily African masks, but Modigliani-like—as in *Sewing* (fig. 41), or perhaps somewhat more African in *Sowing* (plate 12).

Although Gwathmey's work could be colorful, dramatic, and quite often easily accessible, he did not want to be considered a "decorative" artist or a painter of pretty pictures. He disapproved, for example, of Andrew Wyeth's art because it seemed too representational in an illustrative sense. Wyeth's work appeared to be a more sophisticated version of Norman Rockwell's, who came across as one cut above the level of a cartoonist.[27]

Despite such reservations and feelings, however, Gwathmey did on occasion do illustrative work—usually for the fundamental reason that it paid well. In 1948 he painted a work in oil of a father and son sitting at a desk with a typewriter, an image done on commission to illustrate a story in *Seventeen* magazine (see fig. 42). The most startling aspect of this picture is not the style, which is unmistakably Gwathmey's, but the fact that both figures are not merely Caucasian but blonde—highly unusual for a painting by Gwathmey prior to the 1960s.[28]

Another small genre scene, undoubtedly from the late 1940s or early 1950s as well, is untitled and most likely was also commissioned to accompany a story. Apparently set in the French Quarter of New Orleans (owing to architectural style and wrought-iron balconies), it shows an older black woman who resembles Sarah Wade responding to two white men at her door who appear to be either census takers or religious missionaries. A black man wearing overalls is entering the door of an adjacent home. Because the story this painting was intended to accompany is not known, the narrative that the work is meant to convey remains completely obscure.[29]

FIGURE 41
Sewing (ca. 1952),
watercolor, pencil, and
ink on paper, 18½ × 13.
Arkansas Arts Center
Foundation Collection.
Museum Purchase Plan
of the NEA and the
Tabriz Fund.

In the autumn of 1957 Gwathmey accepted a commission that made him extremely uncomfortable. *Sports Illustrated* invited him to do a sequence of works at the World Series in Milwaukee, where the Braves beat the New York Yankees in seven games. When the same two teams played again the following year, *Sports Illustrated* got extra "mileage" from their artistic commission. From Gwathmey's perspective, doing this kind of commercial work felt "scary," and he simply painted what he believed the magazine wanted. Consequently there is a formal quality to his oils of the players on field and the well-packed grandstand.[30] The strongest impression that he brought home from this experience concerned the presence of family units. The excitement conveyed by parents and children as fans arriving at the game is readily apparent in his charming works done with watercolor and pencil. I assume that doing these casual scenes of anticipatory enthusiasm gave Gwathmey greater pleasure than painting panoramic vistas of the stadium.

Sports Illustrated seems to have been quite satisfied with its selection of the artist, however, and devoted one page in April 1958 to an explanatory text titled "Sport in Art." Considering the intensity of Cold War feelings at that time, we must assume that the editors of the magazine knew nothing about Gwathmey's leftist politics and FBI surveillance.

Robert Gwathmey's work is primarily of the South, of long, linear figures against flat country, with pine trees, corn, cotton and tobacco and the relation of the people to the soil. His assignment to paint the ardor for baseball in the ecstatic city of Milwaukee came about because the style and mood demonstrated in his paintings (which hang in more than 30 museums) seemed particularly suited to the subject. He is, in a sense, a fine-arts illustrator: a story-teller. The influence of medieval art is seen in his attenuated figures with their limited gestures. He prefers flatness with limited perspective rather than deep space, thus giving his work a composed, almost static quality—quiet, harmonious, introspective.

Gwathmey noted that just about everyone in Milwaukee was a baseball fan, and that even at 5 A.M., waiting in line to buy tickets for that day's game, the general tone of the crowd was one of excited expectation and camaraderie. He was impressed that much of the crowd was comprised of family units, often including grandparents and grandchildren. In Milwaukee people go to the game in groups, not alone. Moreover, he noted that the baseball team aroused as much local pride as did Milwaukee's traditionally fine food and beer. Baseball has become part of the city's life.

Gwathmey is a Southerner, born in Richmond in 1903, but he has traveled widely and now lives in New York City where he has taught drawing for 15 years. The simplicity and restraint of his art contrast with the man himself. He is gregarious, affirmative, open, with a lively sense of humor and a very positive attitude toward life.[31]

However distasteful Gwathmey might have found doing illustrative work for mainstream magazines, both the visibility it gave him and its innocuous, apolitical nature may have enabled him to weather a period when the FBI had him under unusually close surveillance. In July 1951 Louis Budenz, a former editor at the *Daily Worker* who became

FIGURE 42
Like Son (1948), o/c,
16 × 20. Courtesy of the
Forum Gallery, New York.

an informant and witness against erstwhile colleagues and friends, told the FBI that Gwathmey was a "concealed communist." Three months later the New York FBI office recommended to J. Edgar Hoover that a Security Index Card be maintained for Gwathmey—a menacing move. His status had shifted from suspected to categorical communist. According to one informant, artist William Gropper had brought Gwathmey "close to" the Communist Party of the United States, and Gwathmey had then cooperated in recruiting artists for the party.[32]

The fourteen-page report on Gwathmey dated October 24, 1951, enumerated an astonishing list of "communist related" organizations the FBI believed he either belonged to or had been associated with. In retrospect the causes of guilt by association are as varied as they are instructive: the American Committee for Yugoslav Relief, Inc.; the American Committee for Protection of the Foreign Born; the American Labor Party; the American Peace Crusade; the Bill of Rights Conference; the Civil Rights Congress; the

Committee to End the "Jim Crow Silver-Gold" System in the Panama Canal Zone; the George Washington Carver School; the Committee for Peaceful Alternatives to the Atlantic Pact; the National Non-Partisan Committee to Defend the Rights of the Twelve Communist Party Leaders; the Cultural and Scientific Conference for World Peace; the International Workers Order; the Joint Anti-Fascist Refugee Committee; the Jefferson School of Social Science; *Masses and Mainstream* (Gwathmey was listed as a contributing editor); the May Day Celebration; the National Council of American-Soviet Friendship; and the World Congress for Peace. Most of the names were gleaned from the published pages of the *Daily Worker* in which petitions signed by Gwathmey had appeared.[33]

In September 1955 the FBI's Subversive Activities Control Board reported to Hoover that on several occasions in March and August 1947 Gwathmey had spoken before the Artists' Club in New York City on "the rights of Negroes," sufficient evidence to mark him as a highly suspicious character. Beginning in December 1953, FBI agents hid in pairs in the entryway to a church across the street from the Gwathmeys' apartment building. When Bob emerged to walk to the subway, the FBI men would come out from the shadows, accost Gwathmey, and attempt to question him. The substance of one such account prepared by the agents conveys a sense of just how intimidating open surveillance could be at that time.

At 8:50 A.M. on 12/7/53 the subject was observed leaving his apartment building at 1 West 68th Street, New York City. He turned north on Central Park West and proceeded to 70th Street at which point he was contacted by the above agents.

The agents identified themselves and shook hands with the subject and told him they wished to discuss a matter involving the security of the United States and because of his background it was felt he could be of assistance to his Government if he so desired.

GWATHMEY smilingly replied that his first reaction was not to talk to the agents inasmuch as he was contacted on the street. He was advised that he was contacted away from his home and residence in order to avoid any possible embarrassment to him or his family. GWATHMEY nodded his head and murmured that he understood.

He then pointed out that he did not feel he was in a position to furnish any information but could not discuss it further as he was on his way to school (Cooper Union, Fourth Avenue and Seventh Street). He was advised the agents would gladly make an appointment with him to further discuss this matter if he so wished. GWATHMEY replied that he did not wish to make any decision until he had consulted his lawyer. He stated he would notify the New York Office whatever his decision might be. GWATHMEY then departed and the interview was terminated at 9:02 A.M.

During the course of the interview GWATHMEY was congenial and smiled frequently. It was observed that despite this appearance of nonchalance the subject exhibited signs of nervousness and was quite hesitant about engaging in any prolonged discussion with the agents regarding his past activities.

In the event that subject does not contact this Office by 12/31/53 Bureau permission is requested to re-contact him. This re-contact will be made in accordance with existing instructions now relating to the captioned program.[34]

The agents made another futile attempt to "interview" Gwathmey on January 18, 1954, but this time the dialogue lasted only ten minutes. Gwathmey had considerable aplomb and finessed awkward situations extremely well. Meanwhile, between 1948 and 1954 especially, the FBI scrutinized every reference and citation in the *Daily Worker* with a fine-toothed comb, noting wherever Gwathmey was "mentioned favorably." Supporting any humanitarian organization seems to have been highly suspect. In speeches that right-wing congressman George A. Dondero of Michigan made in the House of Representatives on March 25 and May 17, 1949, he denounced Gwathmey and others for belonging to the United American Artists in 1938 and for being leaders of the Artists Equity Association, "the latest link in the chain of Red instigated artist organizations."[35] I assume that the FBI served as Dondero's source of negative information. Had they only known that the Gwathmeys owned a red dachshund named Marxy.

The vituperation in Dondero's extended attacks on American "Red artists" was extraordinary, as exemplified in this extract from the speech he gave on March 25: "The veritable wave of would-be painters, sculptors, with which America is drenched is directly traceable to the need of the Red culture group to create a numerically strong Communist art movement. The fact that the quality of both art and artists is inferior in no way deters them—though it should strike a warning note to all real Americans."

Following an extended attack against Herman Baron and the ACA Gallery on May 17, this screed was directed at Gwathmey in particular: "There is a booklet on Robert Gwathmey, whose Red record I have called to your attention, and this pamphlet is written by Paul Robeson, Communist, who has avowed that he would fight for Communist Russia against his own native land, if he had that choice to make."[36] The so-called booklet simply contained Robeson's three-page introduction to a Gwathmey exhibition catalog from 1946.

By 1964, when J. Edgar Hoover submitted detailed informational memorandums to J. Lee Rankin, general counsel to the presidential commission on the assassination of President John F. Kennedy, all traces of nuance had disappeared. The report on Gwathmey flatly declared that his "history of subversive activity extends from at least 1941 to the present." He had, in fact, been politically active in 1957 and 1961 particularly, and the FBI kept close tabs on the Gwathmeys' travel plans as late as June 1969.[37] The observer had been under close observation himself for the better part of twenty-seven years.

Despite these extraordinary circumstances, Gwathmey's response to such sustained and intense surveillance is not reflected in his art. His work changed during the 1950s and 1960s because of social, artistic, and political concerns, yet he never painted any type of pointed satire or didactic work directed at the surveillance of citizens on account of ideological hysteria. William Gropper, in contrast, painted *Witch Hunt* (fig. 43) during

the early 1950s, in which a fully robed Klansman hovers in the air above a witch riding astride a very big fish. Jack Levine painted *The Trial* in 1953–54 and eventually, in 1963, completed a work that he called *Witches' Sabbath*, which he has explained is a response to McCarthyism and the pumpkin/typewriter episode involving Alger Hiss and Whittaker Chambers.[38] Knowing that Gwathmey could not have been oblivious to witch hunts large and small, it is intriguing that he chose not to respond to them.

During the course of an interview in 1968, Social Realist and satirist Jack Levine was asked whether he had ever considered abstract painting. His response speaks volumes about the mood of intimidation during the 1950s. "I think that I tried at one point or another," he answered, "especially during the Joseph McCarthy era when I didn't want any more trouble than I could handle, to get away from some of this sort of muckraking, you know, because it was an intimidating period." A few months later, also in an interview, Philip Evergood drew a contrast between the political activism of the Social Realists during the 1930s and 1940s and the comparative quiescence of artists subsequently.[39]

More than a year earlier, in 1967, Gwathmey had expressed his own disillusionment with efforts to mobilize artists on behalf of social justice or even their own self-interest. He looked back wistfully to the artists' organizations of the 1930s and 1940s: "When the need evaporated, so did the formal organization. All the efforts since, to form artists' organizations on purely political bases, have failed. They've never lasted any length of time."[40]

Seven months later, in a much more extensive interview, Gwathmey made a closely related observation that indicated his other great political and artistic problem of the

FIGURE 43
William Gropper,
Witch Hunt (ca. 1950),
o/c, 20 × 16. Courtesy
of the ACA Galleries,
New York.

1950s: the ascendancy of Abstract Expressionism. He referred to the fact that even the "introverted personalities" were opposed to U.S. involvement in the war in Vietnam. "So here are these guys of good will who are involved in personal, we'll say, problems in paintings [meaning psychological]. And it may lead to what I might consider rather delightful and beautiful decoration. . . . [In the 1930s] almost everyone did some sort of social comment painting. And I think there was a kind of reaction against this in the forties and the fifties because we'd seen it. It had been done. It had been drummed into us. And most of the artists did remove themselves from it rather completely."[41]

That may sound like a rather dispassionate description of some inexorable swing of the pendulum in the art world, but by 1953 a sizable yet diverse group of realists felt enraged by the critical acclaim being showered on the Abstract Expressionists and by their dominance of the museum scene. Later in the 1950s Edward Hopper wrote the following to Andrew Wyeth; Hopper's sentiments were explicitly echoed by Gwathmey on numerous occasions: "In more than a decade the Whitney Museum has presumed to point out the road on which art should travel, as evidenced by its annual exhibition. The last Annual, for example, features 145 paintings, of which 102 are non-objective, 17 abstract, 17 semi-abstract, leaving only nine paintings in which the image had not receded or disappeared. I feel this partisanship is very dangerous." In 1961 George Plimpton asked Wyeth for his feelings about the Abstract Expressionists. Wyeth began on a positive note: "I like their vitality, that's the thing I get out of them." But a single sentence conveys the core of his critique: "I feel that painting has to have something more in it than the sort of texture you find in the old walls of this room we're sitting in."[42]

In 1953 a group that included Hopper, Gwathmey, Jack Levine, Isabel Bishop, Raphael Soyer, and many other representational artists created a publication called *Reality: A Journal of Artists' Opinions*. Although it fired salvos at the abstract artists, it had little impact on their hegemony and lasted less than a year. Invariably well mannered and civil in his discourse about other artists and their chosen ways of working, Gwathmey's response to a pointed query late in 1959 was polite if not covert: "Creativity is the ability to translate . . . experiences in artistic terms, to order and clear the obscure and confused," an allusion to the psychological subjectivity and inscrutability of many Abstract Expressionists.[43]

Rosalie Gwathmey was more direct in the 1990s when an interviewer asked her, "What do you think of Abstract Expressionism?" "I'm not sympathetic to it," she replied. "I've seen some things that I think are beautiful, but I'd rather have a basket of fruit or something. It doesn't leave me with anything; it just doesn't grab me. I don't want to own anything by those artists. I'd much rather have a Shahn and some meaning."[44]

Following the politicization and failure of the State Department's *Advancing American Art* exhibition in 1947–48, the administrations of Harry Truman and Dwight Eisenhower chose to bypass Congress by using governmental agencies such as the U.S. Information Service to finance cultural ventures abroad. They worked closely with the Museum of Modern Art and with critics such as Harold Rosenberg, who wrote the introduction to

an important catalog. The art exhibited tended to be Abstract Expressionist, and the contextualizing essays emphasized the international (that is, Western) aspects of the paintings. We can only speculate about Gwathmey's feelings had he known that the federal government helped to promote abstract art abroad at mid-century.[45]

His most expansive opportunity to express his views on the same subject occurred in 1958, when Gwathmey made a presentation and participated in the wide-ranging discussion at a conference, "Design and Human Problems," in Aspen, Colorado, June 22 to 29, 1958. It was actually the eighth in a series called the International Design Conference that began in 1951 under the sponsorship of Walter Paepcke, founder of the Container Corporation of America. In principle, this should have been an odd venue for a leftist like Gwathmey because the purpose of the conferences was to strengthen and exemplify the alliance between art and commerce that Paepcke had always encouraged. Another figure behind the ongoing conferences was Egbert Jacobson, a man responsible for the Great Ideas advertising campaign.[46]

As it happened, however, the participants in these conferences represented a broad, virtually ecumenical range in terms of ideology as well as aesthetics. One of Gwathmey's colleagues at Aspen in 1958, for example, was the radical sociologist C. Wright Mills, who presented a highly critical paper that lamented "the bringing of art, science and learning into subordinate relation with the dominant institutions of the capitalist economy and the nationalistic state."[47] No perspective seems to have been excluded, and no participant was expected to pull any punches.

It is not clear why Gwathmey was invited to Aspen in 1958; he was the only painter. Other speakers included an urban materials designer, a city planner, an industrial designer, a cultural historian, and Mills. Gwathmey was referred to as a "designer-instructor" in an essay written about the conference.[48] The visibility of his art in *Sports Illustrated* during the fall of 1957 very likely brought him to the attention of the organizers. He appeared to be an accessible painter who used lively colors and accepted commercial assignments. The biographical sketch of Gwathmey in the October 1957 issue of *Sports Illustrated* would have made him seem very attractive and a plausible choice for a speaker. I suspect that his innovative work with serigraphy may have played a part as well. It would be interesting to know how Paepcke and Jacobson responded to Gwathmey's insistence that a clear line of demarcation should be maintained between the fine and the applied arts.

Gwathmey titled his talk "Art for Art's Sake," and the typescript from which he spoke has been preserved in the Archives of American Art. (Only one paragraph from the talk has ever been published.) Because he crossed out quite a few words and replaced them with others, mostly the names of particular artists, we cannot be 100 percent sure of exactly what he said on that occasion. Nevertheless, this document is the most complete statement of Gwathmey's aesthetic values. While it does not seem to have been intended for publication in its entirety, he clearly gave it a great deal of careful thought. Although it is a broad declaration of his artistic orientation and concerns, it responds specifically

and pointedly to Abstract Expressionism as the dominant mode of painting, and particularly to critics such as Clement Greenberg, who were the most prominent champions of Abstract Expressionism and who consequently infuriated realists (or social commentary painters) such as Gwathmey. It is a curious coincidence (if not a major irony) that Gwathmey's determined insistence on flat and smooth surfaces shared an apparent resonance with Greenberg's insistence that "art should be reduced to flat color on a flat plane."

Gwathmey's text is reproduced here almost in its entirety. I have omitted a section devoted to what he called the "range of the formal aspects of painting" because it is least germane to our concerns and because that section is where he substituted the names of some artists for others, most likely because they seemed to him on second (or third) thought to provide more apt illustrations of masterful treatment in categories such as surface, color, line, space, light, and so forth. The text does not scan perfectly because it was neither prepared nor revised for publication. It not only gives us Gwathmey's response to Abstract Expressionism, but does so in the broader context of the artistic and social values that he affirmed.

Art for art's sake is a rather romantic cliché. The connotation of art for art's sake has no meaning except to separate art from its birthright. It was used most extensively and meaningfully in the Thirties to entice artists [who had been engaged] in the struggle for moral values.

Art itself is produced, in part, from the compulsion to express, a unique attribute of man. It is a desire to find and separate truth from the complex of lies and evasions in which he lives. The artist, working free of compromise and out of his philosophical convictions, dominates his subject with experience, order, control, decision, and originality. All of this promotes a sharing of valued emotional experiences and recalls man to his cultural ideals. . . .

The materials and techniques, the history and the conventions are all essential to the understanding of art. This knowledge, if isolated, becomes static and external peculiarities assume exaggerated proportions. Time, place, origin, and rarity take precedence, among the grand arbiters, over artistic understanding. Of course this wide range of facts is of inestimable value but they remain suspended and pretentious unless connected and fused with the whole culture. Within this narrow historical approach the intellectual and the aesthetic are equated, taste becomes confused with fashion, and fashion in art goes deeper than mere acceptance of taste. It means a reevaluation of culture in order to conform. That this appraisal does not come from one's aesthetic background but from external pressures should be self-evident. How else explain New York's New School drawing a curtain across the face of Orozco's mural, which, incidentally, included a likeness of Stalin and men of all races seated around a conference table. Indeed, this curtain was drawn without a ripple from either collector, critic, museum personnel or historian! And, alas! very few artists protested. Perhaps this might help explain the painting over of early Renaissance

works in order to present a given wall surface for a new attitude. It might as well explain the loss of Greco's popularity upon the consolidation of the Church's position in Spain. Surely Greco's subject matter was out of the same book used by the lesser painters who followed. The crux of the matter is that the artist never separates subject from artistic intention.

Now, Alfred Barr of the Museum of Modern Art is quoted by *Time* (January 28, 1957) as having once thought of Monet as "just a bad example". This was coincidental to the Museum's acquisition of one of the last (circa 1925) of Monet's often painted lily ponds. This broad brushy distillation has passages that show a strong association, in method of application, to many of the non-representational expressionists.

The association ends with the formalism expressed and was ostensibly separated from the 85 year old master's preoccupation with his impressionistic interpretations of his favorite subject. Clement Greenberg is even moved to suggest a new subdivision of painting henceforth to be known and labeled "abstract impressionism". Here we have the insight into the process of an avant-garde's thinking which not only pretends to abandon tradition but attempts to bury it.

To even pretend to separate subject from artistic intention is to infringe upon the basic structure, to deny its anatomy. Art is the sheer realization of the anatomy of the configuration of a visual whole. It is the conceptual solution of complicated forms, the perceptual fusion of personality, not humble ornamentation or surface pyrotechnics. Beauty never comes from decorative effects but from structural coherence. Art never grows out of the persuasion of polished eclecticism or the inviting momentum of the band wagon.

Still, a new orthodoxy has been formed and, like all orthodoxies, it is built on dogmatic conformity and escape. Life is hard, the esoteric safer, the private world more remote. The pass words are instinctive, automatic, accidental. The pretense is freedom from reference which almost reaches a state of megalomania. The isolation from man and nature is a denial of humanism, and individualism, rejection of tradition, [and] over-emphasis on the psychological are so restrictive that a new tyranny results.

The cult of non-representation is faced with the inexorable historical phenomenon in that the moment it becomes a vogue, it widens its activity into other fields. When this happens, its creative qualities are depleted and although its trademark is recognizable, it goes the way of all fashion. Is this not the line of demarcation between the fine and applied arts? And who can doubt that that line must be maintained, for the thinner the line between the two, the less depth there is to our civilization.

The stunning Bertoia room divider in one of New York's banks is a case in point.[49] And isn't Greenberg's (*Partisan Review*, Spring 1955) "since we are now able to look at and enjoy Persian carpets as pictures", positively belabored.

In dealing with contemporary values, those with the loudspeakers seem intent on separating subject matter and recognizable images from the whole body of art. This irresponsibility is jaundiced by a self-aggrandizement that has degenerated into a my-

opic state. The untenability of one-sidedness has never been more apparent. With the welcome advance of the scientific comes the urgency of responsibility of complementary forces. Those who would catalogue the science of visual aid within the realm of fine art are indeed blind. To misunderstand sheer visual phenomenon [sic] is to fall for the tricks of the trade.

The leaders of the academy of the non-representative are knowledgeable of the tools, techniques and conventions of painting. One is impressed by their possession of so many rich resources and rewarded by many exquisite and exciting passages in their work, while at the same time dismayed by their self-imposed limitations. In our industrial-scientific age, the artist is among the very few who are able to work as an individual. While this allows the greatest chance of withdrawal, doesn't it, paradoxically, demand a reassertion of values?

These last few years have been shot through with alarms and frustrations, and security seems so tenuous that people are afraid to freely express themselves. This should never allow reaction to subvert scholarship or art, the last stronghold of humanism. In fact, it should provoke responsibility in the realization of Protagoras' admonition that "Man is the measure of all things."[50]

Gwathmey's impatience with trendy art that was divorced from social realities and pretended to explore the inner psyche by means of Jungian or other interpretive texts increased in the following years. By the mid-1960s he had created some pictorial spoofs of Op Art. For the remainder of the 1950s, however, feeling somewhat alienated from dominant forces in the art world, his own painting entered its least fertile and most uncertain phase. He knew what he believed in but needed a few years and changing social circumstances to renew his creativity. He composed attractive paintings of field flowers and developed a favorite seaside motif that he repeated with considerable frequency after 1955. He invariably called that motif *Soft Crabbing* or *Clamming* (see fig. 44), and he carried it out with oil, watercolor, and pencil drawings. As late as 1976, when he made a diploma presentation to the National Academy of Design, he chose soft crabbing as his subject. This activity was one that he personally enjoyed and achieved great success in each summer when the Gwathmeys rented a small, oceanfront cottage at Wrightsville Beach near Wilmington, North Carolina. At low tide, no other activity was as satisfying, and one summer he was informally proclaimed the champion of soft crabbing at Wrightsville.[51]

For an innovative artist like Gwathmey, artistic tradition mattered a great deal. One needed to appreciate it and understand one's own relationship to it. Gwathmey respected tradition in the same way that his fellow Social Realist Jack Levine often invoked the importance of "continuity." After Gwathmey visited a one-man show of work by Leon Kroll in 1959, he wrote to his old friend, along with warm congratulations: "You've never been an academician and you always speak clearly. I'm so tired of the half statement and sloppy 'artistry' that I'd like to pin down a couple of elder statesmen from 10th

FIGURE 44
Clamming (ca. 1962),
o/c, $47^{1}/_{4} \times 33^{1}/_{2}$.
Courtesy of the Terry
Dintenfass Gallery, Inc.,
New York.

Street. How is it possible to flaunt tradition to such an extent? Oh well, history makes more sense to me than fashion and you're on the side of history and I salute you."[52]

The emergence of Abstract Expressionism made Social Realism appear, in retrospect, more cohesive as an artistic movement than it had actually been. The paintings by Ben Shahn and William Gropper, for example, had more explicit political content—at times almost verging on "agit-prop"—than the social commentary by Gwathmey, which was closer in content to works by Raphael Soyer and Isabel Bishop. Needless to say, art critics who felt sympathetic to the newest trends of the 1950s became fiercely dismissive of the Social Realists, often using a critique of one artist as a means of chastising them all. Hilton Kramer, for instance, had little good to say about Jack Levine in 1955, when the latter was only forty. Levine's successes with museums as well as private collectors seemed to infuriate Kramer.

> Levine's paintings represent ideas which he has had in his head for years; they represent an idea of reality, social reality, on which he has not allowed the brute facts of experience to make the slightest alteration. It rather confirms one's suspicion that "social realism" is one of the most extreme forms of mannerism in modern painting. . . .
>
> With his subject matter stabilized (a curious turn of events for a "social realist"), Levine has been free to dwell more and more on the mannered details of his pictures, and the zenith of this concentration is reached in *Reception in Miami* [1948]. Of all the improbabilities imagined during the Federal Arts Project, none would have strained credulity more than a "social realism" gone rococo—but that is precisely where this picture has brought it.[53]

Levine and Gwathmey were friends and neighbors in Greenwich Village for a period starting in the mid-1950s, and both men shared a feeling of disdain for Abstract Expressionism. Levine asserted that it "puts too high a premium on subjective reactions."[54] Gwathmey's closest friend among the Realists, however, remained Philip Evergood, a man two years older than himself who had established his reputation as an artist a full decade before Gwathmey did. They were soul mates in terms of social values and personal style. They enjoyed dining, drinking, and partying together, commonly becoming so loud, boisterous, and childish that they were asked to leave restaurants. (Rosalie recalls that "they were like schoolboys together.") That Evergood cared passionately about social justice is immediately evident in his depictions of factory workers, strikes, the circumstances of southern sharecroppers, and affluent snobs. His explanation of one of his great paintings, *Moon Maiden* (fig. 45), reveals clearly why Gwathmey so often deferred to him. Evergood could be loud and opinionated, but Bob Gwathmey invariably shared his opinions and admired him immensely. "It's meant to be a—showing the shallowness of the theatrical world in New York, the little cigarette girls in night clubs, the nasty old men with their full dress tails, and the sort of emptiness of the tv world, the radio world, the Hollywood world, the emptiness when really important issues are at stake in the world. All the energies of vast numbers of people go towards that kind of nonsense. It

struck me that something ought to be said about it in paint." When asked about the image in the lower right-hand corner, Evergood answered,

> It's a portrait of the base of the Statue of Liberty. And in the base of the Statue of Liberty—that wonderful symbol for us Americans—there are so many dungeons, and there are so many skeletons—skeletons of things not well done so far as liberty is concerned, such as the attacks against Negroes down South, and the blabbering of a lot

FIGURE 46
Philip Evergood,
*There'll Be a Change in
the Weather* (1962), o/c,
48 × 36. Courtesy of the
Terry Dintenfass Gallery,
Inc., New York.

of important political bigwigs about protecting America and building a lot of atom bombs, etcetera, etcetera, things that many of us don't like. And the political prisoners—the bars—so I cut a hole in the side of the base of the Statue of Liberty and made it a prison where the little political prisoners were looking out. They're looking out on the bench where a lot of bums—the romantic side of poverty is displayed in the Bowery, where, you know, people on a slumming party love to go down and see a man sprawled across an area-way with a bottle in his hand and with holes in his shoes. And all this happening in the beautiful land that we love and that we know should be aiming for beauty and liberty—and yet isn't so often.[55]

Racial injustice especially outraged Evergood, and in 1948 he painted *Her World*, depicting a pensive young black woman in a rural setting leaning on a wooden fence rail, one foot resting on barbed wire, with six dilapidated shacks behind her. The Metropolitan Museum of Art in New York acquired it promptly in 1950.[56] Other paintings by Evergood that protest racial intolerance include *Black Lace Handkerchief* (1946), *There'll Be a Change in the Weather* (fig. 46), and a violent lynching scene titled *The Hundredth Psalm* (ca. 1940), in which a black man dangles from a tree and a smoldering fire is just going out while Klansmen dance around playing fiddles.[57] The African American people walking and playing in Evergood's *Sunny Side of the Street* (1950) harken back to Gwathmey's *Street Scene* (fig. 9), not in composition or configuration but in subject matter and the artists' mutual feelings about it.[58]

FIGURE 47
Robert Gwathmey
seated at his easel in his
bedroom, 68th Street
and Central Park West
(1953). Photograph by
Sandra Weiner.

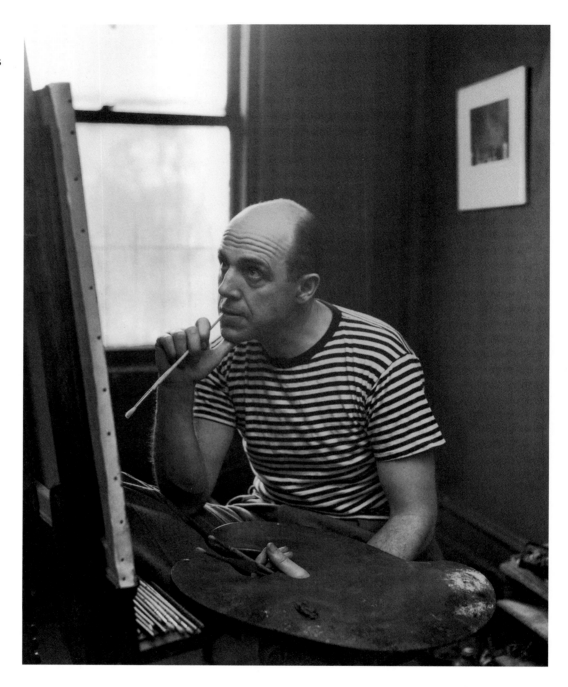

When Charles Gwathmey at age eleven attended an international school in Paris in
1949–50, he had to write an essay about a person. Without any prompting (or assis-
tance) he produced the following:

My father is a man named Robert Gwathmey. He is a painter. Almost every day when
I come home from school he is at his easil busily painting. [See fig. 47.] When I walk

FIGURE 48
Herman and Ella Baron
(n.d.). Private collection.

in the room he looks up at me and says "Hows it go Charlie" so I say fine. At about 5:00-o-clock he comes down stairs because it is too dark to paint. When I see him walk in the living room I say to myself I hope I will be six feet tall some day. Then he gets a book and his big brown eyes start to concentrate. He has a good taist for food. He says "Ho Boy what a meal." In all the art museums he goes to when he sees a good picture he says "what a cracker-jack of a painting." When he writes letters or reads he scratches the top of his bald head. He mostly paints negros on the farm and working in the fields and people talking on the front porch or women sewing or singing. He is not my favorite painter, Phil Evergood is my favorite. He [Gwathmey] has a very strong arm. I found that out when he frogs me for teasing him. But I love him just the same. His nose does not get into many peoples buiney [business] so that means it is not a very big one. And last of all he is a good pop.

Charles's teacher liked the essay so much that she put it in the school paper. Rosalie and Bob were so delighted that they typed it out in full and sent it to Herman and Ella Baron. Charles had hit a home run.[59]

The Barons were beloved by all of the artists they represented (see fig. 48). Perhaps it mattered that they had no children of their own. It certainly helped that if Herman knew one of his artists was hard pressed financially, he took a very modest commission on the sale of a painting. It also mattered that Herman made an innovative arrangement for that time. He set aside 3 percent of all sales to provide health insurance for his artists. (When Baron became ill at the end of the 1950s, his artists in turn took care of him.) Philip Evergood remembered him in 1968: "Baron really was so wonderful. He loved my work very much. And whenever I was in any kind of a financial jam he would always help me."[60]

In that same interview, Evergood recalled the momentum that the Barons' ACA Gallery achieved when it moved from its early location in a loft over the Village Barn, a nightclub, to a house close to the original Whitney Museum on Eighth Street. "And that's when things began to tick. Because it was next to the Whitney Museum and all the people interested in art that visited the Whitney Museum would drop in to the ACA Gallery next door. And they saw the work of, oh, [Anton] Refregier I suppose and Robert Gwathmey and myself. And people began to buy. I can remember I made my first really big sale there. *My Forebears Were Pioneers*."[61]

It did not seem to matter at the time that Ella Baron was not a very good business-woman or that proper records were barely kept of when paintings were acquired or sold, and to whom. Virtually no business records have survived, and there is some doubt as to whether serious ones were ever maintained. Bella Fishko, the wife of politically as-tute labor organizer Sol Fishko, worked for the Barons from the end of World War II until just before the gallery closed in 1960. She and her husband became close friends of Bob and Rosalie Gwathmey. The two couples campaigned avidly together for Henry Wallace in 1948. Like the Barons, Bella Fishko was devoted to the gallery's artists, especially Bob Gwathmey. In 1959, however, he brought to ACA an attractive and charming young woman from Atlantic City named Terry Dintenfass. Herman eventually hired Terry and liked her. Bella soon felt her position at the gallery becoming insecure, and tensions between Terry and Bella marred the last years of ACA prior to Herman's death early in 1961.[62]

Perhaps the political and ideological pressures of the 1950s affected Bob Gwathmey ad-versely, although Ralph Fasanella and Jack Levine both asserted, from different perspec-tives, that Gwathmey remained absolutely unintimidated. Perhaps his outgoing, often exuberant manner masked some changes during the mid- and later 1950s that might have been only behavioral aberrations but possibly were personality changes as well. He drank increasingly—corn whiskey from a bootlegger when the Gwathmeys visited the South, bourbon when they were in the North. Sarai Sherman, the woman who initiated Rosalie into textile designing in 1955, insists that Bob "taught" her husband, a psychia-trist, "how to drink." She also remembers Gwathmey as a "well-contained alcoholic," by which she meant that although he consumed a lot, he held it well. One of his favorite motifs, executed twice in oil and several times in pencil, is a lone man with his head tilted way back, guzzling a drink. The bottle usually has the shape of a soda pop bottle, but Gwathmey poured bourbon into his coffee and even into his morning orange juice. The bottle in his pictures might contain anything and everything.[63]

Under ordinary circumstances Gwathmey punctuated his conversation with profanity. One to one with other men he could be absolutely ribald. In 1954 he wrote to artist Chaim Gross to express sympathy when he heard that Gross had ulcers. "I understand that ulcers in no way affect a man's thing-a-my-gig. . . . Rosalie says she wishes I could

be just a little sick about once a month. . . . Women just want to share everything. . . . I'd even rather be a man with ulcers than a woman with a revolving pussy." He closed this cheer-up-my-friend missive with this reassurance: "I'd rather be in a hospital with ulcers in New York than in Miss Cabot's pants in Boston."[64] The thrust of that last allusion, seemingly a non-sequitur, was actually more geographical than sexual. By the close of the 1950s he had developed a very strong affection for New York City.

Although Gwathmey could be self-indulgent about liquor, profanity, and unusually raffish dress—Jack Levine described him as a "roaring boy"—those who served with him on art juries were impressed by his gentle courtliness. He was always very careful and considerate of opinions that differed from his own.[65] The same is true of his teaching and the feelings that he evoked from his students at Carnegie Tech in Pittsburgh, where he taught from 6:30 to 10:30 five nights each week plus the entire day on Saturday from 1939 to 1942. At the Cooper Union School of Art in Greenwich Village he taught one night each week for three or more hours, initially for $30 a month. (He later taught drawing two evenings and one full day each week.) He also taught painting on an ad hoc basis at the New School for Social Research in New York from 1946 to 1949, and for a few years after he returned from France in 1950. John Hejduk, presently dean of the

FIGURE 49
Robert and Rosalie Gwathmey at Amagansett, New York (1957). Photograph by Dan Weiner. Courtesy of Sandra Weiner.

School of Architecture at Cooper Union, studied with Gwathmey in 1947–48. In the introduction to an exhibition honoring Gwathmey's work in the spring of 1985 Hejduk wrote,

> Good teachers affect lives. Great teachers change lives. Master teachers impact on the genetic codings of the soul. Robert Gwathmey gave to his students and so it is proper and correct that The Cooper Union honors him for his special gift, as a profound teacher and above all for being a man of peace, a man of deep humanity, and simply being an artist. We went to his drawing class on the sixth floor of The Cooper Union Foundation Building with excitement, with anticipation, and with love; for somehow during those six hours once a week during an academic year he gave us *all* those inner senses. Through drawing he drew us inwardly inside of ourselves so that we could expand externally outside of ourselves. Through his teaching we began to understand what art meant. His commitments and his communications were basic . . . right to the heart.[66]

Because Gwathmey had at least partial employment almost continuously from 1930 until his retirement from Cooper Union in 1968 (except during 1937–39 after he was fired from Beaver College), he qualified only briefly for work on WPA art projects. It remains unclear whether his maturation as an artist occurred more slowly as a result, or whether he has received less recognition than most of his contemporaries as a consequence. Although either explanation seems highly plausible, both are worth considering.[67]

Whatever the case, there is scant evidence that Gwathmey felt insecure or misunderstood—at least not at this time in his life. During the 1950s, despite the overwhelming impact of Abstract Expressionism on his own career and the careers of others, he retained the strength and courage of his social commitments and conveyed them in his painting. As he remarked in 1959, "The egoism of the artist is synonymous with convictions. He takes the authority for what he has produced to show the rest of the world. It has nothing to do with the artist being an exhibitionist."[68]

Gwathmey's personal commitments, however, turned out to be more complex and less consistent. In 1957 he and Rosalie planned a summer vacation at the seashore, as they had for more than fifteen years (see fig. 49). This time they rented a modest cottage at Sea Bright on the Atlantic coast of northern New Jersey. Early in the season they were visited by Bob's doting sisters, Katherine and Ida Carrington. Nineteen-year-old Charles was also present. At dinner one evening Rosalie could not contain her pent-up emotions and blurted out to the assembled family: "Bob is having an affair with Terry Dintenfass." Bob and Charles swiftly left the cottage and took a long walk on the beach, both of them in tears. Charles was baffled and stunned by the news, and Bob was upset at the messy scene but unable to deny or explain the situation to his son. First thing the next morning, Bob's sisters packed their bags and left.[69] A relatively tranquil time had just ended, and a tumultuous decade lay ahead.

CHAPTER FIVE

City Scape

Theresa Kline was born on April 4, 1920, to an affluent and cultured family of Hungarian Jewish background. Her father, Ignatz Kline, was sixty-three at the time, and her mother, his third wife, was in her forties when Terry was born. (She once jokingly claimed to have been the only person "conceived on the boardwalk" in Atlantic City.) She had eight half-brothers and half-sisters from her father's previous marriages. Her mother was two years younger than her oldest half-brother. Her only full sibling, a brother four years older than she, became a prominent physician who wrote extensively on psychological depression and manic-depressive psychoses.[1]

Terry Dintenfass (her name after her marriage) recalls that because her father was elderly and her mother was not especially interested in small children, "we were allowed to do whatever we pleased." They were not exactly neglected, however. The family wintered in Palm Beach, Florida, and the children were sent away from Atlantic City in the summertime because their parents feared the presence of "bad elements" there. As Terry put it in 1974, however, "They should know what trouble I could get in outside Atlantic City." In any case, she and her brother were sent to the more sedate confines of Martha's Vineyard each summer "because it wasn't polluted. And then we traveled. We always were taken everywhere to see this and to see that." After her father's death in 1932, Terry and her brother lived sequentially with two bachelor uncles. As she recalls, "The main interest was that I get married and not disgrace the family by producing any offspring before I was married."[2]

At a boarding school, Fairfax Hall in Virginia, Terry loved the art classes and began to paint. That prompted an interest in attending art school. In the meantime, however, a young doctor named Arthur Dintenfass was introduced to the family in the hope that he

might marry Terry's cousin. Terry was warned not to appear. "And that's all they had to tell me," she remembers. "So I appeared on the scene because he was so tall and big and quiet and steady-looking, and I thought that one was for me, I'll go to art school and get that one. That's how it happened." So she attended art school for a year in 1938–39, married Arthur Dintenfass in the fall of 1939, and had a son, John, in September 1940. She continued to take art classes at the Philadelphia Museum Art School, where she studied with Franklin Watkins, who had also been one of Bob Gwathmey's principal teachers more than a decade earlier. She persevered with art classes throughout the war and even after it ended. Her daughter, Susan, was born in 1941, fifteen months after John. A third child, Andrew, appeared in 1948 after the war.[3]

Following World War II Arthur returned to Philadelphia to complete his advanced training in ear, nose, and throat medicine. Much later he became a specialist in reconstructive surgery, especially facial surgery, because so many young people who came to Atlantic City for a wild time during the 1950s and 1960s suffered serious injuries as a result of automobile accidents or bizarre horseplay. Arthur remained a dedicated physician who preferred to live a quiet, "provincial" life in Margate, a few miles from Atlantic City. When he died of Parkinson's disease late in 1993, his funeral was attended by many loyal and dedicated mourners.[4]

While Arthur pursued his specialty, Terry continued to study drawing and painting, but without any thought of becoming a professional artist. She simply enjoyed doing it. When they lived in Columbus, Ohio, late in the war years, she attended classes in the history of art and in Spanish history at Ohio State University. A neighbor who taught at Ohio State became a close friend and recommended many good books that broadened Terry's background. In retrospect she felt that the value of her art lessons lay in gradually comprehending just how difficult it is to produce fine art. "That gave me an opportunity when I would see a painting," she said. "I still see it from how complicated it is—a piece of paper is white and how complicated it is to break into it."[5]

Because Arthur and Terry both loved the sea, they decided to locate in Margate late in the 1940s after his advanced training as a specialist had been completed. She worked as a nurse in his office for several years, even though she knew nothing about nursing. When he taught at the Penn Medical Center on Thursdays, she went with him to attend classes at the museum school. "That's how I kept that up." But she began to feel bored and also culturally defensive about her hometown. Following a trip to Chicago in 1953 she found herself at a party where the primary topic of conversation seemed to be "Atlantic City is falling apart." Terry observed with envy that "Chicago had the Art Institute, and they have theater, and they have this, and they have that. And there's no reason that this town, being the big convention city that it is, couldn't have a gallery."[6]

Most of the partygoers expressed skepticism that a gallery of contemporary American art could succeed in philistine Atlantic City. But Terry received encouragement from several listeners who urged her to talk to the owner of a major hotel about providing space, and to a family friend named Lou Stern, an affluent collector of modern art who even-

tually gave most of his collection to the Philadelphia Museum of Art. Stern promised her financial backing and suggested that she talk to Edith Halpert, one of the most successful dealers in American art in New York City. She also talked to John I. H. Baur and Lloyd Goodrich at the Whitney Museum, who were more than encouraging. According to Terry, Baur "really pushed me into it."[7]

Meanwhile, soon after the war ended, Terry began to use a small trust fund that she had in order to buy one painting a year. The first, a work by Gwathmey, she bought at a Whitney Annual Exhibition. (The selection of a Gwathmey was pure chance.) The next year she got an Evergood, and the following year a Kuniyoshi. "Each year, I would buy something with this money. And of course Arthur didn't care. It wasn't his money. In fact, the Evergoods sort of startled him. He wondered what they were. But that's what I did. So I had built up these pictures. . . . And I bought only what I liked." Her own collection provided a very attractive core, but certainly not an adequate inventory. She visited various dealers in Manhattan and arranged to take works on consignment—by Georgia O'Keeffe, Ben Shahn, John Marin, and others from Edith Halpert. After she moved her gallery from its brief residence in the conservative (Quaker-owned) Dennis Hotel to the more fashionable Traymore in 1955, she also took works on consignment from Herman and Ella Baron's ACA Gallery. Terry was attracted to the Social Realists because the social commentary in their art felt meaningful. Social Realists, in turn, would be attracted to her.[8]

Initially, however, in 1954–55, not really understanding who was who and what was happening in American art, she knew that she needed mentors to give her a crash course concerning both the "administrative mechanics" of running a gallery and what trends were under way. A friend, knowing that Terry owned a Gwathmey, took her to visit Bob because he had a reputation as a marvelous teacher and as a man generous with his time, especially for attractive women.

> So we went to visit Bob Gwathmey in New York. And to me, he seemed like a dirty old man. He was like fifty-three or so, and I was thirty-three. I thought he was a wonderful painter, and I had bought his paintings. He asked me to go to lunch. I said, "Oh, no, no. I won't go to lunch. I'm going to eat with my cousin." And I don't think I'd ever even danced with anybody at a dance let alone go out. . . . You know, the whole thing was a whole big thing. I got back to Atlantic City, and two days later I got this ridiculous letter from him about how glad he was to meet me and all this garbage. You know, I didn't know what it was all about. I handed this letter to my husband. And he said, "Oh, he's some old. . . . Don't pay attention to that." But he did offer to help me.[9]

Terry soon learned about Whitney fellowships for minority artists. Because she wanted to be able to support such artists, she needed access to the Whitney funds, but she did not know how to go about getting it. She telephoned Gwathmey for assistance, and as she explained in 1974, allusively yet quite clearly, "I very calmly dialed Cooper

Union not in the least thinking that anything like this was going to happen. That's how that happened. And he was only too willing to help me. But I wasn't so willing to help him. It took a while for that." Bob Gwathmey introduced her to Philip Evergood, Milton Avery, and many others. During lunches and chats as they went from one studio to another and from one gallery to the next, he provided her with abundant instruction about modern art as well as the traditions it had arisen from and reacted against. As Terry phrased it late in 1974, "And then my life began, my real life. And that's almost twenty years. And then I really started living. Every experience I've had since then has been art related. A few divorces but aside from that"[10]

Although Bob Gwathmey became her principal mentor, and by 1956–57 her lover, she looked to others for instruction as well, particularly if the shared confidences could help to solidify a relationship with an artist whose friendship and work she valued. In 1955 she wrote to Philip Evergood:

I have been reading and talking and throwing the bull and in general making sure that I know what is what when the questions are asked—But no matter how much listening I do from sources that [I] know are true I am full of many holes on many levels. I am sure that this is true of everyone who sees themselves but it is the feeling of wanting to be guided through the forrest of knowledge instead of picking a few real tasty bits here and there. It is like being loved passionately for short periods of time and never being sure. My formal education was very limited and at the time I wasn't grown up enough to absorb what was offered. What ever I know now is only by the touch and feel method with a little book learning. It seems [an] utter waste to jump here and there through books without knowing where to go with meaning. No one can learn it all but effort spent with purpose and perhaps with the feeling of someone nearby who will help if you get lost must be a better way. I keep feeling there is too much and want to be told what and how. Give a helping hand to a damsel in distress.[11]

That blend of earnestness and feminine wiles led to occasional misunderstandings, particularly during the mid-1950s, when she and Bob Gwathmey had not yet become a couple and she was just beginning to be introduced to the art scene in Greenwich Village. She recalled Gwathmey inviting her to a party for Evergood following an opening at the ACA Gallery.

And I went. Here were all these people that I didn't have any idea. . . . Al Lerner, Herman Baron, Bob and Rosalie, Phil and JuJu. I found myself sitting next to Phil Evergood. Of course by that time, I had bought many paintings by Phil Evergood; he is my favorite painter. He said to me, "Wouldn't you rather be in a nice warm bed with me than in this room with all these people you don't know?" Well, I nearly dropped dead. I thought I'd be very smart, and I said, "Well, Mr. Evergood, if I said yes you would run." I didn't realize that insulted him. He jumped up from the chair, and he shouted, "You're sexually insincere."[12]

Evergood was drunk, of course, an increasingly common occurrence. He subsequently sent her a letter in Atlantic City to apologize but suggesting that she, Gwathmey, and Baron might drive up to his place in Woodbury, Connecticut, on occasion. They would, in fact, do so fairly often; but Gwathmey, who did not drive but loved to drink, left the driving to Terry because Herman Baron did not drive either and could not read a map. As Terry put it, "We never got there the same way twice."

And of course, once we got there Phil and Bob got crocked and then the two of us, and Herman had to rest. Oh, those were the best times of my life. We had a wonderful time. Then as time went on—Phil was very, very reticent, he really was really kooky, he was so paranoid he couldn't bring in an outsider at all—we finally talked him into letting us bring [Antonio] Frasconi because I like to drink a bit, and then Frasconi would drive the car back as far as [Norwalk,] Connecticut. We'd stay there overnight. And then the three of them were all politically involved. So they never paid any attention to me. There were lots of crazy . . . It was just the most terrific thing that ever happened to me. Then, I really got the opportunity of sitting down and seeing. . . . Like Phil would paint; he did my portrait, and I would see how he painted. He was painting on something when we got there. And I'd spend days with Bob. He liked to be read to while he was painting, and I would just sit there and read.[13]

Terry's memories of those visits to Evergood in Connecticut remained vivid even though they became chronologically compressed and blurred by time and subsequent distance. She recalled one trip on a beautiful spring day in May, perhaps in 1958. "We would bring steaks, or we would go to the White Horse Inn. Herman wouldn't drink, but Bob, Phil, and I were good drinkers. We would get so wild, and start throwing food around. There was a lot of drinking, and Bob went out to sunbathe. He took off all his clothes. I was sitting for this portrait, and all of a sudden there was this terrible crash. A woman had driven up and Bob had sat up very politely, and she then drove right into a tree."[14]

By 1957 her liaisons with Bob had become intimate, but within a year his feelings of exuberance about their relationship—she felt certain that he wanted to marry her—were clearly clouded by ambivalence if not guilt. As Terry explained to Evergood in August 1958, a time when Gwathmey had become unproductive, "Bob looks wonderful but seems to provide himself with every possible excuse not to paint. Sometimes I feel extremely guilty and only wish that he could find the peace of mind that he seems so to need. I know he knows that it comes only from within, but he cannot bear to face himself in certain ways. I can give him my love but I cannot set his world in order for him." By the early months of 1959 Terry was virtually commuting from Atlantic City to New York in order to see Gwathmey and look for art. She acknowledged that life had become very complex despite the delights of her association with Gwathmey, Evergood, Baron, and other artists as well as collectors she had come to know. She poured out her heart to Evergood in frequent letters. "Your understanding and knowing exactly how I feel about

Bob made me realize that these were truths, not imaginings. His life was so orderly and so much to his choosing and so much under his own control. I have made it complicated and hard, and many things he denied intellectually are no longer locked away. All this holds true for me, too. Games are easy to learn and play but life is real, not a game nor easy, but so completely real and feeling that its intenseness is blinding."[15]

Six months later, however, Gwathmey's spirits seem to have risen. Terry's, in contrast, had fallen because of conflicts with Bella Fishko over which one of them would take over as director of the ACA Gallery as Herman Baron's health entered a decided phase of decline. Whereas Terry had referred to herself as an observer in January, by July she returned to her usual pattern of reserving that label for Gwathmey. "Bob on the other hand requires that the observer take stock of his own lack of discipline and that life is quite serious and real. Bob looks better than he has for a long time and his being away from the city, and comparatively alone has made him happier and less restive. He seems a great deal surer inside and less in need of the supports of city life which most people feel he cannot do without. He is so really honest and has never allowed himself to believe in him as him."[16]

Having worked at ACA in 1959–60 and having surpassed Bella Fishko in Herman Baron's esteem—boosted considerably by Gwathmey's support—Terry Dintenfass seemed poised to assume the directorship of the gallery when the Barons could no longer carry on. Bella, sensing that she had been supplanted, left ACA, very bitter and determined never to see Bob or Terry again. Early in 1961, following Herman's death, Bella and Terry met for coffee at Terry's request. We have only Terry's version of what transpired, and her attendant feelings.

When it was all over I am not at all sure that anything at all was said that made any sense. It is as tho she speaks and at the same time is watching and listening to herself talk. Nothing can really be touched and put down. It is like walking over flypaper. I am very direct and clean cut and if it is one way or the other I will tell you and go on from there. All I seem to have gotten was a lot of words and a lot of querries all of which she already knew the answers. I told her I was honest and direct and whatever was bothering her would have to be said outright. It still remained a lot of goo and an enormous waste of time.[17]

However awkward and messy that power struggle and contest of wills during 1959 and 1960 had been, the outcome swiftly became clear once various attempts at partnerships and buyouts had been unsuccessfully explored. In 1960 Bella Fishko founded the Forum Gallery, which exists today under the presidency of her son Robert. The Forum carries paintings by Evergood and Gwathmey, which is appropriate because Robert Fishko's parents had been very good friends with both men and their wives and owned quite a few major works by both artists. Sidney Bergen, a nephew of Herman Baron, took over the ACA Gallery, which today is run by his son Jeffrey. Terry Dintenfass, with financial support from Armand Erpf, a wealthy collector who had been director of the investment advisory department and then became a partner at Loeb, Rhoades, and Com-

pany, opened her own gallery at 18 East Sixty-seventh Street in November 1961 on a very wintry day. Erpf had bought paintings from her in Atlantic City, and she never ceased to be surprised that a man of his wealth would purchase paintings with a social protest point of view, which is the identity that she wanted for her new gallery.[18]

Bella Fishko was not the only person who felt exceedingly distressed when Terry established her gallery. When the Barons opened their ACA operation in 1932, there were about 30 commercial art galleries in New York City. By 1959 there were more than 200, and quite a few of their owners were highly competitive. Edith Halpert had been happy to help Terry get started in Atlantic City in 1954 because that seemed like a remote, nonthreatening location. Halpert became outraged, however, when Terry relocated to Manhattan in 1961.[19] It is not clear for how long, or when, Terry had planned to run her own gallery in New York. On Valentine's Day in 1959 she told Evergood that she was in love with Bob Gwathmey, which surely came as no surprise. When Paul Cummings asked her in 1974 why she came to New York she replied,

> Well, first of all, Bob was going to marry me. . . . He kept getting to me, "Did you go to the lawyer?" And I couldn't exactly make up my mind. Here I was a nice lady with three children. I really liked my kids. I thought how awful and what a disgrace. Of course, he convinced me it wasn't much of a disgrace. Of course, he didn't marry me; he went right home as soon as I moved here. And Armand Erpf used to say, "You're foolish. You should really open a gallery in New York." And so I thought, well, I'll try it. So I came to New York. I worked for Herman Baron for a year.[20]

Although it is true that Gwathmey very much wanted her to be in New York, and that ultimately he did not get a divorce even though she did in 1964 after being separated from Arthur Dintenfass for several years, it is not true that he went "right home" as soon as she arrived. He vacillated and, in fact, returned to his wife some half a dozen times between 1960 and 1967. According to Rosalie, the Gwathmeys had occasional "dates" during their period of separation. Sometimes he would "stay over," and sometimes he would leave directly afterward. She never knew what to expect. Usually he brought her a gift each time he arrived for a date. Once, however, he did not, and when she teasingly asked why, he replied, "Because I have come home for good." As Rosalie Gwathmey put it, "He treated me like a yo-yo." As she told the Evergoods early in 1967, when they were getting close to a permanent reconciliation: "When Bob decides to throw things into a mess again it shakes me up—I'm getting better each day and thank God I have my work that I can get absorbed in."[21] By 1961–62, however, Terry and Bob had become very much a couple. Their relationship was quite open and accepted by younger friends in the art community, even though it caused concern among some people who had known the Gwathmeys as a family since the mid-1940s.[22]

It is impossible to say what difference age, temperament, novelty, and physical appearance made in tempting Bob Gwathmey to stray. Rosalie had been piquant and lovely (see fig. 6). Bob's intimacies with Terry Dintenfass, who was attractive and vivacious and

loved a good time, began prior to 1958, and by then many friends already regarded him as an uncontrollable womanizer.[23] Nobody attempted to advise restraint; Bob apparently could not or would not restrain himself. Terry understood that perfectly well and tolerated his "indiscretions" throughout their ten-year romance. Acquiescing in his minor affairs left her free to see other men if she chose to, but Bob Gwathmey was intensely jealous of any possible relationships that she might have with anyone else—even when the connections were utterly innocuous.[24]

In her later years, Terry Dintenfass seemed to delight in calling herself "the dirty old lady of the art world." That she loved to party was no secret, but so did many others. The paintings by her artists scarcely qualified as smutty, so her self-designation and self-deprecating quips clearly derived from her sense of personal deportment and the recognition that others certainly must have gossiped about her. As she said in 1975, "Well, I'm a dirty old lady so what would I do with bright and clean? What kind of nonsense is that? I take a lot of showers, but I never come out bright and clean. I think I'm known as the dirty old lady of the art world."[25]

Terry opened her gallery in November 1961 with an exhibition by her five original artists: Gwathmey, Evergood, Sidney Goodman, Herbert Katzman, and Antonio Frasconi. That was soon followed by Goodman's first one-man show. He was a prodigy whose drawings Terry discovered by serendipity in Atlantic City when he was only nineteen. When she took the drawings to New York to show them to Bob and declared that Goodman was only nineteen, Bob snapped back, "Liar! If I could do this at nineteen, I'd be Picasso today." Bob promptly bought one for $100, and according to Terry, Goodman had never seen such a large sum. "I mean, literally, he was a very poor boy. He played the bongo drums in a burlesque house. He did."[26]

From the perspective of most dealers, it is an inescapable fact of their vocational lives that painters come and go—for many reasons, ranging from escalating artistic reputations and egos to financial arrangements (and dissatisfaction concerning them) to geographical relocation. Loyalty does occur, but it is not necessarily the norm, which is all the more reason why it is extraordinary that Terry always remained Bob Gwathmey's dealer, for twenty years after he resumed his permanent domicile with Rosalie. Even a decade after his death, Terry Dintenfass invariably has more works by Gwathmey in her inventory than any other dealer. Moreover, she always speaks of Rosalie Gwathmey with the greatest respect. She will make comic remarks about Bob—referring to him on occasion as Captain Kangaroo—but never about Rosalie.[27]

Bob brought two fine African American artists into the fold for Terry, Jacob Lawrence and Raymond Saunders, both good friends of Bob's. He promoted their work when they were not yet widely known, especially not to white collectors and museum curators. But in 1963 the mercurial Philip Evergood decided to change dealers. He sent Terry Dintenfass an abrupt notice asking for a "complete up-to-date statement of what is owed me." He closed with two sentences: "I still have the same deep fondness for you and Bob. My action is necessitated by financial need—this is a question only of business." Terry re-

sponded by return mail that she was saddened. "My faith in your work is endless and no matter what it will remain so. Keep well and Bob and I will be out [to see you] when spring comes. We love you."[28]

Gwathmey's reaction to his best friend's behavior was charming, as always.

> Since I last saw you a bus took me into Pennsylvania: destination Wilkes-Barre. However, we stopped at Scranton to change [buses] and during the twenty minute stop-over I sat at the lunch counter and ordered (undoubtedly stuttering) a tu-tu-tuna fish sandwich. Sure enough the waitress served me two tuna sandwiches. Needless to say I ate both and, as best I could, acted in a native [natural?] manner. I gave my talk, spent the night and returned the next day. The sheer expance [sic] of the provinces is apalling and its [sic] forever comforting to get lost in Manhattan.

> Of course my little trip to your place was disquieting to a degree, but believe me I do understand and so does Terry. You said many right things of which I'm in complete accord. First and foremost your work must prevail. Surely a change that can guarantee an Italian showing and enough security to relieve the tensions of the collector will become a real stimulus to your creative senses.[29]

Evergood responded two weeks later with a long and convoluted rationale for why he felt compelled to change galleries, concluding that "although your prices were in general higher than mine the personal relationship of Terry to you & to me was on an entirely different plain so it went without saying that she was a little better selling your work than mine." The switch in dealers certainly did not diminish the close bond between Gwathmey and Evergood. Ever since the former had moved to Manhattan, the two of them and serigrapher Harry Sternberg had been accustomed to making the rounds of artists' bars together, drinking, swapping stories, and generally having an uproarious time. Jack Levine recalls occasions when he, Evergood, and Gwathmey would be asked to leave a restaurant because the two "good old boys" created such a disturbance when they were in their cups. Gwathmey bought a beautiful painting by Evergood, *Worker's Victory* (1948), that hangs to this day in Rosalie Gwathmey's dining room.[30] It may have carried special meaning for Gwathmey because a locomotive approaches the viewer from the center rear of the canvas, and a much larger engine looms at the left side of the picture, just beyond the massed workers.

Gwathmey provided strong moral support for Evergood during the most intense phase of the McCarthy era, and he had injected new energy into Evergood's career by bringing him into the Dintenfass gallery at the outset in 1961. The two men remained close friends until Evergood's death in 1973, when Gwathmey wrote a four-page necrology for the American Academy and Institute of Arts and Letters. One extract illuminates the intensity as well as the occasional inanity of their fellowship.

> Such a superior raconteur and drinking companion—only I would reach a point in his story, in my drink, where my concentration would slip, or maybe I'd heard the

story before. Anyway, I could never gauge the effect of the alcohol until we would get into one of his automobiles and though he would head in the right direction he would drive right through the red lights. I realize there was limited traffic at those hours, but I'd yell, "For Christ's sake Phil that was a red light, are you color blind or something?" The immediate reply was, "Why do you paint blacks?"[31]

The inevitable and essential question is: What impact did Gwathmey's romantic relationship with Terry Dintenfass have on his art? It was affected at several levels. First, because the affair was time consuming as well as energy consuming, Gwathmey certainly became a less productive painter in the year following 1956, though not precipitously so. Second, in terms of artistic subject matter, a number of provocatively autobiographical paintings emerged, the most dramatic coinciding with the denouement of the affair in 1967. Initially, as the intimacy between Bob and Terry became common knowledge and they became a couple in public, several of his paintings reflected aspects of their shared exhilaration but also his ambivalence about the situation. An example of the former is *Fishing* (1962), in which a man and woman, whose face is obscured by a hat turned down at a rakish angle, are boating on a beautiful day. There are many other boats visible on the water, so the couple's connection is scarcely covert (see fig. 50).

Gwathmey's ambivalence is apparent in *Man with Apples* (1962), a self-portrait of the artist seated at a table while holding two apples—obvious symbols of woman the temptress. He is devouring one with his left hand while holding on to the other with his right. "Clutching" might be a better word, or even "not letting go." A spectacular display of flowers rests on the table to his right. Gwathmey is tasting the fruit, but the background is a somber deep sienna. The mood combines determined action with ambivalence, accentuated by the intense coloration of flowers that could soon wither and die because they have been cut.

FIGURE 50
Robert Gwathmey and Terry Dintenfass at Deal, New Jersey, summer of 1965. Private collection.

FIGURE 51
Dinner at the Blue Angel
Restaurant in New York
following the opening of
an exhibition of works
by Jacob Lawrence in
1963. At the left, Gwen-
dolyn Knight, Robert
Gwathmey, and Terry
Dintenfass. Opposite
them is Jacob Lawrence,
flanked by Ida Carring-
ton Gwathmey on his
right and Katherine
Gwathmey on his left.
Courtesy of the Terry
Dintenfass Gallery, Inc.,
New York.

Friends describe Bob and Terry as people who "loved a good time," and they did party together exuberantly during the early and mid-1960s, as is evident in fig. 51. In this photo, Bob and Terry are with Jacob and Gwendolyn Lawrence at the Blue Angel Restaurant following the opening of a Lawrence exhibition at the Dintenfass Gallery. Bob became intensely jealous if Terry spent extensive social time with other artists,[32] but that certainly did not apply to Jacob Lawrence, whose work Bob championed and who was very happily married to Gwen Knight, a strong woman in her own right.

On the other side of the table in this picture are Bob's two sisters, Ida Carrington Gwathmey and Katherine Gwathmey. According to Rosalie, they never married because "no one was good enough for them." Be that as it may, they adored their brother and had moved to New York from Richmond to live near him.[33] Despite their apparent dismay when they learned of their brother's affair in 1957, by 1962–63 they had become fond of Terry and participated with gusto in Bob's public life with her and their circle of friends.

Some observers who were close to that circle feel certain that Bob Gwathmey felt no guilt about his extramarital affair. Jack Levine is also confident that Gwathmey chose the rooster head as a prominent emblem in his personal logo (see fig. 1 and plate 34) because he took pride in his sexual prowess. He talked openly and often about his desire for women, and as Levine has said, referring to the rooster head, "That was his image of himself." A close friend of both Gwathmeys for more than four decades believes that part

of Bob's attraction to Terry derived from the way that she flattered him, always making him "feel like the cock of the walk."[34]

It appears that Gwathmey initially preferred that their intimate relationship be less than obvious, if not entirely private. When Terry bought her apartment on Sixty-seventh Street in 1964 and moved there permanently from her gallery where she had lived since her separation in 1962, Gwathmey became upset. "What will the elevator man say?" he asked. To which Terry replied, "I couldn't care less what the elevator men say." She then added in her 1975 interview that "he never came here to stay," and indeed, the two never actually lived together. Gwathmey bounced around from one small apartment to another during the early and mid-1960s, but he stayed principally at a tiny place that he could use as a studio at 304 East Seventy-third Street.[35]

In 1968, in the most extensive interview that he ever gave, Gwathmey conceded that "I do some bad things that I hold in secret. But in painting I want it to be not obscure in any sense at all." Two of his works from the 1960s are not in the least obscure because they express his sense of guilt quite clearly. Andrew Dintenfass, the youngest of Terry's three children, who fondly regarded Bob as an uncle, does not doubt that he harbored feelings of guilt "because he was a very sensitive person."[36]

In 1964 Gwathmey painted *Posters* (plate 26), a poignant work (in oil) of a ragpicker passing in front of a vivid circus poster, unable to look back and face the bold letters "RO" to one side of him and "WIE" to the other. The poster discreetly bears the name "ROSALIE" (her nickname was Rohwie), but his guilt or shame prevents the man from acknowledging his wife's name and the ambiguity of a clown face that may be laughing or may be crying. Ambiguity, once again, is apparent in this diminutive figure who is weighed down by a heavy burden, yet proceeds on his determined way.[37] This painting, like others by Gwathmey, works at several levels. The peeling poster is a reprise of *Bread and Circuses* from 1945 (plate 16) and may also refer to the important role played by artists in creating propagandistic posters in support of both world wars.[38]

Later in the 1960s Gwathmey prepared a lithograph called *Sharecropper* in which a lean and lone older man looks somewhat disconsolately off to his left, with various architectonic structures in the background. Behind him is a discarded bushel basket in which the letters "R.G." are clearly inscribed. Because the picture is also signed "gwathmey" in his characteristic way in the lower right, it is conceivable that the neglected R.G. in the bushel deliberately refers to Rosalie Gwathmey as well as himself. By the time Gwathmey made this lithograph, he had recently retired from Cooper Union and moved to Amagansett with Rosalie, yet his personal relationship with Terry had not ended. When he taught at Boston University's School of Fine Arts in the winter of 1968–69, Terry Dintenfass went to Boston on some weekends to visit him. In that same lengthy interview in 1968, Gwathmey also referred to "my Calvinism. I want to be pure. I want to be honest."[39] Perhaps more so in his art than in his life.

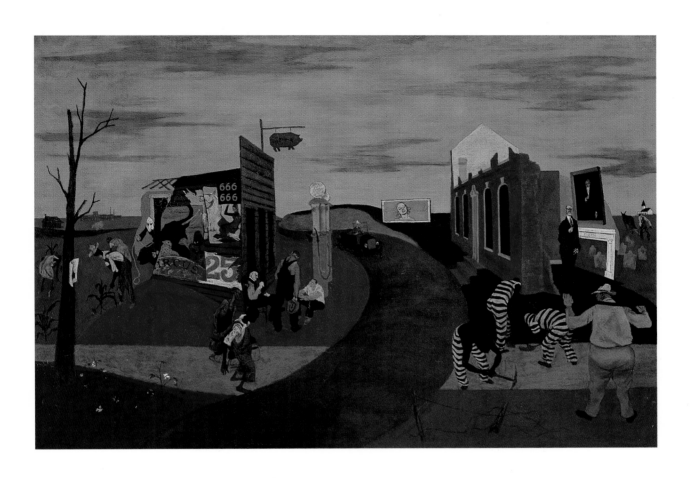

PLATE 1
From Out of the South
(ca. 1941), o/c, 39^1/$_2$ ×
60. David and Alfred
Smart Museum of Art,
University of Chicago.
Mary and Earl Ludgin
Collection.

PLATE 2
*Ancestor Worship
(My Ancestors)* (1945),
o/c, 38$\frac{1}{2}$ × 31. Courtesy
of Charles Gwathmey.

PLATE 3
Hoeing (1943), o/c,
40 × 60¼. Carnegie
Museum of Art, Pitts-
burgh, Pa. Patrons
Art Fund.

PLATE 4
Poll Tax Country
(1945), o/c, 41¹/₄ × 28¹/₄.
Hirshhorn Museum
and Sculpture Garden,
Smithsonian Institution,
Washington, D.C. Gift
of Joseph H. Hirshhorn
Foundation, 1966. Photo
by Lee Stalsworth.

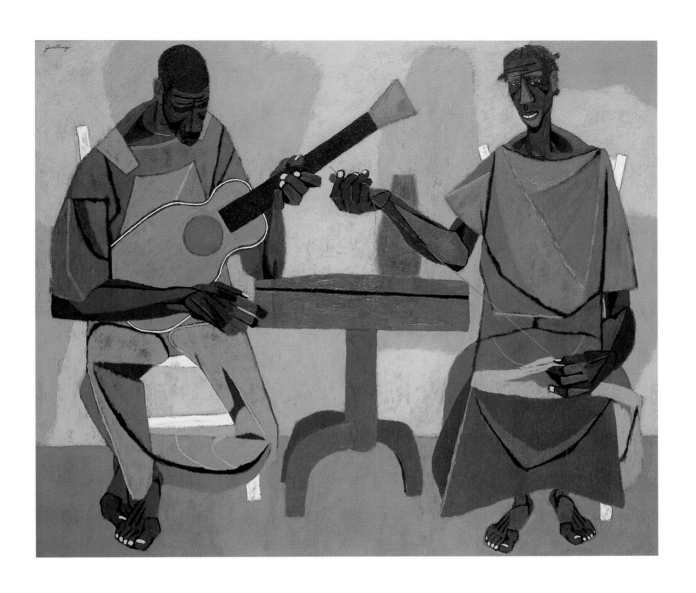

PLATE 5
Singing and Mending
(1945), o/c, 30 × 36¼.
Hirshhorn Museum
and Sculpture Garden,
Smithsonian Institution,
Washington, D.C. Gift
of Joseph H. Hirshhorn,
1966. Photo by Lee
Stalsworth.

PLATE 6
Winter's Playground
(ca. 1947), o/c,
25$\frac{1}{2}$ × 36. Courtesy
of Michael Rosenfeld
Gallery, New York.

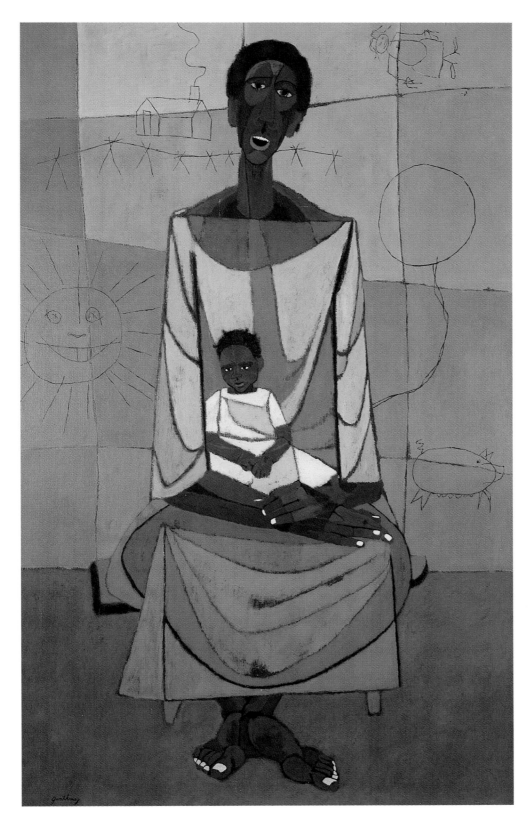

PLATE 7
Lullaby (ca. 1945), o/c,
43 × 27³/₄. Courtesy of
Mr. and Mrs. James R.
Palmer.

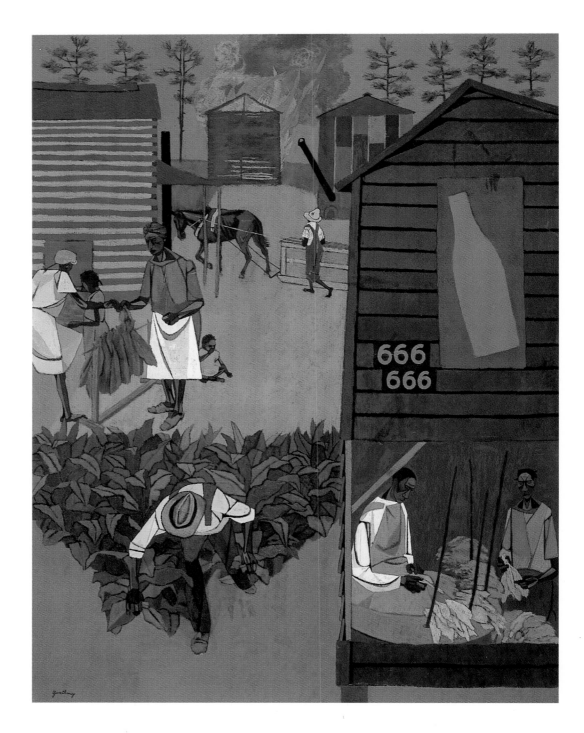

PLATE 8
Tobacco (1947), o/c,
44 × 35¼. Los Angeles
County Museum of
Art. Mira T. Hershey
Memorial Collection.

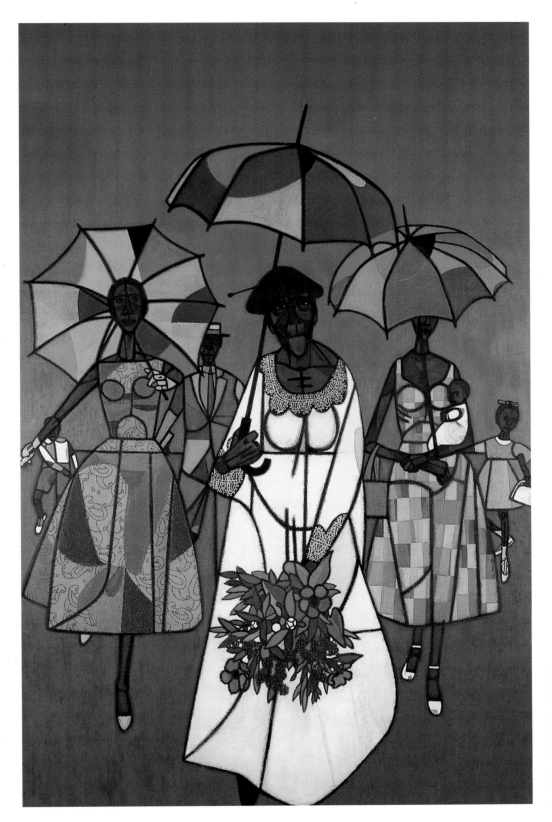

PLATE 9
Sunday Morning
(ca. 1948), o/c, 60 × 40.
Collection of the
Columbus Museum,
Columbus, Ga. Museum
purchase made possible
by the Art Acquisition
and Restoration Fund.

PLATE 10
Children Dancing (1948),
o/c, 32 × 40. Butler
Institute of American Art,
Youngstown, Ohio.

PLATE 11
Saturday Afternoon
(1949), o/c, 31³/₄ × 48.
Courtesy of Mr. and
Mrs. Sherle Wagner.

PLATE 12
Sowing (1949), o/c,
36 × 40. Collection of the
Whitney Museum of
American Art, New York.

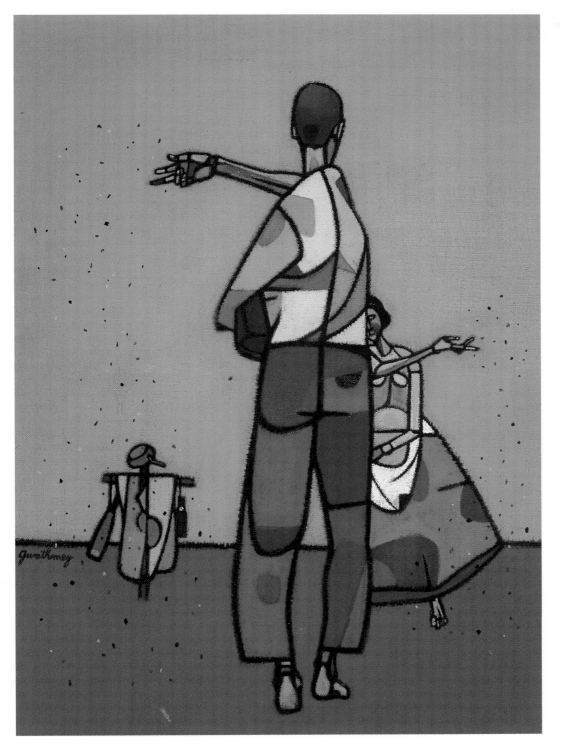

PLATE 13
Sowing (n.d.), o/c,
19¹/₈ × 14¹/₂. Courtesy
of Mr. and Mrs. Sherle
Wagner.

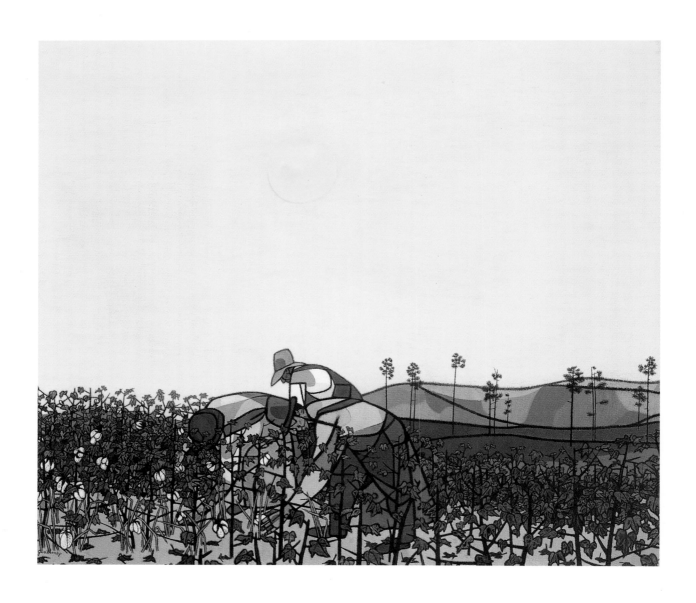

PLATE 14
Cotton Pickers (1954),
o/c, 37 × 43¹/₂. Courtesy
of a private collection
and Ledbetter Lusk
Gallery, Memphis, Tenn.

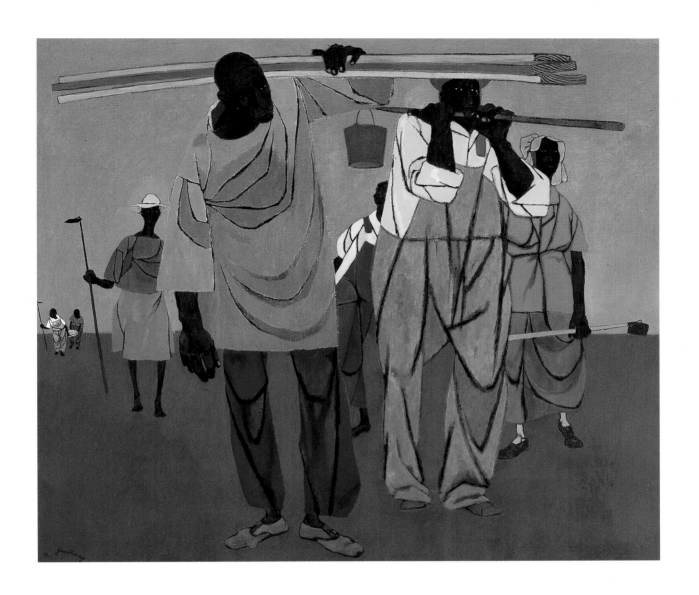

PLATE 15
End of Day (1944),
color serigraph on paper,
12¼ × 14. Private
collection.

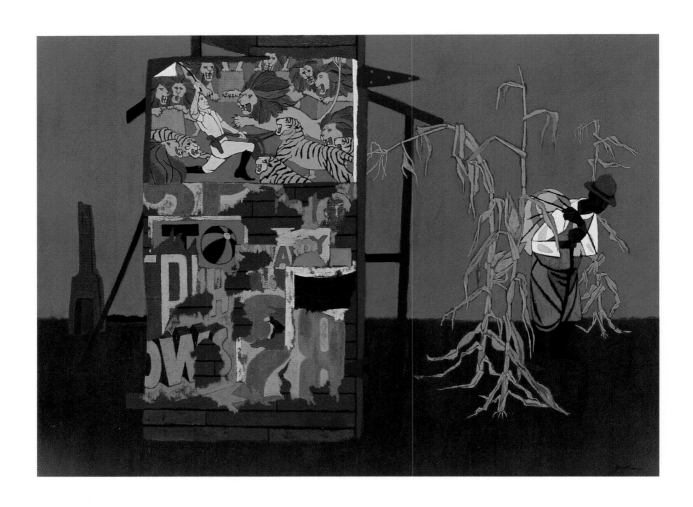

PLATE 16
Bread and Circuses
(1945), o/c, 28 × 40.
Museum of Fine Arts,
Springfield, Mass. James
Philip Gray Collection.

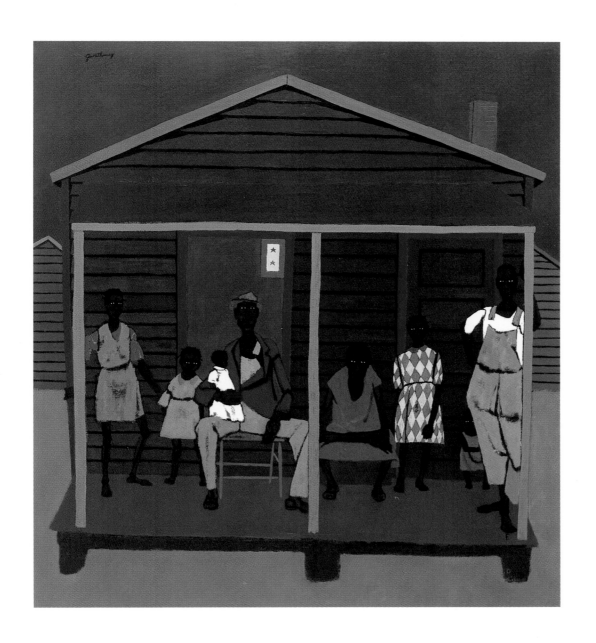

PLATE 17
Family Portrait
(ca. 1945), o/c, 30 × 28.
Virginia Museum of
Fine Arts, Richmond,
Va. Kathleen Rhoads
Memorial Fund. Photo
by Katherine Wetzel.
© Virginia Museum of
Fine Arts.

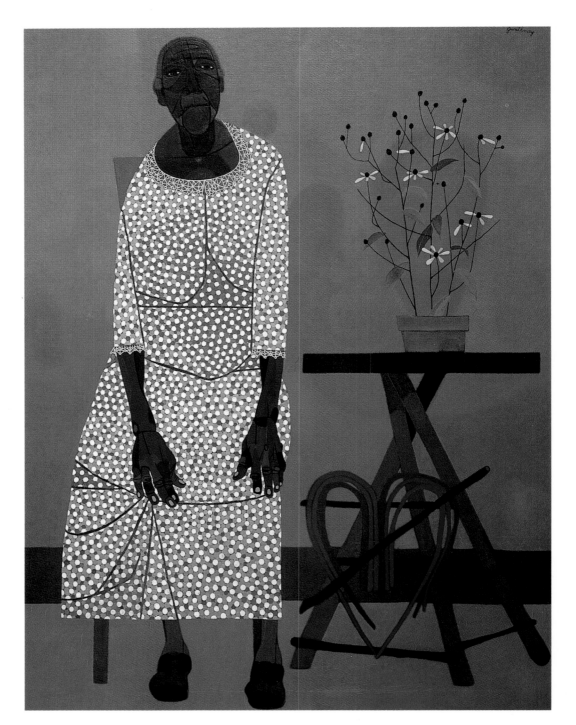

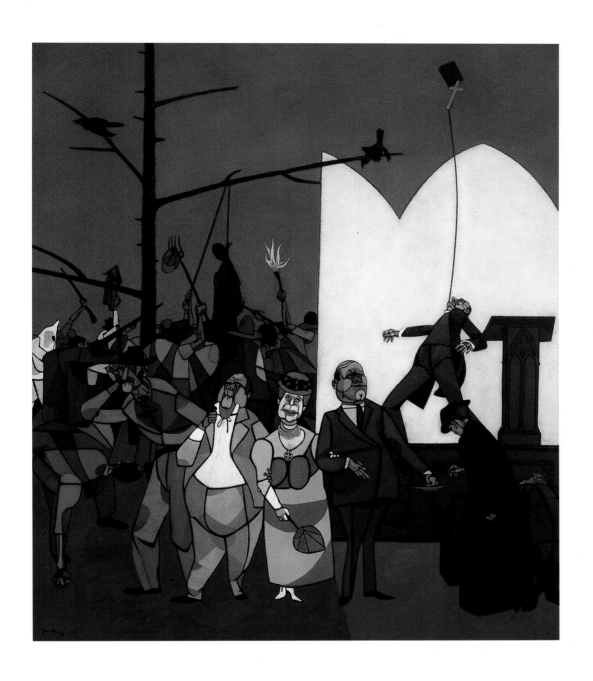

PLATE 19
Revival Meeting (n.d.),
o/c, 38¼ × 34¼.
Courtesy of the Terry
Dintenfass Gallery, Inc.,
New York.

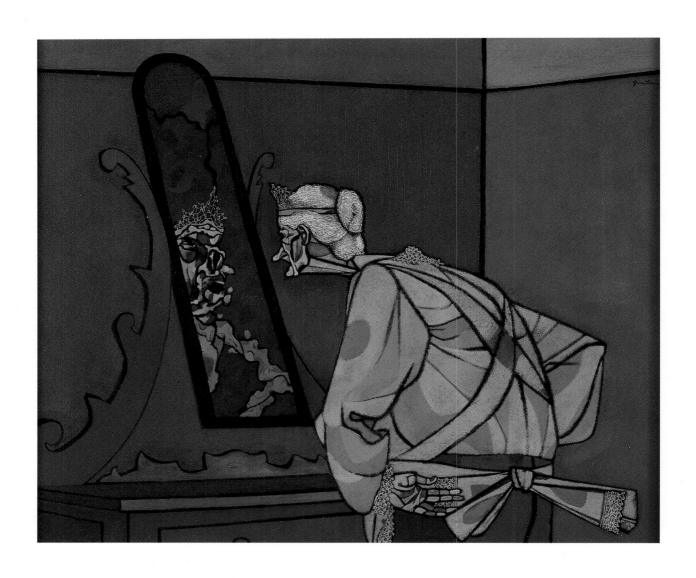

PLATE 20
Reflections (ca. 1950),
o/c, 26³/₄ × 32.
Morris Museum of Art,
Augusta, Ga.

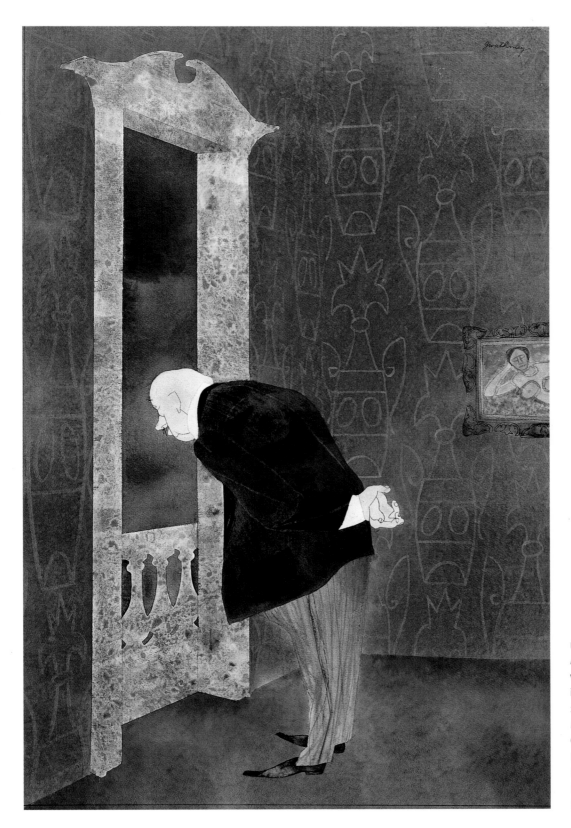

PLATE 21
Parade (1951),
watercolor and pen and
ink on paperboard sheet,
21³/16 × 15. Hirshhorn
Museum and Sculpture
Garden, Smithsonian
Institution, Washington,
D.C. Gift of Joseph H.
Hirshhorn, 1966. Photo
by Wendy Vail.

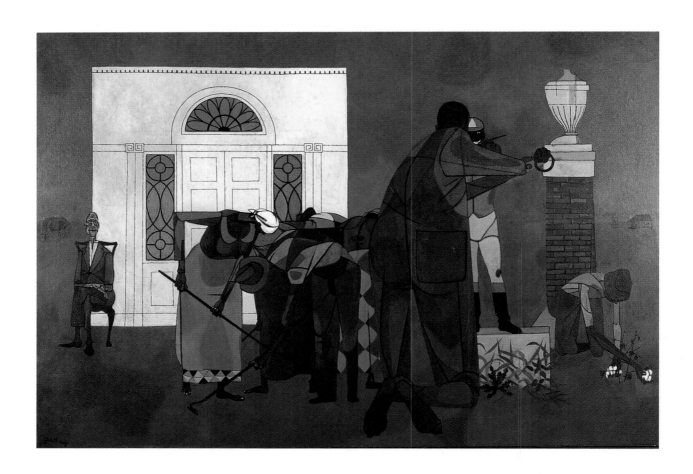

PLATE 22
The Painting of a Smile
(ca. 1950), o/c, 40 × 60.
Sheldon Memorial
Art Gallery, University
of Nebraska, Lincoln.
Nebraska Art Association
Collection. Gift of
Mr. and Mrs. Thomas
Woods Sr. 1954.N-81.

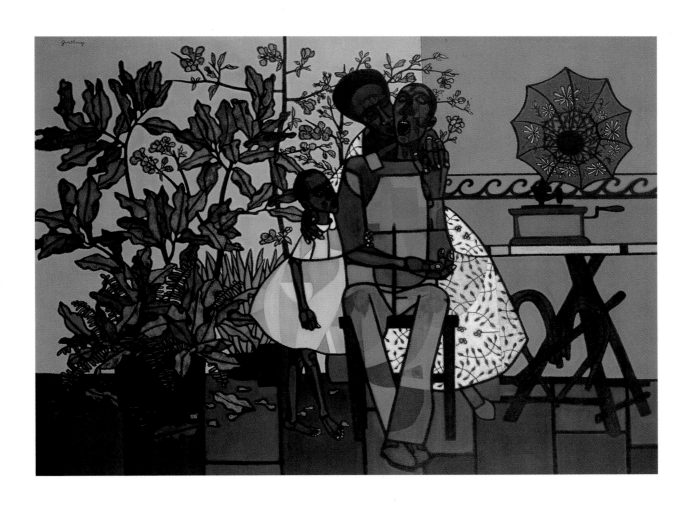

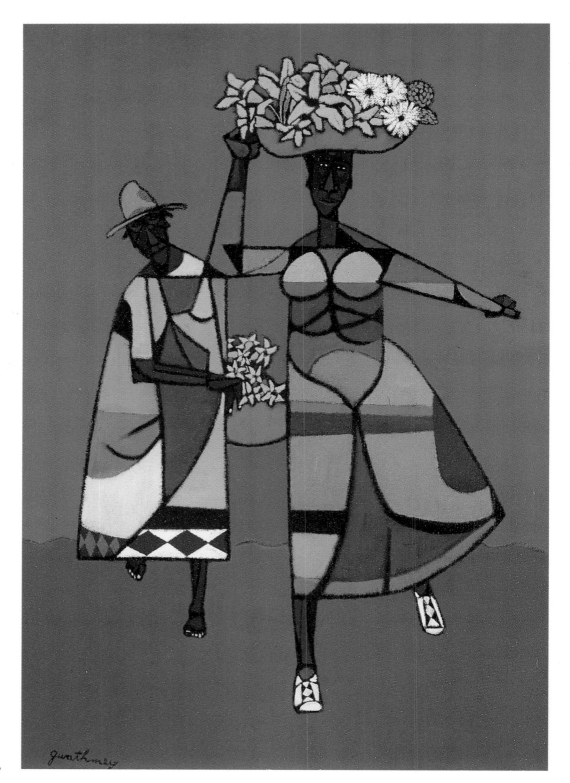

PLATE 24
The Flower Vendor
(1948–49), o/c,
$17^{1}/_{2} \times 12^{1}/_{4}$. Collection
of Carol and Michael
Kammen. Photo courtesy
of the ACA Galleries,
New York.

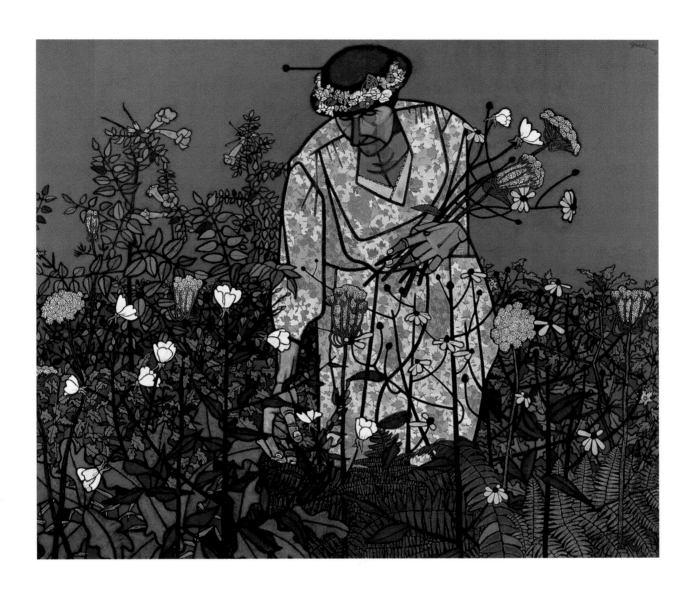

PLATE 25
Flowers for the Pulpit
(ca. 1959), o/c, 48¹⁄₄ ×
40¹⁄₄. Courtesy of a
private collection and
Ledbetter Lusk Gallery,
Memphis, Tenn.

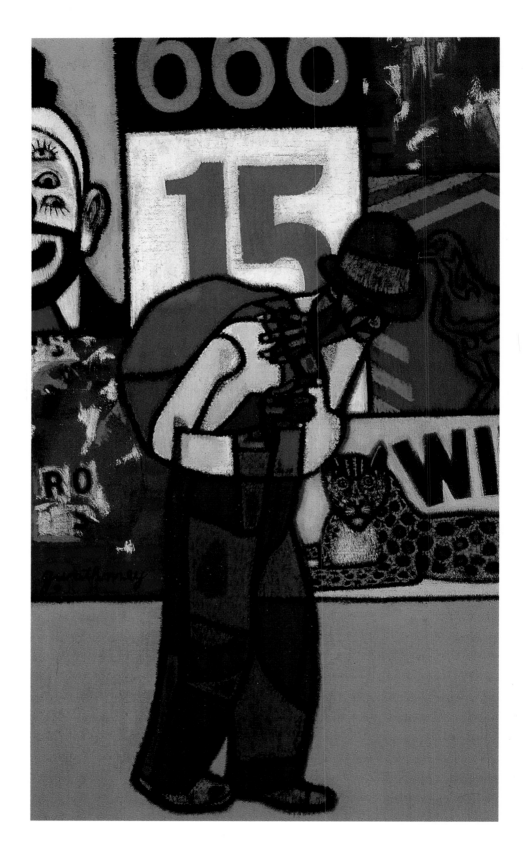

PLATE 26
Posters (1964), o/c,
16 × 10. Collection of
Carol and Michael
Kammen.

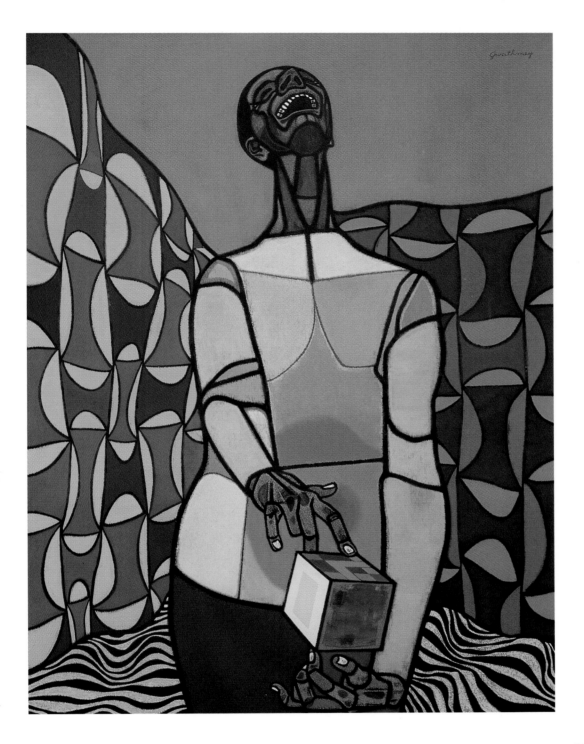

PLATE 27
Laughter (1965), o/c,
46 × 36. Courtesy of
Mr. and Mrs. Sherle
Wagner.

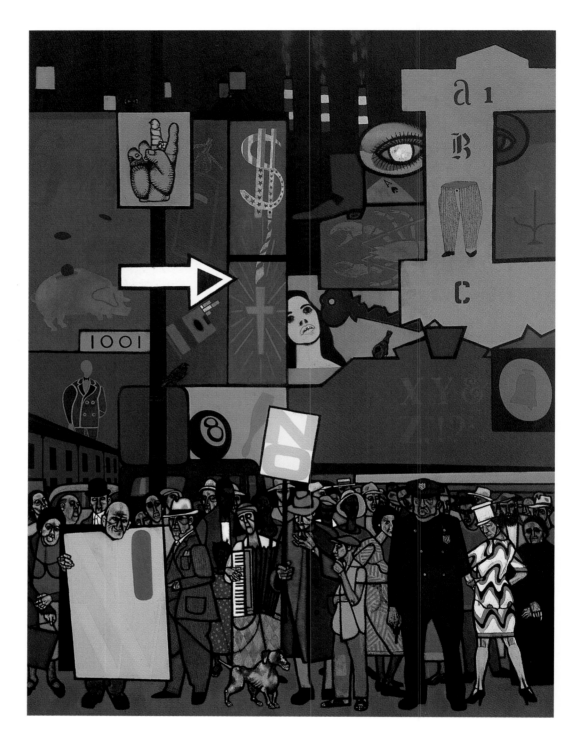

PLATE 28
City Scape (1967), o/c,
51 × 41. Courtesy of the
Terry Dintenfass Gallery,
Inc., New York.

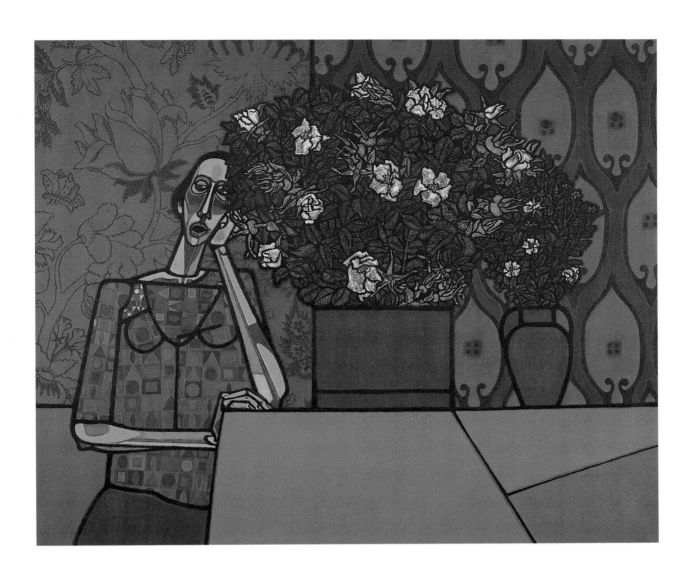

PLATE 29
Wild Roses [*Rose Hip*]
(1966), o/c, 34 × 38.
Private collection. Photo
by R. Jackson Smith.

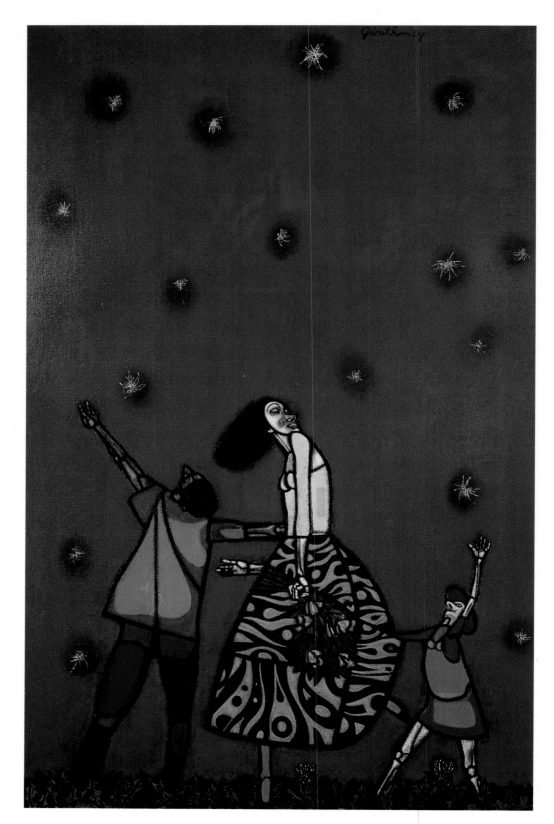

PLATE 30
Phrenetic Profusion
(1969), o/c, 36 × 24.
Courtesy of Andrew and
Ann Dintenfass.

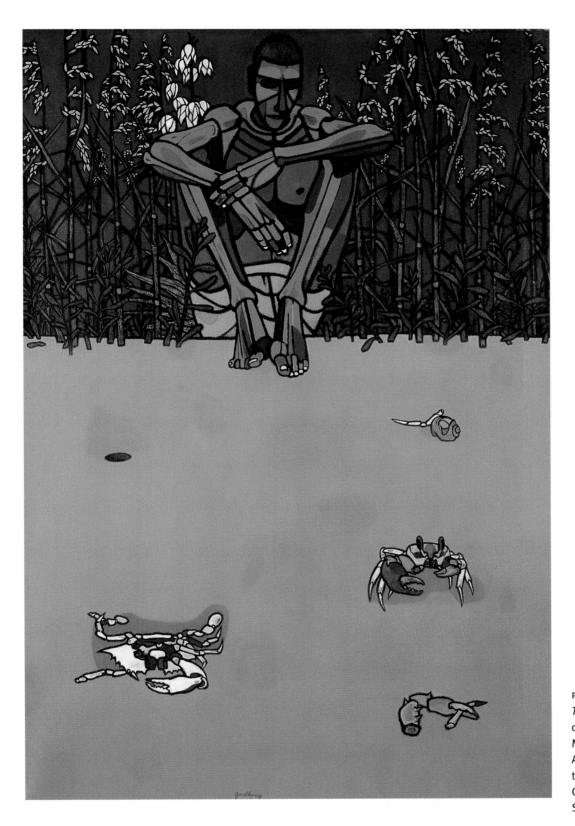

PLATE 31
The Observer (1960),
o/c, 48¹/₈ × 34. National
Museum of American
Art, Smithsonian Institu-
tion, Washington, D.C.
Gift of S. C. Johnson &
Son, Inc.

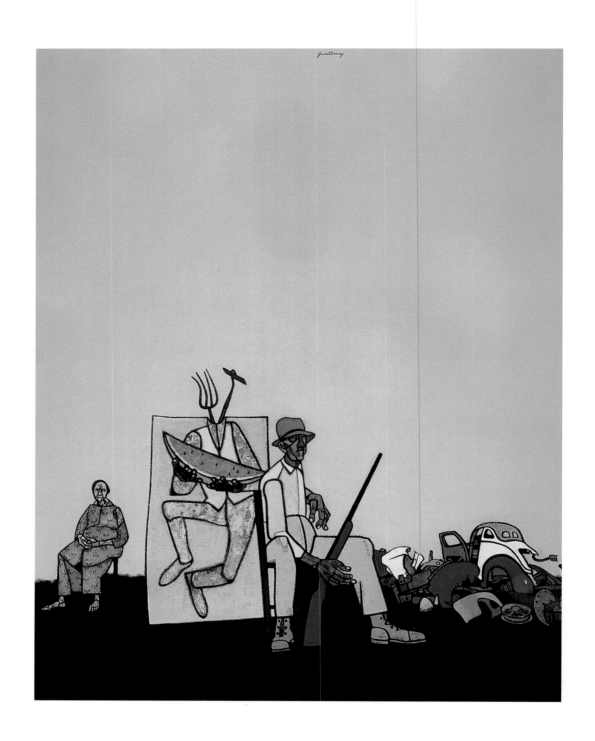

PLATE 32
Custodian (1963), o/c,
46 × 38. Collection of
Philip J. and Suzanne
Schiller.

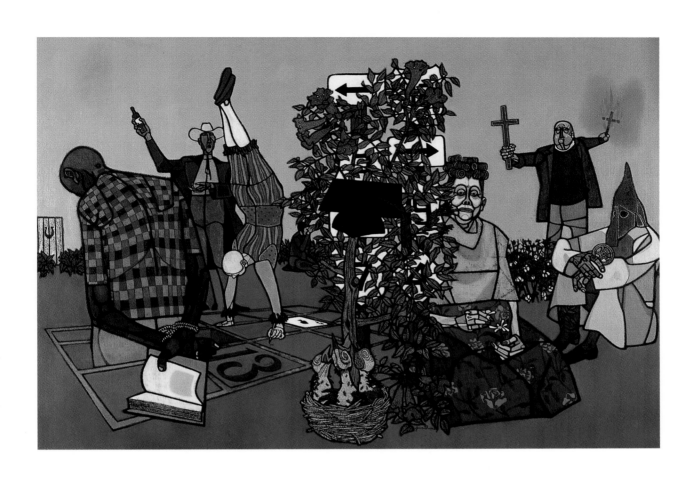

PLATE 33
Belle (1965), o/c,
45 × 67. Reynolda
House, Museum
of American Art,
Winston-Salem, N.C.

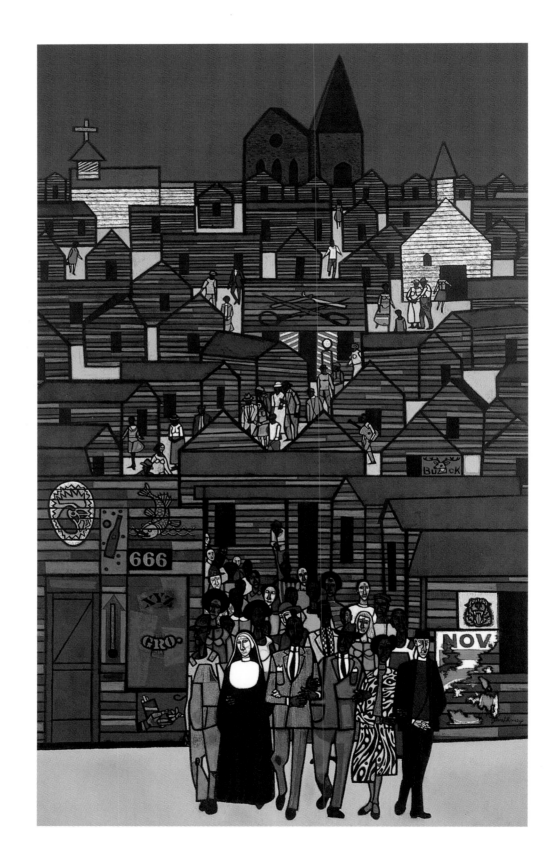

PLATE 34
United (1969), o/c,
62 × 40. Private
collection.

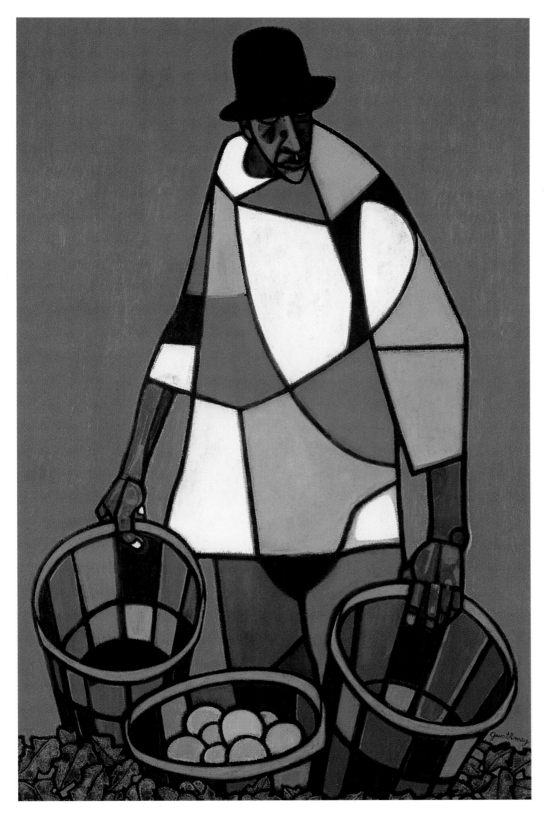

PLATE 35
Migrant (1976), o/c,
42¹/₂ × 28. Private
collection.

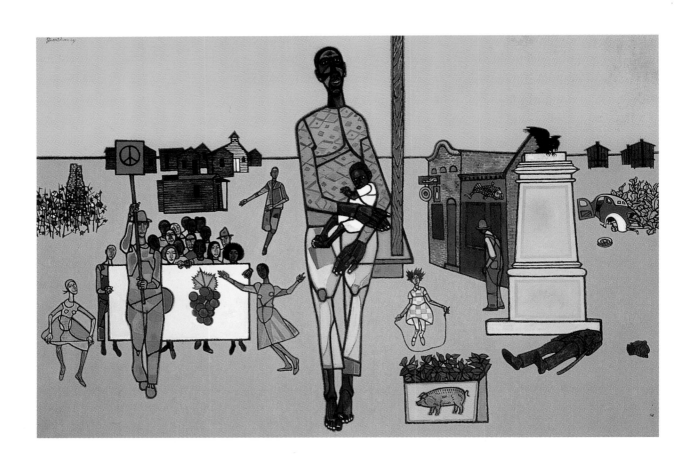

PLATE 36
Father and Child
(1974), o/c, 36 × 56.
Private collection.

PLATE 37
Homo Sapiens, Late Twentieth Century (1973), o/c, 50 × 30. Courtesy of Charles Gwathmey.

PLATE 38
Petrouchka (1979), o/c,
42 × 32. Courtesy of Liza
and Michael Moses.

PLATE 39
The Quilt (1977), o/c,
40 × 30. Courtesy of Liza
and Michael Moses.

PLATE 40
Country Gospel Music
(1971), o/c, 40 × 50.
Private collection. Photo
by Peter Brenner.

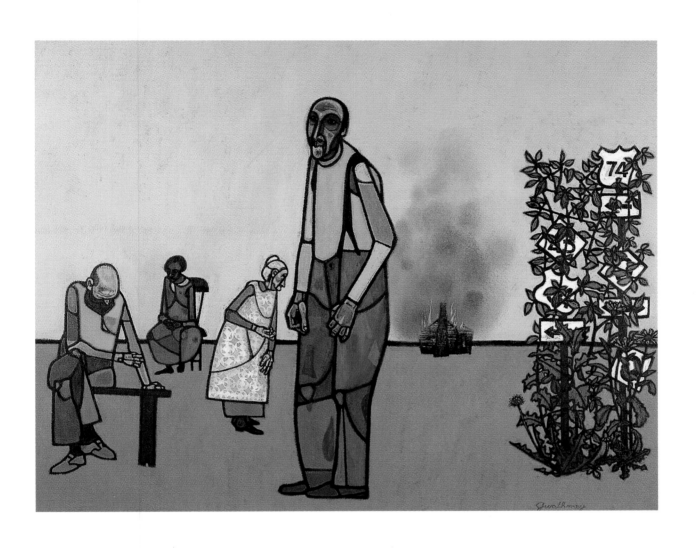

PLATE 41
Isolation (1977), o/c,
30^{1}/$_{4}$ × 40^{1}/$_{4}$. Courtesy
of Stephens, Inc.,
Investment Bankers,
Little Rock, Ark.

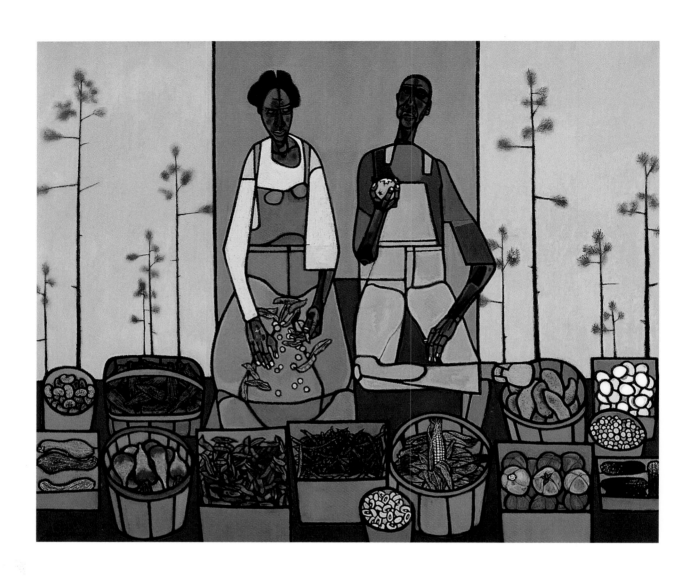

PLATE 42
Farmers' Market (1977),
o/c, 40 × 50. Courtesy
of Richard Hertz and
Doris Meyer.

PLATE 43
Robert Gwathmey, by
Raphael Soyer (1980),
o/c, 58 × 40. Courtesy
of the Forum Gallery,
New York.

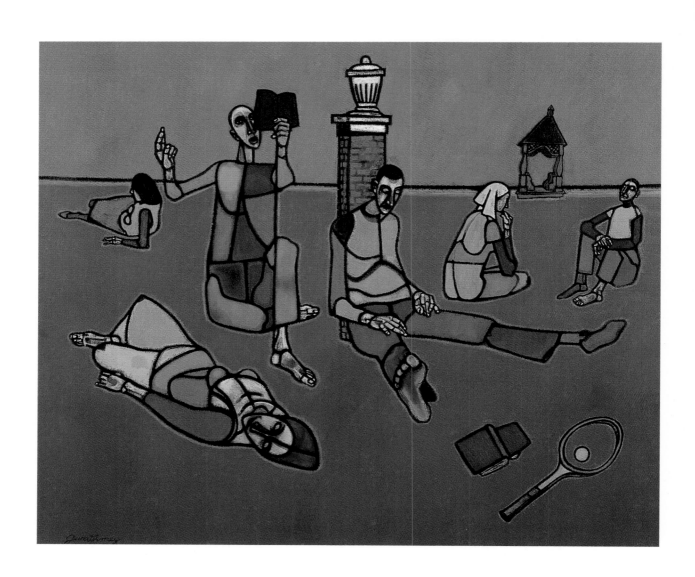

PLATE 44
Nobody Listens (1979),
o/c, 33¹/₂ × 42. Courtesy
of Leon and Rae Moses.

PLATE 45
Drought (1981), o/c,
30 × 36. Courtesy of
Leon and Rae Moses.

PLATE 46
Playground (1981), o/c,
42 × 32. Courtesy of
William M. Landes.

PLATE 47
Mother and Child (1980),
o/c, 40$\frac{1}{4}$ × 34$\frac{1}{4}$.
Columbus Museum of
Art, Columbus, Ohio.
Gift of Arthur J. and
Sara Jo Kobacker.

PLATE 48
End of the Season
(1983), o/c, 29³/₄ × 38.
Courtesy of William M.
Landes.

During these same years, the early and mid-1960s, despite the diversions of his extra-marital affairs—and by all accounts they were numerous—Gwathmey found time to be generous and encouraging to artists younger than himself who had not yet established a reputation. In some instances, as with Ralph Fasanella, the self-trained folk artist, they were not even taken seriously. Sidney Goodman, who in recent years has surpassed Gwathmey in terms of recognition in the art world, regards Gwathmey as "my godfather in art," the man who saw the genius in his early work and commended him to others.[40]

Other artists befriended by Gwathmey included Antonio Frasconi and Raymond Saunders. Each of Gwathmey's protégés had a technique and subject matter notably different from his own and from the other artists he sponsored. Each one remembers Gwathmey with gratitude and great fondness.[41] Also during this period Gwathmey felt and acknowledged his debt to the Social Realist influences of African American artists such as Charles White (who did powerful murals of Booker T. Washington and Sojourner Truth) and Jacob Lawrence. Gwathmey became especially close friends with Lawrence and persuaded him in 1962 to be represented by the Dintenfass gallery.

The similarities as well as the differences between the art of these two painters are equally striking. Both artists favored bright colors and two-dimensional flatness. Both empathized with oppressed minorities and the underclass. Both went through highly creative phases making serigraphs. For more than a dozen years after 1938, however, Lawrence felt most attracted to specific historical figures such as Harriet Tubman and historical events such as "the migration of the Negro." He painted extensive narratives requiring as many as sixty panels. Gwathmey, by contrast, was never explicitly historical. His African Americans are representative types, such as the sharecropper or the farmer's wife, and they perform an array of commonplace activities, from shelling peas to topping tobacco to mending worn clothing. Gwathmey and Lawrence developed complementary ways of describing the vicissitudes, resilience, and autonomy of African American life.

All the artists whose work Gwathmey appreciated and advocated were representational in some sense and frequently figural as well. Moreover, to be welcomed into the Dintenfass circle it helped a great deal if there was some sort of social commentary. As Terry declared in her 1975 interview for the Archives of American Art, "I started out with a social protest point of view." She recognized, in fact, that one of the most distinguishing characteristics of her establishment was its critical perspective on class, race, and social injustice. As she put it, "I have such a heavy point of view. It's not a happy hour gallery."[42] Actually, it was exactly that in a social sense, but not in terms of artistic subject matter.

Abstract Expressionism posed not merely an aesthetic problem but an economic threat for the Social Realists during the 1950s. Their work received much less attention from museums and from the press. It was also far less likely than non-objective art to be purchased. During the 1960s Gwathmey did not exactly mellow, but he recognized the power of trends that he could not buck and battles that he would not win. He actually admired the way many of the Expressionists used color, some "beautifully." But ultimately he insisted that "I'm interested in the image; I still am. And they are not." Yet he could

nevertheless enjoy friendships with artists such as Ad Reinhardt, whose dark squares were about as abstract as one can get, who maintained their commitments to political activism. Hence his fond remembrance of Reinhardt in 1968, the year after his death:

I met Ad during the Depression and when I moved to New York Ad was very active in the Newspaper Guild. And so we used to go up to the Newspaper Guild headquarters. It used to be a two-story building on the southwest corner of Forty-first and Park. And Art Hodes had his little trio up there and every Saturday night we would drink beer and dance. And Ad was very, very much involved in the Newspaper Guild, and up to Ad's death he was very much involved in everything political. For instance, he was one of the co-chairmen of the committee to liberate or rather to hope to liberate Siqueiros from his imprisonment in Mexico. He was one of the sponsors, co-chairmen, of the committee to end the war in Vietnam. He was always a political entity. As a person he became somewhat removed, but when his name was asked for he was always ready.[43]

During the 1960s, as rapid change occurred in the art world, Gwathmey found some limited solace in the return of images by way of Pop Art, even though his enthusiasm for it was fairly limited.

What do I think about the emergence of the new objective painters? Like Warhol or Dine or what you will? I actually have some terrible feelings about them. Now again I shouldn't couple the two because one is much better than the other as a painter from my point of view. Dine is for me. But these guys have done one thing, they have put abstract expressionism in a cubby hole as it were and they have taken the image, although the references often are too vulgar for me. I don't think you have to express one's reaction to bourgeois philosophy by painting tomato cans, just for instance.

Later in the same interview Gwathmey provided an addendum: "Perception is the basic thing. But I would say I could find a vulgar article that may do the job better than a Campbell Soup can repeated ten thousand fold. And I still think this is display art. I still think it's closer to decoration than painting."[44]

Op Art (referring to optical) achieved a certain vogue during the early to mid-1960s and perhaps irritated Gwathmey even more than Abstract Expressionism had. In 1968 he spoke his mind:

Now certainly in some of the optical art I'd look at it amuses me. It really does. Now I always think it's like a trick shot in billiards, if you will. When I walked through the Modern Museum when they had that optical show I butted about six people. I wasn't on an even keel. I really wasn't. I never bump into people. And I say that affected me to the extent that I couldn't walk straight. Now I don't think that is art. I think it's phenomenon or phenomena. I think it is phenomena. Am I straight? [laughing] Well, any way, I do. And that's what I'm attracted by in a sense. But I think it has something to do more with display than it has to do with what I playfully call painting.[45]

FIGURE 52
Bridget Riley, *Arrest III* (1965), emulsion on linen, 69 × 75½. Burrell Collection, Glasgow, Scotland, and courtesy of the artist.

Gwathmey painted several pictures to show that any fool could paint Op Art. But what was the point of it? he wondered, particularly because he found it not merely perplexing but disorienting. Consequently his pictorial commentary on Op Art is deliberately disorienting in terms of perspective, with wildly conflicting patterns of design and colors. In *Laughter* (plate 27) a man stands amidst three different quiltlike fabrics covered with bold geometric forms. His head is thrown back as he laughs uncontrollably, and he holds yet another geometric form that looks like Rubik's puzzling cube. The message very clearly is "I can do that too, but isn't it silly." The colors and patterned shapes are as outlandish as the man's ridiculing response.[46]

In *Striped Table Cloth* (1967) he went a step farther, using an optical illusion background in very bright colors above a black and white striped tablecloth as a spoof aimed at Frank Stella and Bridget Riley, a British Op artist then in vogue, who also specialized in painting stripes, both wavy and straight (see fig. 52). In Gwathmey's painting, a woman

stands behind a bouquet of flowers that disorients the viewer because it conflicts wildly with the geometric background and the zebralike tablecloth. Gwathmey could not have made his point more clearly. Geometry has displaced humanity. His satire had shifted from unattractive social mores to silly trendiness in a fashionable art world.[47]

By the later 1960s Gwathmey blamed the trendiness, prejudices, and poor judgment of art critics and museum directors for the many wrong turns that contemporary art and art institutions seemed to be taking.

> I think our critics in the last twenty years have drifted into a kind of a dead-end of aesthetics. I think a critic should be able to tell me and tell all of us, for the public, why this type of painting exists, how it exists, and so forth. Now there's a new director of the Modern Museum coming in the fall and I read his statement, his first statement. And he says that the old Whitney adjacent to the Modern Museum, now owned by the Modern, will be an educational institution. It will have a foundation to give scholarships to historians and to, we'll say, critics, where they can become or learn to become or be trained. And he was insistent on how is the painting and why is the painting. Like Shakespeare said in *Twelfth Night*, the most wonderful definition of art in which he finally says, "The poet's eye may soar to the heavens and the heavens back to the earth again." Man, that's a round trip if you ever heard of it. And he says, "Imagination may stir wonders" and so forth and so on. And he says he has to have, finally a habitation and a name. I think in dealing with just aesthetic quality like the critics have for a number of years, they have never given the painting a habitation, or never given the painting a name. Never, ever.[48]

This is the most explicit and extensive riposte that Robert Gwathmey ever made to influential critics such as Clement Greenberg, Harold Rosenberg, and Museum of Modern Art director John B. Hightower. But those feelings had been festering for years. As he wrote to Philip Evergood in 1963, "You are the especial American painter, in a sense uncatalogued [meaning not readily categorized], but the perfect antidote for those vain glorious pretenders that the Modern Museum insists is American painting 1963."[49]

What did Robert Gwathmey affirm during these years? What did he like? Architecture became increasingly important to him, in several respects and for an array of reasons. Even in the 1940s, when he painted "the other side of the tracks," the black section of small southern towns, he paid careful attention to structures, public and residential. In 1947, when Charles was only nine years old, Gwathmey said to one of the students in his drawing class at Cooper Union (who many years later became the dean of architecture there), "I really want my son to become an architect."[50]

Rosalie Gwathmey's father and brother had both been architects, and that may have influenced the meticulous attention that Robert paid to the cramped sameness and small size of the African American homes in his paintings, compared with the grandeur of structures owned by whites, usually placed along a high-level horizon line. He also rendered the architecture of tobacco barns with great care. In 1946, when Gwathmey vis-

ited Charleston, South Carolina, he reported to Herman Baron that he found it "a most exciting town architecturally (that is the old city) and has that sea port quality that lends it a cosmopolitan flavor. . . . Honestly, there are so many street scenes that remind one of Utrillo that it really seems one is out of America."[51]

Gwathmey's interest in and enthusiasm for architecture was certainly enhanced around 1960 when his son decided to pursue a career in architecture. The wish expressed more than a decade earlier would be fulfilled beyond Robert Gwathmey's wildest dreams. Meanwhile, living in Manhattan during the 1950s and 1960s made him increasingly an urban animal. He loved New York and decided that it really was the only place to live. As he wrote to Evergood when he returned from that quick visit to Wilkes-Barre in 1963, "The sheer expance of the provinces is appalling and its forever comforting to get lost in Manhattan." Because he enjoyed jazz, Dixieland, and liquor, New York nightclubs attracted him like a moth to a candle. As he speculated in 1965 after attending an artists' party in honor of Moses Soyer, "I wonder what one would do without alcohol. Maybe things that were said wouldn't seem so brilliant and maybe they would even be remembered."[52]

In 1968 Paul Cummings engaged Gwathmey in a fascinating dialogue by asking him whether he had done many paintings of the city, particularly because he had lived there for quite a while and had such affection for it. Gwathmey then thought out loud about "why people don't paint New York City."

RG John Marin did, Feininger did to an extent. Stuart Davis did to an extent. [David] Burliuk did to an extent. But nobody seems to me to have pursued New York City. Prestopino did to an extent. It's a funny thing. When I go to France or go to Italy I think look at these structures. Look at the color of that crazy stucco. Look at those wild combinations. And so I wonder why in New York that nobody does it. . . . Well, of course the Ash Can School did it in a sense. But I don't think New York City has ever really been painted. Is that outrageous? Has it? Reginald Marsh did, and Philip Evergood did, and Raphael Soyer did. But damn it, again . . .
PC Even Georgia O'Keeffe did some. Some. But there are not too many people who've kept it up over the years.
RG Now it kills me. My friends ask me this and I've thought about it many times. I always wondered why New York has not created what you may call an inspired subject matter, again subject matter, a nasty word [among devotees of abstract art].
PC You have done paintings of New York haven't you?
RG No. I did one that I destroyed of the elevated. I always wanted to but I never did. And I think many people want to but never do.[53]

Curiously, Gwathmey did not mention his most urban painting, done only a year earlier in 1967 and titled *City Scape* (plate 28). Although it is not a painting of New York in the sense described above, it is not merely Gwathmey's deeply personal Manhattan, but

the defining icon in his changing relationship with Terry Dintenfass. The most urban painting he ever did is also a massive display of emblems and resentments.[54]

By 1967 Terry Dintenfass had been divorced for three years and hoped that Gwathmey would fulfill his often repeated desire to be divorced also in order to marry her. When he took no steps in that direction, and when Terry learned that Charles Gwathmey had designed an immensely interesting home for his mother in Amagansett, Long Island, just east of the Hamptons, she correctly sensed that marriage with Bob seemed unlikely. He had become intrigued by the new house and by 1966 went out to Amagansett for occasional weekends to help Charles work on the site and clean up debris left by the workmen.[55]

Knowing of these developments, Terry married Dr. Harold Laufman, a brilliant cardiovascular surgeon who was the head of that department at Montefiore Hospital in the Bronx. Laufman played the viola and loved chamber music. A cultured man, he was also wealthy and socially conservative. When Gwathmey learned that "his girl" had gotten married just like that, he felt betrayed and bitterly resentful.[56] He poured his anger and frustration into City Scape. Terry is the woman with a chamber pot upside down on her head in the lower right-hand corner. The big policeman with the piglike reddish face next to her represents Dr. Laufman, her new husband. The woman in red next to him is most likely a woman with whom Gwathmey had been intimate on numerous occasions. The small man, front and center, is Ralph Fasanella, the self-taught "naive" artist whose career Bob had promoted. The heavy woman in red may be Frances Serber, a ceramicist who had rendered some of Gwathmey's images onto plates and small ceramic platters. The man holding the NO sign, whose furious face is concealed, is Robert Gwathmey himself, as is the man whose sign says both NOW and NO. Some of the other symbols, such as the vertical middle finger, are self-explanatory. Others, like the lobster, are a reprise from Gwathmey's earlier art, such as the The Hitchhiker (1936). The key, according to Terry Dintenfass, represents the key to Gwathmey's studio apartment. The woman with the accordion, Dintenfass believes, may represent Rosalie Gwathmey, although the symbolism is obscure if that observation is correct.[57]

The row houses to the left are a remembrance of Philadelphia, where the Gwathmeys met and attended art school. The tidily tailored man may stand for Bob Gwathmey's fastidiousness about his own attire, along with the pantaloons mingling with a, b, and c. The eight ball requires no explanation except for an element of ambiguity about who was now behind it. The dollar sign and the Christian cross presumably were intended as symbols of two powerful forces that Gwathmey had long rejected: the hypocrisy of capitalism and organized religion. The meaning of XY&Z"!?:, could be a declaration of the end, or at least the beginning of the end.

Rosalie Gwathmey had been out of Bob's sight for stretches of time, but never entirely out of mind. In 1964 she bought a lot in Amagansett and asked her son, Charles, to design a home for her where she could continue her work designing textiles. Early in 1965 Bob wrote to Phil Evergood and asked him to do the following with his own litho-

graphed self-portrait: "I want you to make a little drawing on the print and inscribe it to Rosalie. Charles is designing a house for her to be built at Amagansett. She has a lot and construction will begin in a couple of weeks and I want it to go in place." This seems a rather unusual if courtly gesture on the part of a man who had been carrying on an open relationship with another woman for eight years. During Bob's separation from Rosalie, he had "come home" some half a dozen times, and in a 1966 interview at the Brooklyn Museum he declared that "my wife is my favorite model."[58]

In 1966, when Bob began to consider seriously the prospect of reconciliation with Rosalie, he painted an image titled *Wild Roses* (plate 29). (Wild roses flourish in profusion on eastern Long Island, liking both the temperate climate and the sandy soil there.) The work surely is an admission of shame and regret. A woman sits unhappily waiting, the area beneath her eyes darkened from sadness if not weeping. The lone figure depicted in *Wild Roses* is not waiting in an urban ambience. Moreover, in the Op Art design that covers the wall behind her, the highly caricatured face of a schlemiel is repeated in a designed fashion like so many unattractive cans of soup. The painting manages to be highly decorative, a spoof of current fads in the art world, and a confession of painful guilt, all at once.

In 1967 Gwathmey asked his son to design a studio for him on the level land behind Rosalie's new house, a reasonable sign that the artist intended to return home for good. (Gwathmey sold a Picasso drawing for $3,000 in order to make part of the $12,000 payment to build the studio.) Even so, it would not be a smooth or an easy transition. In March of that year Rosalie urged the Evergoods to come out for a visit "when the weather breaks. Right now it is miserable weather for many people but I love it and I can be at peace and almost happy—even now." Two decades earlier Gwathmey had painted a picture of a black man carrying a hoe and a pail, trudging toward a clear destination, an image that he called *Going Home*.[59] Now the artist was going home, even though "home" at first was more of a metaphor than a complete physical or even an emotional reality. He and Rosalie commuted from Manhattan to Amagansett for almost two years until he retired from Cooper Union in 1968. When Bob taught at Boston University in the winter of 1968–69, he received visits from Terry, who always remained his dealer. By the early spring of 1968, Gwathmey could say to Paul Cummings without blinking, "I have no family problems. I have no problems."[60]

In 1967 Gwathmey painted *Peace*, a picture of two women seated side by side at a table. An open book lies on the table before the larger figure, and an elegant white dove is depicted on a pristine page of the folio volume. The smaller woman, with an attractive wallpaper design behind her, dreamily contemplates three pieces of fruit. This image must have reflected his hope that there might be peace in his complex, changing relationship with his wife and his dealer. In 1967, however, that picture represented the aspiration for peace more than the achieved reality. Two years later, however, Gwathmey created a pair of images that almost appear to be in tension with each other rather than a vision of resolution. I do not know for sure which one was created first, but there is a

logical sequence, given his freedom in Boston early in 1969 (Rosalie remained in Amagansett) and their reunited household later that year.

Phrenetic Profusion (plate 30), an oil on canvas that Gwathmey did in several versions, must have been painted initially during the winter of 1968–69. On the left a man with features similar to Gwathmey's appears to supplicate a starry heaven. In the center a rather brazen woman of indeterminate age, whose face is masklike, seems to be twirling like a top, her left shoulder raised high as though in a cosmic shrug—a blithe spirit perhaps. To the right a diminutive and possibly older woman raises her left arm to the sky—perhaps a hosanna to the highest, but perhaps no more than a gesture of hope. Gwathmey still had two women in his phrenetic life, but relationships were in the process of transformation.

Later in 1969 he drew an elegant lithograph titled *Section of Town* (fig. 53). The starry sky of *Phrenetic Profusion* has been replaced by a schematized architectural background that serenely invokes the presence and forceful role of Charles, now a successful thirty-one-year-old architect. In the foreground a rather sedate, older couple, handsomely dressed, strides purposefully arm-in-arm toward the viewer. A church stands in the middle distance, so perhaps they have renewed their vows. Just to the left a ferocious tiger (or tigress) lunges and bares its teeth at the couple, its paws extended and its claws exposed. The tiger does not convey friendly feelings toward the couple. The enigmatic numeral "5" seems to be on the surface of a square that appears to restrain the enraged tiger, or at least contain it like a glass cage.[61]

Most likely the "5" invokes Charles Demuth's 1928 poster portrait of William Carlos Williams, *I Saw the Figure 5 in Gold* (oil on composition board), a work that Gwathmey liked and praised even though he called it billboard art. The Metropolitan Museum of Art had acquired the Demuth painting in 1949, and Gwathmey knew it well. He visited the Metropolitan Museum regularly. Demuth's poster portrait became an influential icon for quite a few American artists during the 1960s. The image appears in Jasper Johns's *The Large Black Five* (1960) and no fewer than five notable works of Pop Art that Robert Indiana created in 1963, including *The Demuth Five* and *The Figure 5*. The latter hung in the White House for a few years starting in 1965 before going to the National Museum of American Art.[62] The resonance of figure 5s suited Gwathmey's commitment to "continuity" in art, and also his ongoing penchant for artistic reprise as he grew older.

In 1968 Gwathmey created a detailed pencil portrait (titled *Dealer*) of a pensive Terry seated rather stolidly. It is artistically meticulous but not particularly flattering. Six years later Gwathmey did another threesome in pencil on paper called *Flying Kites* (fig. 54). The artist depicts himself to the left flying a very ordinary kite that seems to trail little if any tail. A triumphant woman in the center flies an optically ingenious kite, the kind that a clever designer might choose. Another woman follows slightly behind and to the right; her kite is in the form of a devilish or possibly a demonizing mask. *Flying Kites* is clearly an artistic summation of the resolution that had emerged by 1974. As Charles Gwathmey put it succinctly, "Rohwie is definitely triumphant, but Terry is and always was, there."[63]

FIGURE 53
Section of Town
(1969), pencil on paper,
$29 \times 19^{1}/_{2}$. Private
collection.

FIGURE 54
Flying Kites (1974),
pencil on paper,
$22^{1}/_{2} \times 18^{5}/_{8}$. Arkansas
Arts Center Foundation
Collection. Museum
Purchase Plan of the
NEA and the Tabriz Fund.

In 1970 Gwathmey painted *Ophelia*, a work that may or may not be a retrospective contemplation of love and marriage from a man in his sixty-seventh year. A single woman standing with her face in profile casually holds a bouquet of fresh field flowers. Behind her is an elegant wallpaper design done as a kind of black stencil against a salmon background. In *Hamlet*, of course, Ophelia is the young and beautiful daughter of Polonius, lord chamberlain to the king of Denmark. Hamlet falls in love with her, but finding marriage inconsistent with his plans for vengeance, he simulates madness. Ophelia is so profoundly wounded by Hamlet's strange and inexplicable behavior that her mind gives way. I do not pretend to know what Robert Gwathmey had in his mind when he painted *Ophelia*, but in 1967 he wrote a charming letter to Andrew Dintenfass, Terry's third child, then a college student with a new girlfriend, in which Gwathmey quoted Charles Dickens's aphorism that "love was the most forgivable but least understandable of all human weaknesses."[64] Dickens, too, was an unfaithful husband, yet he kept his infidelity carefully concealed—for as long as possible, at least.[65]

Terry Dintenfass's marriage to Harold Laufman lasted four years; she remained too fun-loving and lively to remain with a man her closest friends perceived as stodgy and boring—the absolute antithesis of Bob Gwathmey. On November 25, 1977, a few years after her divorce from Laufman, Terry married Dr. James Morgan Read, a distinguished social scientist who worked at the United Nations with responsibility for refugees and subsequently at the Kettering Foundation. They were married in a traditional Quaker ceremony at a meetinghouse in New York City.

It may be helpful to consider the fortuitous circumstances and elements of serendipity at work in Bob Gwathmey's life: If the first painting that Terry purchased in the mid-1950s had not been by Bob Gwathmey. . . . If Bob's sisters had not been so forgiving of the brother they adored, and had been more supportive of Rosalie. . . . If Abstract Expressionism and Pop Art had not left Gwathmey feeling bypassed and alienated from the mainstream art world beginning in the later 1950s. . . . If the anticommunist hysteria had not taken a good deal of the wind out of his sails during the 1950s and diminished the frequency (more than the intensity) of social and political satire in his art. . . . If Rosalie Gwathmey had not asked her son in 1964 to design what turned out to be an astonishing, radically innovative house. . . . If Sandra and Dan Weiner, both professional photographers and close friends of the Gwathmeys, had not purchased a summer home in Amagansett and begun inviting the Gwathmeys to visit them there in 1957 (see fig. 49). . . .

CHAPTER SIX

The Observer

During the 1960s and 1970s not many people among the general public considered what ever happened to the Social Realists. In fact, not many museum curators or students of American art expressed much curiosity about such a question either. The galleries, museums, critics, and publications concerned with art had swiftly moved along to other, more trendy "isms." Those artists who had been in the forefront of realism generally, such as Edward Hopper, either died during the 1960s or were well advanced in years, their best and most innovative work behind them. For those who survived and continued to paint, the conventional wisdom declared that they had lost their fundamental anger about social issues and consequently their focus as well.[1]

Although that assumption may have been valid for some artists, it was at best a half-truth for Robert Gwathmey and Philip Evergood. They clearly retained their original commitments but chose to diversify their art, in part because they did not want simply to repeat what they had done during the 1930s and 1940s, but also because there were new challenges arising from both the art world and the "real" world. Evergood no longer published essays with titles such as "Sure I'm a Social Painter," because he had made that statement loud and clear at an earlier time. But he continued to express his apprehensions about social justice in other ways and other venues, such as a 1968 interview when he asserted,

Well, [when] I think of anybody living today in America I have painted more social protest paintings than anyone else. I may be wrong. Because Jack Levine has done his share. And Ben Shahn certainly has, too. But I have devoted nine-tenths of my life to painting really social protest paintings, such as *American Tragedy*, the battle between the company police at the Republic Steel works in Gary, Indiana—you remember, when

so many of the workers and their wives were shot down. I think I painted as many of that kind of violent statements of social protest as anybody else.[2]

The surviving Social Realists felt neglected if not abandoned by the museum world and most galleries during the 1960s. Some even wondered whether people had conflated or confused Social Realism, which simply meant art engaged by serious social issues, with Socialist Realism, the officially sanctioned art-in-the-service-of-ideology advocated by the Kremlin and officialdom in nations ranging from Cuba to China. Gwathmey, in particular, retained his commitment to art as social observation and commentary, but with a realistic recognition that changing times and circumstances inevitably affected an artist's choice of subject matter as well as style. He made that point emphatically to Studs Terkel in 1968.

> I wouldn't expect a man in 1930 to think like a man in 1968, would you? Of course not. But there are many people who will take a point of view as artists: I'll be an idealist. I'll be a romanticist, I'll be this or that or the other. You've got to be what you are, churning up the day in which you live and pull out of that experience something that is representative in artistic terms.
>
> Artists have to live, right? Eat, sleep, breathe, build. The great difference [compared with the later 1930s] is when you have a government as a patron or anyone else as a patron, who made no demands on you at all, there were no enlarged notions of making that extra buck. That was a very free and happy period. Social comment was in the wind. Now the wind has changed. But despite the direction any artist follows, he is still pure politically.[3]

The second paragraph referred to the federally sponsored art projects of the later 1930s, which had partially involved Gwathmey through his post office mural for Eutaw, Alabama. Nevertheless, he seemed to feel a certain nostalgia for the remembered freedom of expression that artists had enjoyed three decades earlier. I suspect that he sentimentalized the situation more than it warranted, but that was how he recalled the happy heyday of Social Realism.

During the 1960s Gwathmey's art remained deeply committed to issues of racial justice, but his concerns were presented in some fresh ways as well as more familiar ones that provided visual echoes of his earlier work. In addition, he also explored some images and themes unrelated to race. During the 1960s he had far less direct contact with the southern world of sharecroppers and tenant farmers, yet the civil rights movement engaged him very seriously. Hence there were new dimensions to his visual rendering of race relations and life within black communities. Moreover, in nuanced ways he responded to the major shifts in African American social thought from desiring a color-blind society during the later 1950s through the mid-1960s to becoming more attentive to black nationalism, racial autonomy, and the assertion that "black is beautiful," characteristic of the later 1960s and beyond. He wrote the following in 1967: "I would surely

be tied [frustrated or tried] if I were still awaiting for a 100 year promise to be fulfilled. 'Black power,' is, I believe, a proper and forceful tactic."[4] Whereas most white southern liberals of his generation were highly critical of black power as a movement, Gwathmey made no forced or artificial attempt to be politically correct in these matters. He simply responded to the changing views that many younger African Americans held at the time. Their highly vocal attitudes clearly affected his own.

One of Gwathmey's best known yet least understood paintings is *The Observer* (plate 31). It is not clearly understood because it carries significant meaning at multiple levels, most of which are not self-evident.[5] To Rosalie Gwathmey, for example, it is basically a painting about the survival of the fittest. That is true, but it is only the beginning. *The Observer* is also a statement about the historical treatment of blacks by whites. The crabs in the foreground are of two variant species; they are both crabs, obviously, but two different kinds. One has destroyed the other and left it to bleach in the intense sun. The callous treatment of one subspecies by another is an unambiguous allegorical statement. As an ironic touch, perhaps, the triumphant crab is brilliantly colored with emerald green, yellow, brown, and pink. It strides purposefully. The devastated crab is dead white. Gwathmey may even have been suggesting a reversal of what seems apparent, namely, that colored is more vigorous and valorous than white. That point is ambiguous yet worthy of consideration.[6]

As for the title of the painting as well as its content, Terry Dintenfass and Bob Gwathmey shared a fascination with both the shellfish of Atlantic beaches and the metaphorical concept of the artist as observer. In the mid-1950s Dintenfass wrote to Philip Evergood, "While I am playing with the dear little sand crabs I shall think of you hunting bears." Early in 1959, when Terry struggled to sort through the implications of her relationship with Bob, she wrote the following to Evergood:

> Safe sure things were always beautiful and wondrous to me—the sea, the sun, people, but only as an observer wondering at its complexities. I am no longer a watcher and finding myself so completely torn apart and yet so completely whole at the same time. I know I could never return to the easy way. The thought of hurting anyone, most of all Bob whose own fear of hurting a human is just as great, makes me so sad. I seem to want nothing of life in a material way but just the opportunity to continue learning and living full.

Six months later she praised paintings by Gwathmey and Evergood because of their impact on the viewer: "There is a certain vitality that springs forth from each and every one of your canvasses," she wrote, "that generates a feeling in the viewer that he too can be alive."[7] One cannot escape the sense that there may have been conversations about observers and viewers in 1959–60.

Because Gwathmey had been under FBI surveillance throughout the 1950s, it is possible that *The Observer* is also a reference to that experience. But these elements (or possible aspects) of the painting are less important than its curious racial complexities. The

two men who posed for *The Observer* were Gwathmey's twenty-two-year-old son, Charles, and a North Carolina artist named Claude Howell, both white. Yet the figure appears to be black, or at least a person of color. I believe that *The Observer* marked a new phase in Gwathmey's art—most intense during the early 1960s yet persisting as late as 1972—when he explored the possibilities of nonracial, or non–racially specific, figures in his art. There were many reasons why he would have been disposed to do so.

First, during the 1950s and early 1960s, the principal objective of civil rights advocates such as Martin Luther King Jr., Kenneth Clark, and Thurgood Marshall, along with white liberals such as Hubert Humphrey, was a color-blind society. This goal was not radically new in the arts and in popular culture. In 1944, for example, an essay in the *Daily Worker* had praised an interracial concert for Fats Waller as a "testimonial to a 'good guy' who made music so that all people could live in a world where there aren't black people and white people any more than there are black keys and white keys on the piano." As early as the 1940s some white performers also began emulating black rhythm and blues recordings that were distributed primarily within the black urban community. Most of Woody Guthrie's harmonica pieces blurred the racial identity of the performing musician. Harry Smith's famous Folkways anthology in 1952 attempted to be color-blind in its liner notes, making no racial distinctions. In 1954 some young white working-class southerners started to emulate black "jump" blues, with the result that rock 'n' roll reached a much broader audience than it otherwise would have.[8]

Early in the 1960s the Massachusetts legislature passed a bill to eliminate all references to race, including the use of photographs on applications for admission to the state colleges. A primary goal of liberals at that time was the selection of people without reference to race, a genuinely just society envisioned by some sponsors of the 1964 Civil Rights Act. In 1986–87 many people took notice when the National Gallery of Art in Washington, D.C., displayed a painting by Andrew Wyeth titled *Barracoon*, a nude black woman based on his white model, Helga Testorf.[9]

Gwathmey had experimented with race-blind figures a quarter of a century earlier, in part because he believed with all his heart in the desirability of a society where racial differences were irrelevant, but for two other reasons as well. He knew that many southerners actually were of mixed-race ancestry, and he felt deeply committed to an alliance of working-class blacks and whites because they shared the same economic nexus of oppression. That point of view became the basis for journalist Tom Wicker's major "crusade" in 1996. By 1997 the academic world increasingly began to notice that some scholars were examining the ways in which people moved across boundaries of race and ethnicity. When Toni Morrison published her widely acclaimed novel *Paradise* in 1998, she explained that one of her principal objectives had been to unsettle readers' assumptions about racial identities.

The tradition of writing is that if you don't mention a character's race, he's white. Any deviation from that, you have to say. What I wanted to do was not erase race, but force

readers either to care about it or see if it disturbs them that they don't know. Does it interfere with the story? Does it make you uncomfortable? Or do I succeed in making the characters so clear, their interior lives so distinctive, that you realize (a) it doesn't matter, and (b), more important, that when you know their race, it's the least amount of information to know about a person.[10]

It needs to be noticed just how often Gwathmey painted white as well as black faces as masks. One of his best-known early works, titled *Masks* (1946), is a caricature in which a big-bellied white man holds a foolish white mask in front of his own face and a leering black mask in front of a black sharecropper who is bound to him at the wrist by three heavy strands of rope. It is also worth remembering that Gwathmey was pleased to be referred to as the "white Jacob Lawrence." The confusion or inversion of racial identities suited him just fine.

Throughout the 1960s Gwathmey painted a series of images, usually of a lone farmer standing or walking, in which the skin coloration is anywhere between tawny and dark but the facial features are frequently his own. In fact, they are self-portraits. The most striking of these is *Custodian* (plate 32), a pivotal painting in Gwathmey's career that incorporates figural references to much earlier work, such as *Non-Fiction* (fig. 13), but also anticipates the appearance of headless figures as a device a decade later (fig. 61) in providing vivid commentary on a bankrupt culture. The racial identity of the principal male figure in *Custodian* is somewhat indeterminate though evidently white.[11] In *Southern Farmer* (1966), the man's face is partially concealed by a tin of lard. In *Man with Melon* (n.d.), the head and face are unmistakably Gwathmey's own. In *Potato Blossoms* (1968) the elongated farmer, facing the viewer directly, is literally Gwathmey with segmented skin tones of dark and tan. Off to the right, vertically arranged, are four cartouches of African American field-workers. Rembrandt painted and etched an astonishing number of self-portraits. Several of Andrew Wyeth's paintings are actually covert self-portraits. Close scrutiny reveals quite a few self-portraits in Gwathmey's art of the 1960s. They were not occasioned by vanity or by the absence of models. He genuinely wished to inhabit a world in which race did not matter, particularly not as a basis for discrimination.[12]

Somewhat more enigmatic is an oil painting titled *Butterfly* (1972). In the foreground a casually dressed man (wearing a harlequin playsuit) who obviously is Gwathmey has snared a large white butterfly in a net. In the middle distance are two fashionable women and a teenage girl, all with chalky white faces, in contrast to Gwathmey's ambiguous skin coloration—certainly more colored than white. The meaning of this particular composition, racially or socially, eludes me. Perhaps it is worth considering an observation that Terry Dintenfass made in 1975 when she gave an interview for the Archives of American Art. Paul Cummings had asked her, "If you've been to the studio and watched somebody work on a painting, then six months later the painting comes into the gallery in an exhibition, can you say things about that to somebody?" She responded, "Never. No. I feel that's a personal part. I don't understand the painting any more than the person

FIGURE 55
Bar-B-Q (1978), o/c,
42 × 34. Courtesy of the
Terry Dintenfass Gallery,
Inc., New York.

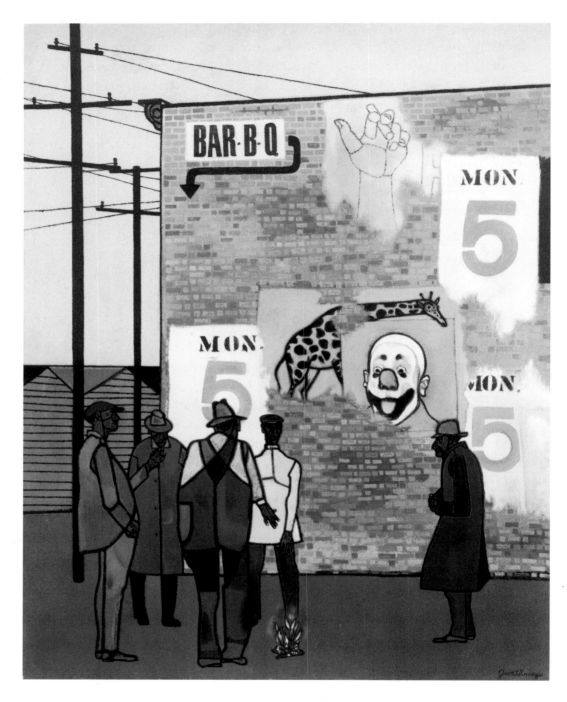

who is buying it, really. And frankly, I've come to the conclusion, dealing with the men that I do deal with, that they don't understand it either. They don't know what it means. They may know what they're trying to say, but it doesn't always come out that way."[13]

In 1978 Gwathmey painted a large oil titled *BAR-B-Q* (fig. 55) that looks reasonably straightforward. Five black men have gathered on a chilly day around a small fire on the

street. On a brick wall behind them are a bold BAR-B-Q sign, a torn circus poster, three notices each bearing a bold "5," and the remains of a poster with a large hand holding a cigarette (a virtuoso of line drawing demonstrates that talent here). It seems a simple composition, except that barbecue is a venerable tradition in southern foodways, a rite as well as a ritual. By the 1950s and 1960s, the status of mythic hero came to be conferred on black barbecue artists. That, according to one authority, contributed "at least sub-consciously, to the erosion of past patterns of racial discrimination and leads to genuine interracial communication and understanding in a context unrivaled by the prevailing practices in most Southern churches."[14] There are connections between the old-time camp meeting and contemporary barbecue cook-offs. Knowing when and how to baste your ribs is a skill that transcends racial lines. I believe that Bob Gwathmey knew that.

As a southerner with a strongly pronounced drawl teaching in New York at mid-century, he frequently found that he had to "prove" himself to be a man not merely without racial prejudice, but one who could relate comfortably to young African Americans. The best illustration of this comes from Faith Ringgold, a distinguished quilt de-signer and artist in her own right. She has vivid memories of entering Gwathmey's drawing class as a first-year student.

I had come into the classroom and all these kids were there and I'm threatened any-way because most of them are coming from Music and Art [high school]. They al-ready know everything about all these art supplies and stuff. I don't know nothing.

And Gwathmey comes on with his drawl. He has this thick Southern drawl and it's 1948 and I am not going to stand there with that man with that drawl! No way. This is City College, and nobody's going to let me slide. Nobody. And I am the only black person in that class and the only black woman in the department. Just me and Al Hollingsworth. That's it. And I cannot afford any failures. That is out of the question. . . . So I heard that and I said, "I'm getting out of here." So I moved toward the door, and he came over and he stopped talking to the class and he said, "Just wait a minute," in his drawl. He said, "I know what you're thinking, but just give me a chance. Just give me a chance." . . . He just told me to wait. To stay in the class and after class be-cause he wanted to have a chance to talk to me about who he was and to prove to me that he wasn't one of "those." So I did and as it turned out he was very encouraging of my work.[15]

After a basis for trust along with superb instruction had been established, Gwathmey gave Ringgold a demonstration of artistic tolerance, a different kind of multiculturalism. He looked at her work one day and observed that in his own art he always tried to max-imize contrast.

FR He said, "This is interesting. You're not doing that at all. You're just trying to not even think about that. I think it's wonderful. Just keep right on."

Not only did that encourage me. It showed me something about teaching that I try to

incorporate as a teacher myself with my students. Sometimes I look at things they're doing and I say to myself, "My god. What is this?"

But I control myself. I don't share that with them because that's ignorance, see. That's a display of my ignorance. I'm looking at something I don't understand and so I'm pooh-poohing it because I don't understand. This kid might be right.

CN That's a very enlightened view.

FR This kid could be right, so what do I say instead? I think about Gwathmey and he taught me that. If nothing else, he taught me that. I say, "That's interesting. Let me see more of that. Try to develop that."

Nevertheless, Gwathmey did not repeat the mistake that caused him to be fired by Beaver College in 1937. He never went drinking with Faith Ringgold.

> Now he didn't do for me what he went ahead and did for Al Hollingsworth. I was discussing him with Al recently. He was a man. They went out and got drunk together and they went to bars and they palled around. So Al has a whole other story to tell on him, and they had a ball together.
>
> He's heard him say some things that he didn't approve of and some other things and they were into the back slapping and the whole thing. So he gave me a whole lot of anecdotes on Gwathmey which I don't have because I'm a woman and I wasn't there when they were doing all of that horsing around. So I don't get to see him in that light.[16]

Having such a strong southern accent provided Gwathmey with a convenient means of playing tricks on people, which he delighted in doing. He would get into a taxi, for example, and lay on an even thicker drawl than his natural one. If the white cab driver proceeded to make prejudicial remarks about blacks, Gwathmey would then launch into a minisermon about toleration, equality, and decency. Yet in 1966 when an interviewer asked Gwathmey twice in as many minutes whether he was a moralist as a painter and as a person, he repeatedly rejected the label. His second denial is especially illuminating. "I don't feel like a moralist at all," he declared. "I feel like an observer, and I feel like an observer who has some left-wing persuasions and I see these things in kind of a social context." He then added as an afterthought, "I don't want to say I moralize, cause it sounds a little stuffy. It's like I did it with a preconceived purpose. But I am purposeful and I do have preconceptions and this thing grows out of it."[17]

Needless to say, Gwathmey became a staunch supporter of the civil rights movement during the early and mid-1960s. Several of his most striking paintings from that era either incorporate descriptive accounts of critical episodes in the movement or satirize the most blatant forms of southern racism. In *Space* (fig. 56), for example, a sweeping look at white southern devotion to myths of the Confederacy and the Lost Cause, he included the burning hulk of a Freedom Ride bus surrounded by bigots brandishing clubs and hurling rocks—an image based on a famous Associated Press photo from 1961. Gwath-

mey's composition coincided with the now-historic Mississippi Freedom Summer of 1964. He provided some comments when the picture was exhibited at the University of Illinois in 1965.

FIGURE 56
Space (1964), o/c, 36 × 48. Private collection.

> *Space* is frankly a social comment painting, composite in arrangement with conglomerate symbols. Principal among the symbols is a child in a toy space suit, straddling an ancient cannon while holding aloft the stars and bars—first on the moon as the game would be played. Following are a group of ignorant poor whites seated at the base of the omnipresent Confederate statue. Then the facades of three small town stores with a member of the business community out front, a burning bus and the cotton picker.[18]

His explanation does not mention the self-portrait of a man drinking thirstily to the left of center, a sociable figure who is from the South yet removed from that mindless determination to maintain its traditional values. *Space*, like so many other paintings by Gwathmey, was purchased by native New Yorkers. There is good reason to believe that

one significant stimulus for his appeal in this market was that his art sustained long-established hostilities held against the South by liberal northerners.

A year later Gwathmey painted one of his two harshest indictments of persistent southern racism (the other one being the lynching scene in *Revival Meeting* [plate 19]). He called it *Belle* (plate 33), although the symbols extend far beyond the caricature of an aging southern woman surrounded by emblems of prejudice: the hooded Klansman, the hypocritical preacher, the African American trapped with his hands tied, the law enforcement official waving a bottle of booze, and the mysterious circus acrobat doing a handstand.* That same acrobat appeared sixteen years later in a painting about religious hypocrisy in the South that he called *Crossroads and Tobacco Barns* (1981), but the figure's exact meaning to Gwathmey remains somewhat oblique. Everything else in the painting is spelled out precisely in a letter that Gwathmey wrote soon after the Reynolda House Museum in Winston-Salem acquired the work in 1978.

> I might have laden down the canvas with too many symbols. Here goes:—Belle is the southern stereotype who was told that if you read too many books you limit your chances of marriage. She accepts the role of submitting to "the man of the house" and would be the antithesis of woman's libe [sic]. At this late date she still plays the game of he loves me, he loves me not. Now there are three double images. As the preacher with two crosses, one the Christian and the other the fiery cross [of the Klan]. Then there is the Klansman hidden under his sheet with two feet protruding, one shoe representing the powers that be while the other shoe is that of the uneducated. The nest of chirping birds is at the base of a fence rail while the morter-board is on the top (bird brain). The highway markers almost obliterated by the botanical growth suggest provincial attitudes. The circus performer is supposed [to] represent "bread and circuses." Then the superstitions, ace of spades and number 13. Also the medicine man with his rustic appeal. Finally the black being given a book with hands tied behind his back.[19]

The acrobat doing a handstand might also be an allusion to an important work by another Social Realist, Ben Shahn. In Shahn's *Epoch* (1950), a man balances (precariously) upside-down on two performing cyclists, one bearing a placard "yes" while the other holds up a resounding "no." The painting is in the Philadelphia Museum of Art. Gwathmey also provided an overview of *Belle's* basic point from a more general perspective a little more than a year after he completed it.

> The proverbial southern woman who has social and financial pretensions, is rather a lost image, a lost person I think, because it's very sad to me because she plays a role of being something out of ante-bellum days, which is not keeping up with the times as it were. Now . . . this is only one phase of the South. In the South today, there are many intellectuals, many on the college campuses, [but] they are so small in number that it's very difficult for them to express themselves politically. But they do have associations. Now Lillian Smith, by the way, wrote a thing recently . . . a piece rather,

*It is possible that Gwathmey may have been amused by John Canaday's well-known negative reference to hypercritical art critics and historians as "verbal acrobats." See Canaday, *Embattled Critic: Views on Modern Art* (New York, 1962), 11.

that explained the position of the progressive Southerner usually in the teaching field, the professional field, who finds himself intellectually persuaded in what I'd call the right direction, yet so small in number that they are not able to organize so-called politically. Are not able to emerge as a political force.[20]

The trumpet vines obscuring road directions and arrows occur again twelve years later in *Isolation* (plate 41), where they signify a loss of direction for the artist rather than for his native region. During Gwathmey's career this particular imagery went from fierce social criticism to self-reflection of a humiliating or hurtful nature.

Gwathmey's most powerful painting pertaining to the civil rights movement is *United* (plate 34), a large, architectonic work reminiscent of *City Scape* (1967), but only in composition. Whereas the latter is filled with deeply personal and painful meanings, *United* is an exuberant visualization of the ecumenical and biracial convergence of men and women who genuinely believed that "We shall overcome" might actually transpire as the start of a transformation in American social relations. Note the persistence of certain time-honored Gwathmey icons, such as the rooster head at the left and the bold "Nov. 5" at the lower right. Why Guy Fawkes Day? I have no idea; it may simply be a reprise of the image from *I Saw the Figure 5 in Gold*, which he also used in 1969 in *Section of Town* (fig. 53). It is likely that those two works were composed sequentially.

Front Line (fig. 57), an enlargement and adaptation of the civil rights marchers in *United*, is one of the most affecting line drawings by Gwathmey that has survived. It conveys unsurpassed simplicity and elegance, along with the power to evoke vivid memories of social activism in the later 1960s.

The architectural intensity and embellishment in *United* are reminders of the pride that Gwathmey felt in his son's swift development as a professional architect during the later 1960s. Robert expressed his enthusiasm and support by emphasizing architecture ever more prominently in his depictions of African American life in small towns and rural areas of the South. *Section* (1961) is an uncomplicated lithograph in which a couple enters a shack to the accompaniment of guitar music from an open doorway above.

Front Porch (fig. 58) is a more complicated work, and not merely because it is a detailed oil painting rather than an austere lithograph. It is architectural because the porch recedes and therefore the wall makes two ninety-degree turns. This is an unusual painting for Gwathmey because it is not two-dimensional and flat. He thereby demonstrated how well he could deal with depth if he chose to. But *Front Porch* is also architectural for a social reason deeply rooted in southern culture. As far back as 1852 Lewis Allen wrote the following in *Rural Architecture*: "No feature of the house in a southern climate can be more expressive of easy, comfortable enjoyment than a spacious veranda. The habits of southern life demand it as a place of exercise in wet weather in the cooler seasons of the year, as well as a place of recreation and social intercourse during the fervid heat of the sum-

FIGURE 57
Front Line (1970),
pencil on paper,
22³/₄ × 29. Virginia
Museum of Fine Arts,
Richmond. Adolph D.
and Wilkins C. Williams
Fund. © Virginia
Museum of Fine Arts.

mer. Indeed many southern people almost live under the shade of their verandas. It is a delightful place to take their meals, to receive their visitors and friends."[21]

More recently southerners have spoken about the porch as a cherished tradition, something a proper home would literally be incomplete without. As an elderly South Carolinian put it, "A house ain't a house without a porch." In the large oil shown in fig. 58, the woman is quite clearly Caucasian. But Gwathmey also did a much smaller oil version of the same genre (1966) in which the lone woman is apparently African American rather than white. As Gwathmey wrote when the large version of *Front Porch* was exhibited at several venues in 1967–68, "On the other side of the tracks so much of the activity takes place outside the poor abode, the front porch, the street. The search for beauty is suggested by the flowers and the utilization of the emptied grocery boxes with their stenciled images. A woman sits awaiting a neighbor's company."[22] Anne Moody reinforced that perception from a different perspective in her 1968 memoir, *Coming of Age in Mississippi:* "Most evenings, after the Negroes had come from the fields, washed and

160

FIGURE 58
Front Porch (1966),
o/c, 32 × 41. Maier
Museum of Art,
Randolph-Macon
Woman's College,
Lynchburg, Va.

eaten, they would sit on their porches, look up toward Mr. Carter's house and talk. Sometimes, as we sat on our porch Mama told me stories about what was going on in that big white house. She would point out all the brightly lit rooms, saying that Old Lady Carter was baking tea cakes in the kitchen, Mrs. Carter was reading in the living room, the children were studying upstairs, and Mr. Carter was counting all the money he made off Negroes."[23]

Barrie Greenbie captured the most basic service and function of front porches in the South when he observed that on the porch a person "could enjoy the presence and casual company of neighbors and even strangers without any more involvement than one wished." That seems especially apt for Gwathmey's large oil because the white woman appears to be intently preoccupied, perhaps even judgmental, but not especially welcoming. By contrast, the African American woman in the smaller version of *Front Porch* looks directly at the approaching viewer, rather than down, thereby reminding us of the

importance of porches in working-class southern life as a place for gracious social gatherings and relaxation.[24] (See also fig. 37 for Gwathmey's 1947 version of three African Americans on a front porch.)

Gwathmey could gracefully and handsomely combine his attraction to humble architecture with his traditional devotion to figural representation. In *Four Figures* (1972), an oil painting, he simply elaborated on the basic configuration of structures in *Section of Town* (fig. 53) but replaced the arm-in-arm older couple with a farmer and his wife working in the foreground, a man chopping tobacco in the upper left, and a woman wearing a poke bonnet hoeing weeds in the upper right corner of the painting.

During the 1960s Gwathmey visited the South far less frequently than he had previously because he no longer had close relatives and friends living there. Consequently he painted fewer scenes of African American life in the rural South, though there certainly were some striking exceptions, such as *Gathering* (1961) and *Prologue II* (fig. 59), the latter a group of thirteen people who appear to have congregated on a Sunday morning prior to attending church. He referred to it as "a strong phalanx completely united" and declared "that this is a complete unit of the total Negro neighborhood."[25] It is also a reprise of selected pictures that he had done over a period of almost two decades because it includes slight variations of the young girl holding a child in *Hoeing* and in *Non-Fiction* (both 1943), the older woman from *Portrait of a Farmer's Wife* (1951), and the seated woman with sagging breasts from *Sewing* (ca. 1952). A composition such as this one, crowded with people and structures, brings to mind yet another proleptic passage from Sherwood Anderson's *Dark Laughter* (1925): "If you are a canvas do you shudder sometimes when the painter stands before you? All the others lending their color to him. A composition being made. Himself the composition. . . . Consciousness of brown men, brown women, coming more and more into American life — by that token coming into him too" (p. 74).

Curiously, however, Anderson was a midwesterner who remarried and made a permanent home in rural southwestern Virginia, where he felt comfortable, whereas Gwathmey became the distanced Virginian who felt that New York alone seemed a fit place to live. There were generational as well as temperamental differences between the two men, because Anderson, despite his apparent empathy with African Americans, occasionally revealed a stereotypical attitude and used language that Gwathmey used only in jest and with very close friends — language and references that sometimes become allusively opaque.

> Bruce lay lazy in bed. The brown girl's body was like the thick waving leaf of a young banana plant. If you were a painter now, you could paint that, maybe. Paint a brown nigger girl in a broad leaf waving and send it up North. Why not sell it to a society woman of New Orleans? Get some money to loaf a while longer on. She wouldn't know, would never guess. Paint a brown laborer's narrow suave flanks onto the trunk

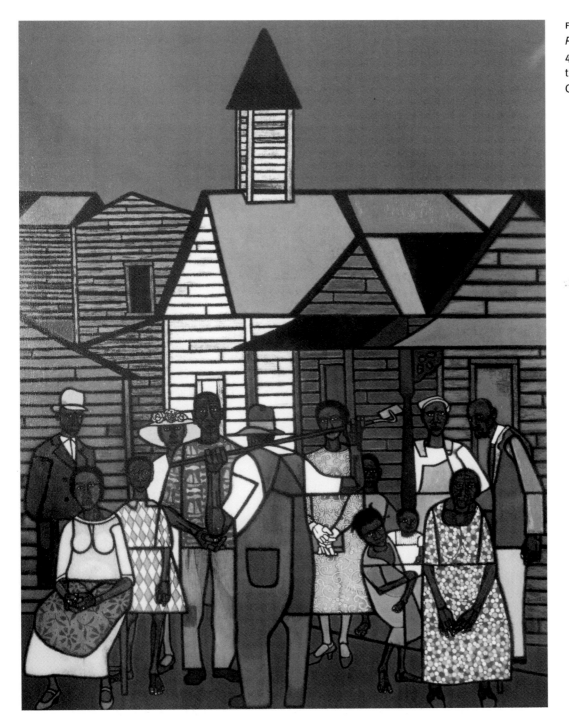

FIGURE 59
Prologue II (1962), o/c,
46 × 36. Courtesy of
the Coca-Cola Bottling
Company, Philadelphia.

of a tree. Send it to the Art Institute in Chicago. Send it to the Anderson Galleries in New York. (p. 80)

Black women in Gwathmey's art are usually performing essential tasks, such as mending clothing, sowing seeds, quilting, picking cotton, and hoeing tobacco, whereas the white women in his art, most prominent from the later 1960s through the early 1980s, are at their leisure rather than being purposeful. They are lounging on a beach or relaxing with a book or objects in a still life, or are merely preoccupied with themselves in the interior of a room whose detailed wallpaper receives as much exquisite attention as the woman herself. Many of Gwathmey's women, white and black, are depicted in repose; but the black women invariably perform some socially useful function, such as sewing, while the white women are largely decorative, women with time on their hands rather than tasks to be done.[26]

By the 1970s, as the goal of a color-blind, integrated society came to be challenged by white ethnocentrism, black nationalism, separatism, and efforts to define a distinctive African American culture and aesthetic, Gwathmey stopped painting his racially indeterminate figures and returned to images of people who are unambiguously black or white performing familiar chores or indulging in amusements. Works such as *Shovelling* (1973), showing two men in a field doing exactly that, and *Country Tune* (1974), depicting a man playing a guitar alone in a rural field, provide examples, as does the brilliantly colored *Migrant* (plate 35), a work that seemed to please Gwathmey sufficiently that he made a serigraph of it in 1978 based on the oil painting of 1976. These pictures recall what Gwathmey declared in a 1966 interview: "The Negroes I paint have a sense of dignity . . . because they are inherent with dignity."[27]

Jack Levine has made the provocative observation that Gwathmey wanted to create a visual epic with African American figures. According to Levine, he may have had in mind a heroic black persona from folklore, John Henry, the steel-driving man who competed with the machine and lost. The legend seems to date from West Virginia in the later nineteenth century, perhaps as early as the 1870s. Although Gwathmey enjoyed listening to recordings of "John Henry" (folk singer Pete Seeger was a social friend and political ally), he never painted the mighty steel driver or any other particular black folk hero.[28] The African Americans in Gwathmey's art are not romanticized or sentimentalized. Nor do they convey the kind of sexuality that Sherwood Anderson and some other contemporary writers were attracted to or ascribed to blacks. They do have inherent dignity, but they are less than "epic" when compared, for example, with the African American nation-builders in the historical murals painted by Thomas Hart Benton during the 1920s.[29]

There is, however, one particular stereotype of African American life that Gwathmey took pains to repudiate: the fatherless family or the disintegrating family unit. As early as 1948 in *Children Dancing* (plate 10), Gwathmey affectionately called attention to the black family as a complete and cohesive entity. In 1974, however, nine years after the

Moynihan report stressed the "single-headed" black family as not merely a terrible legacy of slavery but a pathological situation in contemporary society,[30] Gwathmey painted *Father and Child* (plate 36). It is a complex and fascinating work that puts the paternal role as a responsible parent front and center, survivor of an Old South that has been shattered, symbolized by the toppled statue of Johnny Reb (the Confederate soldier), replaced by the ubiquitous black crow, a wrecked car, and woebegone shops. To the left of the loving father is Gwathmey himself (also a loving father) holding up a peace sign with a cluster of people of both races behind him, unified spatially and by the social demonstration they are supporting.[31] If it is a picture of protest, the forces of good appear to have triumphed over regional myths of racial hierarchy and domination. The outlandish color combinations, a salmon sky above a lavender foreground, are vintage Gwathmey. They remind us once again of the aptness in Sherwood Anderson's words: "If you are a canvas do you shudder sometimes when the painter stands before you? All the others lending their color to him. A composition being made. Himself the composition."

Gwathmey was not alone among the Social Realists in emphasizing the black father as a caring and nurturing figure. Joseph Hirsch, for example, made a beautiful and moving lithograph titled *Father and Son* (1945) in an edition of 250 impressions.[32] Other realists created comparable images. Some of these artists do, indeed, romanticize African American family life, but no more so than mainstream artists romanticized white family life throughout the nineteenth century and especially during the Victorian decades.[33]

Collectors with socially progressive values had been attracted to Gwathmey's art since the 1940s, and his work continued to be in demand through the 1960s, even though it never commanded the huge prices that were paid for works by widely popular realists such as Andrew Wyeth or Abstract Expressionists, who were so warmly promoted by influential art critics. Several of the most prominent and broadly respected critics writing during the 1960s and early 1970s tended to be appreciative yet guarded in their responses to Gwathmey's race-related art. Their praise was subdued, and they commonly conveyed a caveat about constraints or limitations. John Canaday, for example, the controversial yet admired art critic who wrote for the *New York Times*, invariably gave with the right hand but took away with the left when reviewing Gwathmey exhibitions at the Terry Dintenfass Gallery.[34] In response to a show early in 1968 he wrote,

> More and more acutely refined, the artificialities of Mr. Gwathmey's quite arbitrary pictorial manner seem less and less adaptable to the social comment that he frequently makes. The most ambitious single picture in this new show, "Belle," is an allegory of Ku Klux Klanism, but its literary parallel would be an indictment delivered in the form of a triolet sequence. Style and content are more harmonious in some flower pieces where decorative conventionalizations and painstakingly adjusted patterns are allowed to exist for themselves as visual pleasures.[35]

Another Canaday review almost four years later is curious because it seems to demean Gwathmey's most recent work by comparing it unfavorably to his earlier painting, all the while indicating that Gwathmey enjoyed a worthy reputation even though his artistic style deserved higher marks than his subject matter. Canaday's concluding sentences seem to suggest that the critic had personally lost interest in African American life as a significant motif for American art. Four years younger than Gwathmey, Canaday became the principal art critic for the *New York Times* in 1959, the year he published his award winning *Mainstreams of Modern Art: David to Picasso.*

Although he is a white Southern gentleman who might be type-cast as Augustine St. Clare in "Uncle Tom's Cabin," Mr. Gwathmey is a dean of painters of the American Negro and has managed to present black life in the South neither as the realm of happy, banjo-pickin' Rastus nor as hell on earth. The picturesque aspects of black life have interested him as pictorial raw material even while he has also been aware of the social tragedy underlying them and the historical struggle for black freedom. The polemics now associated with paintings on the subject, especially when they become abusive, are not his dish at all, and in this new show he seems to have retired further into the sidelines. His familiar style of highly simplified forms neatly disposed in decorative compositions, now even more simplified and, even more neatly disposed, is of greater interest than his subject matter. Another step or two he might be giving us a set of geometrical abstractions.[36]

Having painted African Americans predominantly for more than three decades, Gwathmey found himself typecast—almost trapped, as it were—in terms of his identity as a social observer, activist, and artist. For several years prior to those two reviews by Canaday, Gwathmey had been adding other "strings to his bow," both for the sake of his own interest and to avoid playing the same tunes repetitiously. As he said in an interview given in 1966, "I'm working on another canvas now of a picnic. . . . It's not anything that has anything to do with a kind of social awareness I reckon except that I do think it's an interesting symbol that good people can get together and have a good time and without fear of the Atomic bomb."[37]

Two years later, in 1968, he declared that an artist had to be "acutely aware of his immediate surroundings," referring to his newfound interest in the vegetation of eastern Long Island. He acknowledged as he reached age sixty-five that his "subject matter still has some traces now harking back to the olden days," but also that his subject matter was inevitably changing and diversifying. Referring to flowers around Amagansett, he observed that "there's always a new blossom, a variety, species every two weeks. And so I got hooked on these crazy wild flowers. And if you'd asked me in 1936, 'Do you think you'll ever paint a still-life?' I'd say, 'You out of your head?' I wouldn't have believed it. But now I paint still-lifes with these beautiful flowers and I enjoy it very much, you'd be surprised."[38]

His floral still lifes from this period are, indeed, exquisite in every detail. *Queen Anne's*

Lace (1966) supplies a superb example. Now well into his seventh decade, Gwathmey chose to paint whatever he "got a bang out of," to use one of his favorite phrases, and painting fresh field flowers gave him a bang throughout the 1960s even while he remained committed as a social activist. When Paul Cummings asked Gwathmey in 1968 whether painting flowers marked his first major shift in subject matter, the artist felt it imperative to specify what kinds of flowers fascinated him and why. He declared that "out in the country," meaning around Amagansett, "there's a new species every ten days."

> One on top of the other. And I tell you I don't like cultivated flowers any more than I like cultivated vegetables if you will. And some are so small I look at them with a magnifying glass to find the basic structure. And the basic structure is repeated many times in many plants, incidentally. That's engaging as well. But I've always done vegetation. . . . I've done corn, I've done cotton, I've done tobacco, pine trees. I've always been interested in vegetation. But I never got so close, we'll say, to this kind of vegetation. Out there where I live now the only farmers are potato farmers basically. There are some cabbages, cauliflower they have. But basically potatoes. And so I haven't looked at these crops with any excitement, not like tobacco, not like cotton. It doesn't seem to be as spectacular.[39]

Gwathmey had painted several versions of *Flower Vendor* late in the 1940s and early in the 1950s (see plate 24), once in light and bright colors and once in deep, intense colors. Each time he used two women, one dominant and in the foreground, the other secondary, walking either slightly behind or off to one side. I cannot say whether the two-woman motif at that time was a wry allusion to his personal life. But when he painted *Vendor* in 1974, it was notable for several reasons. First, this vendor (for which Rosalie served as the model) is white and is alone rather than with a second woman. Second, the vendor's raised hand is oversized, a particular reminder of a famous work from Picasso's blue period, *Lady with a Fan* (1905). That painting came to the National Gallery of Art in 1972, and Picasso died on April 10 the following year. I suspect that Gwathmey's *Vendor* is an indirect expression of homage to Picasso, whose work had always meant so much to him.

The year he painted *Vendor* was also the year when the Hirshhorn Museum and Sculpture Garden opened on the Mall in Washington, D.C., a meaningful event for Gwathmey. Several major museums in prominent locations did not own works by him. Most of his paintings that had been purchased were either in southern museums or in university art galleries. But Joseph Hirshhorn had been a strong Gwathmey admirer during the 1940s, and the new museum based on his immense collection included fourteen paintings by Gwathmey. (Five have been deaccessioned since 1990, leaving nine, still the largest number in any art museum.)[40] Hirshhorn's deputy, Abram Lerner, had worked for the Barons at the ACA Gallery until the mid-1940s. He had been responsible for quite a few of Hirshhorn's acquisitions and served as the museum's initial director. With the new museum about to open, Al Lerner asked Bob, a friend of more than three decades, to write a statement elucidating his aesthetic values.

Gwathmey's covering note began "Dear Al-but," mocking his own southern drawl. It closed with these two sentences: "I know it's been a long time since the museum passed Congress but I hope your patience is proverbial. Hope the book, the building and all attendent matters [are] on OK GO."[41] Gwathmey's statement exists in two versions, a short one in the Hirshhorn Archives and a long one, undated, in the Archives of American Art. Here is the long one, which may have been composed in the later 1960s and abridged for Lerner in 1974.

The proposition is to unite the two opposite poles of our faculties—intellectual analysis and sensory perception. What one conceives as well as what one perceives. The overemphasis on one, conception, leads to the limitation of autobiography and cold objectivity. The overemphasis on the other, namely, perception, leads to a mystique bordering on anarchy and high flown pretension.

Again and again there has to be a unison of the two—intellect and intuition. To create a schism between outer reality and inner being can destroy art as a means of communication.

Finally—art is the conceptual solution of complicated forms, plus the perceptual fusion of personality. Never humble orientation or surface pyrotechnics. Never does beauty come from decorative effects, but from structural coherence. It never grows out of the persuasion of polished eclecticism [sic] or the inviting momentum of the bandwagon.

The artist desires to find and to separate truth from the complex of lies and evasions in which he lives.

To engage—enjoin.[42]

During the 1960s and 1970s, Robert Gwathmey's art became increasingly autobiographical, but never entirely so. Far from it. He did, indeed, heed his own maxim and blend intellect with intuition. He also managed to combine his inner being with the outer realities of American society that concerned him deeply. His distinctive personality invariably emerged from his art, rendering it unlike the work of any other painter. Professor Milton W. Brown, an art historian who knew Gwathmey well and wrote an appreciative introduction to the catalog for his 1985 exhibition, felt that Gwathmey's later work was less important than his innovative painting between 1939 and 1960, that it became more disparate and had less emotional content. From Brown's perspective, Gwathmey's earlier work had a sharper focus and conveyed his sense of social justice and anger more clearly than his later work. Although there is considerable validity to that judgment, I question the decline of emotional content. Moreover, when Gwathmey reached his sixties and seventies, he did exactly what Jack Levine has said of his own work when he became older: sometimes "I'm entertaining myself. It's something which is its own reason to do. . . . It becomes possible for me to enjoy myself with prismatic color and perhaps not be so bloody meaningful, but to have a good time."[43]

Gwathmey had invariably managed to have a good time in his personal life. By the 1960s and 1970s he could still do so in his art as well.

Homo Sapiens,

Late Twentieth Century

Robert Gwathmey remained a politically engaged citizen through much of the 1970s, despite living at Amagansett in retirement from teaching. His art frequently reflected that engagement, especially his opposition to the U.S. prosecution of the war in Vietnam and his strong commitment to the peace movement. Because his concerns also encompassed other political causes, as well as social and religious hypocrisy, personal matters, and recent trends in art, the motifs of his paintings did become more diffuse during this decade. At the core of his thinking, however, one underlying concern not only dominated the rest but pervaded quite a few issues: man's inhumanity to man.

Gwathmey did not suddenly turn into a social philosopher in his eighth decade, but his art reflected broader, more generalized expressions of distress about the physical and psychological brutalities that people inflict on one another. Therefore his later paintings conveyed that distress in ways that often transcended the considerations of race and class that had been the basic arrows in his quiver for four decades. Consequently some of his last major works are the most difficult to read or interpret in particular terms—or in terms of their particularities—though their overall message comes through loud and clear. Quite a few of these large works are not "beautiful" or "attractive" the way so many previous paintings were. Instead, they are often agitated and troubling. They arose from Gwathmey's sense of a world gone awry, and they are meant to unsettle or even discomfort the viewer. If we take them collectively to constitute a reflection of the artist as an older man, his vision of the future for humankind had grown more grim. Yet his manner of illuminating that vision remained vivid despite its somber tones.

In 1968 when Gwathmey turned sixty-five the Cooper Union School of Art required him to retire. Despite his well-known dedication and extraordinary effectiveness as a teacher, the institution was glad to see Gwathmey leave, because he prompted administrative headaches. Predictably, Gwathmey had been instrumental in demands for a pension arrangement for part-time and adjunct faculty. They had always been poorly paid and received no benefits.[1]

He did not accept mandatory retirement gracefully because he genuinely enjoyed part-time teaching. He liked interacting with students. In an interview in March 1968 he reacted candidly to the prospect of being put out to pasture. "I would like to teach two more years. I really would but if I don't, I mean economically, I don't have to. It's just the matter of stimulation of teaching is attractive to me. Not over a long hour period, not twenty hours a week. I will say two days a week. I tell you the truth, I would teach one day a week for nothing. Yeah, I almost would. I wouldn't exactly. Don't repeat this. Don't record this. No, I would *almost* teach one day for nothing. The stimulation of meeting students, their peculiar attraction and their own devious interests."[2]

Gwathmey had not been unusually gregarious or personally interactive as a teacher. John Hejduk, who took a drawing class with him in 1947–48, does not recall Gwathmey ever talking about political matters in class, for example, though Hejduk does remember vividly that Gwathmey urged students to see the Roberto Rossellini film *Open City* (1946), a study of resistance and survival in Italy during World War II that is considered a classic in cinematic realism. Nor did Gwathmey ever go to lunch with his students, even though the class met from nine until noon and then from one until four o'clock. Nor did he invite students to his home. What came across so powerfully to the students was their instructor's passionate love of art. On one occasion, for example, Gwathmey enthusiastically brought to class a huge volume of reproductions of Botticelli's drawings of winged angels. The students also noticed Gwathmey constantly using the school library to take out books pertaining to art.[3]

Later during 1968, with unaccustomed time on his hands, Gwathmey and his wife began to think about foreign travel, such as the trip to Spain that they eventually made in April 1970, mainly to see paintings by Goya. Nevertheless, Gwathmey's social conscience did not relax. When Studs Terkel interviewed him in 1968, Gwathmey expressed his irritation at the indifference to poverty that he felt around him. "It's fearful to think that today's times are so affluent for me. I live real, real well. I'm in the upper ten percent. But when I see poverty, it's still poverty. I hate it. During the Depression, we were all more or less engulfed. Today when people say poverty, they turn their head. They don't want to admit poverty exists. They're living too high, so on-the-fat, right?"[4] When Gwathmey wrote the foreword to a small catalog that accompanied an exhibition by Ralph Fasanella, the so-called primitive painter, he praised Fasanella as "the very personification of this island [Manhattan]. Well, that part of the island that knew the tenements, the minority groupings, the poverty and prejudices, as well as the aspirations."[5]

As the 1970s began, Gwathmey felt agitated by the unfulfilled promise of the civil

rights movement as well as by the swelling peace movement in response to President Richard Nixon's escalation of the war in Vietnam. His painting *Phrenetic Confusion* (fig. 60) reflects the artist's own involvement in multiple causes occasioned by those politically tumultuous times. A series of geometric designs across the bottom of the picture—the apparent shirts or blouses of angry agitators—indicates his ongoing contempt for Op Art. The upraised hands pictured on posters refer to an array of attitudes and concerns that moved Gwathmey personally as well as politically: the clenched fist meaning power to the people; a woman's hand wearing multiple wedding rings; the hand of a dead person with a string attached to the forefinger for remembrance; crossed fingers on a woman's hand for insincerity ("I don't really mean what I am saying"); an "up yours" finger; and a pointing forefinger in the lower right that was an old American printer's device. The pointing finger appears on the 1952 Folkways American Folk Music handbook that accompanied three recordings. As a good friend of Pete Seeger, Gwathmey surely knew that printer's device from the album. More generally, Studs Terkel's 1968 interview with Gwathmey refers to the popularity of "palmistry and the occult."[6]

Phrenetic Confusion is not an easy painting to live with, and it has changed hands, so to speak, several times in a span of twenty-five years. But it powerfully captures the public mood of 1971, especially among dissidents. So does an equally potent (and somewhat perplexing) work from 1974 titled *Late Twentieth Century* (fig. 61), which is, perhaps, overloaded with critical symbols, some of which are self-explanatory while others remain obscure. There is no mistaking the meaning of the headless soldier with a skull and a mortarboard resting on poles that protrude from his neck: an education and a life wasted; what might have been. Gwathmey himself holds up a poster with the palmistry hand, a question mark in bright blue below it. The face of a man protrudes from a big box on the front of which is a graph of declining fortunes—perhaps of such Social Realists as Robert Gwathmey.[7]

In the foreground of this large painting that manages to be simultaneously messy and precise appears the detritus of a disintegrating civilization—certainly one in considerable disarray. Against a bleak sky are zodiac symbols, a rocket zooming into space, and a big fish that is leaping despite the absence of water. A fish in the sky may signify something comparable to those acrobats doing handstands: things not in their normal position, or himself as a fish out of water. Gwathmey had previously made a meticulous line drawing of the same motif in 1970, but with a few interesting differences, some of which are inexplicable. The soldier and skull in the center are replaced by a headless minstrel strumming a big banjo, a reprise of Gwathmey's oil painting *Non-Fiction* (1943). Gwathmey's face still pops out of the box to the right, but the graph on the front shows improving rather than declining fortunes. The detritus of an automobile graveyard dominates the foreground (an echo of *Custodian*), while zodiac symbols, a rocket, and a Spartan helmet float through the atmosphere above. The personal and the political have been conflated with calculation in this disturbing drawing from 1970.[8]

The graph might have been depicted as rising in the earlier drawing because by the

FIGURE 60
Phrenetic Confusion
(1971), o/c, 45 × 30.
Courtesy of the Terry
Dintenfass Gallery, Inc.,
New York.

end of the 1960s the FBI decided to leave Gwathmey alone, perhaps on account of his age rather than any diminution of his activism. They had kept close tabs on him during the early to mid-1960s, and careful scrutiny of what they reported conveys a sense of his diverse political commitments. Gwathmey had become involved with a group called U.S. Friends of Mexico. On November 7, 1961, he accompanied Dr. Corliss Lamont and attorney Stanley Faulkner on a flight to Mexico City in order to present an appeal to authorities there against the imprisonment of Marxist muralist David Alfaro Siqueiros. The trio interviewed Siqueiros but were not permitted to discuss his case with any official.[9] Even a cursory look at some of the tortured and tragic figures in Siqueiros's crowded but expressive paintings helps us to understand one major source of inspiration for Gwathmey's two versions of Late Twentieth Century (1970 and 1974).[10]

Information appears in a twenty-two-page report that the FBI's New York office sent to Washington detailing Gwathmey's association with numerous suspected communist "Front Groups." Late in November 1961 the New York office made a decision not to interview Gwathmey on grounds that doing so "could possibly constitute a source of embarrassment to the Bureau." The report does not explain why. At the end of January 1962 the FBI placed Gwathmey's case "in a closed status," once again for undisclosed reasons.[11]

Closing his file did not mean the end of surveillance, however. There are subsequent reports, for example, observing that on March 17, 1962, Gwathmey participated in a picket demonstration held at the United Nations Plaza by the Artists' Committee to Free Siqueiros. In 1963 the FBI "re-evaluated" his case because agents learned that he had been listed as a sponsor of the National Committee to Abolish the House Un-American Activities Committee and that he "is, at least, a person of interest to the Permanent Student Committee for Travel to Cuba." In 1964 the FBI spotted Gwathmey as the treasurer of the New York Citizens Committee of Inquiry organized by Mark Lane, erstwhile defense counsel for Lee Harvey Oswald. The group wanted to "raise issues in the case" in order to reveal "the facts" involving the assassination of John F. Kennedy.[12] On March 16, 1964, J. Edgar Hoover transmitted to J. Lee Rankin, general counsel to the President's Commission on the Assassination, a five-page summary of information gathered over more than two decades. The first substantive paragraph began, "Gwathmey's history of subversive activity extends from at least 1941 to the present." Thus the irresponsible escalation of ideological rhetoric.[13] He was no longer listed as *suspected* of possible subversion. He positively *had been* subversive.

In June 1969, the FBI decided that "the subject gives no indication of carrying out his plans to travel abroad in the near future, [and] this matter is being closed subject to reopening in the event the subject does indicate an intention to leave the country."[14] The Gwathmeys did visit Spain less than a year later, but the FBI seems to have lost interest by then. Bob's file ends in 1969, twenty-seven years after surveillance began.

The FBI chronology is curious in one respect yet quite comprehensible in another. It makes sense because so many of the organizations and causes that Gwathmey advocated

FIGURE 61
Late Twentieth Century
(1974), o/c, 45 × 30.
Courtesy of the Terry
Dintenfass Gallery, Inc.,
New York.

did not generate very broad support and turned out to be ephemeral. In a brief 1967 interview he even acknowledged that political organizations by and for artists "just do not last." The FBI's indifference to Gwathmey after the late 1960s remains puzzling, however, because he actively supported the peace movement, and a great many demonstrations against the war in Vietnam took place in New York after 1966. Early in the 1970s Gwathmey made a drawing called *Peace Marchers*, and in 1974 he executed a work in pencil and wash called *Peace Makers*. The latter features a middle-aged couple with a woman singing or chanting while her stolid male companion, a few steps behind, holds aloft a placard with a bold peace sign.[15]

This seemingly innocent drawing is, in fact, engagingly autobiographical. In the spring of 1970 a friend of Charles Gwathmey's, knowing that Charles's parents opposed the war, brought to Amagansett a commercially produced, traditional American flag with a peace sign emblazoned on it. The inverted trident was attached to the field of blue. Soon after Robert Gwathmey displayed it in front of his home, a local resident named Chris Miller made a citizen's arrest on the basis of a sixty-five-year-old New York State statute that made it a crime to deface the American flag. The local police, who were not involved, felt rather embarrassed by the incident, even though it was indicative of conservative sentiments in the Hamptons. New York State troopers made the eventual arrest and handcuffed Gwathmey for booking, though he was subsequently released on $100 bail.[16]

The actual wording of the 1905 state law is comprehensive and quite specific. According to the passage pertinent to Gwathmey's case, it was unlawful if

> any person . . . in any manner, for exhibition or display, shall place or cause to be placed, any word, figure, mark, picture, design, drawing, or any advertisement, of any nature upon any flag, standard, color, shield or ensign of the United States of America, or the state of New York, or shall expose or cause to be exposed to public view any such flag, standard, color, shield or ensign, upon which after the first day of September, nineteen hundred and five, shall have been printed, painted or otherwise placed, or to which shall be attached, appended, affixed or annexed, any word, figure, mark, picture, design, or drawing, or any advertisement of any nature.

Following six additional, very detailed clauses, the statute concluded, "The possession by any person, other than a public officer, as such, of any such flag, standard, color, shield or ensign, on which shall be anything made unlawful at any time by this section, or of any article or substance or thing on which shall be anything made unlawful at any time by this section shall be presumptive evidence that the same is in violation of this section."[17]

Victor Rabinowitz, a prominent civil liberties lawyer in Manhattan, took the case on a pro bono basis and brought a federal court action to have the statute declared unconstitutional on the grounds that it violated the first amendment. When Judge Anthony J. Travia declared the law to be constitutional, Rabinowitz appealed. What happened next is best described in Rabinowitz's own words.

Travia was one of those exceptionally stupid and reactionary judges who make their way to the bench with regrettable frequency, and he had greeted my argument with an angry snarl. I never expected anything much from him. But the Court of Appeals is different. It has its reactionary judges, but very few are stupid and a few even have a sense of humor. For this argument, I prepared a 4' x 4' poster on which I had mounted a few examples of everyday uses of the design of the flag in ways clearly in violation of the statute. The centerpiece was a picture of Raquel Welch in a bikini made from the American flag. That appealed to Judge Lumbard, the presiding judge who remarked "That is one flag I could wear close to my heart." A campaign button distributed by Spiro Agnew also caused some amusement.

The court held the statute unconstitutional. For some reason I could not understand, the State of New York appealed and the Supreme Court held on to the case for a few years before affirming the decision of the Court of Appeals.[18]

A number of Gwathmey's friends attended the appeal hearing. Jack Levine, for one, recalls the three judges at the appellate level being very amused. There are some complex procedural problems involved when a federal court passes on the constitutionality of a state statute, and that, rather than the substance of the litigation, caused the delay in reaching closure. Thus Gwathmey was directly involved in a little-known episode concerning an issue that has heated up in recent years, especially in 1984 when Gregory Johnson burned a flag during the Republican National Convention, and once again in 1995–96 when Senator Bob Dole announced his support for a constitutional amendment to ban desecration of the American flag.[19]

In an ironic way this 1970–71 episode, which occurred at an intensely divisive time in American political and social history, provided particular resonance for a work of art that Gwathmey had created in more patriotic and consensual times during the mid-1940s. He made several versions, oil and watercolor, of an image called *Standard Bearer* (fig. 20) in which an overstuffed white man holds a lynch rope and an inverted banner on which the unbalanced scales of justice are prominent.[20]

Gwathmey may have enjoyed the last laugh in the "peace flag" incident, but that episode along with assorted events during the preceding decade—including assassinations, police brutality, race riots, and the devastation in Vietnam—put him from time to time in a somber mood about man's capacity for inhumanity to man. From his introspection came his composition in 1973 of one of his grimmest paintings, *Homo Sapiens, Late Twentieth Century* (plate 37). Against a deep lavender sky and a full eclipse of the sun, two stripped-down men, racially indeterminate, battle to the death with bare hands and a club. To accentuate the brutality, and perhaps to suggest that this is not an unprecedented struggle, two sun-bleached bones lie on the blood-red ground.

Significantly, perhaps, when Terry Dintenfass gave the first part of her extended interview late in 1974 for the Archives of American Art, she responded in an interesting way to a question about why she had never handled a totally nonfigurative artist in her

gallery. "I started out with a social protest point of view," she said. "And I really believe in man's inhumanity to man being of utmost interest to me. And the men that are in the gallery deal with the human figure and the humanness of life even if it's nature."[21]

The artistic inspiration for Gwathmey's *Homo Sapiens*, not surprisingly, came once again from his great favorite, Honoré Daumier. In 1849–50 Daumier made charcoal drawings of two men fighting viciously on the ground. His inspiration was a fable by Jean de la Fontaine, *Les voleurs et l'âne* [The thieves and the ass], but his particular occasion was an adaptation of that fable to the nasty circumstances of the Austro-Hungarian War of 1849, when Hungarian patriots suffered defeat after Russian forces arrived in support of the Austrians. Soon after that (ca. 1852–55) he executed the same subject in oil (now at the Louvre), and then seven years later he drew an exact reproduction *backward* onto a lithographic stone so that the lithographs would perfectly replicate the original in oil. How he achieved that feat remains part of his artistic genius—and his secret.[22]

The motif of two determined men struggling bitterly must have fascinated Daumier because numerous sketches by him in black chalk of powerfully built figures wrestling have survived, some of which were apparently based on Gustave Courbet's *Wrestlers* (1853). In addition, Daumier also made a lithograph, less caricatured but equally as brutish as *The Thieves and the Ass*, of two ragged and drunken street brawlers sprawled on paving stones, going at one another unmercifully. I have no doubt that Gwathmey at least saw the lithographs during his stay in Paris in 1949–50. He transformed them stylistically because, except for the sketches, Daumier's men struggle horizontally on the ground rather than standing up. The concept and the connection between the brutality of war and hand-to-hand combat, however, he clearly derived from Daumier.[23]

Gwathmey may also have been familiar with Paul Manship's bronze with a green patina, *The Wrestlers* (1915), which is in the Metropolitan Museum of Art and was acquired in 1927. Jack Levine, moreover, has done *Cain and Abel* twice, once thirteen years before *Homo Sapiens* and a second time ten years after. The first (which is in the Vatican Museums) is more brutal. Cain is brandishing a jawbone and is holding Abel down, about to smash him with this primitive but devastating weapon.

In Levine's 1983 painting, Cain has already killed Abel and is standing next to him, holding a huge rock and contemplating his vanquished brother—a comparatively mean version but calmer and less violent. The vicious act has preceded the scene depicted. Like Gwathmey, Levine is intrigued by the biblical notion of the "mark of Cain," and his second rendering of that motif is deliberately intended to be more mysterious. Because homicide had never before occurred, Levine feels that Cain could not fully understand that he had done something wrong. The act had not yet been defined or judged.[24]

It made a strong impression on Levine that when Bob Gwathmey was in his drinking mode at parties, he seemed to enjoy knocking people on the arm, perhaps harder than he realized, since his mood was jocular, not hostile. Levine recalls a party in Greenwich Village during the early 1960s when Edward Hopper, by then elderly and frail, circled warily, keeping his distance from Gwathmey to avoid being hit on the arms. Gwathmey

could become very physical, and Hopper genuinely feared suffering a broken bone.[25]

There is an intriguing asymmetry between the violence that Gwathmey depicted among men during the 1970s and his changing depictions of women. The latter are more difficult to explain unless we ascribe the serenity and declining physical mobility in his late pictures of women to his own advanced years. Was he literally feeling his age and projecting that onto his female subjects? *Ecstasy* (1968) and *Silhouette* (1970) are large oil paintings of women in motion. The woman in *Ecstasy* is literally twirling and dancing, a bouquet of flowers in one hand and an immense aureole of flowers above her head. (This work may well have been inspired after he viewed pictures by Gustav Klimt and then took a flight of fancy while seated at the easel.) The prominently rumped woman in *Silhouette* holds a large feather duster in her left hand while she adjusts a large vase of flowers with her right. In each picture the colors are as vivid as the women are active.

During the mid-1970s, however, Gwathmey's women are not mobile. In *Vendor* (1974) the woman stands perfectly still, holding a piece of fruit in each hand while a colorful array of produce is displayed behind her, arranged ever so tidily like a Louise Nevelson configuration of horizontal open boxes. In *The Appraisal* (1976) the subject is seated and holds a red vase for a man who looks like Gwathmey to inspect. It is either a moment prior to an auction or else a client is seeking to learn the market value of an objet d'art. In either case the painting has no life, and the woman's chalky white face (in contrast to the client's tawny skin tone) is like a death mask.

Except for the chalky face, which appeared with growing frequency on Gwathmey's women in his later years, it is not even a characteristically Gwathmey painting. A clue to what he intended by this ultra-white device can be found in an unexpected place, however: the necrology that he wrote in 1973 about his best friend, Philip Evergood, for the American Academy and Institute of Arts and Letters. He noted Evergood's penchant for accepting portrait commissions that he eventually hated because he disliked the people and their pretentious lifestyle. "One time it was an ill-advised husband who had lost his way in 'the little woman and the kids' syndrome. The props were made to order. The wife was youngish, blondish, dressyish and richish—one of those white-on-white cosmetic displays that are seen at intermission on opening nights. The two sons, weak and clinging, completed the grouping."[26] White-on-white cosmetic displays became Gwathmey's metaphor for fashionably stylish, bourgeois, vain women. He did not like them and made a statement of them by exaggerating their chalky faces to the point of caricature.

By the close of the 1970s his depictions of women became even more complex: almost expressionless and enigmatic, yet sometimes explicable nonetheless. *Petrouchka* (plate 38) took its inspiration from a ballet for which Igor Stravinsky wrote the music. It was first performed in Paris on June 13, 1911. Sergei Diaghilev saw the dramatic possibilities in a ballet about puppets that come to life and persuaded Stravinsky to compose an appropriate score. We do not know what brought *Petrouchka* to Gwathmey's attention in 1980, but it turns out to have been tailor-made for his lifelong concerns about racism as well as his distress during the 1970s about the inherent human capacity for cruelty.

The intensely dramatic narrative in *Petrouchka* concerns an old Charlatan who produces for an astonished crowd three puppets that he brings to life by touching them with a flute: Petrouchka, the male (and the "good guy"), the Ballerina he loves, and a wicked Moor. Petrouchka and the Ballerina are white, and the Moor, of course, is black. In the third tableau the Ballerina enters carrying a cornet. She dances faster and faster, accompanied by the Moor, who takes her in his arms. When a wildly jealous Petrouchka appears and tries to seize the Ballerina, the Moor uses his sword to drive Petrouchka away while the Ballerina faints. In the fourth and final tableau, as night is approaching and snow is falling, Petrouchka dashes out of the little theater followed by the Moor, who catches up with him and kills him with a blow to the head from his sword. Petrouchka dies with a faint cry on his lips. The Charlatan then attempts to reassure the anguished crowd by changing Petrouchka back into a puppet again. Although the crowd disperses, the Charlatan is terror stricken by a vision of the ghost of Petrouchka, who threatens him and mocks all who have been fooled by the Charlatan.[27]

In this classic of modernism in music and ballet, Gwathmey found a narrative of interracial rivalry and brutal violence—horrible inhumanity once again. In the painting the Ballerina's feet are dainty and wearing toe shoes. Her hands are not real because they are the hands of a puppet. The evil Moor cannot possibly be paired with the pale-faced Ballerina. The audience must be led to fear him first and then despise him because of his brutality. This interweaving of racial tension and violence clearly intrigued Gwathmey because he made a serigraph of *Petrouchka* in 1980 and a smaller version in oil a year later.

There may even have been a carryover from the folk-influenced melodic vocabulary in *Petrouchka* because Gwathmey also painted *Folk Dancers I* and *II* in 1980, a large and a small composition, each with two black women carrying baskets on their heads. Although their feet are planted in a ballet position, they lack movement and convey only a hint of potential vitality, like puppets that could come to life given some provocation or perhaps a Charlatan with a magic flute. *Vegetable Lady* (1980) also lacks the vitality and energy that Gwathmey had instilled in *Ecstasy* and *Silhouette* a decade earlier. Even the Ballerina who dances with such verve in *Petrouchka* the ballet only steps forward daintily and tentatively in Gwathmey's *Petrouchka*.

As a counterbalance to this female sobriety and self-restraint in 1979–81, there were occasional exceptions in Gwathmey's late art depicting women. These were inspired moments when the creativity, affirmation, rich coloration, and satirical touch of the two decades following 1945 reappeared. In 1977, for example, he painted *The Quilt* (plate 39), giving us once again a purposeful black woman with a wonderful African masklike face, an improbable mixture of tobacco plants and other vegetation in the background, a luminescent tangerine-colored sky, and most important, a meticulously draped quilt in blue and lavender, all adding up to a combination of colors that should not succeed yet astonishes and delights the eye.

The Quilt as well as the quilt itself offers a satirical comment, once again, on Op Art, because Gwathmey is showing that he, too, can be a master of that kind of geometric

image. He places it, however, in a more complex composition where a human figure is doing something socially and culturally useful against a background of lush natural growth, all enlivened by brilliant colors that do not blend so much as spark one another. It is a painting that demands multiple looks by the viewer: to the masked face, to the diverse and flourishing plants, to the horizontal planes of the earth-line and horizon at cross purposes with the vertical insistence of the woman's arms, like a semaphore, accentuated by the verticality of her torso and what rises behind her—perhaps a porch pillar. (The verticality in this composition repeats the upraised arms of a farmer in *Dialogue* [1964].) If, indeed, she is quilting on a porch, with the cultivated field behind her, then Gwathmey has managed to pull into a single mature work, at age seventy-four, an array of motifs and messages that draw us back to his social emphases in the 1940s combined with his artistic criticism of the decade 1958–68 and his more personal, contemplative compositions that followed *Homo Sapiens* in 1973. *The Quilt* is a splendid tour de force of a career above which the sun had passed its zenith.

The Quilt also calls to our attention an array of artistic touches so typical of Gwathmey. One that has been noted several times is the use of African American masklike faces, a trope that may well have been influenced by Picasso but is rendered in a manner that is distinctively Gwathmey's own. A second touch is the richly decorative portrait of a woman whose costume and casual pose compel us to look and look again, as Diego Rivera did in works such as his *Portrait of Senorita Matilda Palou* (1951).[28] A third (not yet mentioned) is the way that structural lines in the built environment or lines in the natural setting run continuously through the human figure. Here the horizontal line of the woman's waist is continuous with the horizon line, just as in *Saturday Afternoon* so many lines run vertically from the buildings into human bodies (plate 11). Over the years this had become one of Gwathmey's most characteristic signature traits.[29]

In tandem with his careful cultivation of a personal style, Gwathmey also believed in national artistic tendencies—a point of view much at odds with the internationalism of the 1950s and 1960s, and one that marks Gwathmey once again as a maverick. He became quite adamant about this point in his extensive 1968 interview for the Archives of American Art.

RG I mean, you're an Englishman, you're a Frenchman, you're an American, whatever you are. You are *that*. And I don't want to be insular, of course, I am not. But still and all there's something underneath us, something within us, something in our orbit that marks us as being American, English, French, Dutch, so forth.

PC You can't get away from what you are.

RG No, and you shouldn't strive to. Now to be insular is, again, a dirty word. And I don't want to be insular because it suggests that you have no breadth. I know I'm insular to an extent but it doesn't mean that I don't enjoy French culture, of course I do. Or Italian culture. Or that I don't enjoy visiting those people. Gosh, it's the greatest bang. But still I leave there lonely. After the excursion I leave there lonely. I come back home and

I'm no longer lonely. And so you are what you are. Your spirit impels this. And it's nothing to be ashamed of. When people say that art now is an international style, well, I can still see that Japanese non-objective painting is not American non-objective painting.[30]

Gwathmey's affection for certain aspects of the American scene comes through clearly in several works done in the decade following 1970, paintings with elements of pleasure and affirmation that counterbalance the grim vision of *Phrenetic Confusion* and *Homo Sapiens*. In *Country Gospel Music* (plate 40), for example, eight figures are singing their hearts out, with a rural church not far behind them in the background. A fiddler and a guitar player perform calmly while three young men and three women seem deeply moved by their total engagement in song. It should be noted that in the 1968 presidential campaign, Richard M. Nixon borrowed a successful tactic from George C. Wallace for his so-called Southern Strategy: using country and western bands to attract the "common man (and woman)." Gwathmey could have had that ambiguity or irony in mind, because the political culture of 1968 engaged him intensely.

In *A Big One* (1981), Gwathmey presents a man in a skiff trying to land an immense fish that has leaped and twisted above the water line. He had customarily gone to the seashore for a month or more each summer and very much enjoyed fishing and clamming. (As late as 1974 he was still inclined to make the very large composition called *Clamming* [fig. 44]), in which a young man with a rake has his ear to the sand, listening at low tide for the tell-tale squish that meant clams were just below.) I suspect that *A Big One* is the sort of work that Jack Levine has described as something an artist does purely for his own pleasure. It is an enthusiastic painting that offers the viewer gusto in its action as well as its vivid colors.

Both *Country Gospel Music* (1971) and *A Big One* (1981) have panoramic orange-red backgrounds, a vast sky in shades that we have become accustomed to with Gwathmey. Just as *The Quilt* provided a commentary on the limitations of Op Art, these two works may well be ruminations by Gwathmey on the sterile limitations of large monochromatic surfaces by artists such as Barnett Newman or Mark Rothko. Once again Gwathmey seems to be saying that he, too, can fill a large canvas with a dominant color subtly shaded into off-tone nuances here and there. But isn't it more interesting to insert a few human figures to give the painting, quite literally, some life, not to mention giving the viewer some focus?

By the late 1970s Gwathmey clearly began to feel doubts, and perhaps even occasional depression, about his waning creativity as an artist and his isolation as an exponent of Social Realism, a movement in the art world whose time had come and gone. A painting such as *Isolation* (plate 41) may well reflect feelings of geographical and social isolation as well as having been bypassed as an artist. Amagansett, after all, is several hours from Manhattan, which Gwathmey had viewed as the center of the universe since the 1940s.

The mood and meaning of *Isolation* are particularly poignant because Robert and Rosalie Gwathmey had always been such gregarious and social people. During the 1940s and 1950s their seven-room apartment on Central Park West had been the frequent meeting place both for their Marxist discussion group and for purely social gatherings. Men and women now in their seventies and eighties warmly recall the wonderful parties given by the Gwathmeys, parties at which liquor flowed freely and artists, writers, and actors mingled with lively characters such as Zero Mostel, Mel Brooks, and Pete Seeger. A Gwathmey party was predictably a special event.[31]

The Gwathmeys swiftly acquired many friends in the Hamptons once they stopped commuting to Manhattan and settled there permanently in 1968. Perpetuating their customary lifestyle during the 1940s and 1950s, their home was always available for lively social gatherings as well as fund-raising parties for worthy causes, such as antinuclear and civil rights activism, aid for migrant farmworkers, and financial support for Alger Hiss's legal fees. Gwathmey also donated paintings to benefit causes that he believed in. He was involved in 1972 when Artists of the Hamptons raised money to support George McGovern's presidential campaign, and again in 1976 when forty-eight artists signed a statement protesting the selection of Baghdad as the site for the eighth World Conference of the International Association of Art. On July 4, 1976, the bicentennial of American in-

dependence, the *New York Times* reported that the Gwathmeys had hosted a fund-raiser for the National Emergency Civil Liberties Foundation, at which Alger Hiss spoke.[32]

It certainly did not hurt that the Gwathmeys lived in one of the most interesting and written-about homes in the United States—a collage of volumetric forms—frequently featured in essays about contemporary architecture and gracious exurban living (fig. 62). The house is not large, but its level lawn extends forward and back so that in lovely weather people can spread out and enjoy the sea breeze from the Atlantic Ocean two blocks away. The main attraction, as always, however, was the Gwathmeys' personal charm and gracious hospitality.

An enchanting symbol of that abundant hospitality is *Farmers' Market* (plate 42), in which an elderly but handsome African American couple sit with their available produce spread before them. The painting is arrestingly colorful and clever, not merely because of the couple's clothing and their baskets, but because Gwathmey deliberately painted the background two different shades of Carolina blue that almost but do not quite match. He seems to be saying that the couple share a common background, but they have been rejoined harmoniously despite the fact that at some point that shared history was sundered. I know of no better explanation for the fact that each of the two figures has a slightly different shade of blue as a backdrop, rather than a seamless expanse of color. The Gwathmeys' lives together since 1929 had been close but not seamless.[33]

Although people who did not see Gwathmey often, or who saw him only socially, recall his disposition as sunny, the trajectory of his overall outlook during the 1970s might be summarized succinctly as veering toward frustration and isolation. Obviously he did not appear sullen every day of the year, but frustration and isolation were becoming the predominant messages projected in his art. American prosecution of the war in Vietnam, urban riots, and violence in trouble spots around the world prompted him to accentuate the human capacity for beastliness—not merely the potential for it but the actual realization described daily and graphically in the media. His manifest activism, particularly in the peace movement but in other political causes as well, persisted through 1976 and then began to ebb as he reached his mid-seventies.

To the extent that Gwathmey's art was a manifestation of his mood, in the 1970s it moved back and forth between positive and negative poles. Both his style and his subject matter became somewhat less distinctive and more diversified, in part because his creativity may have been waning but mainly, I believe, because subjects other than African American life and race relations engaged his attention. He began the decade with expressions of concern about the consequences of relative affluence for many people and poverty for others. He ended the decade with artistic ruminations about religious hypocrisy and affirmations of reconciliation with Rosalie, epitomized, for example, by a modest painting titled *Harmonizing* (1979).[34] Even so, his son regards *Homo Sapiens* not merely as a protest against man's inhumanity to man, but also "a statement of incredible loneliness."[35]

CHAPTER EIGHT

End of the Season

In the summer of 1980 the well-known Social Realist painter Raphael Soyer and his wife went to the Hamptons and rented a house in Amagansett. They did not have a car because neither one knew how to drive. As permanent denizens of New York City, they did not need to and had no space for a car, in any case. Soyer promptly declared that he would like to paint a portrait of Robert Gwathmey. Assuming that the requisite sittings would require only several days, Gwathmey agreed, and he posed in his own studio (plate 43). Somehow, Soyer's work went ever so slowly and dragged on for a month.

Meanwhile, the arrangement became an unanticipated burden for Rosalie Gwathmey. She had offered to pick Raphael Soyer up each day and bring him to their home, where the studio was located. As she recalls, however, Rebecca Soyer, "dear soul, would be standing at the door, pocketbook in hand and [would say], 'as long as the car is going thought I might as well go.' So I took her shopping, laundromat, P.O., etc. When I returned Raphael we picked up laundry at the laundromat. I hated the portrait and Bob could never have looked as sad (like crying) as Raphael portrayed him. He must have put 'Singing & Mending' [plate 5] in it but Bob never had his work hanging. I don't recall that."[1]

Milton W. Brown, a distinguished art historian, offers the perspective of someone who did not have to serve as chauffeur and hostess. A personal friend of both Raphael Soyer and Robert Gwathmey, Brown had his portrait painted twice by Soyer not long before the painter died in 1987 at age eighty-eight. Writing the introduction for a catalog to accompany a posthumous Soyer exhibition in 1989, Brown asserted that Soyer "was one of the finest portrait painters of our time. His sitters all seem to have brought into the studio and for that moment their burdens as well as the context of their lives. The

catharsis lies in our recognition of the artist's all encompassing insight and empathy. It is clear that all his people, including his portraits, have something of Raphael in them." Like Gwathmey, Soyer remained, to the end of his days, a committed advocate of Social Realism, but in its urban matrix. Brown considered Soyer the very last of the Ashcan school of painters, insisting that "gentle and shy as he seemed, he was an intellectual and moral tiger."[2] Perhaps this Russian-born child of New York City poverty felt out of place in tidy and affluent Amagansett. In any case, whether or not his portrait of Gwathmey is a good one may best be determined by comparing it with a photographic portrait made three months later (fig. 63).

Virtually all of the images that Soyer situated in the background behind Gwathmey are identifiable and aptly chosen: Gwathmey's own *Singing and Mending*; a print of Picasso's famous *Three Musicians* (above Gwathmey's head); Van Gogh's *Sunflowers* (upper right); a sculptured nude by Gaston Lachaise; and a portrait of a woman by Soyer himself, perhaps an allusion to Gwathmey's attraction to and for women. Finally, the rather solid panel of a red painting directly behind Gwathmey's head may allude to the dominance of large, predominantly monochromatic works by Barnett Newman, Ad Reinhardt, Mark Rothko, and others—work that Gwathmey did not care for and that may account for the exceedingly pensive (even sad) expression on Gwathmey's face in the portrait. If that impression is correct, then Soyer's choice is more descriptive than ironic. It is a portrait of an elderly painter who felt distressed by the strange fate of modern art in the United States.

Rosalie Gwathmey has always been gracious and hospitable. Between feeling put upon and disliking the portrait as well, it surely must have been a trying month. To me, however, the portrait captures a career as well as a mood. The picture on the wall above Gwathmey's head, appropriately enough, is a photograph of Phil Evergood, his best friend until 1973, when Evergood, either drunk or possibly suffering a heart attack, allowed his shirt and mattress to catch fire from a cigarette that he was smoking in bed; he died tragically in a blaze that consumed him as well as his bed. The loss of his boon companion of three decades was a difficult blow for Gwathmey and initiated, at age seventy, his own intimations of mortality.[3]

The two men had shaped and shared a heartfelt mutual admiration society. Gwathmey genuinely regarded Evergood as a genius. "I do consider you our greatest draughtsman," he wrote in 1965. "Ben Shahn more and more seems artificial to me—rather manufactured and forced." Two months earlier Evergood had told Terry Dintenfass, "I'm looking forward to Bob's show in January—besides loving him personally I think he is one of the greatest humanist painters of to-day."[4]

When Gwathmey gave a memorial address for Evergood at the American Academy and Institute of Arts and Letters, he began by bringing attention to an aspect of Evergood's temperament that was the very opposite of his own. "Where to begin, with this many-faceted original? Perhaps with his houses in all their clutter. . . . There was clutter at the Evergoods, but it was an accumulation, not a collection. However, all of these odds and ends had quality and they mushroomed accordingly. There weren't enough mantle-

FIGURE 63
Robert Gwathmey in his
studio at Amagansett,
September 25, 1981.
Photograph by Lenore
Seroka, Great Neck, N.Y.

pieces [*sic*] to go around and the shelves were creaking, and finally the top of the corner cupboard was almost out of sight. One had to put stuff on the floor in order to set the table." Gwathmey concluded by calling attention to Evergood's habit of jotting down aphorisms on scraps of paper and then randomly tacking them to the walls of his studio. One of the very last postings in this modest museum of maxims came from Thomas Mann and conveyed Evergood's contempt for trendiness, for following bandwagons, and the failure or absence of personal conviction. As Gwathmey wrote, "The essence of it was that in the history of writing, the great authors were recognizably, at seventy-five years, the same writers as they were at thirty-five. He was assured and staunch in his beliefs—no metamorphosis."[5] In that respect he found grounds of convergence rather than difference. Gwathmey might just as easily have been describing himself in his seventies. He, too, had remained true to his long-standing commitments.

Gwathmey had been elected to membership in the American Academy and Institute of Arts and Letters in 1971. Two years later he received another, somewhat belated honor: election to the National Academy of Design as an associate academician, an entry-level recognition that has since been abolished. For generations election to full membership in the National Academy took place in two stages: associate and then (usually several

years later) full. For a long time the honored artist had been required to donate a self-portrait as the "price of admission." By 1973, however, the requirement had been sensibly altered to a painting characteristic of the artist's work. Consequently, on January 7, 1974, Gwathmey gave the academy *Three Share-Croppers* (n.d., oil on canvas, 20" × 20"), in which the ground is pale mustard and the sky lavender. Against that backdrop three men hold a shovel, a hoe, and a sack, respectively. Two years later, when Gwathmey achieved the status of full membership, his "diploma presentation" was *Soft Crabbing* (n.d., oil on canvas, 20" × 15"), which has a pink background inflected with patches of gray, against which appear an African American man and a boat that seems to be wedged against a sandbar. These two small, retrospective pieces are unspectacular, yet they could scarcely be more representative and consequently are instantly recognizable as quintessential works by Gwathmey.[6]

I do not believe that he spent much time contemplating his artistic immortality or his posthumous reputation in the history of art. Over a span of more than three decades Gwathmey had read too many reviews and assertions written by art critics that turned out to be ridiculously wrongheaded. As early as 1949, for example, almost the first time Gwathmey saw his work reviewed in the *New York Times*, he encountered an essay by a serious critic (in a piece quite complimentary to Gwathmey) who regarded Matisse primarily as a clever colorist and a highly decorative painter—a charge that would be leveled against Gwathmey himself years later. This reviewer was perceptive enough, however, to notice Gwathmey's debt to both Picasso and Matisse, but then went on to add, "Gwathmey is a decided individualist and he has too much respect for the individual to deny him or to disdain frankly emotive painting. When he depicts the individual it is not illustratively as a figure in an anecdote but as a symbol of a race or a group, which lends a satisfying universality to subjects that in other hands might become mere story-telling."[7]

A 1965 letter that Gwathmey wrote to Evergood, however, reveals not merely his knowledge of art history, but his awareness of the capricious vagaries of reputation in the realm of painting.

> Just yesterday I mailed you a paperback on Glackens and the others of the Eight. I picked it up and enjoyed the anecdotes and bits of information. However, the book written by Glackens' son is too homey and saccharine and never seems to reach his fathers' fibre. Your friend John Sloan seems hardly to exist and the "sweetness and innocence" of the Prendergast two [Maurice (1859–1924) and Charles (1868–1948)] seems to occupy him no end. Oh well, you'll be provoked into reminiscenses.
>
> By the way I spent several sessions posing for Moses [Soyer] who, like you, is filled up to there with tales of the several periods—the twenties, today, with the depression and the war in between. It isn't right that this should go unrecorded. Milton Brown's book—the Armory show and up to the depression stops too short.[8]

Despite Gwathmey's realistic understanding that reputations in the art world could be so ephemeral, that the persistent pattern of trendiness in painting had become even

more pronounced since the 1950s, and that art critics could be a feckless, opinionated bunch, he nonetheless entered a moody phase between 1977 and 1981. That phase is explicitly conveyed in his visual work, but our confidence about what the most crucial paintings were meant to say subjectively is limited. He never discussed their content with either his wife or his dealer.

In *Isolation* (plate 41), for example, Gwathmey himself appears to stand front and center as a sadly shabby man, his arms hanging limp and helpless by his sides, before a vivid pink background. The symbols included are unambiguous. First, there is a set of road signs so choked with vines that it is impossible to determine any clear direction. The subject, and perhaps the painter as well, are hopelessly lost. Second, we find a trio of elderly people to the left, two women and a man. Third, in the distance stands an old structure burning—Gwathmey's favorite image for the passage of time and, even more, for all that is ephemeral. Earlier in his career, ruined tobacco barns had served as a visual metaphor for the backward, burned-out South (see fig. 20). Late in life they seem to have become a symbol of himself as an artist in precipitous decline. It is a poignant and direct pictorial statement.

In 1979, following a visit to Little Rock, Arkansas, however, where *Isolation* had been brought after its purchase and put on public display at the Arkansas Arts Center, Gwathmey responded to an explicit request that he elucidate his picture.

> There were a number of prosecutions of owners of old people's nursing homes in this area [Long Island]. Peculation of funds, defrauding government agencies, double book-keeping etc. There was so much talk of lonelyness and isolation that I was stirred and incensed.
> Now the symbols: —
> The figures are separated both in attitude and placement.
> The route signs almost obliterated by vines suggests lack of mobility.
> The burning house suggests loss of identity or place.
> Now to put it together: —
> Add a bit of humility (not too much).
> Consider the ingredients.
> 1. Surface
> 2. Color
> 3. line
> 4. the two dimension aspects
> 5. the three dimension aspects
> 6. light[9]

In this fascinating situation Gwathmey subsumed deeply personal feelings into a pictorial account of a major and highly publicized scandal of just the sort that would have outraged him in any case, but particularly at age seventy-four. It is characteristic of Gwathmey that his elucidation of the painting gave comparable weight to the socioeco-

nomic stimulus, to the symbolism, and to his enduring concern for aesthetic qualities. The scandal remained prominent in the news throughout 1976–77 and resulted in legislation that opened nursing home financial records and inspection reports to public view. It also provided that nursing home owners convicted of felonies in connection with their operations would automatically lose their licenses—most notably for overbilling Medicaid, one of the most egregious offenses exposed in the courts that year. In this instance Gwathmey had personalized a stunning public exposé while giving vent to his anger at a crisis uncovered in twenty states almost simultaneously.[10]

In 1979 he also painted *Nobody Listens* (plate 44), another uncomplicated icon in which a doll- or puppetlike white man sits sprawled, his head bowed, in front of a column and urn that customarily stood for the crumbling of southern myths and self-deception. Gwathmey is seated nearby, holding a book and gesticulating while reading aloud to members of a crowd who pay no attention whatsoever. A white woman lies collapsed on her back in front of him, either asleep or dazed. It is a scene of slothful immobility and utter indifference. It is also unmistakably Gwathmey in terms of style, but perhaps not so distinctively in its subject matter. We know, for example, that during the last decade of his life Thomas Cole felt that his views concerning art and society were being totally ignored. For artists to feel that no one listens was hardly a new phenomenon.[11]

Two years later Gwathmey painted *Drought* (plate 45), a subtle image of two men kneeling in dialogue, one of whom is apparently the artist. The remains of a dilapidated structure (once again) stand precariously behind them. To the left, two rural mailboxes rest on a wagon wheel; one of them, at least, appears to be empty. Perhaps that is an emblem of the absence of invitations for museum purchases or exhibitions. More important, however, is the likelihood that Gwathmey recognized he had not ceased to be productive as an artist but that his work was no longer either new or innovative. It was *that* kind of drought. This picture is less openly a cri de coeur than *Isolation* and *Nobody Listens*, yet it resonates powerfully with those two images nonetheless.

Moreover, when we turn from these three introspective pictures to the rest of his output during the last years that he painted, we have reason to be impressed by his contemplative candor rather than by his loneliness or self-pity. He may have known as early as 1980–81 that he had Parkinson's disease, a progressive disorder of the central nervous system. The disease seems to have been arrested until about 1984, the last year for which we have documented work, yet Gwathmey was clearly aware that his remaining days as a productive artist were numbered.[12]

His final paintings seem to fall into four categories. First, there are still lifes of physical objects rather than flowers (which require greater precision), works that are somewhat unusual for Gwathmey because they have varying degrees of depth and perspective rather than his customary flatness and uncompromising use of no more than two dimensions. In *Dark Table* (fig. 64) it is not clear whether we are looking down into a room or back into one or perhaps both. In either case, depth has been declared by symmetrical geometric lines.

FIGURE 64
Dark Table (1976), o/c,
36 × 30. Courtesy of the
Terry Dintenfass Gallery,
Inc., New York.

In *Star, Lemon, Egg* (1981) the emphasis once again is on geometric forms and depth in a painting that actually required considerable precision. Perhaps after he was diagnosed with Parkinson's, Gwathmey felt determined to demonstrate that he still had the skills of a draftsman. *Yellow Tables* (1982) is also an exercise in geometry and symmetry, though the two tables placed side by side—one with a gray background and the other with blue—may be a metaphor for himself and Rosalie, still sturdy and side by side after forty-seven

FIGURE 65
Charles Gwathmey
in a basket, 1938.
Photograph by
Rosalie Gwathmey.

years, even though one of them is losing color and beginning to fade. That is no more than speculation, though it is not idle or uninformed speculation.

In a second category, *By the Sea* (1979) (it has since been destroyed in a fire), shows a crowded beach scene that harks back to *Winter's Playground* (plate 6), but the colors are more sober. There is a head without a body lying just to the left of center, between the well-tanned torsoes of a man flexing his muscles in the manner of Charles Atlas and a bikini-clad woman whose hat covers her face so completely that her identity is obscured. It is an unusual composition for this period because there is such a blending of bodies and beach umbrellas. Most of his work at this time was becoming more austere, with multiple figures being supplanted by expanses of open space in colors that might be called minor key—that is, sad tones.

The third category of work seems to combine nostalgia with a reluctant acceptance of what time inevitably brings—aging and decline. In *Farmer and Scareman* (1980) a farmer wipes his brow despite the absence of any sun as he stares at a scareman in a field devoid of vegetation. The stare is vacant, however, because Gwathmey has given the farmer blank rings for eyes—a quiet message that Gwathmey himself suffered from cataracts in his later years, which appreciably dimmed the brilliance of his coloration and occasionally depressed him. The scareman might well be emblematic of the grim reaper, although he has not frightened a big black crow brazenly perched on his shoulder. The sky is colored a very grim gray.

In *Playground* (plate 46), an aging Gwathmey wearing only shorts and clutching a horseshoe in each hand walks in front of a railroad signal. Hoping for good luck and avoiding bad luck had always been prominent in his iconology. But Gwathmey loved to

play horseshoes in Amagansett. Off to the side three much younger men, who seem to be undistracted by the possibility of an oncoming train, try their luck doing a precarious walk along one rail of a track and flying a kite. The trio bear a striking resemblance to young Charles Gwathmey and two close friends, captured in a photograph taken decades earlier by Rosalie at a summer beach house.

A third image in this group is unquestionably nostalgic and affectionate, *Mother and Child* (plate 47). It seems to have been Gwathmey's last painting conceived in a genuinely upbeat mood and contains unmistakable Gwathmey characteristics. The top of the mother's right arm is absolutely aligned with the clothesline, and the heavy dark line evokes those medieval stained glass windows that Gwathmey so loved. His signature feedbags from the 1940s are also present, but the deeply personal and autobiographical aspect of this painting is the baby in a basket in the lower right-hand corner. This image is derived directly from a photograph taken by Rosalie in 1938 when Charles Gwathmey was six weeks old (see fig. 65). By 1981, of course, Charles had indeed become a "star" in the firmament of American architectural practice, already elected, like his father, to membership in the American Academy and Institute of Arts and Letters.

The exemplar of negative nostalgia in this third cluster is *Crossroads and Tobacco Barns* (1981). Gwathmey's last work of social satire, it is reminiscent of several works in this genre that he had done decades before. The painting includes a hypocritical preacher balancing a cross extended from a pole resting precariously on his chin; an acrobat doing a perfect handstand using only one arm—a feat of strength, balance, and body control impossible for an elderly man with Parkinson's disease; a sharecropper warming himself at the remains of a chimney; and a black farming couple behind barbed wire and cotton, two elements responsible for the "imprisonment" of poor southerners who worked the land, especially while Gwathmey was growing up. This picture uses the same sobering blue that Gwathmey emphasized in *By the Sea* (1979) and *Yellow Tables* (1982). It also places in the middle distance and background the small-town, unpainted architecture that had been so prominent and familiar in his work since the early 1940s.

The fourth category, virtually his final phase, follows logically on the cooling beached sobriety of *By the Sea* (1979). *The Large Umbrella* (1982) depicts a slender white woman holding up a big parasol against a deep blue sky whose implications are ambiguous. Hers is not a happy face even though the hat she wears is richly garlanded. This is the last and largest blue panel; the pastel pink and lavender of the open umbrella are almost jarring against the strident, intense azure of a sky that is either blazing or foreboding, but in either case not comfortable. Gwathmey insisted on the desirability of "contrast" in his work to the very end.[13]

Sun (1982) seems to be a companion piece, but here Gwathmey has eliminated the element of ambiguity. A stolid woman draped in a grim gray and brown caftan holds up a parasol despite a menacing sky above her. Her face is turned upward, and she extends a hand beyond the space covered by the umbrella, perhaps to check for rain. Well behind her, however, is a lengthy row of beach umbrellas in vivid hues. Perhaps the people there

are indeed enjoying strong sun and do not feel threatened by rain. If so, this painting appears to be a generational statement: what threatens the elderly does not threaten younger men and women, who perhaps feel invulnerable to the elements, if not immortal. In any event, *Sun* is a careful study in contrasts—of color, mood, and assumptions.

End of the Season (plate 48) is pictorially somewhat less gloomy, perhaps, but three women with parasols on the beach are virtually alone because the area is all but abandoned. Moreover, the women are fairly well covered, so it is very likely a cool day. The parasols protect them from burning even though the air temperature must not be very high. *End of the Season* seems to be a self-evident image that stands for the end of an artistic career, an old trope in Western art, actually, in which the cycle of the seasons is commonly conflated with the human life cycle. In 1968 Gwathmey did say, soon after sampling life in Amagansett, "I love the seasonal changes here." Fifteen years later, however, when he was eighty years old, the seasonal cycle conveyed a more ominous burden of meaning.[14]

The last painting by Gwathmey whose date seems reasonably certain is technically untitled, though it is informally called *Man Drinking* (1984). It manages to be colorful, even lively, although the solitary man portrayed does suggest loneliness and a problem that he either cannot or does not choose to control. Inset, as a kind of cartouche, an equally singular man stoops in a field to pick cotton. Perhaps it serves as a reminder that Gwathmey himself had picked cotton on Mr. Brown's farm near Rocky Mount, North Carolina, in 1944, or perhaps it is a reminder that he had painted that motif during every decade of his career. (The earliest recorded version of *Man Drinking* was painted around 1945. In the Parke-Bernet sale records for January 19, 1950, it is described in the following manner: "A barefooted man in working clothes, his head thrown back, is about to drink from a wooden cup with a long red handle which he is holding in his raised right hand, the left extended to grasp a yellow broomstick; a wooden pail before him and a woman busy with her laundry in the background.") He thereby signed off in this familiar pose with a reprise of his personal life as well as his artistic career.

Perhaps that psychological self-portrait, possibly his last completed painting, simply says, "It's all over. I think I will indulge." Gwathmey surely knew that Daumier, one of his idols, had painted many images of men drinking, though never in Gwathmey's characteristic manner, with the head tilted way back, taking a liberal swig.[15] Gwathmey also never concealed his unquenchable thirst for liquor. If anything, he seemed to revel in it. Early in 1979 he responded to a query from a curator at the Hirshhorn in his inimitable fashion, blending art history, autobiography, and wry humor.

The first secular painting, completely free of any religious connotation, was the Lorenzetti in the city hall of Sienna. The central figure is "Peace". One grouping represents good government, another bad government. Another section of the mural depicts the division of the land. That's a fine start. Then Giotto, whose life overlapped Lorenzetti's took St. Francis, Patron saint of the birds and beasts translated into do-

mestic animals. Son of wealth took the [vow] of poverty and the whole life is depicted, birth to death on a number of frescos. Fine propaganda for the rural farmer coming into the emerging towns. Surely these are my roots and the tradition does run through Brughel, Goya, Daumier, Van Gogh etc.

Pardon the scribble, I don't feel like thinking this week.

Just got back from two weeks in Peru. We made it to the headwaters of the Amazon and I was trying to recount the world's over-sized rivers and my wife wasn't much help so I said, "Of course the Amazon, Missippi, Nile and the Vodka."

That reminds me and I feel better already.[16]

Robert Gwathmey was no closet drinker. Rather, his enjoyment of alcohol seemed to amuse him. On May 23, 1985, the Cooper Union opened a retrospective exhibition of Gwathmey's drawings, watercolors, and paintings in his honor. At the reception that afternoon a young waiter approached Gwathmey and asked him, "What would you like to drink, Mr. Gwathmey?" His six-word response came swiftly: "Whatever you have the most of."[17]

That handsomely diverse exhibition of fifty examples of his work turned out to be one of the last during his lifetime as well as the most comprehensive prior to the major posthumous retrospective organized by the Butler Institute of American Art in Youngstown, Ohio, that opened in September 1999. (Joseph Butler admired and purchased several important works by Gwathmey; his wife, Dorothy, lived with Rosalie Hook when the two young women attended the Pennsylvania Academy of the Fine Arts at the beginning of the 1930s.)

The Cooper Union show incorporated works spanning half a century, ranging from *Senator*, a pencil drawing done in the 1930s, to *Yellow Tables*, the oil done in 1982. It included many of his most significant and symptomatic pieces, such as *Ancestor Worship* (1945), *Sowing* (1949), *Soft Crabbing* in several media versions, *Queen Anne's Lace* (1966), *Striped Table Cloth* (1967), *Section of Town* (1969), *United* (1969), *Phrenetic Confusion* (1971), *Homo Sapiens, Late Twentieth Century* (1973), *Farmers' Market* (1977), *The Quilt* (1977), *Nobody Listens* (1979), *Petrouchka* (1979), and *Drought* (1981). The show thereby offered several glimpses of the artist in self-portraits, along with rarely seen line drawings that were meticulous, bare-bones versions of some of his best-known oils.[18]

Less than a year before, the Guild Hall Museum in East Hampton had organized a retrospective in conjunction with Terry Dintenfass that was 20 percent smaller (thirty-nine pieces) and contained some of the same works but more major oil paintings, among them *Poll Tax Country* (1945), *Across the Tracks* (1946), *Field Flowers* (1947), *Portrait of a Farmer's Wife* (1951), *The Observer* (1960), *Belle* (1965), *Country Gospel Music* (1971), *By the Sea* (1979), and *End of the Season* (1983). This show was more intensely vivid than the one held at Cooper Union in 1985. It could be seen at the Guild Hall from late July to mid-September 1984, and at the Dintenfass Gallery in New York City from September 18 to October 11 that year.[19]

When the exhibition first opened in July 1984, the *New York Times* gave it an ample and appreciative review, largely taken up with an in-depth and candid interview that Gwathmey gave to the writer. He began by acknowledging that he had had a bout with Parkinson's disease, but that it was currently arrested and that he still strolled back to his studio every day. He denied being a "preacher," insisting that "I'm just as interested in composition, color, and surface as I am in subject matter. . . . But things are what they are and, as an observer, I paint what I see."[20] His inclusion of surface as a priority is noteworthy because Gwathmey had almost made a fetish of achieving an extremely smooth surface on his oil paintings. He admired Van Gogh's style and colors, but he had no interest whatever in building up multiple layers of paint or applying it with a palette knife.

Later in the interview Gwathmey suggested that his style had changed over time because of influences from artists such as Picasso and Evergood. He developed a mode of painting, he explained, that "transcends the camera view," thereby acknowledging his early debt to photographic vistas and visions created by Ben Shahn, Walker Evans, and his wife, Rosalie. Instead he conceded, albeit with caveats, that he had become "part of the abstract school, in a way," by developing his art in semiabstract, cubist forms that allowed him the "freedom of modernism without ignoring the object." Ultimately, however, he did insist on having maintained the gyroscope of steadfastness and continuity in his work. "My artistic point of view has not been prevalent these past 40 years," he acknowledged, "but I've never compromised. Come hell or high water, I've painted what I wanted to paint." He felt heartened by the cyclical nature of fashions in art because he saw sure signs of a return to the image. "I guess if you hang around long enough, everything happens," he grinned, "like this retrospective."[21]

During the summer of 1985 the Vered Gallery in East Hampton also gave Gwathmey a small but selective show, the last exhibition that took place while he was still alive. It elicited an especially perceptive if brief notice in the *New York Times*. The reviewer appreciated *Harmonizing* as no one else had, not only for its warm colors and expressive distortion, but because of the "tipped planes, bold patterns and surface designs that emphasize rhythmic linear repetitions. The work is quite special, too, in the way it places its musician figures against a distant passageway to create a dynamic push-pull relationship between Modernist flattened forms and a Renaissance illusion of perspective." The writer then added that "perhaps no one since Millet has so effectively treated labor as allegory."[22]

Because this flurry of exhibitions occurred between the summers of 1984 and 1985, Gwathmey got a gallery of illustrated notices in various magazines devoted to art. Most of the reviews were relatively brief and offered restrained praise for his work. In one, for example, responding to the Guild Hall show after it moved to the Dintenfass gallery, the reviewer singled out Gwathmey's watercolors for laudatory attention. "In these," she wrote, "there is a directness and spontaneity of touch that seems at odds with the stylization of the oils."[23]

Other reviewers looked at Gwathmey's entire career in greater depth and took the

trouble to interview a few former students and contemporary artists who knew him well. "I've known Bob for a long time," whispered eighty-five-year-old Raphael Soyer, who was barely three years older than Gwathmey. "He deserves more recognition. He's very shy and reticent about his art. Yet he's always so outgoing and friendly. From my point of view," Soyer added, "he's very unique in American art."[24] That observation would have been readily apparent to anyone who saw his work in more than forty museums and public collections located primarily in the United States.

The author of this 1985 overview, which compressed a lot of useful information into a compact appraisal, also supplied an appreciative summation of the Gwathmey painting subsequently destroyed by fire, a picture that luminously reflected the artist's fascination with medieval stained glass.

By the Sea (1979) forms its own cathedral of light. Black-outlined beach umbrellas are patterned in jazzy fragments, becoming icon-like geodesic domes. They form the taut background to the odd lot of sun worshippers cavorting on the flat stage of sand. All fashions of swimsuits and builds pose in a dizzying array of stances. Gwathmey's peculiarly geometric anatomy—no one paints kneecaps as he does—brings to mind Fernand Léger and the legacy of French Cubism. A head sticking out of the sand could be a tribal mask. Isolated hands, like severed crab claws, hug the canvas edges. The composition vibrates with a mastery of modernism.[25]

Although everyone who knew him agreed that Gwathmey was, indeed, vexingly diffident to the point of reticence about his art, he did have a few whimsical vanities, and one of them involved his attire. When Gwathmey knew that he would be photographed for the interviews that were folded into these stories about him in 1984–85, he wore a boat-necked sailor's shirt—not like the one he wore at age six (fig. 4), but exactly like the one Picasso wore in a famous photograph taken in 1952—a white pullover with horizontal black stripes. Gwathmey had bought a batch of these pullovers in Nice, France, as a bemused act of homage to the artist he most admired.[26] Picasso is standing behind a window with his hands pressed against the glass in a pose that seems to say, "Privacy, please. I do not wish to be disturbed" (figs. 66 and 67). Michael Moses, who saw Gwathmey at several of these exhibition openings in 1984–85, perceived him as friendly yet distant, "an observer of a scene going by," a person in "an observational rather than an engaging mood."[27] Those who knew Gwathmey well also insist that he was not a sentimental person. But when the artist and his wife learned that Picasso had died on April 10, 1973, they walked for hours along the beach at Amagansett and cried uncontrollably.[28]

By 1986 Parkinson's disease had become a serious problem for Gwathmey, and he stopped painting entirely. Early in 1988 the illness had disabled him to the point where he needed to be hospitalized. He was then placed in a nursing home where he could receive treatment and care that Rosalie could no longer manage alone at their home with its narrow spiral staircase. Unlike Picasso, however, he did not appeal for privacy; visitors to his bedside came away with heartwarming tales. One friend, the writer Morton M.

Hunt, related that Gwathmey's tongue had balked when he tried to express a thought. He then looked at Hunt, smiled, and said, "I owe you a sentence."[29] He never lost the personal charm that people in his circle remembered and loved.

Terry Dintenfass, who knew Bob Gwathmey well for more than three decades, believes that beneath his bonhomie, ribald stories, laughter, and warmth, there was an underlying sense of ineffable sadness. That aspect of his temperament became more evident in his last years when Parkinson's disease took its toll. He had always cared about his appearance and felt embarrassed by his physical decline during the 1980s. In 1987 he remarked to a close friend who served as a trustee on the board at Cooper Union, "Just think, George, if I had died five years ago they would have said, 'What a fine figure of a man.'"[30]

Robert Gwathmey died of cardiac arrest in the nursing home on the morning of September 21, 1988, the last day of summer—the literal and figurative end of the season. His body was cremated, and an afternoon of tributes held on Sunday, October 16, at the Guild Hall in East Hampton was attended by large numbers of friends, prominent and

FIGURE 66
Robert Doisneau,
La ligne de chance
[The line of luck] (1952).
Nouvelles Images S.A.
editeurs et R. Doisneau
Photographe.

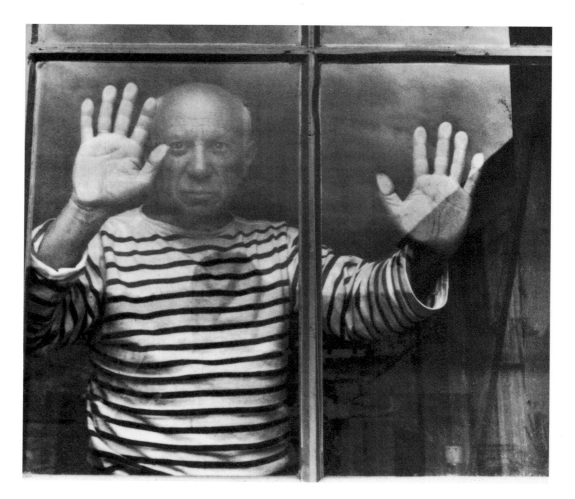

FIGURE 67
Robert Gwathmey
(1984). Courtesy of the
New York Times.

humble, black and white, dressed for the most part colorfully, as Gwathmey would have preferred. All of his obituaries called attention to his long record of social activism on behalf of people disadvantaged by economic adversity, race, or ideology. A friend who was a gallery owner in Bridgehampton recalled that "he was a terribly amusing man. He was a great story teller," she added, "a true raconteur."[31] Other speakers included Abram Lerner, the publisher of the *East Hampton Star*, the chairman of the board of Cooper Union, and Charles Gwathmey.

In one way or another, most of the artist's obituaries pointed out that Gwathmey had managed to devote much of his art to social commentary without descending into propaganda or homiletics. The *International Herald-Tribune* accurately observed that he "used a formalized, geometric and usually brightly colored style to depict the lives of sharecroppers and migrant workers with a sense of dignity and grandeur." The best of these necrologies, however, did not neglect his self-deprecating sense of humor. *Newsday*, for instance, a New York paper with a particular orientation to Long Island at that time, took special note of the fact that after the advent of Abstract Expressionism, Gwathmey's work became unfashionable, yet he swam against the tide. "Don't tell anyone I have subject matter," he was quoted as saying. "That's a dirty word."[32]

Despite the decades of slights that all of the Social Realists had suffered, I doubt whether Gwathmey worried excessively about his artistic impact and historical legacy. In October 1976 a meeting of the Mid-America College Art Association held at the University of Nebraska devoted a major retrospective panel to American art during the 1930s. Gwathmey flew out as one of three artist participants along with John I. H. Baur, director emeritus of the Whitney Museum of American Art. After the moderator introduced Gwathmey, the latter began, characteristically, by saying that he was indeed a "product" of the 1930s and the Depression. Then he reminisced that when he left home to study art in Baltimore in 1925, his mother "admonished" him with the following: "Never make personal remarks. Never force anything mechanical. Never kick anything inanimate. Never get uptight about the inevitable. And don't forget that last year's all-American is today's forgotten man."[33]

On April 4, 1989, Charles Gwathmey spoke about his father at a dinner meeting of the American Academy of Arts and Letters. Much of what he said echoed the eloquent reminiscence of his childhood and the bonds of companionship and exploration that existed between father and son that he had emphasized at the memorial service in East Hampton six months earlier. Near the outset of this memoir, however, Charles asserted his father's belief "that art must affect morality" and become "a means of communicating a statement and a hope. Life as an artist was contributive, noncompetitive, and private."* Charles Gwathmey concluded his warm tribute with these words:

I mention these reflections to illustrate a conclusion. I lived my early childhood with a father who could not wait for me to be an adult (he shaved me when I was

*In an undated letter written during the 1960s, Gwathmey added this P.S. to Sidney Goodman: "Your racket is essentially non-competitive—what a relief!" Raymond Saunders told me (on Feb. 18, 1998) that one of the pleasures of belonging to the Dintenfass Gallery was that her artists were "not competitive with one another."

eleven) so that in some way he could see if he "did alright" as a father, and then somehow reverse roles and relive a childhood he never experienced, through his son.

I feel privileged and humbled by my father's life example that is both inspirational and demanding. I love a man who always left more than he took, who believed passionately in the nobility of his fellow man, and who dignified compassion. I miss the one person who without question was my best friend in life, and who remains my conscience in death.[34]

In 1993 Charles Gwathmey gave $600,000 in the form of a matching grant to Cooper Union to stimulate the creation of an endowed chair that would be held in alternate terms of three to five years by a professor of art and then a professor of architecture. The creation of that chair was announced on November 18, 1993, in a celebration held at the Guggenheim Museum on Fifth Avenue, whose renovation Charles Gwathmey had been responsible for in 1992. At a press interview held just prior to the announcement of the new chair, Charles reflected on the immense impact the design of his parents' home had upon his own career and reputation. "After the Amagansett house, my father became known as Charles Gwathmey's father. . . . That was an interesting transition that we both laughed about."[35]

When Abram Lerner, a longtime admirer of Robert Gwathmey's, wrote the introduction to his friend's 1984 exhibition catalog, he sought to give Gwathmey a broader identity that would be "beyond category." "We have harbored a misconception in identifying him as a 'social realist,'" Lerner wrote, "when in fact he is closer to the aesthetics of Charles Sheeler and Fernand Léger than to those for whom it used to be said that 'art is a weapon.'"[36] Be that as it may, we had best follow the designations that Gwathmey himself felt most comfortable using. In 1979 he told a Hirshhorn Museum curator that "I consider myself a 'social realist'. I'm interested in the human figure and the human condition." Six years later, after Lerner's essay had appeared, Gwathmey voiced his sense of self casually but succinctly in responding to a writer for the *New York Times*: "I guess I'm a social commentator."[37]

When Milton W. Brown conducted an extensive interview with Raphael Soyer in 1981 for the Archives of American Art, they spent a considerable amount of time trying to reach a consensus about the most useful definition or meaning of Social Realism. Soyer recognized full well that such an arbitrary rubric could either be applied exclusively or inclusively, and he ruminated out loud in the process of trying to understand where he himself fit in.

Social Realism is one of those confusing words, you know, a confusing phrase—social realism. Like the word realism itself, it has many connotations today. I mean there are many meanings to realism. . . . For instance, I never painted a picture of people in a factory. I never painted a picture of a policeman beating up strikers. I never painted a picture of a meeting in Union Square or something like that. I never painted a very beautiful worker and a very ugly captain. Now I guess those were considered social

realism. But then I painted people in the street. I painted people who were out of work, who just sat either in the sun or in the shade and did nothing. I painted them a lot.

After considerable discussion devoted to distinguishing between Social Realism and Socialist Realism, Brown attempted to clear the air by acknowledging the dynamics of both diversity and complexity in Social Realism. He was ultimately seeking to arrive at a workable definition that would not be so broad and diluted as to be meaningless, but also one that could acknowledge a fundamental reality, namely, that each artist must inevitably define his own categorical identity or else defy them all.

> A social realist dealt with the problems . . . of present day society. And theoretically, ideologically what they said was that art has to be a weapon of the class struggle. And this was where the difficulty was because some artists felt that art didn't serve very well as a weapon in the class struggle, that some artists were not capable of that kind of expression. In other words, there were different opinions. And then there were some artists who said, if we simply paint the reality that's around us, it will be critical of society. . . . I think at present, for instance, we have a tendency in art history to deal with the period for that kind of art in general as social art, that is, an art which is concerned with contemporary life in a social sense. So it includes people like Gropper who did cartoons or you [Soyer] who did street scenes, or Joe Jones who did things on a farm. These were all contemporary social life in America.[38]

When Soyer ultimately responded that he was more impressed by the *differences* in approach represented by artists loosely lumped together as Social Realists, Brown basically accepted his point about the need for discrimination in order to avoid crude aggregations. He concluded by agreeing that "Philip Evergood and Gwathmey and Jack Levine painted totally different things."[39] Indeed they did. Nevertheless, in their art they adhere much more closely to one another in content than any of them does to, say, Abstract Expressionism, never mind what followed it in the 1960s and 1970s.

No one would, for a minute, describe Robert Gwathmey as a history painter in any conventional sense. Nevertheless, it might also be acknowledged that the recent history of his own time and region, as well as earlier aspects of American history, are reflected in his art. Social history in the South, the history of race relations, and the history of political protest all pervade his art. He is surely an exemplar of what Carl Becker once called "Everyman His Own Historian." Because Gwathmey could not escape history the way he had partially escaped from the South, his art eventually became a brightly colored thread connecting history with memory, reaching back to the nineteenth century in terms of the socioeconomic underpinnings of southern agriculture, but also in terms of artistic innovations that we associate with Goya, Daumier, and Millet.[40]

Gwathmey did not honor the past because he recognized too much in it that warranted critical or satirical attention. So much a man of his own time, he agitated ceaselessly for political and social change. Nevertheless, he was too shrewd to believe that he

could simply ignore the past. It had shaped the world that he needed to understand in order to improve it. Neither a historian nor a futurist, he certainly kept an eye on both even as he functioned very much in the present—sometimes as a hedonist. He lived life to the fullest and managed to combine two characteristics not commonly found conjoined: the observer as activist. Gwathmey never ceased being a passionate observer, yet he always remained a giver. As his son phrased it so well, he "always left more than he took."

CHRONOLOGY

1903 Born in Richmond, Va., January 24

1924–25 Took business courses at North Carolina State College, Raleigh

1925 Worked on a freighter that went to ports in Europe and the Americas

1925–26 Studied art at the Maryland Institute of Design, Baltimore

1926–30 Studied at the Pennsylvania Academy of the Fine Arts, Philadelphia, with Franklin Watkins, Daniel Garber, and George Harding

1929–30 Cresson summer fellowships for travel and study in Europe

1930–37 Taught at Beaver College in Glenside, Pa., near Philadelphia

1935 Married Rosalie Hook of Charlotte, N.C., November 2

1936 *The Hitchhiker*, his earliest surviving painting; made into a serigraph the following year

1938 Destroyed virtually all of his previous work; birth of son, Charles

1939 Won a competition to hold a one-man exhibition at the ACA Gallery, which took place in 1941

1939–41 Painted *The Countryside*, a post office mural in Eutaw, Ala.

1939–42 Taught at the Carnegie Institute of Technology, Pittsburgh, Pa.

1941–61 Represented by Herman Baron and the ACA Gallery in New York City

1942–68 Taught life drawing at the Cooper Union School of Art, New York City

1942–69	FBI surveillance of his political activities and commitments
1944	Rosenwald Foundation fellowship enabled him to spend the summer living on a North Carolina tobacco farm where he worked with sharecroppers for three months
1944–55	Lived in an apartment on 68th Street and Central Park West in New York City
1946	One-man exhibition at the ACA Gallery; Paul Robeson wrote the catalog introduction
	Joint exhibition with Rosalie Gwathmey at the Virginia Museum of Fine Arts, Richmond
1949–50	Spent ten months in Paris; some travel in Europe
1953	Joined figural artists who created *Reality* as a protest journal against Abstract Expressionism
1957	Series of paintings on the World Series for *Sports Illustrated*
1958	Spoke at the eighth annual International Design Conference, Aspen, Colo.; critique of Abstract Expressionism
1961–88	Represented by the Terry Dintenfass Gallery, New York City
1968	Moved to Amagansett, Long Island; home and studio there designed by architect son, Charles
1968–69	Taught two days a week at Boston University, where he had an exhibition
1971	Elected to the American Academy and Institute of Arts and Letters
1976	Elected to full membership in the National Academy of Design
1976	Exhibition at St. Mary's, Maryland, and New York City
1984	Exhibition at East Hampton and New York City
1985	Exhibition at the Cooper Union School of Art
1988	Died of cardiac arrest and Parkinson's disease, September 21

NOTES

Abbreviations

AAA Archives of American Art, National Museum of American Art,
Washington, D.C.

CG Charles Gwathmey

GP Gwathmey Papers

HMSG Hirshhorn Museum and Sculpture Garden, Washington, D.C.

MFA Museum of Fine Arts, Boston, Mass.

MK Michael Kammen

NMAA National Museum of American Art, Washington, D.C.

NYT *New York Times*

PAFA Pennsylvania Academy of the Fine Arts, Philadelphia

PE Philip Evergood

RG Robert Gwathmey

RHG Rosalie Hook Gwathmey

TD Terry Dintenfass

Introduction

1. In a well-known passage, Pablo Picasso explained to the photographer Brassaï why he dated his pictures. "Because it is not sufficient to know an artist's works—it is also necessary to know when he did them, why, how, under what circumstances. . . . Some day there will undoubtedly be a science—it may be called the science of man—which will seek to learn more about man in general through the study of the creative man. I often think about such a science, and I want to leave to posterity a documentation that will be as complete as possible. That's why I put a date on everything I do" (quoted in Arthur C. Danto, "Picasso and the Portrait," *Nation*, Aug. 26, 1996, 34). Sidney Goodman has made the astute observation that Gwathmey surely believed his distinctive artistic style served very well as his signature (telephone conversation, Feb. 18, 1998).

2. Interview with TD, Jan. 3, 1998; interviews with RHG, Abram Lerner, and Milton W. Brown, Jan. 4, 1998; RG to Inez Garson, Jan. 30, 1979, Hirshhorn Archives, HMSG.

3. RG to Garson, Jan. 30, 1979, and his response on a biographical form from the Hirshhorn dated Aug. 22, 1977, Hirshhorn Archives; Arlene Jacobowitz interview with RG, Sept. 29, 1966, 10–11, Brooklyn Museum, Brooklyn, N.Y.

4. Harry Salpeter, "Gwathmey's Editorial Art," *Esquire*, June 1944, 83, 131–32, is an unusual essay because it conveys the impression that Gwathmey engaged in "pulpit-thumping."

5. See Joseph Blotner, *Robert Penn Warren: A Biography* (New York, 1997), 323–24.

6. Paul Cummings interview with RG, Mar. 19, 1968, 64, AAA. The French call a spoiled son who develops in such a situation a *fils gaté*. See Herman Lebovics, "Malraux's Mission," *Wilson Quarterly* 21 (Winter 1997): 79.

7. Interview with RHG, Jan. 4, 1998; interview with TD, Jan. 3, 1998; RG to PE, Mar. 16, 1963, Evergood papers, Dintenfass file, AAA.

8. Interviews with RHG and Abram Lerner, Jan. 4, 1998; interview with TD, Jan. 3, 1998.

9. Quoted by Allan S. Weller, "Gwathmey," in *Art USA Now*, ed. Lee Nordness (New York, 1963), 1:122, 123.

10. Louise Elliott Rago, "Robert Gwathmey Speaks on the Artist," *School Arts* 59 (Jan. 1960): 31; interview with Milton W. Brown, Jan. 4, 1998.

11. See Charles K. Piehl, "A Southern Artist at Home in the North: Robert Gwathmey's Acceptance of His Identity," *Southern Quarterly* 26 (Fall 1987): 1–17; Piehl, "Robert Gwathmey: The Social and Historical Context of a Southerner's Art in the Mid-Twentieth Century," *Arts in Virginia* 29, no. 1 (1989): 2–15; Piehl, "The Southern Social Art of Robert Gwathmey," *Transactions of the Wisconsin Academy of Sciences, Arts and Letters* 73 (1985): 54–62.

12. Rago, "Gwathmey Speaks on the Artist," 31.

13. All of these particular linkages are derived from three exhibitions presented late in 1997 at the Metropolitan Museum of Art in New York.

14. Jacobowitz interview, 15, 27, 28.

15. Biographical form from the Hirshhorn, Aug. 22, 1977, Hirshhorn Archives.

16. See Studs Terkel, *Hard Times: An Oral History of the Great Depression* (New York, 1970), 374.

Chapter One

1. Information from the *Richmond Times-Dispatch*, Sunday, May 3, 1914, updated for the extended kin group by Brooke Gwathmey Harris in 1976; Paul Cummings interview with RG, Mar. 5, 1968, 22, AAA.

2. Genealogical information from Frances Pollard, Senior Librarian, Virginia Historical Society, Richmond; *Richmond Times-Dispatch*, June 2, 3, 1941; interview with RHG, Jan. 4, 1998.

3. Cummings interview with RG, Mar. 5, 1968, 1; RG to ?, [winter 1949–50], GP, AAA.

4. Cummings interview with RG, Mar. 5, 1968, 22.

5. See Marie Tyler-McGraw, *At the Falls: Richmond, Virginia, and Its People* (Chapel Hill, 1994); Karl E. Fortess interview with RG, July 30, 1967, Fortess taped interviews, AAA.

6. Cummings interview with RG, Mar. 5, 1968, 8. For examples of Garber's work, see *The Boys* (1915) at the Everson Museum in Syracuse, N.Y.; *Old Church, Carversville* (1916), Virginia Museum of Fine Arts, Richmond; *Tohickon* (ca. 1921), NMAA; and Kathleen A. Foster, *Daniel Garber, 1880–1958* (Philadelphia, 1980).

7. See Andrew Carnduff Ritchie, *Franklin C. Watkins* (New York, 1950), 14, for *Crucifixion*, and 18, for *Negro Spiritual*; Henry Clifford, *Franklin Watkins* (Philadelphia, 1964), 4, 21, for better plates of the same works; and Ben Wolf, *Franklin C. Watkins: Portrait of a Painter* (Philadelphia, 1966), plate 94, for a *Crucifixion* (1964) that might even have been influenced by Gwathmey's *Unfinished Business* (1941), which appears in Elizabeth McCausland, "Robert Gwathmey," *American Magazine of Art* 39 (Apr. 1946): 148.

8. Wolf, *Watkins*, 17; Franklin C. Watkins, "A Painter Talks to His Students," in *Painters and Sculptors of Modern America* (New York, 1942), 52–60.

9. Gwathmey file, PAFA Archives.

10. Ibid., Aug. 27, 1927.

11. Ibid., Dec. 12, 1927.

12. Ibid., documents dated June 11, 14, 1929.

13. Cummings interview with RG, Mar. 5, 1968, 16.

14. Glenda Elizabeth Gilmore, *Gender and Jim Crow: Women and the Politics of White Supremacy in North Carolina, 1896–1920* (Chapel Hill, 1996), 178, 192, 199; interviews with RHG, June 1, 1996, and Jan. 4, 1998, at Amagansett, N.Y.

15. Studs Terkel, *Hard Times: An Oral History of the Great Depression* (New York, 1970), 374–75. There is also an account of this episode in Paul Cummings's 1968 interview, but it seems to be inaccurate on some minor points.

16. Anne Bowen Parsons interview with RG, Aug. 20, 1967, 1, AAA; Cummings interview with RG, Mar. 5, 1968, 5.

17. "Robert Gwathmey," in Terkel, *Hard Times*, 373; Cummings interview with RG, Mar. 5, 1968, 45. Where RG used the word "conflict," we might use "tension."

18. Barbara Delatiner, "He Paints What Is in His Heart," *NYT*, July 22, 1984; Arlene Jacobowitz interview with RG, Sept. 29, 1966, 7, 13–14, Brooklyn Museum, Brooklyn, N.Y. For a rich lode of folklore that Gwathmey must have encountered, see Jan Harold Brunvand, "Roadside Ghosts: The Vanishing Hitchhiker," in *The Vanishing Hitchhiker: American Urban Legends and Their Meanings* (New York, 1981), 24–46. During the 1940s, "The Hitchhiker" was the title of a famous radio drama, unrelated to Gwathmey's painting.

19. "Robert Gwathmey," in *Current Biography, 1943* (New York, 1944), 262; Jacobowitz interview, 1.

20. Blair Rouse, *Ellen Glasgow* (New York, 1962); E. Stanly Godbold, *Ellen Glasgow and the Woman Within* (Baton Rouge, 1972); Edgar E. MacDonald, "Glasgow, Cabell, and Richmond," in *Ellen Glasgow: Centennial Essays*, ed. M. Thomas Inge (Charlottesville, 1976), 25–45.

21. Dean Flower, "Cabell," *Dictionary of American Biography*, supplement 6 (New York, 1980), 94–95; Joe Lee Davis, *James Branch Cabell* (New York, 1962); Edgar MacDonald, *James Branch Cabell and Richmond-in-Virginia* (Jackson, Miss., 1983).

22. Rex J. Burbank, *Sherwood Anderson* (New York, 1964); Kim Townsend, *Sherwood Anderson* (Boston, 1987), chaps. 10–11.

23. Dan B. Miller, *Erskine Caldwell: The Journey from Tobacco Road* (New York, 1995), 71–72, 74–75, 206, 262.

24. Ibid., 99, 102.

25. Ibid., 196–99, 200, 202–3. The success of *Tobacco Road* was in marked contrast to the fate of *Black Souls: A Play in Six Acts*, written by Annie Nathan Meyer, a first cousin of Judge Benjamin Cardozo. Staged in 1932 in Greenwich Village's Provincetown Playhouse, it closed quickly after unfavorable notices from the critics. Set in the Deep South directly following World War I, it told the tragic story of a love affair between a white woman and a black man.

26. John Egerton, *Speak Now against the Day: The Generation before the Civil Rights Movement in the South* (New York, 1994), 4, 51, 71, 96. See also Pete Daniel, *Breaking the Land: The Transformation of Cotton, Tobacco, and Rice Cultures since 1880* (Urbana, 1985); Arthur Raper, *Preface to Peasantry: A Tale of Two Black Belt Counties* (Chapel Hill, 1936), an account of the desperate difficulties of white and black sharecroppers in rural Georgia; Jack Temple Kirby, *Rural Worlds Lost: The American South, 1920–1960* (Baton Rouge, 1987).

27. See esp. Fred Hobson, *Tell about the South: The Southern Rage to Explain* (Baton Rouge, 1983), chaps. 3 and 4; Daniel Joseph Singal, *The War Within: From Victorian to Modernist Thought in the South, 1919–1945* (Chapel Hill, 1982), chap. 9; Hank O'Neal, *A Vision Shared: A Classic Portrait of America and Its People, 1935–1943* (New York, 1976), 14, 43, 54, 56, 65.

28. Egerton, *Speak Now against the Day*, 90–92, 96.

29. Anthony J. Badger, *Prosperity Road: The New Deal, Tobacco, and North Carolina* (Chapel Hill, 1980); Arthur F. Raper and Ira De A. Reid, *Sharecroppers All* (Chapel Hill, 1941).

30. Quoted in Egerton, *Speak Now against the Day*, 106.

31. Singal, *War Within*, chap. 5; Egerton, *Speak Now against the Day*, 63; David Cohn, *God Shakes the Creation* (New York, 1935).

32. Egerton, *Speak Now against the Day*, 77; Lynn Moss Sanders, "'An Effort toward Good Will and Good Wishes': Folk Studies and Howard Odum's Changing View of Race," *Southern Cultures* 3 (Summer 1997): 47–66.

33. Egerton, *Speak Now against the Day*, 126, 154; Morton Sosna, *In Search of the Silent South: Southern Liberals and the Race Issue* (New York, 1977), 79, 81.

34. Egerton, *Speak Now against the Day*, 123–24; Stewart E. Tolnay and E. M. Beck, *A Festival of Violence: An Analysis of Southern Lynchings, 1882–1930* (Urbana, 1995); W. Fitzhugh Brundage, ed., *Under Sentence of Death: Lynching in the South* (Chapel Hill, 1997).

35. Egerton, *Speak Now against the Day*, 130–31. Gwathmey refers to Graham in a letter to Herman and Ella Baron, ca. summer 1945, Gwathmey folder, Vertical files, NMAA.

36. Robin D. G. Kelley, *Race Rebels: Culture, Politics, and the Black Working Class* (New York, 1994); Kelley, "African-American Communists and the Politics of Culture, 1919–1934," in *Imagining Home: Class, Culture, and Nationalism in the African Diaspora*, ed. Sidney J. Lemelle and Robin D. G. Kelley (New York, 1994), 35–54; Rena Fraden, *Blueprints for a Black Federal Theatre, 1935–39* (New York, 1994), 15.

37. Roy Stryker and Nancy Wood, *In This Proud Land: America, 1935–1943, as Seen in the Farm Security Administration Photographs* (New York, 1973); Carl Fleischauer and Beverly Brannan, eds., *Documenting America, 1935–1943* (Berkeley, Calif., 1988), 76–89, 114–27; Miller, *Erskine Caldwell*, 231–41.

38. Cummings interview with RG, Mar. 5, 1968, 25.

39. Joseph L. Morrison, *W. J. Cash: Southern Prophet* (New York, 1967), 129–35.

40. Cummings interview with RG, Mar. 5, 1968, 25. See Karal Ann Marling, *Wall-to-Wall America: A Cultural History of Post-Office Murals in the Great Depression* (Minneapolis, 1982), chap. 1.

41. "Speaking of Pictures: This Is Mural America for Rural Americans," *Life*, Dec. 4, 1939, 12; Charles K. Piehl, "The Eutaw Mural and the Southern Art of Robert Gwathmey," *Alabama Review* 45 (Apr. 1992): 103–7, a wonderfully researched essay.

42. Piehl, "Eutaw Mural," 107–10.

43. Ibid., 110–11.

44. Ibid., 111–13.

45. Quoted in Belisario Contreras, *Tradition and Innovation in New Deal Art* (Lewisburg, Pa., 1983), 184.

46. Richard D. McKinzie, *The New Deal for Artists* (Princeton, 1973), 10.

47. Cummings interview with RG, Mar. 5, 1968, 25.

48. The Artists Union in which Baron and Gwathmey were so active during the 1930s should not be confused with Artists Equity, which Gwathmey and other prominent artists founded in New York in 1947. The latter has been defined as a "nonprofit and aesthetically nonpartisan organization. It is a direct membership association in which members join the national organization and may elect to join a local chapter at their option." See Mary Swift, "Advocacy for Artists: Artists Equity Association," *American Artist* 47 (Mar. 1983): 58–59; "Artists Equity Association Declaration of Artists' Rights," *American Artist* 39 (Jan. 1975): 40–41. Gwathmey was a supportive signer of the AEA declaration of October 9, 1974.

49. Herman Baron, "The ACA Gallery: Impressions and Recollections," in *Contemporary Artists* (New York, 1957), unpaginated pamphlet. See also Francis V. O'Connor, ed., *Art for the Millions* (Boston, 1975); Matthew Baigell and Julia Williams, introduction to *Artists against War and Fascism: Papers of the First American Artists' Congress* (New Brunswick, N.J., 1986).

50. Quoted in "Robert Gwathmey," 262.

Chapter Two

1. "Robert Gwathmey," in *Current Biography, 1943* (New York, 1944), 262.

2. Ibid., 261, 263.

3. RG to Joseph Fraser, May 3, 1942, PAFA Archives.

4. Interviews with RHG, May 31, 1996, and Jan. 4, 1998. For a charming account of his arrival in New York in 1941, see Claude Lévi-Strauss, *The View from Afar* (New York, 1985), 258–67. He describes a vibrant city of contradictions and, from a European perspective, a city of the future. Perhaps most germane to Gwathmey's arrival there in 1942, Lévi-Strauss described "not a city but, on the colossal scale whose measure one can take only by setting foot in the New World, an agglomeration of villages" (259).

5. RG to Kroll, Mar. 22, 1944, Kroll papers, reel 326, AAA; "Kroll," in *Dictionary of American Art*, by Matthew Baigell (New York, 1979), 198.

6. Studs Terkel, *Hard Times: An Oral History of the Great Depression* (New York, 1970), 374. Gwathmey is referring to bright leaf (or flue-cured) tobacco.

7. Interview with RHG, May 31, June 1, 1996; *Rosalie Gwathmey: Photographs from the Forties* (East Hampton, N.Y.: Glenn Horowitz, Bookseller, 1994).

8. Peter H. Wood and Karen C. C. Dalton, *Winslow Homer's Images of Blacks: The Civil War and Reconstruction Years* (Austin, Tex., 1988); August P. Trovioli and Roulhac B. Toledano, *William Aiken Walker, Southern Genre Painter* (Baton Rouge, 1972); Cynthia Seibels, *The Sunny South: The Life and Art of William Aiken Walker* (Spartanburg, S.C., 1995); John I. H. Baur, *An American Genre Painter: Eastman Johnson, 1824–1906* (Brooklyn, 1940). *The Cotton Pickers* is located in the Los Angeles County Museum of Art.

9. See Henry Adams, *Thomas Hart Benton: An American Original* (New York, 1989).

10. John Egerton, *Speak Now against the Day: The Generation before the Civil Rights Movement in the South* (New York, 1994), 52–53.

11. I am especially indebted here to Paul Anbinder, ed., *American Paintings and Sculpture to 1945 in the Carnegie Museum of Art* (New York, 1992), 218–19.

12. See Robert L. Herbert, *Jean-François Millet* (London, 1976), 137–39.

13. Egerton, *Speak Now against the Day*, 20–21.

14. Ibid., 17, 21–22, 127. For a more complex perspective on the impact of the Rusts, see Nicholas Lemann, *The Promised Land: The Great Black Migration and How It Changed America* (New York, 1991), 3–5.

15. For a superb summation of these changes, rich with empirical detail, see Jack Temple Kirby, *Rural Worlds Lost: The American South, 1920–1960* (Baton Rouge, 1987), esp. chap. 7, "Black and White, Distance and Propinquity."

16. W. G. Constable to RG, Sept. 25, 1941, and RG to Constable, Oct. 6, 1941, MFA Archives.

17. Arianwen Howard to RG, July 26, 1963, and RG to Howard, Aug. 1, 1963, ibid.

18. Paul Cummings interview with RG, Mar. 19, 1968, 44, AAA.

19. Ibid., 47. For an early example of billboards and posters in American art, see Thomas Le Clear (1818–82), *Looking for Fun* (ca. 1854), Metropolitan Museum of Art, New York.

20. Charles K. Piehl, "The Southern Social Art of Robert Gwathmey," *Transactions of the Wisconsin Academy of Sciences, Arts and Letters* 73 (1985): 55. For political background, see James R. Green, "The Brotherhood of Timber Workers, 1910–1913: A Radical Response to Industrial Capitalism in the Southern U.S.A.," *Past and Present*, no. 60 (Aug. 1973): 161–200.

21. Interview with RHG, May 31, 1996. Walker Evans photographed several posters for black minstrel shows during the later 1930s. See Eric Lott, *Love and Theft: Blackface Minstrelsy and the American Working Class* (New York, 1993), and for a fascinating account of a minstrel show presented by an all-black troupe in Georgia in 1934, see Kirby, *Rural Worlds Lost*, 251–52.

22. I am grateful to Marjorie B. Searl, curator of education at the University of Rochester Memorial Art Museum, for sharing with me the text of her unpublished talk "Non-Fiction," Feb. 28, 1989.

23. RG to Hudson and Ione Walker et al., ca. Nov. 9, 1949, Walker papers, reel D353, AAA; Arlene Jacobowitz interview with RG, Sept. 29, 1966, 27–28, Brooklyn Museum, Brooklyn, N.Y. Raymond Saunders, an artist who knew Gwathmey well, feels that his use of black outlining is reminiscent of Fernand Léger (telephone conversation, Jan. 21, 1998). See also RG's interview with Paul Cummings on Mar. 5, 19, 1968, where he described his painting as "decidedly delineated and compartmentalized." "Watkins did paint very fluidly and I painted confined, a little more compartmentalized." "Yeah, they're pretty well enclosed. Pretty much confined. . . . Sometimes a black line which may surround an image may carry over into a piece of vegetation or carry over into a bit of architecture or carry over into a bit of another figure as it were. So they are not isolated in that sense. They do intertwine, I hope" (36, 45, 51).

24. RHG to MK, July 2, 1997.

25. Jacobowitz interview, 27.

26. Elizabeth McCausland, "Robert Gwathmey," *American Magazine of Art* 39 (Apr. 1946): 151.

27. "Robert Gwathmey," 262; "Satirical Flair in Show by Gwathmey," *Art News* 39 (Jan. 4, 1944): 12; NYT, Jan. 5, 1941, and *New York Herald Tribune*, Jan. 27, 1946, and undated clipping, all in clipping file, CG papers, in CG's possession, New York, N.Y.

28. Cummings interview with RG, Mar. 19, 1968, 50–51. See also RG's letter to me, quoted in Michael Kammen, *Mystic Chords of Memory: The Transformation of Tradition in American Culture* (New York, 1991), 495–96.

29. See Oliver W. Larkin, *Daumier: Man of His Time* (Boston, 1966), 122–23.

30. It is owned by the Frederick R. Weisman Art Museum at the University of Minnesota in Minneapolis.

31. Jacobowitz interview, 20–21.

32. Gwathmey's FBI file, obtained under the Freedom of Information Act (FOIPA no. 409,729), is 195 pages long. The names of numerous informants as well as some other information have been blacked out.

33. George H. Roeder Jr., *The Censored War: American Visual Experience during World War II* (New Haven, 1993).

34. David Thomson, *Rosebud: The Story of Orson Welles* (New York, 1996), 190, 248; Dan B. Miller, *Erskine Caldwell: The Journey from Tobacco Road* (New York, 1995), 360.

35. FBI report, Dec. 16, 1942, no. 100-1146.

36. FBI report, Feb. 1, 1943, no. 100-1586.

37. FBI report, Jan. 19, 1944, no. 100-42001.

38. FBI memorandum from New York City to the director, May 17, 1945, no. 100-171543.

39. Interview with RHG, Jan. 4, 1998.

40. RG to Joseph T. Fraser, Jan. 4, 1941, PAFA Archives; Artists for Victory papers, microfilm reels 115–16, AAA; NYT, Feb. 20, 1944. See also Ellen G. Landau, "'A Certain Rightness': Artists for Victory's 'America in the War' Exhibition of 1943," *Arts Magazine* 60 (Feb. 1986): 43–54, esp. 46.

41. Reba White Williams, "The Prints of Robert Gwathmey," in *Hot off the Press: Prints and Politics*, ed. Linda Tyler and Barry Walker (Albuquerque, 1994), 34–35. *Rural Home Front* is based on a large oil painting by Gwathmey, *The Farmer Wanted a Son* (1942), located in the Art Institute of Chicago.

42. See Jane De Hart Mathews, "Art and Politics in Cold War America," *American Historical Review* 81 (Oct. 1976): 762–87; "Your Money Bought These Paintings," *Look Magazine*, Feb. 18, 1947, 80; Michael Kammen, "Culture and the State in America," *Journal of American History* 83 (Dec. 1996): 797; Richard Meryman, *Andrew Wyeth: A Secret Life* (New York, 1996), 186. See also Margaret Lynne Ausfeld and Vir-

ginia M. Mecklenburg, *Advancing American Art: Politics and Aesthetics in the State Department Exhibition, 1946–48* (Montgomery, Ala., 1984), 80 and 95 for the two paintings by Gwathmey (both 1946) that were purchased and included in this controversial exhibition.

43. Paul Cummings interview with Franklin Watkins, Aug. 19, 1971, 54, AAA. For thriving Klan activity at this time, usually regarded as a period of Klan dormancy, see Glenn Feldman, "Soft Opposition: Elite Acquiescence and Klan-Sponsored Terrorism in Alabama, 1946–1950," *Historical Journal* 40 (Sept. 1997): 753–77. Klan-related tensions increased at that time because of a noticeable rise in black voting aspirations.

44. Egerton, *Speak Now against the Day*, 218. For activism during the 1940s by southern liberals opposed to the poll tax, see Hollinger F. Barnard, ed., *Outside the Magic Circle: The Autobiography of Virginia Foster Durr* (1985; New York, 1987), chaps. 9–11.

45. *Robert Gwathmey* (New York, 1946), n.p., *Lullaby* is number 11; interview with RHG, May 31, 1996.

46. Located, respectively, in the Georgia Museum of Art, Athens, Ga., and the Museu de arte Contemporanea de Universidad de São Paulo, Brazil. A watercolor version of *Standard Bearer* is owned by Mrs. Sandra Weiner of Manhattan.

47. See Ilene Susan Fort and Michael Quick, *American Art: A Catalogue of the Los Angeles County Museum of Art Collection* (Los Angeles, 1991), 363–64.

48. Jacobowitz interview, 16–17.

49. See Harry Salpeter, "Gwathmey's Editorial Art," *Esquire*, June 1944, 83, 131–32; Greta Berman and Jeffrey Wechsler, *Realism and Realities: The Other Side of American Painting, 1940–1960* (New Brunswick, N.J., 1981); *Life*, Nov. 25, 1946, 72–89.

50. Paul Cummings interview with Hudson Walker, Oct. 22, 1969, 95–96, AAA; Jill Vetter (archivist at the Walker Art Center) to MK, Dec. 15, 1997, with exhibition brochures enclosed, in MK's possession.

51. See NYT, Jan. 27, 1946, and Apr. 17, 1949. See also Barbara Delatiner, "He Paints What Is in His Heart," NYT, July 22, 1984.

52. RG to the Walker Art Center, Dec. 9, 1981, Walker Art Center Archives.

53. Interview with RHG, Jan. 4, 1998.

54. Cummings interview with RG, Mar. 19, 1968, 53.

55. Ibid., 53–54.

56. See Jack D. Flam, *Matisse: The Dance* (Washington, D.C., 1993), 23–24. *Dance I* has pink dancers against a green foreground and a deep blue background. All five are women.

57. Howard Devree, "A Memorable Decade That Has Provided a New Outlook—Gwathmey, Seliger," NYT, Apr. 17, 1949.

58. See Anbinder, *American Paintings and Sculpture*, 217–18.

59. RG to Baron, late summer 1949, Baron papers, AAA.

60. Ibid.

61. NMAA. A small oil version of *Sowing* is owned by Andrew Dintenfass in Pacific Palisades, Calif.

62. Alexandra R. Murphy, *Jean-François Millet* (Boston, 1984), 31–32.

63. Ibid., 32.

64. The autobiographical writing of bell hooks, who grew up poor and black in the rural South, connects with Gwathmey's vision in notable ways. See hooks, *Black Looks: Race and Representation* (Boston, 1992).

65. RG to Arianwen Howard, Aug. 1, 1963, MFA Archives; Kathleen A. Foster, *Daniel Garber, 1880–1958* (Philadelphia, 1980), 19–24.

66. Joseph T. Fraser to RG, July 21, 1942, and Jan. 25, 1946, PAFA Archives; *Syracuse, N.Y., Herald*, Apr. 2, 1949, clipping from the PAFA Archives.

67. Interview with RHG, Jan. 4, 1998. For useful context explaining why southern liberals felt increasingly nervous at the end of the 1940s, even if they were living in Washington, D.C., or the North, see Barnard, *Autobiography of Virginia Foster Durr*, chaps. 13–15.

68. See Michael Kammen, *A Machine That Would Go of Itself: The Constitution in American Culture* (New York, 1986), 345; Stanley I. Kutler, ed., *The Supreme Court and the Constitution: Readings in American Constitutional History* (New York, 1977), 432–38.

69. Margaret Lowengrund, "Gwathmey Paints the Lean and the Strong," *Art Digest* 23 (Apr. 15, 1949): 21.

70. RG to Baron, late summer 1949.

Chapter Three

1. See *Claude Howell: A Retrospective Exhibition of Paintings* (Raleigh, N.C., 1975), esp. plates 13, 14, 16, 17, 18, and 35.

2. Quoted in Elizabeth McCausland, "Robert Gwathmey," *American Magazine of Art* 39 (Apr. 1946): 152. Gwathmey enjoyed moviegoing in general and realistic films in particular.

3. Ibid., 151.

4. Frederick Lewis Allen, "Today," *Proceedings of the American Philosophical Society* 83 (Sept. 1940): 521–22.

5. Charles K. Piehl, "The Southern Social Art of Robert Gwathmey," *Transactions of the Wisconsin Academy of Sciences, Arts and Letters* 73 (1985): 57; Barbara Delatiner, "He Paints What Is in His Heart," NYT, July 22, 1984.

6. Judd Tully, "Robert Gwathmey," *American Artist* 49 (June 1985): 47.

7. Ibid., 92.

8. See Deborah Weisgall, "Paying Homage as Only Another Master Can," NYT, Jan. 18, 1998; Anne Hollander, "The Art in the Air," *New Republic*, Mar. 9, 1998, 33–38. Gauguin is quoted in Harold E. Stearns, ed., *Civilization in the United States: An Inquiry by Thirty Americans* (New York, 1922), 190.

9. In *The Song of the Lark* (1884), by Jules Breton (1827–1906), a young peasant woman holds a sickle, her face smudged with dirt and her mouth open with exhaustion at the end of a day. Two haystacks stand behind her, and she clearly has been brutalized by agricultural labor. Purchased by American railroad magnate James J. Hill, the painting is now in the Art Institute of Chicago. The power of this image of a peasant's subjugation to field labor was felt as late as 1933 when visitors to the Chicago World's Fair voted it the most admired picture there.

10. During the fall and winter of 1889–90, when Van Gogh was a voluntary patient at the asylum in Saint-Rémy, he painted twenty-one copies of works by Millet, an artist he greatly admired. Van Gogh considered his copies "improvisations" or "translations," akin to a musician's interpretation of a great composer's work. See, for example, Van Gogh, *First Steps, after Millet* (Jan. 1890), in the Metropolitan Museum of Art, and Richard R. Brettell and Caroline B. Brettell, *Painters and Peasants in the Nineteenth Century* (Geneva, 1983), 44–45, 84, 95.

11. See Robert L. Herbert, *Jean-François Millet* (London, 1976), 80–81; John Hejduk, introduction to *Robert Gwathmey: Drawings, Watercolors, and Paintings* (New York, 1985), centerfold.

12. Herbert, *Millet*, 155; the Burchfield belongs to the PAFA.

13. Herbert, *Millet*, 136–37. See also Laura Meixner, *An International Episode: Millet, Monet, and Their North American Counterparts* (Memphis, Tenn., 1982), 11–106.

14. Colta Ives, Margret Stuffman, and Martin Sonnabend, *Daumier Drawings* (New York, 1992), 232; Bruce Laughton, *Honoré Daumier* (New Haven, 1976), 147.

15. See *Les Amateurs de Tableaux* [The picture connoisseurs], ca. 1858–62, in *Honoré Daumier, 1808–1879*

(Los Angeles: Armand Hammer Daumier Collection, 1982), 218–19. See also Daniel Grant on Gwathmey, "Compassion Colored by a Lifetime," *Newsday*, July 22, 1984.

16. During the summer of 1926 Evergood's future wife, Julia Cross, worked as a guide at Millet's house in Barbizon. She gave the young painter a thorough tour, which he found thrilling. Evergood then stayed at Barbizon for several days in order to paint Millet's house with its current owner, an elderly woman, standing in front. See Kendall Taylor, *Philip Evergood: Never Separate from the Heart* (London, 1987), 70–71.

17. Forrest Selvig interview with PE, Dec. 3, 1968, 30–31, AAA. The Metropolitan Museum of Art acquired a medium-sized version of this subject in 1929. A later, more finished version is at the National Gallery of Canada in Ottawa.

18. Michael Kimmelman, "Photographs That Fed Picasso's Vision," NYT, Jan. 11, 1998.

19. Charles K. Piehl, "The Eutaw Mural and the Southern Art of Robert Gwathmey," *Alabama Review* 45 (Apr. 1992): 126–27; Delatiner, "He Paints What Is in His Heart."

20. Dan B. Miller, *Erskine Caldwell: The Journey from Tobacco Road* (New York, 1995), 236–37, 268; Nicholas Natanson, *The Black Image in the New Deal: The Politics of FSA Photography* (Knoxville, Tenn., 1992).

21. Erskine Caldwell and Margaret Bourke-White, *You Have Seen Their Faces* (New York, 1937), is unpaginated.

22. Miller, *Erskine Caldwell*, 240–41; Burl F. Noggle, "With Pen and Camera: In Quest of the American South in the 1930s," in *The South Is Another Land: Essays on the Twentieth Century South*, ed. Bruce Clayton and John A. Salmond (Westport, Conn., 1987), 191.

23. William Stott, *Documentary Expression and Thirties America* (New York, 1973), 220–71, quoted in Noggle, "With Pen and Camera," 192–93.

24. Charles K. Piehl, "A Southern Artist at Home in the North: Robert Gwathmey's Acceptance of His Identity," *Southern Quarterly* 26 (Fall 1987): 8; Caldwell and Bourke-White, *You Have Seen Their Faces*, n.p.

25. Paul Cummings interview with RG, Mar. 19, 1968, 46–47, AAA. See Gilles Mora and John T. Hill, *Walker Evans: The Hungry Eye* (New York, 1993).

26. See Judith Keller, *Walker Evans: The Getty Museum Collection* (Malibu, Calif., 1995), 163–64.

27. Margaret R. Weiss, ed., *Ben Shahn, Photographer: An Album from the Thirties* (New York, 1973), plates 71 and 72; RG to Hudson and Ione Walker et al., Nov. 9–10, 1949, Walker papers, reel D353, AAA.

28. The price of *Bread and Circuses* was $1,200, but the MFA received a 20 percent discount. See RG to Herman Baron, July 9, 1946, Baron papers, AAA.

29. Allen Chaffee, *Sully Joins the Circus* (New York, 1926), 130; Dixie Willson, *Where the World Folds Up at Night* (New York, 1932), 61. For a huge peeling poster that shows extremely well dressed African Americans going to the circus (possibly an all-black circus) in a photograph taken by Walker Evans in 1936, see Hank O'Neal, *A Vision Shared: A Classic Portrait of America and Its People, 1935–1943* (New York, 1976), 56.

30. Ringling Brothers, "The Plantation Darkey at the Circus," in *With the Circus: Official Route Book, 1895–1896* (Buffalo, N.Y.: Courier Co., Show Printers, 1896), 109–10.

31. "A Conversation with Rosalie Gwathmey," in *Rosalie Gwathmey: Photographs from the Forties* (East Hampton, N.Y.: Glenn Horowitz, Bookseller, 1994), 7.

32. Anne Tucker, "Photographic Crossroads: The Photo League," *Journal of the National Gallery of Canada* 25 (Apr. 6, 1978): 1–8; telephone interview with Walter Rosenblum, Jan. 16, 1998; *Rosalie Gwathmey*, 8.

33. *Rosalie Gwathmey*, 8–9; Erika Duncan, "'I Just Quit,' Rosalie Gwathmey Said. And She Walked Away," NYT (Long Island ed.), Sept. 4, 1994; telephone conversation with RHG, Jan. 19, 1998.

34. Duncan, "'I Just Quit,'" 1; *Rosalie Gwathmey*, 9.

35. Interview with RHG, May 31, 1996; *Rosalie Gwathmey*, 10–12; RG to Herman Baron, July 9, 1946; Piehl, "Southern Artist at Home in the North," 8.

36. *Rosalie Gwathmey*, 5, 11–12.

37. Unpublished remarks by CG at a memorial service for his father in East Hampton, Oct. 16, 1988, 2–3, CG papers, in CG's possession, New York, N.Y.

38. Ibid., 2, 4. See also James Brady, "When Airports Were Fun," *Advertising Age*, May 15, 1989, n.p., clipping file, CG papers.

39. Conversation with CG, Nov. 26, 1997.

40. Remarks by CG at a memorial service, Apr. 5, 1989, 3–4, CG papers.

41. On November 18, 1993, CG delivered an expanded version of these remarks at the dedication of a chair that he endowed at the Cooper Union Art School in honor of his father. See hand-revised typescript prepared for oral delivery, 4, CG papers.

42. RG to Floyd _____, n.d., GP, AAA. "Floyd" was RG's nickname for a druggist in Philadelphia that the Gwathmeys had known since their student days. His real name was Lloyd. In 1932, *Cabin in the Cotton*, a film about sharecropping, had done well at the box office. Five years later, *They Won't Forget*, a film about lynching set in a middle-sized southern city, concentrated on sectional antagonisms rather than on racism. See Andrew Bergman, *We're in the Money: Depression America and Its Films* (New York, 1971), 93, 120.

43. Edward Rothstein, "Ethnicity and Disney: It's a Whole New Myth," NYT, Dec. 14, 1997; Steven Watts, *The Magic Kingdom: Walt Disney and the American Way of Life* (Boston, 1997), 273–80.

44. In 1944 Sternberg made *Portrait of Robert Gwathmey* as a color serigraph in an edition of twenty-five copies, each signed by the artist. Rosalie Gwathmey has always disliked that portrait because it makes her husband look unhealthy, with sunken chest, sallow coloring, etc. It does, however, contain the appropriate symbols—barbed wire, old boards, and black children—that Gwathmey had highlighted in paintings made in the years immediately preceding.

45. Reba White Williams, "Searching for Serigraphs," *American Artist* 51 (Sept. 1987): 71, 73; Albert Reese, *American Prize Prints of the Twentieth Century* (New York, 1949), 73.

46. Reba White Williams and Dave Williams, *American Screenprints* (New York, 1987), 23–24.

47. Robert Gwathmey, "Serigraphy," *American Artist* 9 (Dec. 1945): 8–11 (quotation at 8).

48. Ibid., 8, 9–10.

49. Ibid., 8.

50. Ibid.

51. Reba White Williams, "The Prints of Robert Gwathmey," in *Hot off the Press: Prints and Politics*, ed. Linda Tyler and Barry Walker (Albuquerque, 1994), 34. Gwathmey did, on occasion, repeat a motif some years later, usually not with positive results. Compare the *Sunday Morning* (1948) in plate 9 with the uninspired *Sunday Morning* (1957) in the New Orleans Museum of Art and illustrated in plate 1 of a portfolio in *Southern Quarterly* 26 (Fall 1987): opposite p. 58.

52. Paul Cummings interview with RG, Mar. 5, 1968, 32, AAA.

53. "Country Music Is Big Business," *Newsweek*, Aug. 11, 1952, 82–85; Joe Klein, *Woody Guthrie: A Life* (New York, 1980); "Readin' Country Music," special issue of *South Atlantic Quarterly* 94 (Winter 1995).

54. Interview with RHG, May 31, 1996; William Styron, *Sophie's Choice* (New York, 1979). In 1959 Gwathmey read Robert Elias, *Theodore Dreiser: Apostle of Nature* (1949), a study of one of America's most influential literary realists. The sketchbooks are in the possession of RHG. See interview with TD, Jan. 3, 1998.

55. Odum to Johnson, Jan. 4, 1928, Odum papers, quoted in Morton Sosna, *In Search of the Silent South: Southern Liberals and the Race Issue* (New York, 1977), 51.

56. Miller, *Erskine Caldwell*, 206, 207, 223, 245.

57. Louise Blackwell and Frances Clay, *Lillian Smith* (New York, 1971), chaps. 1–2. Smith may very

well have been influenced by reading John Dollard's classic, *Caste and Class in a Southern Town* (New Haven, 1937).

58. Lillian Smith, *Strange Fruit* (New York: Reynal and Hitchcock, 1944). See also Fred Hobson, *Tell about the South: The Southern Rage to Explain* (Baton Rouge, 1983), 307–23.

59. Blackwell and Clay, *Lillian Smith*, chap. 3; interview with RHG, Jan. 4, 1998. See Kathy A. Perkins and Judith L. Stephens, eds., *Strange Fruit: Plays on Lynching by American Women* (Bloomington, Ind., 1998).

60. Michael Denning, *The Cultural Front: The Laboring of American Culture in the Twentieth Century* (London, 1996), 323, 327; David W. Stowe, "The Politics of Café Society," *Journal of American History* 84 (Mar. 1998): 1395.

61. Denning, *Cultural Front*, 327–28; interview with RHG, Jan. 4, 1998. See also the grim lithograph by Boris Gorelick, *Strange Fruit* (1939), in Frances K. Pohl, *In the Eye of the Storm: An Art of Conscience, 1930–1970* (San Francisco, 1995), 50, 52.

62. Denning, *Cultural Front*, 328, 343, 348; Billie Holiday with William Dufty, *Lady Sings the Blues* (1956; New York, 1984), 84–86.

63. Interview with RHG, May 31, 1996.

64. *Rosalie Gwathmey*, 14. See Alan Holder, "Encounter in Alabama: Agee and the Tenant Farmer," *Virginia Quarterly Review* 42 (Spring 1966): 189–206.

65. Arlene Jacobowitz interview with RG, Sept. 29, 1966, 24, Brooklyn Museum, Brooklyn, N.Y.

66. Richard L. Perry, "The Front Porch as Stage and Symbol in the Deep South," *Journal of American Culture* 8 (Summer 1985): 13–18.

67. *American Artist* 12 (Feb. 1948): 20; Ilene Susan Fort and Michael Quick, *American Art: A Catalogue of the Los Angeles County Museum of Art Collection* (Los Angeles, 1991), 333–36; NYT, July 12, 1996. It seems especially odd that Gwathmey never mentions his contemporary Aaron Douglas (1899–1979), an important figure in the Harlem Renaissance after his move to New York in 1925 from the Midwest.

68. Richard Wright, *Later Works* (New York: Library of America, 1991), 880.

Chapter Four

1. RHG to Herman and Ella Baron, Jan. 18, 1950, Baron papers, AAA.

2. RG to the Barons, n.d., ibid.

3. Paul Cummings interview with RG, Mar. 5, 1968, 14, 15, AAA. William Phillips, coeditor of *Partisan Review*, also traveled in Europe in 1949–50 (for the first time) under the auspices of the Rockefeller Foundation. For a very different account of an American's experience in and response to Europe at that time, see Phillips, *A Partisan View: Five Decades of the Literary Life* (New York, 1983), esp. 202, 221.

4. RHG to Herman and Ella Baron, Jan. 18, 1950. The artist Jack Levine (1915–), who knew Robert Gwathmey quite well, said to me on January 23, 1998, "I am a child of Daumier," referring to his own penchant for fierce satire, and declared his belief that Daumier's lithographs constituted his finest work. Both Levine and Gwathmey also shared a great admiration for Goya.

5. Interview with RHG, Jan. 4, 1998; interview by telephone with Raymond Saunders, Jan. 21, 1998; Judd Tully, "Robert Gwathmey," *American Artist* 49 (June 1985): 90.

6. Arlene Jacobowitz interview with RG, Sept. 29, 1966, 16, Brooklyn Museum, Brooklyn, N.Y.

7. Estill Curtis Pennington, *A Southern Collection* (Augusta, Ga., 1992), 166. Gwathmey may also have been intrigued by Picasso's *Girl before a Mirror* (1932), owned by the Museum of Modern Art in New York.

8. See Loys Delteil, *Le Peintre-Graveur Illustré: Honoré Daumier* (Paris, 1926), nos. 3706 and 3949.

9. *Monsieur Arlépaire* first appeared as a lithograph in *La Caricature*, June 5, 1833, and appears on the

cover of Susan Coyle, ed., *The Human Comedy: Daumier and His Contemporaries* (Minneapolis, 1981). For *La Parade*, see Bruce Laughton, *Honoré Daumier* (New Haven, 1976), 132–33. Telephone conversation with CG, Nov. 27, 1997.

10. See Charles K. Piehl, "Robert Gwathmey: The Social and Historical Context of a Southerner's Art in the Mid-Twentieth Century," *Arts in Virginia* 29, no. 1 (1989): 13. Piehl does invoke an admirable appellation for Gwathmey's new style: "Social Surrealistic."

11. Gwathmey and Jacob Lawrence, who owns *Painting the Image White*, first met at an awards ceremony in 1947 and promptly became fast friends (telephone interview with Lawrence, Feb. 25, 1998). In the winter of 1997–98 a bizarre episode occurred in Washington, D.C., when the ambassador from Cameroon to the United States, His Excellency Jerome Mendouga, retained a black lawn jockey on the lawn of a home purchased by his government in northwest Washington. See *Washington Post*, Jan. 9, 1998.

12. RG to Herman Baron, late summer 1949 and Aug. 21, 1951, Baron papers, AAA.

13. RG to Herman and Ella Baron, Aug. 21, 1951, ibid.; RG to Jacquelyn L. Sheehan, late Jan. 1972, and hand-printed statement by RG, late 1977, Hirshhorn Archives, HMSG.

14. The painting is in the Art Museum of San Francisco. The quotation is from *University of Illinois Exhibition of Contemporary American Painting, College of Fine and Applied Arts, March 4–April 15, 1951* (Urbana, 1951), 184.

15. Gwathmey frequently remarked that southern sharecroppers wore an astonishing ensemble of colors: whatever they could find.

16. The painting, privately owned, was sold by the Forum Gallery of New York early in 1997. Jacobowitz interview, 12.

17. See Sarah Cash, *Ominous Hush: The Thunderstorm Paintings of Martin Johnson Heade* (Fort Worth, Tex., 1994), plates 1 and 3.

18. Presently owned by the Michael Rosenfeld Gallery in New York.

19. RG to Mrs. Betty Greenstein, Jan. 12, 1969, copy in CG papers, in CG's possession, New York, N.Y. There is a curious glaze on the woman's forehead that is quite noticeable from some angles yet invisible from others. The same problem affects a great work by Paul Cezanne, *The Smoker* (ca. 1890–92), located at the Hermitage Museum in St. Petersburg. Cezanne seems to have experimented with creating planes on the pipe smoker's head, clearly anticipating cubism. There is a glaze on the man's forehead that is problematic from straight-ahead viewing (at a distance of twelve feet, for example), yet it disappears when the viewer moves closer to the right or to the left.

20. *United Family* is in the Fogg Art Museum at Harvard. See James B. Lynch Jr., *Rufino Tamayo: Fifty Years of His Painting* (Mt. Vernon, N.Y., 1978), 43, and Octavio Paz, *Rufino Tamayo* (2nd ed.: Barcelona, 1995), 284, 292, and plates 262, 269.

21. Jacobowitz interview, 23; Paul Cummings interview with RG, Mar. 19, 1968, 54, AAA.

22. Quoted in Reba White Williams, "The Prints of Robert Gwathmey," in *Hot off the Press: Prints and Politics*, ed. Linda Tyler and Barry Walker (Albuquerque, 1994), 38.

23. Telephone interview with Sarai Sherman, Jan. 26, 1998; interview with RHG, Jan. 4, 1998; Erika Duncan, "'I Just Quit,' Rosalie Gwathmey Said. And She Walked Away," NYT (Long Island ed.), Sept. 4, 1994.

24. RG to Inez Garson, Jan. 30, 1979, Hirshhorn Archives.

25. Cummings interview with RG, Mar. 19, 1968, 21. RG said much the same in an extended interview with Karl E. Fortess, July 30, 1967, Fortess taped interviews, AAA.

26. Interview with Jack Levine, Jan. 23, 1998.

27. Interview with CG, Nov. 27, 1997.

28. See James L. Summers, "Like Son," *Seventeen*, Nov. 1948, 84–85, 145–46.

29. The painting is owned by Terry Dintenfass, Inc., in New York City.

30. Interview with RHG, May 31, 1996.

31. See *Sports Illustrated*, Apr. 14, 1958, 102–8, and the cover illustration on Sept. 29, 1958, which is a detailed section of Gwathmey's rendering of the Braves' victory in the fifth game on Oct. 7, 1957.

32. FBI file no. 409,729 concerning RG, obtained by MK under the Freedom of Information Act.

33. FBI office memorandum, Oct. 24, 1951, no. 100-171543.

34. FBI office memorandum, Dec. 15, 1953, no. 100-42001; description corroborated by RHG in an interview on May 31, 1996. For a notable account of what it is like to undergo such an experience, see Nat Hentoff, *Speaking Freely: A Memoir* (New York, 1997), 128–30.

35. FBI office memorandum, Jan. 21, 1954, no. 100-42001. See Griffin Fariello, *Red Scare: Memories of the American Inquisition, an Oral History* (New York, 1995), 161; Robert Griffith, *The Politics of Fear: Joseph R. McCarthy and the Senate* (Lexington, Ky., 1970), 37, 97. Oddly enough, Dondero's bitterest attacks were aimed at the "Red art termites" of Abstract Expressionism.

36. *Congressional Record*, 81st Cong., 1st sess., 1949, vol. 95, pts. 3 and 5, 3235, 6374. Dondero's other attacks on artists occurred on Mar. 11 and Aug. 16, 1949.

37. Hoover to Rankin, Mar. 16, 1964, Gwathmey FBI file no. 100-171543.

38. Stephen Robert Frankel, ed., *Jack Levine* (New York, 1989), 65, 99–100.

39. Forrest Selvig interview with Jack Levine, Sept. 5, 1968, 16, and Selvig interview with PE, Dec. 3, 1968, 27, AAA.

40. Anne Bowen Parsons interview with RG, Aug. 20, 1967, 2, AAA.

41. Cummings interview with RG, Mar. 19, 1968, 41.

42. Hopper is quoted in Richard Meryman, *Andrew Wyeth: A Secret Life* (New York, 1996), 393; "Andrew Wyeth," an interview by George Plimpton and Donald Stewart, *Horizon*, Sept. 1961, 88.

43. Louise Elliott Rago, "Robert Gwathmey Speaks on the Artist," *School Arts* 59 (Jan. 1960): 31. For the best treatment of changing perceptions of the Abstract Expressionists, see Michael Leja, *Reframing Abstract Expressionism: Subjectivity and Painting in the 1940s* (New Haven, 1993).

44. "A Conversation with Rosalie Gwathmey," in *Rosalie Gwathmey: Photographs from the Forties* (East Hampton, N.Y.: Glenn Horowitz, Bookseller, 1994), 13.

45. Serge Guilbaut, *How New York Stole the Idea of Modern Art: Abstract Expressionism, Freedom, and the Cold War* (Chicago, 1983), 4, 148–50.

46. See James Sloan Allen, *The Romance of Commerce and Culture: Capitalism, Modernism, and the Chicago-Aspen Crusade for Cultural Reform* (Chicago, 1983), 269–79; Reyner Banham, ed., *The Aspen Papers: Twenty Years of Design Theory from the International Design Conference in Aspen* (London, 1974).

47. C. Wright Mills, "Man in the Middle: The Designer," in *Power, Politics, and People: The Collected Essays of C. Wright Mills*, ed. Irving Louis Horowitz (New York, 1963), 374–86 (quotation at 374).

48. "Notes on the Future: Aspen Design Conference," *Print* 12 (Sept.–Oct. 1958): 53–57.

49. In 1954 sculptor Harry Bertoia created a sculpture screen of welded metal (16' × 70' × 2') for the Manufacturers Hanover Trust Co. See June Kompass Nelson, *Harry Bertoia: Sculptor* (Detroit, 1970), plate 22.

50. Robert Gwathmey, "Art for Art's Sake," typescript, with annotations, of a talk delivered at the International Design Conference in Aspen, Colo., in 1958, GP, roll D245, last three frames, AAA.

51. Telephone conversation with RHG, Jan. 20, 1998.

52. RG to Leon Kroll, Apr. 9, 1959, Kroll papers, reel 326, AAA.

53. Hilton Kramer, "The Hazards of Modern Painting," reprinted from *Commentary*, in *Social Realism: Art as a Weapon*, ed. David Shapiro (New York, 1973), 272. *Reception in Miami* is a statement about the corruption of the moneyed classes. See Frankel, *Jack Levine*, 48–49, where Levine explains what prompted him to paint this highly amusing satire:

Reception in Miami was the result of reading one day in Earl Wilson's column in the *New York Post* that the Duke and Duchess of Windsor had come to Miami, and that at one of their appearances in the lobby there was much bowing and curtsying on the part of our fellow Americans. I thought this disgusting. That was the basis for something like a drawing-room comedy, with all kinds of effete snobs (as someone said later) bowing and scraping, like puppets at the end of a string, and becoming British subjects for the evening. I thought that was a good topic. I think I probably considered my entry into any painting on the basis of subject matter. It's something I would never discard. Subject matter is all important.

54. Frederick S. Wight, "Jack Levine," in Shapiro, *Social Realism*, 259.

55. John I. H. Baur interview with PE, June 1959, 22–23, AAA; for Gwathmey taking a "back seat" to Evergood, my sources are a telephone conversation with Walter Rosenblum, Jan. 9, 1998, and an interview with RHG, Jan. 4, 1998.

56. For a color plate, see John I. H. Baur, *Philip Evergood* (New York, 1975), plate 84.

57. See Selvig interview with PE, Dec. 4, 1968, 50.

58. The Evergood painting is in the Corcoran Gallery of Art, Washington, D.C.

59. RHG to Herman and Ella Baron, Jan. 18, 1950.

60. Interviews with TD, Jan. 4, 23, 1998; Selvig interview with PE, Dec. 4, 1968, 46.

61. Selvig interview with PE, Dec. 3, 1968, 35.

62. Interview with Robert Fishko, Jan. 24, 1998. For Baron's obituary, see NYT, Jan. 28, 1961.

63. Interview with RHG, Jan. 4, 1998; telephone interview with Sarai Sherman, Jan. 26, 1998; telephone interview with Sidney Goodman, Jan. 19, 1998.

64. RG to Chaim Gross, Oct. 24, 1954, Gross papers, box 1, Special Collections, Syracuse University Library, Syracuse, N.Y.

65. Interview with Jack Levine, Jan. 23, 1998.

66. *Robert Gwathmey: Drawings, Watercolors, and Paintings, the Cooper Union, New York, May 23–June 20, 1985* (n.p., n.d.), 3.

67. Eric Steel considers these possibilities in "Just and Always Himself: Robert Gwathmey" (senior essay, Yale University, Apr. 1985), 8–9.

68. Quoted in Rago, "Gwathmey Speaks on the Artist," 32.

69. Telephone conversation with CG, Nov. 27, 1997; interview with RHG, Jan. 4, 1998.

Chapter Five

1. Paul Cummings interview with TD, Dec. 2, 1974, 1–3, Dintenfass papers, AAA; Nathan S. Kline, *From Sad to Glad: Kline on Depression* (New York, 1974).

2. Cummings interview with TD, Dec. 2, 1974, 4–5.

3. Ibid., 6.

4. Telephone interview with Andrew Dintenfass, Jan. 27, 1998.

5. Cummings interview with TD, Dec. 2, 1974, 8–9.

6. Ibid., 11–12.

7. Ibid., 13.

8. Ibid., 14–17. Sarai Sherman, a close friend of the Gwathmeys, observed to me in conversation on Jan. 26, 1998, that "Terry was married to a wealthy doctor and had nothing to do."

9. Cummings interview with TD, Dec. 2, 1974, 17–18. Terry was 33 in 1953, but Bob was 50 rather than 53.

10. Ibid., 18–19.

11. TD to PE, June 14, 1955, Evergood papers, AAA.

12. Cummings interview with TD, Dec. 2, 1974, 20. JuJu was Evergood's wife, Julia. Unlike Gwathmey, Evergood was not sexually promiscuous, because he adored Julia.

13. Ibid., 20–21.

14. Quoted in Kendall Taylor, *Philip Evergood: Never Separate from the Heart* (London, 1987), 122.

15. TD to PE, Oct. 28, 1957, Aug. 4, 1958, Jan. 17, 1959, Evergood papers. See also Cummings interview with TD, Dec. 2, 1974, 21, 24, 28, 57.

16. TD to PE, July 7, 1959, Evergood papers.

17. Interview with Robert Fishko, Jan. 24, 1998; TD to PE, Feb. 17, 1961, Evergood papers.

18. Interview with Sidney Bergen, May 30, 1996; interview with Robert Fishko, Jan. 24, 1998; Cummings interview with TD, Dec. 2, 1974, and Jan. 13, 1975, 22, 32, 60, 61. Terry Dintenfass finalized dealer's contracts with both Gwathmey and Evergood in September 1961.

19. Herman Baron, "The ACA Gallery: Impressions and Recollections," in *31 Contemporary Artists* (New York: ACA Gallery, 1959), n.p.; interview with Jack Levine, Jan. 23, 1998.

20. TD to PE, Feb. 14, 1959, Evergood papers; Cummings interview with TD, Dec. 2, 1974, 28.

21. TD to PE, Apr. 28, 1964, Evergood papers; interview with RHG, Jan. 4, 1998; RHG to Julia and Philip Evergood, Mar. 10, 1967, Evergood papers.

22. PE to TD, Mar. 5, 1963; TD to PE, Mar. 8, 1963; Lucy Lippard to PE, Mar. 19, 1964, all in Evergood papers; telephone interview with Sidney Goodman, Jan. 16, 1998; interview with Blanche and Milton W. Brown, Jan. 4, 1998.

23. Telephone interview with Sarai Sherman, Jan. 21, 1998; interview with Sandra Weiner, Feb. 2, 1998.

24. Cummings interview with TD, Dec. 2, 1974, 22; telephone interview with Sidney Goodman, Jan. 16, 1998. Goodman, who was extremely close to both Bob and Terry, feels that they were terrific as a couple but that marriage would have been highly problematic because Terry was his dealer. The other artists she handled in her gallery might have been inclined to assume that she would promote Bob's work above that of the rest. In Goodman's view they were better off "simply" as lovers. For confirmation of Goodman's perception, see PE to RG, Apr. 2, 1963, Evergood papers.

25. Cummings interview with TD, Jan. 13, 1975, 62.

26. Ibid., Dec. 2, 1974, 32–33.

27. Ibid., Jan. 13, 1975, 50, 74; interviews with TD, Jan. 3, 23, 1998. Terry Dintenfass's customary commission was one-third of the sale price of a painting. Today it is not unusual for dealers to get 50 percent (or even 60 percent) if they actively promote an artist's work.

28. PE to TD, Mar. 5, 1963, and TD to PE, Mar. 8, 1963, Evergood papers. For Evergood's detailed account of why he felt dissatisfied with his situation at the Dintenfass gallery, see PE to RG, Apr. 2, 1963, ibid. For Terry's brief version, see Cummings interview with TD, Jan. 13, 1975, 74.

29. RG to PE, Mar. 16, 1963, Evergood papers.

30. PE to RG, Apr. 2, 1963, ibid.; Taylor, *Philip Evergood*, 100; interview with Jack Levine, Jan. 23, 1998; *Worker's Victory* is plate 86 in Taylor, *Philip Evergood*.

31. Taylor, *Philip Evergood*, 100; Robert Gwathmey, "Philip Evergood, 1901–1973," *Proceedings of the American Academy of Arts and Letters*, 2nd ser., no. 24 (1974): 122–25 (quotation at 123).

32. Cummings interview with TD, Dec. 2, 1974, 22.

33. Interview with RHG, Jan 4, 1998; interview with Sandra Weiner, Feb. 2, 1998. RHG referred to RG's sisters as "social climbers."

34. Interview with Robert Fishko, Jan. 24, 1998; interview with Jack Levine, Jan. 23, 1998; interview with Sandra Weiner, Feb. 2, 1998. In 1934 one of Walt Disney's best cartoonists created "Cock o'

the Walk," a highly successful cartoon that featured a swaggering, macho rooster. See Steven Watts, *The Magic Kingdom: Walt Disney and the American Way of Life* (Boston, 1997), 93.

35. Cummings interview with TD, Jan. 13, 1975, 42; Paul Cummings interview with RG, Mar. 5, 1968, 34, AAA. The Gwathmeys sold their house on East Tenth Street in 1960.

36. Paul Cummings interview with RG, Mar. 19, 1968, 51, AAA; telephone interview with Andrew Dintenfass, Jan. 27, 1998.

37. For a possible inspiration for the actual image, see Daumier's *The Heavy Burden* (Burrell Collection Art Gallery, Glasgow, Scotland), illustrated in Oliver W. Larkin, *Daumier: Man of His Time* (Boston, 1966), 136.

38. See Steven Smith, "Personalities in the Crowd: The Idea of the 'Masses' in American Popular Culture," *Prospects: An Annual of American Cultural Studies* 19 (1994): 240–43.

39. Cummings interview with RG, Mar. 19, 1968, 51. Because "R.G." is actually part of the *Sharecropper* lithograph, whereas his signature is in pencil, I may be making too much of the apparent double entendre. Nevertheless, I feel it is no accident that "R.G." is placed in the discarded bushel. The farmer wears a distinct look of guilt or, at least, is distinctly ill at ease.

40. Telephone interview with Ralph and Eva Fasanella, July 25, 1996; letter from Ralph Fasanella to MK, July 26, 1996; telephone interview with Sidney Goodman, Dec. 18, 1997; Taylor, *Philip Evergood*, 101. See also John B. Ravenal, *Sidney Goodman: Paintings and Drawings, 1959–95* (Philadelphia, 1996).

41. Telephone interview with Raymond Saunders, Jan. 27, 1998; telephone interview with Antonio Frasconi, Mar. 3, 1998.

42. Cummings interview with TD, Jan. 13, 1975, 56, 61.

43. Cummings interview with RG, Mar. 19, 1968, 57.

44. Ibid., 38, 63.

45. Ibid., 63.

46. Gwathmey made several very careful studies in pencil of the part of *Laughter* that he really cared about: the head of a man laughing very hard as seen from below—a self-portrait, actually. The best of these is in the personal collection of Terry Dintenfass.

47. See John Canaday, *Embattled Critic: Views on Modern Art* (New York, 1962), 11; Maurice de Sausmarez, *Bridget Riley* (Greenwich, Conn., 1970), 15–20 ("Introductory Observations on Optical Painting"), 26–31 ("The Development of Bridget Riley's Work, 1959–1965"). I believe that Charles K. Piehl fails to appreciate the harsh satire of Op Art being offered in *Striped Table Cloth*. See Piehl, "A Southern Artist at Home in the North: Robert Gwathmey's Acceptance of His Identity," *Southern Quarterly* 26 (Fall 1987): 16.

48. Cummings interview with RG, Mar. 19, 1968, 63.

49. RG to PE, Mar. 16, 1963, Evergood papers.

50. Interview with John Hejduk, Feb. 2, 1998. For an example of Dean Hejduk's work done in Gwathmey's drawing class in 1947–48, see Hejduk, *Mask of Medusa: Works, 1947–1983* (New York, 1985), 171.

51. RG to Herman Baron, July 9, 1946, Baron papers, AAA.

52. RG to PE, Mar. 16, 1963, Feb. 17, 1965, Evergood papers. In his 1967 introduction to a one-man exhibition of paintings by Ralph Fasanella, Gwathmey referred to himself as "an intransigent citizen" of New York City. Sent to MK by Fasanella on July 26, 1996.

53. Cummings interview with RG, Mar. 19, 1968, 61.

54. For representative examples of New York City art with lots of tall buildings but no people, see Georgia O'Keeffe, *Cityscape with Roses* (1932) in the NMAA, and Jan Matulka, *Cityscape* (1923), an etching in the Museum of Modern Art. Matulka was an American artist (1890–1972).

55. Cummings interview with TD, Dec. 2, 1974, 23–24; interview with RHG, June 1, 1996; telephone interview with CG, Nov. 27, 1997.

56. Telephone interview with Andrew Dintenfass, Jan. 27, 1998.

57. Interviews with TD, Jan. 3, 23, 1998.

58. RG to PE, Jan. 27, 1965, Evergood papers; interview with RHG, Jan. 4, 1998; Arlene Jacobowitz interview with RG, Sept. 29, 1966, 4, Brooklyn Museum, Brooklyn, N.Y. Even when the Gwathmeys were separated in 1964–67, he sometimes sent her part of the proceeds from a painting that sold (interview with RHG, Jan. 4, 1998).

59. Telephone interview with CG, Nov. 26, 1997; RHG to Julia and PE, Mar. 10, 1967, Evergood papers. *Going Home* (n.d.) belongs to the HMSG.

60. Interview with RHG, Jan. 4, 1998; Cummings interview with RG, Mar. 19, 1968, 57; Cummings interview with TD, Jan. 13, 1975, 55.

61. In Great Britain, November 5 is celebrated as Guy Fawkes Day because on November 5, 1605, Guy Fawkes was discovered in the cellar of the Houses of Parliament, surrounded by casks of gunpowder. Along with his co-conspirators, Fawkes intended to kill King James I and other leaders for persecuting Roman Catholics. Gwathmey undoubtedly knew about Guy Fawkes Day, but it ranks low on the list of possible reasons why he used the figure "5" so often as an icon.

62. See Emily Farnham, *Charles Demuth: Behind a Laughing Mask* (Norman, Okla., 1971), 101–2, 177–78; William Carlos Williams, *Autobiography* (New York, 1951), chap. 26; Jacobowitz interview, 14.

63. CG to MK, Dec. 22, 1997.

64. RG to Andrew Dintenfass, Nov. 24, 1967, in possession of Andrew Dintenfass.

65. For Dickens's complex relationship with actress Ellen Ternan, 1857–70, see Fred Kaplan, *Dickens: A Biography* (New York, 1988), 361–413. Dickens separated from his wife in 1858 and wrote the following about himself in his notebook: "A misplaced and mismarried man. Always, as it were, playing hide and seek with the world and never finding what Fortune seems to have hidden when he was born" (quoted in Kaplan, *Dickens*, 376).

Chapter Six

1. Interview with Milton W. Brown, Jan. 4, 1998; interview with Robert Fishko, Jan. 24, 1998.

2. Philip Evergood, "Sure I'm a Social Painter," *Magazine of Art* 36 (Nov. 1943): 254–59; Forrest Selvig interview with PE, Dec. 3, 1968, 50, AAA. Evergood's memory failed him. The 1937 painting is actually based on a bloody battle between picketing strikers and police outside a steel mill in Chicago on Memorial Day in 1937. Evergood composed it from newspaper photographs.

3. Studs Terkel, *Hard Times: An Oral History of the Great Depression* (1970; New York, 1986), 375. See also the Karl E. Fortess interview with RG, July 30, 1967, Fortess taped interviews, AAA.

4. RG to Andrew Dintenfass, Nov. 24, 1967, in possession of Andrew Dintenfass. In September 1966 Stokely Carmichael wrote that "integration is a subterfuge for the maintenance of white supremacy and reinforces, among both black and white, the idea that 'white' is automatically better and 'black' is by definition inferior" (David Farber, ed., *The Sixties: From Memory to History* [Chapel Hill, 1994], 119).

5. This painting was displayed in 1964 at the inaugural exhibition of the Museum of Modern Art in Mexico City. For a problematic misreading of *The Observer*, see Charles K. Piehl, "A Southern Artist at Home in the North: Robert Gwathmey's Acceptance of His Identity," *Southern Quarterly* 26 (Fall 1987): 11. Rosalie Gwathmey has acknowledged that *The Observer* was also about race: "That's the way he thought about it. Just a human being" (interview with RHG, Jan. 4, 1998).

6. Gwathmey also painted a small version of *The Observer* (18" × 13"), present location unknown. A Parke-Bernet sale on Oct. 9, 1963, described it as follows: "A young boy wearing a dark swimming

suit is seated on a reed-lined beach facing the observer as he watches a land crab move swiftly across the sand; a lobster and a snail shell are also visible."

7. TD to PE from Atlantic City, June 1955, and TD to PE, Jan. 17, July 7, 1959, Evergood papers, AAA.

8. Dave Farrell, "As 'Fats' Waller Would Have Wanted It," *Daily Worker*, Apr. 1944; Robert Cantwell, *When We Were Good: The Folk Revival* (Cambridge, Mass., 1996), 112, 207–8, 220, 313; David L. Chappell, *Inside Agitators: White Southerners in the Civil Rights Movement* (Baltimore, 1994). See also Susan Gubar, *Race-changes: White Skin, Black Face in American Culture* (New York, 1997).

9. John Wilmerding, *Andrew Wyeth: The Helga Pictures* (New York, 1987), 111–13; Richard Meryman, *Andrew Wyeth: A Secret Life* (New York, 1996), 354, plate opposite 358.

10. Tom Wicker, "Deserting the Democrats: Why African-Americans and the Poor Should Make Common Cause in Their Own Party," *Nation*, June 17, 1996, 11–22; Wicker to MK, July 8, 1996; Karen J. Winkler, "Scholars Explore the Blurred Lines of Race, Gender, and Ethnicity," *Chronicle of Higher Education*, July 11, 1997, A11–12; David Streitfeld, "The Novelist's Prism: Toni Morrison Holds Race up to the Light and Reflects on the Meaning of Color," *Washington Post*, Jan. 6, 1998.

11. In the only previous discussion of this painting, Frances K. Pohl mistakenly perceived the man with the rifle as African American. Rather, he is a poor white man, the self-designated custodian of a ruined past. A mindless figure, he has become the caretaker of something that is utterly worthless. The custodian has huge hands, a Gwathmey hallmark. See Pohl, *In the Eye of the Storm: An Art of Conscience, 1930–1970* (San Francisco, 1995), 90, 93.

12. See Meryman, *Andrew Wyeth*, 227. For an astute discussion of color blindness as a problematic ideal in modern America, see Amy Gutmann's essay "Must Public Policy Be Color Blind?" in *Color Conscious: The Political Morality of Race*, ed. K. Anthony Appiah and Gutmann (Princeton, 1996), 118–38. Gutmann argues persuasively for the limits of color blindness as public policy. As historian David Hollinger has observed, because of the affirmative action programs developed between 1965 and 1975, it became "possible to be 'color-conscious' rather than 'color blind' in public affairs without assuming that persons of a given color were possessed of a particular culture." According to law, at least, the existence of color could be acknowledged without being accompanied by any particular or valid assumptions about cultural "baggage." Recognition of color thereby became acceptable when it was separated from any inevitable givens. Skeptics have since emerged, of course, but that idea became conventional wisdom during the later 1960s and 1970s. Because Robert Gwathmey appears to have shared it, color-consciousness returned to his art. See David Hollinger, "National Culture and Communities of Descent," *Reviews in American History* 26 (Mar. 1998): 316.

13. Paul Cummings interview with TD, Jan. 13, 1975, 58, AAA. Later on that page she added, "I don't think Bob even knows."

14. Steve Smith, "The Rhetoric of Barbeque: A Southern Rite and Ritual," *Studies in Popular Culture* 8, no. 1 (1985): 21–22. For a different iconographic approach to the intensely social nature and meaning of barbecue for African Americans in an urban setting, see the two *Barbeque* paintings (1934 and 1960) in Jontyle Theresa Robinson and Wendy Greenhouse, *The Art of Archibald J. Motley, Jr.* (Chicago, 1991), 105, 140. The 1960 version does feature a dominant black barbecue chef. He appears to be the epicenter of all he surveys.

15. Cynthia Nadelman interview with Faith Ringgold, Sept. 13, 1989, 51–52, AAA.

16. Ibid., 54–55.

17. Interview with Jack Levine, Jan. 23, 1998; Arlene Jacobowitz interview with RG, Sept. 29, 1966, 9–12 (quotations at 11 and 12), Brooklyn Museum, Brooklyn, N.Y.

18. *Twelfth Exhibition of Contemporary American Painting and Sculpture, 1965* (Urbana: College of Fine and Applied Arts, University of Illinois, 1965), 180–81.

19. RG to Nicholas Bragg, Dec. 12, [1978], Reynolda House, Museum of American Art Archives,

Winston-Salem, N.C. Ten days earlier Gwathmey had told an associate of Terry Dintenfass that he wanted to emphasize the contrast between the educator and the "bird brains," that the Klansman wore both a polished shoe and a worker's boot to emphasize the social breadth of Klan membership. The allusion to the circus meant keep everyone happy to avoid social discontent, and "the medicine man cures all" (Luise Ross to Bragg, Dec. 16, 1978, ibid.).

20. Jacobowitz interview, 22. See also Chappell, *Inside Agitators*.

21. Quoted in Richard L. Perry, "The Front Porch as Stage and Symbol in the Deep South," *Journal of American Culture* 8 (Summer 1985): 13. Activities such as shelling peas on the front porch late in the day were characteristic of the South because of the need for shade. Gwathmey painted several versions of *Shelling Peas*. One of the best is at the Greenville County Museum of Art in South Carolina.

22. Perry, "Front Porch as Stage and Symbol," 16; Ellen M. Schall, John Wilmerding, and David M. Sokol, *American Art, American Vision: Paintings from a Century of Collecting* (Alexandria, Va., 1990), 96.

23. Anne Moody, *Coming of Age in Mississippi* (New York, 1968), 13.

24. See Perry, "Front Porch as Stage and Symbol," 14.

25. Jacobowitz interview, 21–22; Fortess interview with RG.

26. See Charles K. Piehl, "Anonymous Heroines: Black Women as Heroic Types in Robert Gwathmey's Art," in *Heroines of Popular Culture*, ed. Pat Browne (Bowling Green, Ohio, 1987), 128–48.

27. Jacobowitz interview, 21–22.

28. Interview with Jack Levine, Jan. 23, 1998, and telephone interview with RHG, Jan. 30, 1998.

29. See Henry Adams, *Thomas Hart Benton: An American Original* (New York, 1989), 124, 127, 137, 144; also 249, 250, for later works that are less "heroic" and closer in mood to Gwathmey's compositions.

30. See Herbert Gutman, *The Black Family in Slavery and Freedom, 1750–1925* (New York, 1976), xix, 461–67, responding to Daniel Patrick Moynihan, *The Negro Family: The Case for National Action* (1965).

31. Telephone interview with William M. Landes, CG's closest friend in secondary school (who accompanied RG and CG to Columbia University football games every Saturday in the autumn), Feb. 6, 1998.

32. See Sylvan Cole Jr., ed., *The Graphic Work of Joseph Hirsch* (New York, 1970), no. 10.

33. See, for example, Eastman Johnson, *Christmas Time* (*The Blodgett Family*) (1864), and Johnson, *The Hatch Family* (1871), both in the American Wing of the Metropolitan Museum of Art.

34. Canaday's books, which were taken very seriously, included *Realism* (1958), *Composition: Pictures as Structures* (1958), *Mainstreams of Modern Art: David to Picasso* (1959), and *Embattled Critic: Views on Modern Art* (1962).

35. NYT, Feb. 3, 1968. A triolet is a poem or stanza of eight lines in which the first is repeated as the fourth and the second and the seventh as the eighth. For Canaday's guarded but negative response to the art of PE, see "On Innocence: With Reference to Philip Evergood," in Canaday, *Embattled Critic*, 158–62.

36. NYT, Dec. 28, 1971.

37. Jacobowitz interview, 24. Not by coincidence, perhaps, Evergood painted his *Picnic* in 1967. See *Philip Evergood: Paintings and Drawings* (New York, 1972), no. 23.

38. Paul Cummings interview with RG, Mar. 5, 1968, 13–14, AAA.

39. Paul Cummings interview with RG, Mar. 19, 1968, 60–61, AAA.

40. See Abram Lerner, ed., *An Introduction to the Hirshhorn Museum and Sculpture Garden* (New York, 1974).

41. RG to Abram Lerner (n.d., 1974), Hirshhorn Archives, HMSG.

42. RG, "Statement" (n.d.), ibid. (not quoted); RG, "A Midsummer Night's Dream" (n.d.), GP, microfilm roll D245, AAA (quoted).

43. Milton W. Brown, "Robert Gwathmey," in *Robert Gwathmey: Drawings, Watercolors, and Paintings*, the Cooper Union, New York, May 23–June 20, 1985 (n.p., n.d.), 4; interview with Brown, Jan. 4, 1998; Stephen Robert Frankel, ed., *Jack Levine* (New York, 1989), 80.

Chapter Seven

1. Interviews with RHG, June 1, 1996, and Jan. 4, 1998.

2. Paul Cummings interview with RG, Mar. 19, 1968, 65, AAA.

3. Interview with John Hejduk, Feb. 2, 1998, and interview with RHG, Jan. 4, 1998.

4. RHG to Gwendolyn and Jacob Lawrence, [fall 1968], Lawrence papers, Special Collections, Syracuse University Library, Syracuse, N.Y.; RHG to MK, June 10, 1996; Studs Terkel, *Hard Times: An Oral History of the Great Depression* (1970; New York, 1986), 375.

5. Fasanella to MK, July 26, 1996, with RG's undated foreword enclosed; Roberta Smith, "Ralph Fasanella, 83, Primitive Painter, Dies," NYT, Dec. 18, 1997.

6. See Robert Cantwell, *When We Were Good: The Folk Revival* (Cambridge, Mass., 1996), 194–95; Terkel, *Hard Times*, 373.

7. For a comparable work by an African American artist who sought to make a critical statement about a century of race relations in the United States, see *The First One Hundred Years* (ca. 1963–72) in Jontyle Theresa Robinson and Wendy Greenhouse, *The Art of Archibald J. Motley, Jr.* (Chicago, 1991), 142–43. *The First One Hundred Years* also resonates very strongly in theme and in mood with Gwathmey's *Space* (1964) (fig. 56).

8. See the catalog *Robert Gwathmey: Drawings, Watercolors, and Paintings*, the Cooper Union, New York, May 23–June 20, 1985 (n.p., n.d.), for a 1970 drawing of this work.

9. Gwathmey's FBI surveillance file obtained under the Freedom of Information Act (190-HQ-1177147), Field Office file no. NY 100-42001, Jan. 29, 1962.

10. See Mario de Michel, *Siqueiros* (New York, 1968).

11. Gwathmey's FBI field office file, Jan. 29, 1962, no. NY 100-42001, and report dated Dec. 20, 1963.

12. Ibid., and reports dated Mar. 5, 10, 1964, sent from the New York office to J. Edgar Hoover.

13. Hoover to Rankin, Mar. 16, 1964 (by courier service), in RG's Field Office file, no. NY 100-42001.

14. New York office to Hoover, June 20, 1969, ibid. For a superb first-person account of what it meant to be under FBI surveillance during those years, and then to obtain the entire file, see Nat Hentoff, *Speaking Freely: A Memoir* (New York, 1997), 121–34.

15. Anne Bowen Parsons interview with RG, Aug. 20, 1967, 2, AAA; *Robert Gwathmey*, cover illustration.

16. Interview with RHG, Jan. 4, 1998; Victor Rabinowitz to MK, July 15, 1996.

17. *McKinney's Consolidated Laws of New York*, vol. 19, *General Business Law* (St. Paul, Minn., 1988), 217–18. See also Albert M. Rosenblatt, "Flag Desecration Statutes: History and Analysis," *Washington University Law Quarterly* 1972, no. 2 (Spring 1972): 193–237.

18. Victor Rabinowitz to MK, July 15, 1996; Rabinowitz, *Unrepentant Leftist: A Lawyer's Memoir* (Urbana, 1996), 314–15.

19. Interview with Jack Levine, Jan. 23, 1998; RHG to MK, June 10, 1996; Robert J. Goldstein, *Saving "Old Glory": The History of the American Flag Desecration Controversy* (Boulder, Colo., 1995).

20. See Charles K. Piehl, "Robert Gwathmey: The Social and Historical Context of a Southerner's Art in the Mid-Twentieth Century," *Arts in Virginia* 29, no. 1 (1989): 5. A version in watercolor is owned by Mrs. Sandra Weiner in Manhattan.

21. Paul Cummings interview with TD, Dec. 18, 1974, 61, AAA.

22. Bruce Laughton, *Honoré Daumier* (New Haven, 1976), 73 and plate 89; Jan Rie Kist, *Honoré Daumier, 1808–1879* (Washington, D.C., 1979), 80.

23. See Laughton, *Daumier*, 130; Oliver W. Larkin, *Daumier: Man of His Time* (Boston, 1966), 33–34. See also Donald Grant, "Compassion Colored by a Lifetime," *Newsday*, July 22, 1984.

24. Stephen Robert Frankel, ed., *Jack Levine* (New York, 1989), 129; telephone interview with Jack Levine, Feb. 17, 1998. See also Levine's *Discord* (1953), in Frances K. Pohl, *In the Eye of the Storm: An Art of Conscience, 1930–1970* (San Francisco, 1995), 82. Two standing men are locked in violent struggle.

25. Interview with Jack Levine, Jan. 23, 1998.

26. Robert Gwathmey, "Philip Evergood, 1901–1973," *Proceedings of the American Academy of Arts and Letters*, 2nd ser., no. 24 (1974): 124. For a prime example of the paintings that Gwathmey had in mind, see Evergood's *Satisfaction in New Jersey* (ca. 1951), in John I. H. Baur, *Philip Evergood* (New York, 1960), 80–81.

27. Andrew Wachtel, ed., *Petrushka: Sources and Contexts* (Evanston, Ill., 1998), chaps. 2, 4. Michel Fokine's modernistic ballet was intended as a biting satire directed against conventional ballet, particularly "ready-made" dance steps and the lack of genuine expressiveness.

28. See Cynthia Newman Helms, ed., *Diego Rivera: A Retrospective* (New York: Detroit Institute of Arts, 1986), 110.

29. I am grateful to Rosalie Gwathmey for calling this to my attention on several occasions, but especially on Jan. 4, 1998. She also finds it in the architectural compositions of Charles Gwathmey.

30. Cummings interview with RG, Mar. 19, 1968, 64.

31. Interview with Jack Levine, Jan. 23, 1998, and interview with Sandra Weiner, Feb. 2, 1998.

32. NYT, Aug. 19, 1972, Aug. 24, 1975, May 28, July 4, 1976.

33. See Rufino Tamayo, *A Marriage Portrait* (1959), in James B. Lynch Jr., *Rufino Tamayo: Fifty Years of His Painting* (Mount Vernon, N.Y., 1978), 50.

34. For *Harmonizing*, see *Art News* 83 (Sept. 1984): 18.

35. CG to MK, Dec. 22, 1997.

Chapter Eight

1. RHG to MK, June 25, 1996.

2. Milton W. Brown, "Raphael Soyer, in Memory," in *Raphael Soyer, 1899–1987* (New York: Forum Gallery, 1987), 1–3; Holland Cotter, "Milton W. Brown, 86, Scholar of Twentieth-Century American Art," NYT, Feb. 15, 1998.

3. Interview with RHG, Jan. 4, 1998; interview with Jack Levine, Jan. 23, 1998; Kendall Taylor, *Philip Evergood: Never Separate from the Heart* (London, 1987), 140. Sidney Goodman remarked that Evergood had always been "accident-prone."

4. RG to PE, Jan. 27, [1965], and PE to TD, Nov. 24, 1964, Evergood papers, AAA.

5. Robert Gwathmey, "Philip Evergood, 1901–1973," *Proceedings of the American Academy of Arts and Letters*, 2nd ser., no. 24 (1974): 122, 125.

6. NYT, Feb. 19, 1971; David B. Dearinger to MK, Dec. 4, 1995. I am also grateful to Mr. Dearinger, associate curator at the National Academy of Design, for taking me into the storage area at the academy on February 2, 1998, to show me these two works by Gwathmey.

7. Howard Devree, "Modern Synthesis," NYT, Apr. 17, 1949.

8. RG to PE, Feb. 17, 1965, Evergood papers. See Milton W. Brown, *American Painting from the Armory Show to the Depression* (Princeton, 1955).

9. RG to Sandy Besser (Arkansas Art Center), Nov. 27, 1979, courtesy of the archives of Stephens, Inc., Investment Bankers, Little Rock, Ark.

10. See *NYT Index 1977: A Book of Record* (New York, 1978), 1006–8.

11. See Angela Miller, *The Empire of the Eye: Landscape Representation and American Cultural Politics, 1825–1875* (Ithaca, 1993), 64. William Styron, a native of Tidewater Virginia like Gwathmey, published *Sophie's*

Choice in 1979, a book that Rosalie read aloud to Bob. Styron, too, is a critical expatriate from the South living in New York City. There may very well be resonances from *Sophie's Choice* in *Nobody Listens*, most notably in the symbol of the collapsed woman.

12. RHG and CG are uncertain just when Parkinson's disease was first diagnosed and when it might have begun to affect his art.

13. Karl E. Fortess interview with RG, July 30, 1967, Fortess taped interviews, AAA.

14. Paul Cummings interview with RG, Mar. 5, 1968, 14, AAA.

15. See Bruce Laughton, *Honoré Daumier* (New Haven, 1976), 43–46.

16. RG to Inez Garson, Jan. 30, 1979, Hirshhorn Archives, HMSG; orthography as in the original.

17. Telephone interview with Sidney Goodman, Dec. 18, 1997.

18. The unpaginated catalog is titled *Robert Gwathmey: Drawings, Watercolors, and Paintings*, the Cooper Union, New York, May 23–June 20, 1985.

19. The catalog is *Gwathmey: Works from 1941–1983* (East Hampton, N.Y., 1984). See also Enez Whipple, *Guild Hall of East Hampton: An Adventure in the Arts, the First Sixty Years* (New York, 1993), 46, for a photograph of the Gwathmeys at the opening; 83, for the *Still Life* (1973) purchased by the Guild Hall, a somewhat unusual work by Gwathmey because of its nonsatirical emphasis on geometric forms; and 254, for a brief description of an interview with Gwathmey given at the time of the exhibit.

20. Barbara Delatiner, "He Paints What Is in His Heart," NYT, July 22, 1984.

21. Ibid.

22. Phyllis Braff, "Forcefulness That Demands Attention," NYT, Aug. 4, 1985.

23. See "Album: Robert Gwathmey," *Arts Magazine* 59 (Sept. 1984): 46–47; Ruth Bass, "Terry Dintenfass, New York: Exhibit," *Art News* 83 (Dec. 1984): 154–55.

24. Judd Tully, "Robert Gwathmey," *American Artist* 49 (June 1985), 46–50, 88, 90–92 (quotation at 90).

25. Ibid., 90.

26. See Delatiner, "He Paints What Is in His Heart," 13; Tully, "Robert Gwathmey," 46; telephone conversation with RHG, Feb. 17, 1998.

27. Telephone conversation with Michael Moses, Feb. 18, 1998. For a dramatic photograph of Gwathmey as an aging observer, see Donald Grant, "Compassion Colored by a Lifetime," *Newsday*, July 22, 1984.

28. Interviews with RHG, May 31, 1996, and Jan. 4, 1998. Gwathmey pronounced the name "Picaaasso."

29. Videotape of the memorial service and tribute held on October 16, 1988, at the Guild Hall in East Hampton, possession of RHG. Morton M. Hunt, an independent writer, is the author of *The Affair: A Portrait of Extra-Marital Love in Contemporary America* (New York, 1969); *The Natural History of Love* (New York, 1969); *Sexual Behavior in the 1970s* (Chicago, 1974); *The Divorce Experience* (New York, 1977); and *Gay: What You Should Know about Homosexuality* (New York, 1977).

30. Interview with George Fox, Mar. 20, 1998. Cecily and George Fox own the important late painting by Gwathmey titled *Farmer and Scareman* (1980), in which the farmer only has blank circles for eyes, as though he is losing or has lost his vision.

31. *East Hampton Star*, Sept. 22, 1988; NYT, Sept. 22, 1988.

32. *International Herald-Tribune*, Sept. 23, 1988; *Chicago Tribune*, Sept. 23, 1988; *Newsday*, Sept. 23, 1988. See also *Los Angeles Times*, Sept. 24, 1988.

33. Tape recording of Gwathmey's remarks supplied to MK by the Sheldon Memorial Art Gallery and Sculpture Garden of the University of Nebraska, Lincoln. Transcribed by MK. On the tape Gwathmey said that he "left home" in Richmond for Baltimore at age twenty-eight. He was actually twenty-two years old at the time.

34. *Proceedings of the American Academy of Arts and Letters*, 2nd ser., no. 40 (1989): 89, 92. From January 7 to 28, 1989, the Terry Dintenfass Gallery, located at 50 West Fifty-seventh Street, had an exhibition titled *Homage: Robert Gwathmey*. The invitation card had one illustration, Gwathmey's *Bouquet* from 1969, a painting owned by TD.

35. William Grimes, "A Gift Pays Tribute to a Father's Artistic Legacy," NYT, Nov. 18, 1993.

36. Abram Lerner, "Robert Gwathmey Observed," in *Gwathmey: Works from 1941–1983*, 7.

37. RG to Inez Garson, Jan. 30, 1979, Hirshhorn Archives; Delatiner, "He Paints What Is in His Heart," 13.

38. Milton Brown interview and dialogue with Raphael Soyer, May 18, 1981, 38–39, AAA.

39. Ibid., 40. See also Cotter, "Milton W. Brown."

40. See Carl Becker, *Everyman His Own Historian: Essays on History and Politics* (New York, 1935), 233–55; C. Vann Woodward, *The Burden of Southern History* (Baton Rouge, 1960), esp. chaps. 1 and 8.

ACKNOWLEDGMENTS

This book could not have been written without the full cooperation and candor of Rosalie Gwathmey, Charles Gwathmey, and Terry Dintenfass. They generously shared documents, memories, photographs, and a great many slides (35mm) of works of art by Robert Gwathmey. They also provided color transparencies of paintings as well. I appreciate their abiding commitment, understanding, and patience, as well as their complete and gracious permissions, more than I can adequately say. In addition, Chanda S. Chapin and Jennifer Rogovin of Terry Dintenfass, Inc., responded to all of my endless inquiries with goodwill and good cheer.

Many individuals assisted me by giving invaluable interviews, most in person and some by telephone. All who did so are cited in the notes; but particular thanks must go to those who talked at special length, with unusual frankness, and in several cases more than once: the late Milton W. Brown, Andrew Dintenfass, Robert Fishko, Sidney Goodman, William M. Landes, Jack Levine, Walter Rosenblum, Raymond Saunders, and Sandra Weiner.

Michael Moses, a Gwathmey aficionado, prompted me to think harder about two important phases of the artist's work. I deeply appreciate his time and generosity. Charles McGovern of the National Museum of American History in Washington, D.C., has an astonishing knowledge of American popular culture in the twentieth century, and particularly of pop music. He provided me with easy access to a tape recording of Billie Holiday's "Strange Fruit" (1939).

The staffs of the Archives of American Art have been exceedingly cooperative over the years, most notably Judith E. Throm in Washington, D.C., and Nancy Malloy at the New York Regional Center in Manhattan. Librarians at the National Museum of American Art and at the Hirshhorn Museum and Sculpture Garden, both in Washington, D.C., helped me solve numerous problems. Anne-Louise Marquis of the Hirshhorn Museum took me within the storage area of that museum twice so that I could examine closely all nine works by Gwathmey owned by the museum. David B. Dearinger did the same for me at the National Academy of Design in New York City. Sharon Frost facilitated my use of the photographs taken by Rosalie Gwathmey that are now located at the Division of Prints and Photographs in the New York Public Library. Cheryl Leibold, archivist at the Pennsylvania Academy of the Fine Arts, in Philadelphia, called to my attention important items pertaining to Gwathmey's art that I might otherwise have missed. Frances Pollard, senior librarian at the Virginia Historical Society in Richmond, very patiently put on hats that are not her favorites: genealogist and newspaper detective. Amanda Kaiser, librarian at the Museum of Contemporary Art in Chicago, responded in resourceful ways to my appeals for help in locating information about several paintings.

I owe a special debt to a man I never met, Paul Cummings (1933–1997). A curator and historian of American art, he directed an oral history program for the Archives of American Art, 1968–78, and in that capacity he conducted extensive interviews with 250 artists and patrons of the arts in the United

States. His "subjects" included Robert Gwathmey (1968) and Terry Dintenfass (1974–75), in lengthy interviews that extended over several sessions. I have relied on numerous other interviews as well, but without Cummings's sensitive prompting of Gwathmey and Dintenfass, this book would have less of the quiddity that comes from listening to the voices and views of principal participants.

During 1997–98, when this book was written, I received fellowship support from the National Endowment for the Humanities and was a guest scholar during a critical four-month period at the Woodrow Wilson International Center for Scholars in Washington, D.C. I feel deeply obliged to both institutions for their support. At Cornell University my undergraduate assistant, Craig W. Ginsberg, did a great deal of conscientious and reliable digging to help solve mysteries large and small. Judith Holliday and Barbara Prior of the Fine Arts Library at Cornell tracked down some elusive references and resources. Jennifer Evangelista prepared the manuscript with her customary dispatch, patience, and good cheer. Alex Russell helped in countless ways at the Wilson Center, as did Mark Barron and Sara Sinha at Cornell. Kathryn Torgeson of Ithaca once again crafted my index with particular care.

I am exceedingly grateful to Dr. A. L. Freundlich for sharing with me his enthusiasm for Robert Gwathmey's art, for curating the retrospective exhibition that opened in September 1999 at the Butler Institute of American Art, and for giving me a notably helpful reading of this manuscript. Others who reviewed it critically and constructively include Dan T. Carter, Wilton S. Dillon, Elizabeth Johns, Carol Kammen, Townsend Ludington, Nannette V. Maciejunes, George H. Roeder Jr., Morton Sosna, and Adam D. Weinberg. Each reader improved the project in very significant ways.

The staff of the University of North Carolina Press, notably Director Kate Torrey, Editor in Chief David Perry, and above all my truly remarkable editor, Sian Hunter, believed in the project when several other publishers viewed it as financially nonfeasible. I shall always remember their good faith and commitment to a costly undertaking. April Leidig-Higgins, also of the University of North Carolina Press, is a creative designer with vision; Managing Editor Ron Maner was meticulous in supervising the manuscript's progress; and Stephanie Wenzel handled the line editing with care and consideration.

A very special expression of appreciation goes to Liza and Michael Moses for their gift of substantial support to the University of North Carolina Press, making it possible to enhance significantly the number of color plates of Gwathmey's art included in this book. Their thoughtful and generous assistance was given in memory of Michael's parents, Jean and Charles Moses, who loved and collected the art of Robert Gwathmey.

Finally, Carol Kammen was involved from start to finish, helped immeasurably with quite a few of the interviews, and above all, has shared my affection for the art of Robert Gwathmey.

M.K.
September 1998
Above Cayuga's Waters

INDEX

Paintings, other works of art, and books are indexed by title.